Domestic and Divine

DOMESTIC AND DIVINE

ROMAN MOSAICS IN THE HOUSE OF DIONYSOS

Christine Kondoleon

Cornell University Press
Ithaca and London

Published with the assistance of the J. Paul Getty Trust and of Williams College.

First published 1994 by Cornell University Press.

Printed in the United States of America

♾ The paper in this book meets the minimum requirements
of the American National Standard for Information Sciences—
Permanence of Paper for Printed Library Materials, ANSI Z39.48-1984.

Library of Congress Cataloging-in-Publication Data

Kondoleon, Christine.
 Domestic and divine : Roman mosaics in the House of Dionysos /
 Christine Kondoleon.
 p. cm.
 Includes bibliographical references (p. –) and index.
 ISBN 0-8014-3058-5 (hardcover : acid-free)
 1. Mosaics, Roman—Cyprus—Paphos. 2. Pavements, Mosaic—Cyprus—
 Paphos. 3. Mythology, Greek, in art. 4. House of Dionysos
 (Paphos, Cyprus) I. Title.
 NA3770.K66 1994
 729'.7'093937—dc20 94-33565

To the memory of Kyriakos Nicolaou

Contents

Acknowledgments

The questions teased out by the bold and unusual mosaics in the House of Dionysos at Paphos in Cyprus sparked my interest over a decade ago and prompted the initial research that led to this book. The anomalies presented by these compositions, especially for the work of the middle Roman date established by the archaeological finds, offered a rare opportunity to examine a host of issues currently pressing social historians. Close analysis of these pavements yielded strategies for "reading" Roman interiors. Analogous mosaics, reliefs, and paintings elsewhere indicate a dynamic history of cultural and economic exchanges among Mediterranean communities, from which we can trace the impact of Romanization on domestic life.

Among the many individuals and institutions to which I am indebted for assistance during the writing of this book, Ernst Kitzinger must be named first for his continued advice and suggestions. For the initial invitation to study and publish these mosaics, I am deeply grateful to the late Kyriakos Nicolaou, excavator of the site at Paphos. His generous and open attitude was greatly appreciated by his colleagues. In keeping with her husband's wishes and with her own gracious spirit, Ino Nicolaou aided my work by sharing important plans and drawings. From my early field research to the final stages of publication I was dependent on the cooperation and excellent services of the Department of Antiquities, Cyprus. For their permission to study and to photograph mosaics at sites and museums, Vassos Karageorghis and Athanasios Papageorghiou, former Directors of the Department of Antiquities, Cyprus, were instrumental. A. H. S. Megaw set me on course with his profound knowledge of Cypriot archaeology during the

excavation of the Basilica at Kourion. Demetrios Michaelides, friend, esteemed colleague, and fellow mosaic enthusiast, offered much informed and valued advice. Stuart Swiny, as Director of the Cyprus American Archaeological Research Institute, provided the services of that institution and, with Laina Swiny, hospitality and friendship during my various visits.

Because this book draws so many parallels from the repertoire of North African mosaics, I wish especially to acknowledge authorities in Tunisian institutions. Above all, I express my thanks to Aïcha Ben Abed-Ben Khader, former Conservateur of the National Museum of the Bardo and Co-Director of the Corpus of Tunisian Mosaics, for courtesies in her official capacity and for innumerable acts of friendship. For their permission to study and photograph sites, I thank M. A. Ennabli, M. M. Ennaifer, and H. Slim of the National Institute of Archaeology and Art, Tunis. Margaret Alexander, Co-Director of the Corpus of Tunisian Mosaics, has been involved in this project from its outset and has given freely of her expertise and time.

Funds for research trips and photographs were generously provided by Williams College and a Fulbright-Hays Fellowship. The cost of the final publication has been aided by subventions from the J. Paul Getty Trust and Williams College. When it seemed that I faced too many obstacles, the persistent faith and interest of Bernhard Kendler, executive editor at Cornell University Press, was an effective prod. Judith Saltzman, as an architect and a drawer of Roman mosaics, produced clear plans and valued suggestions. For their close readings of certain parts of this text, I thank Mirka Beneš, Bettina Bergmann, Katherine Dunbabin, Miranda Marvin, and Guy Métraux. For help at various stages of preparation, I thank Margaret Burchenal, Anna Gonosová, and Sharon Slodki.

To a man, Frederic Wittmann, and a boy, Lucas Wittmann, who kept pace over many a Mediterranean pavement, I owe the greatest debt for their enduring patience and good will.

C. K.

Domestic and Divine

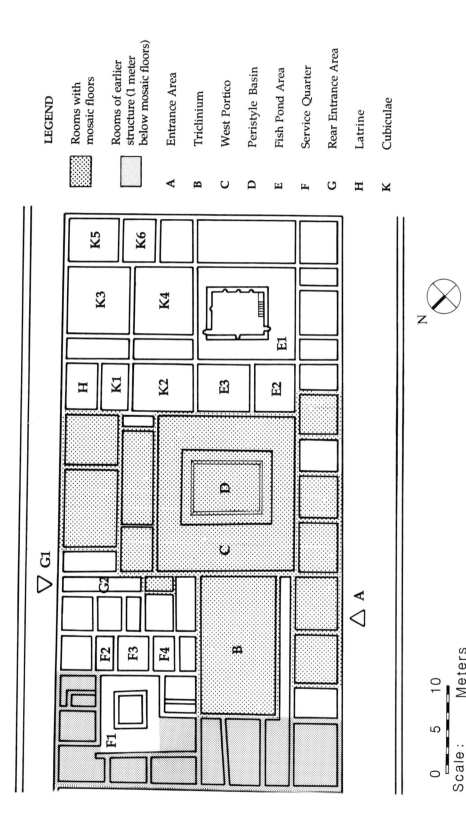

LEGEND

| | Rooms with mosaic floors |
| | Rooms of earlier structure (1 meter below mosaic floors) |

A Entrance Area
B Triclinium
C West Portico
D Peristyle Basin
E Fish Pond Area
F Service Quarter
G Rear Entrance Area
H Latrine
K Cubiculae

N

FLOOR PLAN

THE HOUSE OF DIONYSOS

NEA PAPHOS

Scale: 0 5 10 Meters

Figure 1. Floor plan, drawn by J. Saltzman

Introduction

RECENT SCHOLARSHIP, as well as this book, draws on the premise that the art and architecture of Roman houses express the social realities of their inhabitants.[1] It assumes that these houses—their floor plans, the shapes of their rooms, and their decorations—reflect not only the private lives of citizens and their familial interactions but their public affairs as well. Because of the inter-penetration of *res privata* and *res publica* within the Roman household, the house itself is an excellent object of study for social historians who seek in the ritualizations of domestic life the preoccupations and values of a society. To the extent that the public life of the *dominus*—the head of the household—was enacted within his home, the *domus* can serve as a sociopolitical document. The constructions of domestic life declared the status of the owner-patron, his class aspirations, and his achievements.

There is much, however, that we do not know about Roman houses. The epigraphic evidence for individual houses is scant, and most houses cannot be matched with a specific patron or family. Nor is it often possible to trace the names of a series of owners for any particular house. Questions remain about the way

1. For some recent studies, see Clarke 1991b on the houses of Roman Italy; Wallace-Hadrill 1988 on social structures in the Roman house; Wallace-Hadrill 1994 and Thébert 1987 for reflections on Roman houses in North Africa; Allison 1992 on the relationship between wall decoration and room type in Pompeian houses; Neudecker 1988 for sculptural decor in Roman villas; and Gazda 1991 for an anthology on Roman private arts.

property was transmitted and just how the social elite reproduced itself. Most of our evidence is drawn from the houses of the middle and upper classes, and so our conclusions are about the privileged in Roman society. Excavations, especially of grand villas, go after the glamorous remains—reception rooms, baths, audience halls—ignoring the utilitarian quarters of slaves and servants. As we admire the sumptuous spaces filled with luxurious decorations, including mosaics, statuary, textiles, and furnishings, we should not lose sight of the fact that these spaces and accoutrements were designed and selected to celebrate the social and political power of the owner.

Unlike the nineteenth-century bourgeois who withdrew from public life into his private drawing room, Romans commanded their domestic interiors as public stages integrating commercial, social, and familial practices.[2] Although some of the imagery of these interiors might be characterized as fanciful and even private, there is an overriding impression of intentional display, of themes and presentations that self-consciously represent the owners and promote their own ruling culture.

Of all the types of domestic ornament, mosaics provide the most abundant extant evidence and are therefore a rich resource for contextual inquiries. The nineteenth-century architect Gottfried Semper held theories about interior decoration, especially the allied (even ancestral) medium of textiles, which are helpful when we examine the function of mosaics. On the basis of emerging archaeological evidence, Semper argues that ancient buildings were sheathed in polychromy—painted walls, colored stuccoes, hanging carpets—to such an extent that these decorative devices, and not the architectural plan, defined space.[3] At first, interior spaces were formed by the use of textiles; to Semper building began with ornament.[4] In other words, space was constructed by the language of decoration, be it woven fabrics that served as makeshift walls or paintings whose illusionism might dissemble walls or reinforce them with imitation masonry, or floor mosaics that could physically guide the visitor through the floor plan with a multiplicity of indicators. The architectural plan, the structure of the house, and its decoration are of one body. With Semper's model in mind, one can set the mosaics within the framework of the house; therein they become eloquent witnesses to the elusive dialogue between inhabitants and guests, between owners and clients, and to the

2. Walter Benjamin in his essay "Paris, Capital of the Nineteenth Century" characterized nineteenth-century living space as a "box in the world theater": the individual creates an environment in which "he gathers remote places and past" but assiduously avoids references to his commercial and public life (1978, 154).

3. Semper presents these theories in "The Four Elements of Architecture" and "Style: The Textile Art" (1989, 104, 254, respectively).

4. In a commentary on Semper, M. Wigley puts the case succinctly: "Building originates with the use of woven fabrics to define social space. Specifically, the space of domesticity. The textiles are not simply placed within space to define a certain interiority. Rather, they are the production of space itself" (1992, 367).

persistent intermingling of public and private—the boundaries of which were vague, at best, in Roman life.[5]

The House of Dionysos at Paphos and its floor mosaics of the first and second centuries, the middle Roman period, offer an intriguing case for the study of the *domus* as cultural document. My task is not to present a catalogue of these Cypriot pavements but to reconstruct the concerns and intentions of its inhabitants through the decoration. Although I address questions of chronology, archaeology, technique, and iconography, the ultimate goal of each chapter is contextual interpretation. This is possible at Paphos because the pavements are preserved in an archaeologically excavated site with a complete floor plan. The site also offers an unusually rich view of the process by which provincials assimilated Roman habits and institutions.

Can local mentalities be read in their selection, interpretation, and combination of mosaic themes? Certain design strategies are distinctively Roman and should be read as cultural expressions that respond to the patrons' desires. Some mosaics can stand alone as symbols of status; multiplied, they reinforce that impression. Our knowledge of the reception of specific designs is assisted by our reading of ancient literary sources.[6] Of course, not every pattern or figure was purposefully selected; workshop practices and artistic traditions play a dominant role in mosaic production. In our consideration of the sources and meanings of the mosaic themes found in the Paphian house, a balance of approaches proves most rewarding.

THE SITE AND ITS HISTORY

The chance discovery of a mosaic pavement in 1962 led to the excavation of the so-called House of Dionysos at Kato Paphos on the southwestern coast of Cyprus.[7] The impressive size of this private dwelling of over forty rooms, spread over

5. For a textured treatment of the interplay of these spheres in Roman houses, see Wallace-Hadrill 1988, 43–97, and 1994, 17–37.

6. The application of literary reception theory to the poetry and painting of late Republican and Augustan Rome presented by Leach 1988 offers a theoretically based model for the reconstruction of the ancient beholder's response. For criticisms of this approach, see Ross 1991, 262–67; and Bergmann 1991, 179–81.

7. The house was named for the prominence given Dionysiac themes in its mosaics; see K. Nicolaou 1963, 56n.1. The site received two preliminary publications, K. Nicolaou 1963 and 1967. Annual accounts of the excavations (to avoid confusion with other listings for these same authors in the bibliography, I give full citations here) are reported by V.Karageorghis, "Chronique des fouilles et découvertes archéologiques à Chypre en . . ." as follows: *BCH* 87 (1963), 382–85; *BCH* 88 (1964), 372; *BCH* 89 (1965), 292; *BCH* 95 (1971), 415–17; *BCH* 97 (1973), 678; *BCH* 98 (1974), 892–93; and *BCH* 100 (1976), 841. See also K. Nicolaou, "Archaeology in Cyprus, 1965–66," *ArchReports* (1966), 39–41; id., "1966–69," (1969), 50–51; id., "1969–76," *ArchReports* (1976), 59; id., "Archaeological News from Cyprus 1970," *AJA* 76 (1972), 315–16; and K. Nicolaou 1968a, 48–53. For an iconographic and stylistic discussion of the mosaics, see Vermeule 1976, 78–79, 80–81, 101–14, pls. IV.A, 1–4, pls. III.8,10–11,13. Illustrations of the mosaics may also be found in K. Nicolaou 1968b, pls. 38–44; more recent publications are cited below in Chapter 2, n.4.

an area of 2,000 square meters, and the elegance of its decoration, including fifteen mosaic floors and walls covered with painted stucco, attest to the high standard of life under Roman rule and the degree to which certain elements of Cypriot society were Romanized (fig. 1). This view is supported by the Polish excavation of the even grander House of Theseus, probably the governor's palace, located 100 meters south (see map, fig. 2) of the House of Dionysos, and by topographical and archaeological surveys that reveal the remains of other fine residences adorned with mosaic pavements.[8] Two of these have been under excavation by the Cypriot Department of Antiquities; they are located immediately west of the House of Theseus and are called the House of Orpheus and the House of the Four Seasons.[9] Taken together, these discoveries indicate a residential quarter in the southwestern sector of the city near the western sea wall, with the ancient harbor to the extreme east and the acropolis to the north.

The remains of religious and civic buildings from the first and second centuries testify to the prosperity of Paphos and the generosity of the local elites who paid for these structures. Undoubtedly, they were the inhabitants of the richly appointed houses with mosaics. On the eastern slope of the hill called the acropolis, not more than 250 meters northeast of the House of Dionysos, an Odeon, an Asklepeion, and an Agora have been excavated and dated to the first half of the second century (fig. 2).[10] Other public edifices included an amphitheater identified by an oval depression near the harbor, a gymnasium located by an inscription found near the Odeon, and a rock-cut theater still visible near the northeast gate.[11] The principal temples were probably in the sacred precinct of the Paphian Aphrodite in the old city (Palaipaphos).[12] Even more lavish Roman monuments are to be found at Salamis at the northeastern end of the island, and along with the ruins at Kourion and Kition, they provide an overview of the Cypriot *polis* in Roman times.

Given these impressive physical remains, the relative silence of the literary and epigraphic sources on the role of Cyprus in Roman Imperial history is curious.[13]

8. For the House of Theseus, see Daszewski 1968, 33–61; Daszewski 1972, 204–36; Daszewski 1976, 185–225; and Daszewski 1977; for the mosaics, see Daszewski and Michaelides 1988b, 53–76. Immediately to the east of the House of Dionysos, on the other side of the eastern street, begins another house—only its geometric mosaics are extant; see K. Nicolaou, "Archaeology in Cyprus, 1965–66," *ArchReports* (1966), 40.

9. The excavations of the House of Orpheus have been undertaken by D. Michaelides; see Michaelides 1986b, 475n.17, for a record of the short archaeological reports. Three figural mosaics (Orpheus, an Amazon with her horse, and Hercules and the Nemean Lion), provisionally dated to the late 2d century, have been discovered thus far; see Michaelides 1987, 12–14, nos. 4–6, for descriptions and bibliography. For the House of the Four Seasons, see Michaelides 1986a, 212–21; he is currently excavating this house.

10. Karageorghis, "Chronique des fouilles et découvertes archéologiques à Chypre en 1978," *BCH* 103 (1979), 717–18; and K. Nicolaou, "Archaeology in Cyprus, 1980–1981," *ArchReports* (1981), 68–69, who dates the complex after an earthquake of A.D. 76/77.

11. K. Nicolaou 1966, 561–601, esp. 578–83.

12. See ibid., 583–87, on the temples within Nea Paphos; and Mitford 1980a, 1313–15, on the precinct at Palaipaphos.

13. The following historical account is culled mainly from Mitford 1971, 1974, and 1980a, 1286–1384; Hill 1940; Chapot 1912, 59–83; and Seyrig 1927, 139–54.

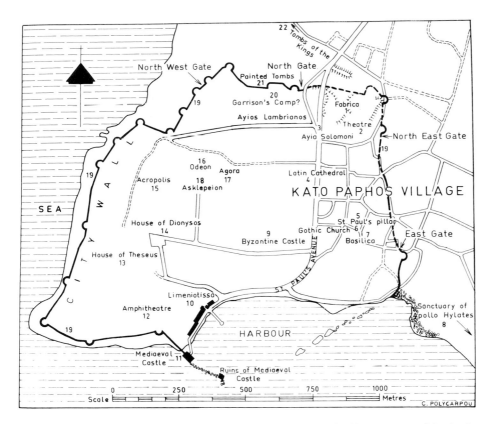

Figure 2. Site of Nea Paphos, by C. Polycarpou (courtesy of the Department of Antiquities, Cyprus)

The Romans held Cyprus as a minor senatorial province under the empire and, judging from the minimal attention of ancient historians, it was considered a provincial backwater. Some historians postulate that its minor position was a result of its intimate association with Ptolemaic Egypt; Ptolemaic Cyprus had been ceded to Rome as an outcome of the Battle of Actium.[14] This connection may account for the facts that Cyprus possessed no colonies and that no Cypriot held a significant position in the Roman government during the Imperial period. Although Roman citizenship was uncommon and seemingly unobtainable even for the magistrates, these same Cypriot notables supported institutions of the *polis* and affirmed their *Romanitas*.[15] The archaeological evidence records far more eloquently the Romanization, prosperity, and cultural activities of Cyprus.

The spectacular mosaics, largely from Paphos, support the notion that there was a rise in prosperity in the late-second century which coincided with the reign

14. Mitford 1980b, 286; and Mitford 1980a, 1296.
15. On the incidence of Roman citizenship in Cyprus, see Mitford 1980b, 284; and 1980a, 1362–65.

of the Severans (A.D. 193–235).[16] As the home of the cult of the Paphian Aphrodite and her internationally known temple, Paphos held the position of island capital from the Ptolemaic through the Roman periods.[17] The bestowal of such titles as *Augusta* and *metropolis* showed the favor of the Roman rulers.[18] In response, Paphos was quick to adopt an Augustan calendar and to assimilate Roman customs.[19] In more general ways, Paphos shared a cultural and architectural uniformity with its sister cities of the Roman east which attests to the effectiveness of its curial class in managing to imprint a Roman quality upon a Hellenic city.

Social amenities (baths, theaters, temples) and testaments to urban life (public inscriptions and statuary), albeit on a more modest scale, parallel those found in other cities of the Roman east (e.g., Kos, Corinth) and indicate the homogeneity of the Roman civic experience.[20] These cities were governed externally as part of senatorial provinces and internally by a *koinon* or city council, and in each case the urban plan of the Hellenistic *polis* set the outlines for the Roman city by literally furnishing the foundations for the Roman buildings.[21] Trade and communication with the coast of Asia Minor were easy and led naturally to cultural exchanges. There were also sizable communities of Romans, mostly *negotiatores* (traders), as in Cyprus, who must have reinforced the ties to Rome.[22] The comparisons that can be made among the house designs and mosaics of the burghers in these cities demonstrate that a koine of private art and culture existed at the highest levels of society throughout the Empire and that signs of Romanization may be traced in the private realm as well as in the public.[23]

ARCHAEOLOGICAL EVIDENCE

The excavations of the House of Dionysos were conducted by the Department of Antiquities of Cyprus under the direction of K. Nicolaou from 1962 to

16. The grandeur of the Severan tombs has also been cited as proof of a "golden age"; see Michaelides 1987, 3.

17. The reverence of the Julians for Aphrodite led naturally to the gift of the title of *Augusta* for Paphos; see Mitford 1980b, 286.

18. Her rival for these honors was Salamis, the industrial center of the island; Salamis was, in fact, rebuffed by Rome for taking the title *metropolis* that was "clearly the prerogative of Paphos" (Mitford 1980a, 1312).

19. For a lengthy discussion of the use of the Augustan calendar in Paphos, see Mitford 1980a, 1357–61.

20. For Roman Kos, see Sherwin-White 1978, passim, esp. 24–28, 145–52, and 247–55. For the possession of sacred and public land in Cyprus in the early Imperial period, see ibid., 149n.361. For Roman Corinth, see Wiseman 1979, 439–547. For a general overview of aspects of Roman rule in the east, see A. H. M. Jones 1963, 3–19. For a rich discussion of the social and political realities of Roman life in Asia Minor in the province of Cilicia, which is closely tied to Cyprus historically and geographically, see C. P. Jones 1978, passim, esp. 65–82 on Apamea and Tarsus.

21. For an excellent historical overview of civic life in the Roman east, see Harl 1987, esp.1–5.

22. See Sherwin-White 1978, 252–55, for the Romans on Kos; and Mitford 1980b for a discussion of the Roman trading communities. See also Mitford 1980a, 1297.

23. For the mosaics of Roman Kos, see Morricone 1950, 219–46, with references and illustrations of the mosaics discovered. For the mosaics of Roman Corinth, see the convenient list in Waywell 1979, 297–98, Corinth nos. 16–23, which includes the bibliography for each site.

1974.[24] At first the mosaics, all from a single period, were dated on stylistic criteria to the late third century A.D., but J. Hayes's subsequent analysis of the pottery finds and the analysis of the mosaics below indicate a date about one century earlier.[25]

Unfortunately, the stratigraphy of the House of Dionysos is disrupted because the house stands at a much higher level than the other buildings in the area, very close to the modern surface and to the plowed topsoil. As a result, the relationship of the Roman house to an earlier structure on the site and to the time of its own destruction cannot be precisely determined. Clearly, the house was destroyed as a result of seismic activity occurring soon after the mosaics were completed. The extent of the destruction and the use of the site as a source of building stones by later inhabitants preclude even an exact determination of the boundaries of the house. It is not certain, for example, whether the wall that collapsed on a man during an earthquake (as evidenced by the discovery of a skeleton at the southeast corner of street bordering the western wall of the house) belongs to the house with the mosaics or to an earlier structure.[26] Fortunately, a pocketful of twelve coins, the latest dated A.D. 126, was found with the skeleton and provides clear evidence of an earthquake in late Hadrianic times.[27] These data coincide with the evidence of the pottery found in the latest destruction levels outside the House of Dionysos; all of this pottery belongs to the late first and early second centuries.[28] All the rooms adjacent to the western wall (fig. 1) are one meter lower than the level of the mosaic floors and, therefore, do not seem to belong to the House of Dionysos.[29] It seems highly unlikely then that the house with the mosaics was leveled by the Hadrianic earthquake. Rather, it must have been built over the debris of the earlier structure. This view is supported by the style of the mosaics, which indicates a date not before the middle of the second century.

The pottery finds as analyzed by J. Hayes provide the most reliable information for the date of the building.[30] Wares found in the levels sealed by the mosaics provide a reliable *terminus post quem* of the early second century for the House of Dionysos. These deposits reveal a concentration of Italian Sigillata which is surprising for an eastern site. Typically, Eastern Sigillata, produced in Antioch, appear more frequently in the east, where it was the predominant export ware.

24. See above note 7 for a full list of the archaeological reports.

25. The 3d-century date was suggested by K. Nicolaou (1963, 72, and 1967, 101) and accepted by many scholars on the basis of the style of these mosaics.

26. K. Nicolaou 1967, 107–8 and fig. 6. In a conversation with me, K. Nicolaou himself questioned whether this collapsed wall belonged to the House of Dionysos or to the earlier structure.

27. For description of these coins, see I. Nicolaou 1990, 144–46.

28. Hayes 1977, 97.

29. K. Nicolaou 1967, 118. J. Hayes told me that his pottery analysis of this sector supports the conclusion that it does not belong to the House of Dionysos. The room farthest west at the same level as the mosaics is the one immediately adjacent to room 1 on the western wall (fig. 3).

30. For the ensuing discussion of the pottery finds, I am indebted to J. Hayes for sharing his great knowledge of Roman ceramics. For the final report on this material, see Hayes 1991, passim.

Cypriot Sigillata, local versions of the popular Antiochene ware, supplanted eastern imports during the first and second centuries.[31] The Cypriot imitations offered serious competition to other Sigillata wares, as evidenced by their considerable presence at Palestinian, Egyptian (Alexandria), and Aegean (Rhodes) sites and as far west as Sabratha and Pompeii. The major wares represented at the Paphian site are the Cypriot and Italian Sigillata.

The imitation of Antiochene pottery in Cypriot workshops provides an interesting parallel to the production of the Paphian floors and their relationship to the Antiochene mosaics, which will be discussed further in Chapter 2. Equally compelling is the unusually high percentage of imported Italian wares, including many types scarcely recorded elsewhere in the east, which were found in the sealed deposits below the mosaics.[32] These strongly suggest direct trade links with Campania and support the stylistic and iconographic parallels—traced later in this book—between western artistic developments, especially Italian and North African, and Paphian mosaics. The appearance of this Italian Sigillata ware in Paphos and the discovery of Cypriot Sigillata in Alexandria and the Aegean may indicate a role, hitherto unrecognized, for Paphos in the trade among Rome, Alexandria, and the east.[33] Such a role certainly would offer an explanation for the cultural exchanges reflected in the mosaics and architecture.

The only reliable evidence providing a *terminus ante quem* for the mosaics—that is, a date for the final destruction of the house—comes from a deposit of many wine amphorae found in the far north corner of the east portico.[34] The pottery, comprised of what seem to be Cypriot versions of well-known amphora types and Pompeian Red Ware cooking dishes, has been assigned to the second century by Hayes, who finds no evidence that these types were produced after A.D. 200.[35] Modern leveling operations have destroyed all other traces of stratigraphy above the floors, so that the dating of these wine amphorae is of prime importance for the chronology of the house. The lack of closely datable fine wares after the first half of the second century makes it difficult to provide a firmer date for these amphorae, but, even if they were of Antonine manufacture, they could have been used as storage jars until a later period. On the basis of these destruction deposits, Hayes proposes a late-second-century date for the destruction (by an

31. Hayes (1967, 65–77) gives a detailed analysis of this local ware and its relationship with other eastern pottery.

32. Hayes 1977, 99.

33. Hayes has made a strong case for this observation in personal conversations as well. Corroborative evidence for trading activities of this nature was found in the form of 600 stamped amphora handles of the Rhodian type used for transport and trade in the artificial harbor at Nea Paphos; see K. Nicolaou 1966, 601n.94.

34. Large numbers of amphora fragments were deposited in the corridors of the north and east sides of the peristyle; see Hayes 1991, 205, pls. I.3 and I.4, for photographs of the caches in situ.

35. Hayes (1991, 212; 1977, 96–97; and 100n.7) points out that similar examples of classic Pompeian Red Ware fabric are known from Greek sites as late as the middle of the 2d century. Because there are no attested pottery kiln sites on Cyprus, the suggestion that these are local imitation wares remains hypothetical; see Hayes 1991, 90.

earthquake?) of the House of Dionysos.[36] This theory is supported by the absence of third- and fourth-century pottery and coins at the site, a fact that is especially striking in light of the third-century date originally assigned to these mosaics. If the house was built on the debris of the Hadrianic destruction, then the mosaics were in place a relatively short time before they were buried by a late-second-century earthquake. The question of a date for the House of Dionysos will be kept in sight throughout this book, as the stylistic and iconographic discussions of the mosaics reveal internal evidence for the chronology. Comparative dating problems at other sites are reviewed in the Conclusion.

ARCHITECTURE: THE PLAN

Paphos may be taken as an example of a modest eastern provincial city under Imperial rule, and the House of Dionysos can serve as a model of an elite residence that incorporates the cultural habits of Rome in a Greek eastern setting. Aspects of the plan, as well as the mosaic decoration of this Paphian town house, reflect the political position of the capital as "ostentatiously pro-Roman."[37] The *domus* was built on the ashlar foundations of an earlier Hellenistic house.[38] The house was redesigned and rebuilt with features characteristic of Roman houses of the period, namely a peristyle (courtyard), a triclinium (dining room) (B), and a fish pond (E); see floor plan, fig. 1.

A general view of the house reveals a quadrangular plan of roughly 56 meters by 30 meters (2,000 sq. m.) with over forty rooms (figs. 3, 4). As is typical of a peristyle house, the rooms appear to radiate from the porticoed courtyard (fig. 1, area C/D), but the layout of the rooms reveals an arrangement of three discrete blocks placed laterally along the north-south axis. Each area can be generally defined by its utilitarian, hospitable, or familial function; each has its own court, namely eastern, central, or western. The western section contains the main entrance, the triclinium (B) with its subsidiary service quarters tucked into the northwest quarter and centered on a small courtyard with a basin (F). The central block is identified by the large peristyle (D), the nucleus of the whole house. This area received the most lavish decoration, as evidenced by the number of mosaic floors to the north and south of the peristyle; it clearly served the reception needs of the owner. Since the triclinium opens eastward onto the west portico of the peristyle court (C), it is in direct correspondence with the hospitable section of

36. This proposal refutes an earlier theory that the building was destroyed by one of the historically recorded earthquakes in the 4th century; see Hayes 1991, 212.

37. This phrase is used by Mitford 1980b, 275.

38. K. Nicolaou 1967, 108. The floor plan in fig. 1 herein represents a simplified version (i.e. all walls are indicated with a solid line, although not all of them are extant) of the plan published by K. Nicolaou 1967, 102, fig. 1. For the sake of clarity, two plans are offered in this text: the first shows room types marked by letters (fig. 1); the second identifies the mosaic subjects by room numbers (fig. 3).

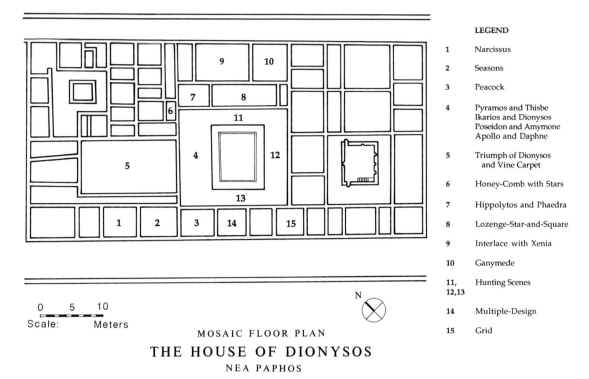

0 5 10
Scale: Meters

N

MOSAIC FLOOR PLAN

THE HOUSE OF DIONYSOS
NEA PAPHOS

Figure 3. Mosaic floor plan, drawn by J. Saltzman

the house. The third zone is located in the eastern wing with bedrooms set near the fish pond; latrines have also been located in this part.

The plan functioned to isolate guests from inhabitants. Those invited had access to the central core of the house, the triclinium-peristyle zone. A guest might enter off the south street,[39] proceed through the rooms with their salutatory mosaics, and either enter into the triclinium or walk into the peristyle with its sumptuously decorated rooms arranged along the north and south flanks. We can see how the peristyle serves to order the various parts of the house: the utilitarian section lies along its west side, the hospitable zone in the center, and the area reserved for familial use on its eastern side.

A critical factor determining the sequence and use of the rooms is circulation, and circulation depends heavily on the location of entrances. Because not a single entrance has been marked on the excavator's 1965 plan, this exercise is challenging at best. Nonetheless, the mosaics themselves indicate traffic patterns and the sequence and function of rooms. Whenever possible, I interpret the architectural plan with the aid of the mosaics. Because much recent scholarship has concerned itself with the material documents of private life, we are now in a better position

39. A discussion on the location of the entrance follows below.

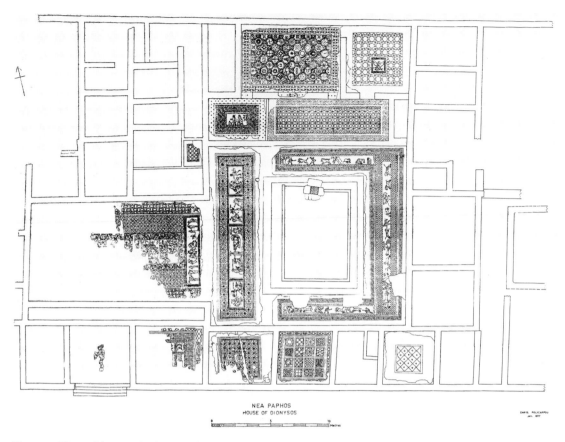

NEA PAPHOS
HOUSE OF DIONYSOS

Figure 4. Plan with mosaic designs, by C. Polycarpou (courtesy of I. Nicolaou)

to postulate the habits and movements of the proprietors, servants, and visitors (clients, friends) who were the "public" audience of a *domus.* The ancient sources guide us in this effort. Vitruvius (*De architectura* 6.5.1) noted the differences between the private familial sections of the house and those parts accessible to visitors. Pliny (*Epistles* 2.17.5–10) remarked on how the decoration, location, and proportions of rooms were related to their functions and types.

Although fascinating as material documents of daily life, the western and eastern zones of the house are of less concern here because the floors of most rooms are of beaten earth or paved with pebbles. A few remarks, however, may serve to highlight just how effectively the house was designed and decorated for its diverse functions. The archaeological evidence confirms that the service quarters were in the west wing. This area had a separate entrance from the north street (G1) which led into a long passage (G2) with an antechamber (fig. 3, room 6).[40] Floors of beaten earth and numerous cooking pots suggest that the kitchens were

40. K. Nicolaou 1967, 116.

here (fig. 1, F2, F3, F4).[41] There are five rooms adjacent to the western walls of the kitchens; the remains from these rooms and their beaten-earth floors led Nicolaou to identify them as workshops.[42] The utilitarian character of these rooms is shown by their arrangement around a small court with a central basin (F1) and by the treatment of their floors. Traces of lime cement were found on the floor of the basin, as well as evidence of a drainage system, both of which indicate that this was a properly equipped impluviate system.[43] In fact it is the only basin in the house with a waterproof lining.[44] Judging from its location, this smaller basin certainly provided water for laundry and other service needs, and it could well have provided water for the household.

Let us cross the central core of the house for the moment and enter the east wing with the fish pond (E1).[45] The deep reservoir is coated with a thin layer of lime cement and has a flight of steps to its bottom, where several niches are cut into the sides. A well-stocked Roman fish pond, or *piscina*, was one of the luxurious features of Italian patrician villas, and owners were often held in contempt for the lavish indulgence they showed their marine pets.[46] Terracotta amphorae were built into the sides of these pools to provide shady retreats and breeding areas for the fish, and these correspond in function to the niches found in the Paphian pool.[47] Unlike the house owners of Campania who substituted painted reproductions of fish inventories, the patron at Paphos incorporated, albeit on a small scale, this opulent appointment of Italian aristocratic estates within the confines of an urban *domus*.[48]

A suite of rooms to the north of the *piscina* (K1–K6), the floors paved with small pebbles coated with lime cement, have been identified by the excavator as bedrooms.[49] The discovery of a latrine with seating facilities and a drainage system (H) seems to support this suggestion.[50] In addition, narrow corridor-like spaces are set between these rooms (between K1, K2, and K3, K4) in an arrange-

41. For a summary description of these rooms and their remains, see ibid., 116–17.

42. See ibid., 117.

43. Despite the impluviate nature of this basin, the court should not be called an atrium because, among other reasons, it is sited in the midst of the utilitarian quarter.

44. For a description of the peristyle basin, see below.

45. K. Nicolaou 1967, 101 and 103, fig. 2.

46. See Jashemski 1979, 108; and McKay 1975, 115. For a related discussion of the social status of the *piscina* and marine decorations, see Kondoleon 1991, 106–7. The addition of fish ponds increased the property values of Roman houses; see D'Arms 1981, 82n.43.

47. Fish hatcheries in the form of small amphorae embedded in the masonry of a central basin were found in the House of Castorius at Djemila; see Thébert 1987, 367–68. For an illustration of such devices, see Jashemski 1979, 110, fig. 178.

48. See Jashemski 1979, 110, fig. 179, for a garden painting in the Villa of Diomedes showing a well-stocked fish pond on the garden wall.

49. K. Nicolaou 1967, 101, 115. Five bedrooms are identified, including rooms K3, K4, K5, K6, and others are thought to lie to the southeast of the fish pond as well, but only the remains of the Hellenistic house survive in this area.

50. K. Nicolaou 1967, 115.

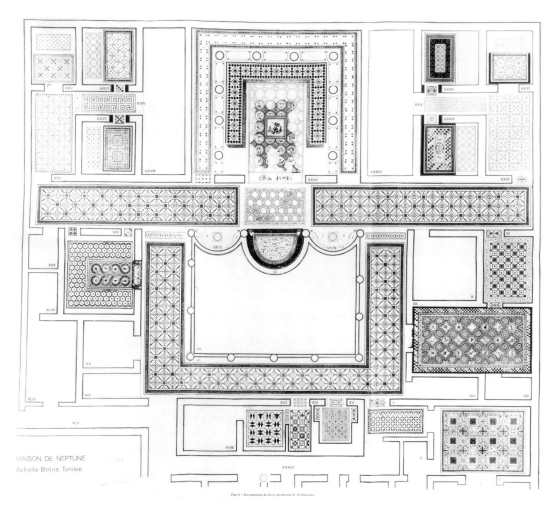

Figure 5. Plan of the House of Neptune, Acholla, drawn by R. Prudhomme (courtesy of S. Gozlan)

ment for bedrooms or *cubicula*.[51] Similarly disposed rooms occur in the west wing of the House of Neptune at Acholla, where two groups of chambers are symmetrically arranged to the north and south of the great *oecus* (fig. 5).[52] In each wing are three narrow rooms flanked by even narrower side chambers, all paved

51. Perhaps the smaller K6 adjacent to the larger room K5 abutting the north wall of the house serves as a kind of antechamber as well; K. Nicolaou describes these two rooms as bedrooms (1967, 115).

52. These rooms were paved with polychrome geometric mosaics; for a description of them and the plan see Gozlan 1992, 6, 114–74 (on the mosaics), plan I. See also Thébert 1987, 352, fig. 15, who labels these as "bedrooms abutting antechambers or corridors." A similar arrangement can be found in the use of an antechamber (5) between two bedrooms (6 and 4) in the west wing of the Sollertiana Domus at El Jem; see ibid., 366, fig. 23.

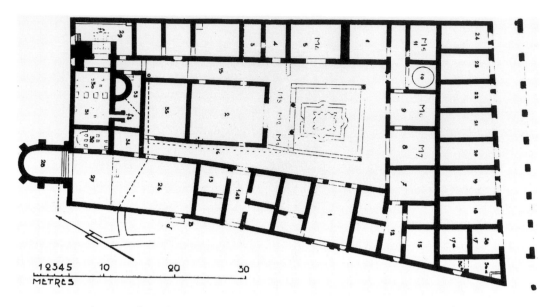

Figure 6. Plan of the House of the Labors of Hercules, Volubilis (after Étienne 1960, pl. 4)

in mosaic and served by a large rectangular room (an antechamber?). This North African house, dated to the last quarter of the second century, offers many other points of comparison with the Paphian house, and we shall be looking at these again. The early-third-century House of the Labors of Hercules at Volubilis also includes a suite of apartments set off the peristyle in the southeast section of the plan (fig. 6).[53] The addition of a circular basin (fig. 6, no. 10 on the plan) within the suite at Volubilis parallels the use of the fish pond at Paphos and attests to the prevalent taste for aqueous embellishments and references in the private as well as in the public areas.[54] A long corridor connects these rooms (10 and 11) to room 6 and to the second dining room (5), which is paved with a cushion mosaic depicting the Labors of Hercules (fig. 73); the perpendicular arrangement of the bedrooms and the Hercules triclinium(5) at Volubilis mirrors what occurs in the Paphian plan, in which the east wing bedrooms abut in the northeast corner a suite of reception rooms off the north portico (fig. 3, rooms 8, 9, and 10) of the peristyle.[55]

The use of linked reception/bedroom suites is common in Roman houses, and for the smaller-scale plans they proved quite practical because the master could entertain more privately in such rooms.[56] Although it is logical to assume that the

53. See Étienne 1960, 32, room nos.6, 8, 9, 10, 11, pl. IV, for the plan.
54. See ibid., 32.
55. Further discussion of this reception suite follows at the end of this section.
56. One of the clearest cases for such a suite occurs in the House of the Vettii, dated to the final building period in Pompeii; see Richardson 1988, 329; Wallace-Hadrill 1988, 93–94, and fig. 10 for the plan; and

antechambers and corridors next to the bedrooms were used as sleeping quarters for the personal slaves of the mistress and master, namely the *cubicularii*,[57] they could easily have served a dual function. A. Wallace-Hadrill summarized this point succinctly: "The juxtaposition of the two rooms is the consequence of the desire to use the cubiculum for reception."[58] Such transitional spaces could have served as vestibules for the reception of more intimate friends who awaited entry into the chambers of the *dominus* or *domina*. They created secluded zones and effectively staged the visitor's or servant's progression through these apartments.

Because practically nothing survives of the east rooms of the east wing, little can be added about them. The two rooms that open off the east portico (E2 and E3) still bear some of the red paint that decorated their walls; the costliness of the cinnabar pigment might indicate that these rooms were accessible to visitors.[59]

The western and eastern parts of the house remain independent, subsidiary wings; the peristyle dominates the rest of the plan. The focus of the house, and of this book, is the central core of the house defined by the large peristyle (15.20 m. × 11.75 m.) around which are arranged rooms decorated with mosaic. Its importance was reinforced by the decoration of the four porticoes with long panel mosaics of hunting scenes (fig. 172). The discovery of columns, capitals, bases, and moldings in the area of the basin confirms that it was bordered by a colonnade supporting an entablature and a sloped roof that covered the porticoes.[60]

A shallow rectangular basin (7.40 m. × 5.40 m. × 0.50 m.) in the middle of this courtyard led the excavator and others to call this an *impluvium*, but its earth floor shows that, unlike the service courtyard (F1), it was not used for the collection of drinking water. Earth floors in basins are not incompatible with ornamental pools.[61] At the west end of the basin, two outlets with lead strainers ran off into drains set under the western portico and out to the south street.[62] The presence of another basin (F1), properly lined to collect clean drinking water, in the northwest wing reinforces the conclusion that the peristyle basin (D), strictly speaking, was part of an impluviate system as in an Italian atrium. Indeed, the

Clarke 1991b, 221n.82 and fig. 20, where peristyle 3, its triclinium, and the adjoining *cubiculum* make up such a suite.

57. For a description of the service quarters in the Roman house, see Wallace-Hadrill 1988, 78; and 1994, esp. 38–44. For an interesting, but brief, discussion of what the sources tell us about the activities of the bedrooms, see Thébert 1987, 378–79.

58. Wallace-Hadrill 1988, 94.

59. On the use of color in establishing spatial hierarchies in domestic decoration, see ibid., 74.

60. K. Nicolaou 1963, 59 and 62.

61. Throughout the two preliminary reports, K. Nicolaou refers to this basin as an *impluvium* and to the courtyard as a peristyle atrium (1963, 59; and 1967, 110). In the most recent publications the plan is described as an atrium house with *impluvium*; see Daszewski in Daszewski and Michaelides 1988b, 20; Michaelides 1987a, 14; and J. Balty 1981, 418–19.

62. The drains are lined with lime cement and run along under rooms 2, 4, and 14 (fig. 3) and out to the south street; the drainage system is drawn in on an early plan of the house, see K. Nicolaou 1963, 59 (fig. 2), and 62. A deep well at the north end of the basin might have belonged to an earlier period, but remained in use; see ibid., 59, fig. 2, for its location on the excavator's plan.

dimensions and the relationship between the shape of the basin and that of the peristyle make the court an improbable candidate for an Italic atrium.[63] Compluviate and impluviate systems ordinarily required that the pitch of the roof allow rainwater to drain directly into the *impluvium*. In a study of the peristyle houses at Volubilis, R. Étienne concluded, partly on the basis of the water systems, that one could not employ the terms "atrium" or "*impluvium*" for the forms found in these third-century houses and that the function of the basins was purely decorative.[64]

The axiality and symmetry of the *vestibulum* (entrance lobby)-*atrium* (central hall)-*tablinum* (record room) complexes, which are hallmarks of the Italian *domus* or villa, do not exist at Paphos. The only pure axial relationship is that between the grand triclinium (B) and the west portico of the peristyle (C). Each wing of the house opens onto the central court—source of light and air—through its own screen colonnade. In this way, the peristyle centralizes the plan and differentiates the parts at the same time.

One explanation for the Paphian plan rests in its Hellenistic foundations; excavations reveal them as having belonged to a typical Greek peristyle house, such as those found at Olynthos or Delos.[65] The plan also evokes North African houses, for which the atrium was eliminated and the peristyle was the locus where the public and private coexisted.[66] The peristyle of the House of Neptune at Acholla illustrates this development: it can be reached directly from the entry corridor; three grand reception rooms open off three sides of it; its porticoes are paved with mosaic; there is a tightly bound alignment of the grand *oecus*, or reception room, west portico mosaic, and decorative basins that face into the *oecus*; and private chambers are adjacent to reception areas and share the same porticoes (fig. 5). In this house at Acholla, as in the House of Dionysos at Paphos, the absence of an atrium suggests that visitors were received at the entrances in the vestibules, while more important guests were led into the sumptuous zone of the *oeci* and triclinia, and intimates met in more private chambers. The North African peristyle was comprehensive and could accommodate routine and exceptional events; it was the space around which the complex activities—representational and hospitable—were organized.

North African house plans of the second and third centuries offer the most compelling parallels for the Paphian *domus*.[67] Not only is the size (11.70 m. × 9.20 m.) of the Acholla peristyle roughly comparable to that at Paphos, but the arrangement of the rooms reflects a similar approach to domestic design. In both

63. Although it is likely that the portico mosaics were roofed, the open area between colonnades and basin was too wide for a functional *impluvium*.

64. Étienne 1960, 122 and esp. 120, on the misapplication of the terms "atrium" and "*impluvium*" in the scholarship.

65. A pebble mosaic of late 4th/early 3d century B.C. representing Scylla was found in this Hellenistic structure; see Michaelides 1987a, 10, no. 1, pl. I; and K. Nicolaou 1967, 104.

66. For an evocative discussion of the North African peristyle, see Thébert 1987, 357–64.

67. Thébert discusses a large selection of these plans; see especially the House of the Laberii at Oudna,

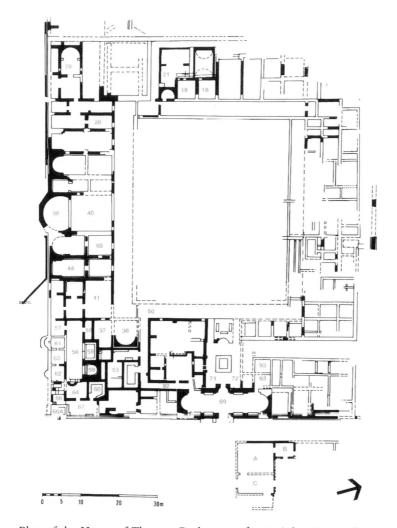

Figure 7. Plan of the House of Theseus, Paphos, as of 1984 (after Daszewski 1985, fig. 1)

cases, the plans reveal an asymmetric disposition of multifunctional spaces ordered by the columnar architecture of the peristyle, which provides a centralizing and regularizing focus for the diverse parts of the *domus*.

In certain respects these peristyle town houses functioned more like courtyard palaces than like Italic houses. A brief look at the plan of the House of Theseus next door to the House of Dionysos provides a convenient illustration of such a palatial structure. A large central courtyard of beaten earth is surrounded by corridors forming four wings that contain no less than one hundred rooms (fig. 7).[68] Despite the immense size of its courtyard, long corridors create axial rela-

the House of the Dionysiac Procession at El Jem, Sollertiana Domus at El Jem, the House of the Cascade at Utica (1987, 325–409, passim). For the large group of peristyle houses at Volubilis, see Étienne 1960, passim.

68. For a recent plan, see Daszewski and Michaelides 1988b, 58, fig. 25.

tionships and control the spatial perceptions and circulation patterns of the visitors and residents. The plan may be classified as a variation of the grand corridor-villa, a complex of self-contained suites grouped around a courtyard.[69] It includes a monumental entrance complex set orthogonally to the official reception area, several basilical halls that are part of internal suites, and separate service quarters. These spatial arrangements underline the palatial nature of the plan of the House of Theseus, and its corridors can be compared in function to the porticoes of the peristyle in the House of Dionysos, even though the latter are on a more intimate scale. Another example of later monumental residences with private but monumental peristyles is the Palace of the Giants in the Agora of Athens, built and used during the fourth and fifth centuries.[70] The complex, probably constructed as an official residence for occasional Imperial visits, is defined by three peristyle units of decreasing size (the largest being the north court, then the south, and the smallest is the southeast court) around which are arranged a series of rooms with clearly articulated domestic and ceremonial functions. The residential subcomplex of the Palace of the Giants is located around the southeastern court, and it is this unit that most closely resembles a peristyle house.[71] From these palatial examples it is possible to construct a model, albeit on a grand scale, of how the peristyle functioned to organize a diversity of interior spaces at domestic residences such as the House of Dionysos at Paphos.

MOSAICS AND THE PLAN

Aside from the plan, the floor decoration in the House of Dionysos is a useful indicator of uses and meanings. The juxtaposition of the most mundane rooms with those reserved for the important guests or events suggests that spatial hierarchies were encoded by the decoration rather than by architectural design. In terms of what remains (paintings, stucco, and architectural decorations being mostly lost), the choice of material for the floors indicates in a general way how these rooms ranked within an internal order and sequence. The humblest areas were left with beaten earth. The bedrooms had small pebbles with lime cement, while the most public rooms had magnificent mosaics, in a contrast that was not merely functional but also meaningful. The pavements serve to accent certain entrances, to emphasize axial relationships, and to reveal room functions by their themes. In fact, the floors are the best clue to all this because many of the features of the house could not be determined: the walls were robbed down to their foundations by later builders.[72] The mosaic pavements are thus crucial: the place-

69. The Villa at Fishbourne (Sussex) provides an excellent example of this type of plan; see McKay 1975, 189–90, figs. 63–64.
70. For a full description and analysis, see Frantz 1988, 95–116, pls. 52–54.
71. See ibid., 111.
72. K. Nicolaou 1967, 108.

ment of certain themes at particular locations indicates that there was a program of architectural sequence and decorations by the architect, the mosaicist, and the owner. The mosaics can be used to reconstruct the itinerary of the ancient visitor and resident.

The first issue of itinerary for which the mosaics act as a guide is the most basic: how did one enter the house? Excavators have not found archaeological evidence or architectural decoration that locates a main entrance. In the plan, there is no entrance complex equivalent to those found in Italic atrium houses, where the *fauces* (entryway passage) and *vestibulum* were axially aligned with the atrium and *tablinum* to produce an uninterrupted procession from the street into the main body of the house.[73] For the House of Dionysos, Nicolaou proposed that the narrow corridor (G2) off the north street was the secondary or back entrance to the house (fig. 1), but he confessed to being unable to locate the main entrance.[74] Nevertheless, we can ascertain the location of the main entrance to the house by using the iconographic information in the mosaic decoration in conjunction with the architectural plan. The combined evidence points to a principal entrance off the south (A) street and into the narrow corridor that runs along the south side of triclinium (B).[75] It is here that there is a greeting.

The mosaics of room 2 are sure evidence of a major entrance along the south side of the house. They are salutatory in nature. On entering the house, the visitor would turn eastward toward room 2, paved with personifications of the Seasons (figs. 3 and 4) and at the west threshold of this room the visitor reads a panel inscribed with the Greek letters "KAICY" (And You).[76] On the opposite threshold there is a panel inscribed with Greek greeting "XAIPEI" (Welcome), which leads eastward toward the peacock in the adjoining room 3 (figs. 3 and 4). The "KAICY" inscription was frequently used as a protective device at the entrance to buildings, intended to revert any threat or malevolence wished on the house or its owners back to the offending party. "XAIPEI" was a formula of salutation.[77] If the entrance was between these two rooms, it led into a long narrow passage (unmarked on fig. 3) that was parallel to the triclinium (room 5) with its right side giving access to the peristyle; those entering would have to make a sharp right to proceed toward the core of the house. Similarly, in the House of the Dionysiac Procession at El Jem (ancient Thysdrus) in Africa Proconsularis, the visitor would have entered into a rather wide vestibule and then turned right into a narrow corridor that leads into a corner of the peristyle through a narrow opening; this corridor runs parallel to the grand triclinium, as at Paphos.[78]

73. Ibid., 32–33.
74. Ibid., 108.
75. K. Nicolaou calls this corridor area XVIa, but it is not indicated as such on the plan (1967, 109).
76. The following discussion of mosaic subjects and room functions should also be guided by the plan with the mosaic designs drawn in; see fig. 4.
77. For a discussion of the meaning of these inscriptions, see below, Chapter 3.
78. For the plan and description of this mid-2d-century house, see Foucher 1963, V1 and V2 on pl. III, and p. 25.

A major entrance must have been located somewhere between the Seasons room and room 1 to the west with its Narcissus mosaic (figs. 1 and 3). Proceeding east toward the interior of the house, the guest would next encounter a splendid peacock facing north displayed to those entering room 3 (fig. 3). As room 3 opened onto the west portico, the bird served as an appropriate introduction to the triclinium/peristyle complex with its dominant Dionysiac themes (fig. 4). Visually and spatially, the Seasons, peacock, and Dionysiac scenes can be taken as a thematic ensemble celebrating luxury, natural abundance, and the well-being of the owners. As we shall see, the succession of images which followed was meant not only to greet and impress the welcomed guest but also to guard against the ones whose malignity would blight all these good things.

The location and structure of the triclinium entrance are not clear except insofar as the mosaics serve as a guide to the axial relationship of the triclinium to the peristyle and the progression envisioned by the designers. The second mosaic from the south of the west portico illustrates the invention of wine and sets the stage (fig. 111). Since the artist chose to depict the myth in two episodes—Dionysos' gift of wine to Ikarios and the drunkenness of the "First Wine-Drinkers"—the panel is twice as long as those of the other three myths in the series, and it is more elaborate because it had more figures, props, and inscriptions. In this way, the panel was made to stand out, and the viewer kinesthetically responds by pausing at it longer, discovering that the panel is centered on an axis with the triclinium (fig. 4). The figures face eastward and were meant to be seen from inside the peristyle, in a westward progression toward the grandest hall in the house. The thematic and physical connection to the Dionysiac vintage and the Triumph of Dionysos of the triclinium underlines how this longer west portico panel was distinguished in its function from the three shorter panels. In other words, the mosaic effectively turns this part of the west portico into an antechamber or threshold for the triclinium. From here the guests are compelled to move toward the long panel with the Triumph of Dionysos with the Dioscuri at either end. One might even read this grouping as a formal presentation of the deities protecting the house.[79] Once inside, diners were provided diversions by the large vintage scene on all sides of the room (fig. 145). A sequence of Dionysiac themes unfolds as the visitor moves from the peristyle into the major reception room of the house.

The layout of the mosaics indicates that the triclinium was entered through a long central opening. A similar use of mosaics to accent the spatial relationship between the peristyle and main reception hall occurs in the House of Neptune at Acholla (fig. 5). On the west side of the house, the portico adjacent to the *oecus-*

79. In fact, a Cypriot oath of allegiance to Tiberius was discovered near Paphos; it invokes a series of deities, including Aphrodite, Apollo, and "our own Saving Dioscuri, the Common Hearth of Cyprus within the Council House," attesting to the role of the Twins as traditional protectors. See Mitford 1980a, 1348, for the translation.

triclinium is broken up into three separate geometric carpets, a central short one set between two corridor-length panels.[80] The shorter carpet spans the width of the entrance into the great *oecus* and serves as a threshold to the Dionysiac procession—a significant parallel to the Paphian Triumph—set at the entrance.[81]

The arrangement of the figure panels in the triclinium at Paphos follows the customary T-shape used for the pavements of triclinia throughout the Empire (fig. 4). The main panel (shaft of the T) is read from within, the entrance panel (bar of the T) from the portico. A U-shaped geometric surround marks the area where the three dining couches were placed. The great size of the Paphian dining room, but especially its layout and its axial coordination with a basin in the courtyard, recalls that from second- and third-century Antioch.[82] The triclinium in the House of the Triumph of Dionysos at Antioch, although in a fragmentary state of preservation, has the same subject for the entrance panel as that at Paphos, and its width of 8.70 meters, one of the largest in Antioch, is close to the measure of its Paphian counterpart (8.50 m.).[83]

One other set of rooms around the peristyle can be differentiated by function if we follow their arrangement within the plan and the iconography of their mosaics. These rooms (8, 9, and 10, fig. 3) form the ensemble that abuts the bedrooms in the northeast corner of the house.[84] The theme of Ganymede found at the center of room 10 and the unusual selection of *xenia* (still-lifes) motifs found in room 9 (see Chapter 4) indicate that these rooms were a second reception area. Both were accessible from the north portico through the long room 8 with its star-and-lozenge pattern (figs. 3 and 4). Their physical relationship within the architectural plan is underlined by the remains of post holes for doors between room 8 and rooms 9 and 10, as well as between 9 and 10 (fig. 3).[85] In other words, one had to pass through the narrower and longer room 8 to enter either the room with Ganymede (room 10) or the one with the *xenia* motifs (room 9). Room 8 functioned as an intermediary space between the peristyle and these two chambers along the north wall of the house. The suite of antechamber (room 8), chamber (room 9), and chamber (room 10) formed a circular progression of spaces of varying sizes, but of increasing intimacy. The larger room 9 relates to the

80. Gozlan 1974, 80–82.

81. For a more detailed comparison between the Paphian and Acholla mosaics, read toward the end of Chapter 6 on the Triumph of Dionysos.

82. Stillwell 1961, 47–57.

83. Stillwell, who has studied the houses of Antioch, notes that the principal rooms get larger in later times. He used this observation to date the House of the Triumph of Dionysos to the 3d century as opposed to Levi's date, based on stylistic argument, of the third quarter of the 2d century (1961, 49–50 and 55n.27, fig. 5).

84. Because room 7 (fig. 3), with the scene of Hippolytos and Phaedra, opens directly onto the peristyle and is on axis with the mythological mosaics of the west portico—the amorous subjects of which it appears to complement—it should be considered apart from this suite of rooms; see fig. 4 as well. The thematic connection of the Hippolytos myth to the west portico ensemble is explored in Chapter 5.

85. For the archaeological evidence, see K. Nicolaou 1967, 109.

more public areas at the western side of the house. Perceived as two parts of a suite entered through room 8, these rooms offered several options for receptions. Compared to the grand dimensions of the triclinium, room 9 would provide a congenial scale for familial entertainments.

The grouping of several reception rooms of differing sizes around the peristyle is common in North Africa, where many of the parallels for the "cushion" pattern from room 8 at Paphos are found in dining rooms.[86] We need only turn to two plans in which there are no less than three reception halls in each, including rooms with "cushion" patterns. In the House of Neptune at Acholla three large dining rooms open off the peristyle: the grand *oecus* off the east portico; the triclinium in the south wing; and a long room to the north decorated with a "cushion" pattern filled with *xenia* motifs (fig. 5).[87] The House of the Labors of Hercules at Volubilis of the early third century also clearly includes a grand *oecus* (room 2) and two triclinia off the east portico (rooms 5 and 6, fig. 6).[88]

Campanian peristyle houses of the late Pompeian period—that is, the two decades preceding the final eruption—also provide parallels to the courtyard-dominated plan at Paphos. The House of the Vettii, for example, had four reception rooms opening directly to the peristyle.[89] It was not unusual to have multiple dining areas that ranged from the largest triclinium for official reception functions to the smaller rooms for private dining parties. Eastern houses, as evidenced by those excavated in Antioch, incorporate a variety of reception areas within a single plan, although not necessarily arrayed around a peristyle. In the third-century House of Menander at Antioch there are at least five such rooms, several of which open off modest columned courts with basins.[90] It is only logical to assume that the Paphian house had another dining area off the peristyle; the size, location, and decoration of the Ganymede room (10) and the long hall with the interlace and *xenia* (9) make them the most likely candidates.

In its general plan, the Paphian house reveals the same combination of eastern and western features noted in its mosaics. Given the similarities with the Antiochene triclinia, and the close parallels drawn between the mosaics of Paphos and those of the Antiochene workshops throughout this book, one would expect to find domestic plans at Antioch comparable to those of the Paphian house. Unfortunately, because only the cores of these houses were excavated owing to the great haste of the expedition and the extensive pillaging of their walls, their full plans are unknown.[91] One feature that appears to have been standard was a semicircu-

86. On the reception rooms in North Africa, see Thébert 1987, 364–73; Gozlan 1971–72, 82–85; and Étienne 1960, 125.

87. The letter designations for rooms can be found on Gozlan's plan (1971–72, figs. 1–2).

88. See Thébert 1987, 379, fig. 30, for a description of this plan; and Étienne 1960, 31–34, pl. 4.

89. See Richardson 1988, 324–29; and Clarke 1991b, 221, esp. n. 82.

90. See Stillwell 1961, 52–53, fig. 15.

91. For a review of what can be gleaned about the architectural character of these houses from the excavation reports and from the study of the mosaics, see ibid., passim.

lar, often multi-apsed, *nymphaeum* set into a colonnaded court facing the tri-clinium.[92] This architectural sequence of reception room, cross-axial corridor, and fountain establishes a continuous spatial ensemble that is self-contained. In terms of use, it clearly provided an attractive and impressive backdrop for the reception of guests. Such formal and hierarchical sequences are found to have been in increasing favor in provincial houses during the second and third centuries, but they were not fully exploited until the fourth century.[93] A similar association of triclinia with semicircular fountain courts can be found in third- and fourth-century houses at Ostia, where the designs are attributed to the influence of Syrian merchants.[94] Something akin to this sequencing of spaces can be noted in the axial layout of the triclinium and west portico with the peristyle basin in the Paphos plan. Yet there are significant differences in the treatments of these features. For example, the ornamental basin at Paphos is situated in the center of the peristyle and serves to embellish each wing of the house; it is not exclusively tied to the reception room as are the *nymphaea* at Antioch. In addition, these fountains at Antioch are typically set into shallow porticoes, often a one-sided screen of columns. We do not understand how these porticoes related to the rest of the house, or whether they were, in fact, connected to larger peristyle structures. In terms of the reception sequence, however, the small scale of such porticoes reinforced the intimacy of these internal formal suites. This is not the case at Paphos, where the grand scale of the peristyle and its role in the organization of the entire house necessarily negates the isolation of the reception space. The Ostian houses attest that Antiochene architecture traveled west, but the Paphian town house does not reflect the Ostian form. Instead, some of the closest parallels for the Paphian plan are the peristyle houses of North Africa. These connections are underlined by the analysis of the mosaic designs in the chapters that follow and indicate a variety of Mediterranean-wide relations.

92. Ibid., 48.

93. I am grateful to G. Métraux for sharing his thoughts on this critical development in late antique architecture. His ideas will appear in his forthcoming book *The Villa: An Architectural History*. Also, Ellis's study looks specifically at the social implications, especially with regards to the representation of the *dominus*, in the design and decoration of reception halls (1991, passim).

94. Stillwell 1961, 56; and McKay 1975, 79n.113.

Chapter 2

Technique and Style
Mythological Mosaics and Geometric Ornament

 A BRIEF INTRODUCTION to the technical aspects of mosaic production may help lay the groundwork for our later investigation of this art form as a social document. As examples, I especially examine two of the mythological scenes—Narcissus in room 1 and Hippolytos and Phaedra in room 7—and I selected geometric patterns that best elucidate workshop methods, the use of models, and the nature of regional exchanges as expressed through the diffusion of taste and composition. In each case—the figural and ornamental—issues of transmission, models, and copying are precisely defined and shed some light on a subject for which too little textual or archaeological evidence has been found.

The mosaics of the House of Dionysos appear to be produced by a curious mixture of hands trained in the Greek east with tastes formed by western contacts. What is surprising and, in fact, enlightening about the evidence at Paphos is the fact that although many of the mythological mosaics point to an Antiochene influence, even to an on-site presence of Antioch craftsmen, certain of the geometric mosaics demonstrate an unmistakable knowledge of patterns and motifs found only in the west.[1] The geometric mosaics that confirm close contacts with Antioch

1. Michaelides 1989b, 272–92, briefly charts the points of correspondence with Antioch and with the west. Many of the same examples were presented in detail in my dissertation, "The Mosaics of the House of the Dionysos at Paphos: A Contribution to the Study of Roman Art" (Harvard University, 1985), and are included herein. A case for these western contacts as signs of domestic *Romanitas* is made in Kondoleon 1994.

are also included in this chapter. Several other mosaics in the building could similarly support the following observations, but they are treated in other chapters.[2]

The mosaics of the House of Dionysos at Paphos survive in generally good condition with only a few extensive modern restorations despite the leveling operations that destroyed some parts of the pavements.[3] The tesserae are made from local limestone, marbles, other natural materials, and from glass, providing a rich range of colors for the mosaicist's palette.[4] Those stones used for backgrounds, surrounds, and frames are generally cut larger than those used for the figures, in which the smallest tesserae are used for the faces.[5]

The house has two types of pavements: sixteen framed figural mosaics in six rooms and on all four sides of the peristyle; and five geometric mosaics in five rooms.[6] The figural mosaics are surrounded by multiple frames that effectively set them off as panel pictures, or pseudo-*emblemata*. Landscape and architecture are summarily referred to by proplike devices, and there are no receding planes or spatially complex arrangements. The figures are given curved foot shadows to indicate a groundline, but are otherwise set against a white background; they rarely overlap. Their gestures and positions seem stiff and staged, lacking the naturalness and ease of motion which some mosaicists are able to capture. In some instances, the mosaics seem to be composed of isolated, disconnected figures.

Many hands and models were involved in the production of these mosaics. Two styles should be singled out for their highly distinctive approach to musculature and drapery. One style, clearly discerned in the Triumph of Dionysos (fig. 119) at

2. See, e.g., the interlace-"cushion" pattern in room 9 and the Triumph of Dionysos panel in the triclinium (area B, fig. 1), but these mosaics address other issues as well; these are discussed in Chapters 4 and 6, respectively.

3. The areas of mosaic that have been heavily restored following damage by the ripper's tines are the west side of room 1 (triclinium); much of room 1 (Narcissus); and room 2 (Seasons); see K. Nicolaou 1967, 11, 114, and 112, respectively, and pl. 21.

4. Some of the yellows, olive-greens, and all the blues (ultramarine, turquoise, and aquamarine) are glass tesserae. The following list of sources of natural tesserae is based on information generously provided by F. Koucky. All the pinks (rose and pale shades), grays, and whites are limestone. The browns, yellows, red-browns (high iron), and blacks (high manganese) are taken from the marmoria formation— sedimentary rocks with differing degrees of mineral content. The purple tesserae are shale taken from the mines. The greens (a light-green and a black-green) are epidote and serpentine. The reds and oranges are chips of chert taken from the mines. The bluish-gray used in the background of the Dioscuroi panels at the entrance to the triclinium are cut from imported marble; the same stones are found in the Amazon panel from the House of Orpheus nearby and dated to the late 2d or early 3d century; see Michaelides 1991, 4.

5. The tesserae size for the backgrounds ranges from .010 m. to .012 m.; for the geometric mosaics .008 m.–.012 m.; for the drapery and bodies of the figures .008 m.–.010 m. and for the faces .005 m.–.008 m.

6. The figural panels are located in the following rooms (fig. 1): Narcissus (1); Seasons (2); peacock (3); Hippolytos and Phaedra (7); Ganymede (10); Triumph of Dionysos (5); the Dioscuri (5); the vine carpet (5); Pyramos and Thisbe, Ikarios and Dionysos, Amymone and Poseidon, and Apollo and Daphne are in the west portico (4); hunting scenes (11, 12, 13). The geometric pavements are located as follows: multiple-design (14); lozenge-star-and-square (8); interlace "cushion" (9); honeycomb with stars (6); diagonal grid (15). Recent publications of these mosaics include: Balty 1981a, 418–22; Eliades 1980 (a descriptive guide); Michaelides 1987a, 14–21; Michaelides 1987b, 244–45; Daszewski and Michaelides 1988b, 18–45; Daszewski and Michaelides 1988a, 11–45, with good color illus. figs. 5–34.

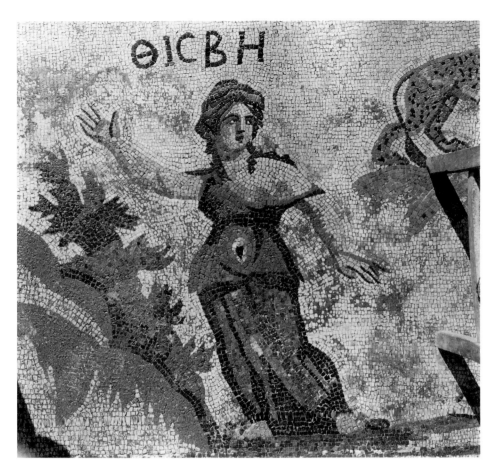

Figure 8. Thisbe, detail of west portico (courtesy of the Department of Antiquities, Cyprus)

the entrance to the triclinium, is distinguished by the use of thick continuous lines of color, usually pink, to articulate the form of the torso. Highlights are also indicated in this linear manner, so that long curved shapes are filled in white. This "hand" also prefers a range of pinks for the coloring of flesh. The other style is marked by the use of either a stepped or a saw-tooth line to differentiate grada-tions of colors and to suggest shading. The body is therefore composed of areas of sharply delineated color. This technique can easily be discerned in figures found in the west portico, especially on the right arm of Thisbe (fig. 8) and on the left arm of Ikarios (fig. 9).[7] Flesh tones are executed in whites, grays, and browns, along with a full range of pinks.

The wealth of mosaic finds on Cyprus and their formal similarities attest to the

7. For the use of the same technique in Antioch, see the arm of the Silenos in the triclinium of the House of Dionysos and Ariadne; Levi 1947, pl. 28c.

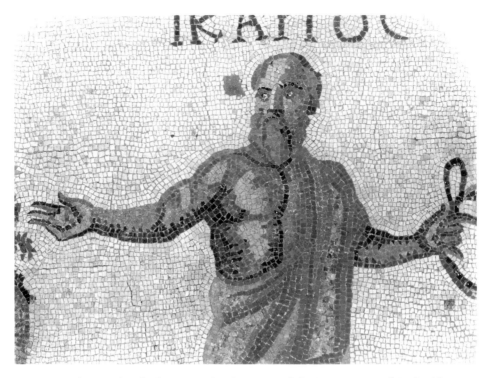

Figure 9. Ikarios, detail of west portico (courtesy of the Department of Antiquities, Cyprus)

existence of a local workshop active for several generations.[8] The group of pavements in the House of Dionysos offers the opportunity for a detailed analysis of this putative workshop. Although it is not certain that there was a workshop in Paphos which existed independently from other workshops on the island, the term "Paphian workshop" is used throughout this book to refer to the group of craftsmen who produced the mosaics in the House of Dionysos. Certain stylistic and iconographic tendencies characterize these mosaics and help shape our understanding of the mechanics of mosaic production and the transmission of compositions. In addition, one or more journeymen from Antioch were most likely present in the workshop, as will be demonstrated below. Significant evidence for the mobility of mosaic craftsmen comes from a third-century mosaic found in Chania, Crete, where a partially preserved inscription has been reconstructed to read as "[the Antiochene] from Daphne made it."[9] Equally compelling is the inscription that accompanies the Orpheus mosaic in the early-third-century House of Or-

8. This observation is underscored by recent studies of Cypriot mosaics; see Michaelides 1987a, esp. 3–4, on the question of local workshops.

9. See Markoulaki 1986, 461–62, pl. 65, for comparative inscriptions and for her reasonable reconstruction. The inscription occurs above a mosaic of Dionysos on a panther, and there are some correspondences with the mosaics of Antioch in terms of the subjects selected and the manner of their presentation. I am grateful to the author for drawing my attention to this important find.

pheus at Paphos, where a three-part Latin name, "Gaius Pinnius Restitutus," followed by "*epoiei*" suggests to D. Michaelides, the excavator of the mosaic, the name of the patron who paid for it.[10] Whether of artists or patrons, these signatures buttress the notion of exchanges that could have influenced the local idiom. The term "Antiochene workshop" is employed below to refer to those who produced the mosaics at Antioch and its immediate environs. It does not fall within the bounds of this book to determine how many workshops existed in Antioch or to differentiate among them.[11]

The question of quality arises when we assess the work of the Paphian craftsmen. At a modest level of production, the members of a workshop might have reproduced a model with little comprehension of its significance or symbolism. They might have misinterpreted figure types, producing muddled or diluted compositions. The effective selection of figures depended on the competence of the craftsman and his understanding of his subject. Just how the designers arrived at their models and figure types is a question that vexes scholars. There are two major positions on this matter: one group believes that model books filled with stock images circulated from workshop to workshop, and another speculates that the artists, trained in an apprentice tradition, developed drawings/cartoons for their own use.[12] Whatever quality the Paphian mosaics do or do not possess, they demonstrate that the transmission of models does not tell the whole story. Local workshops reworked inherited schemes and introduced their own interpretations with varying degrees of success. Themes, once freed from their sources, may only dimly recall their models and acquire new regional identities. The ad hoc combination of figures might have resulted in a fresh composition that enriched the existing repertoire of models. The mythological scenes at Paphos, especially those found in the west portico, and the vine-carpet and hunting mosaics are all successful and very local creations. On the other hand, the Triumph of Dionysos panel is filled with curious errors and is presented in a dry and uninspired manner.

MYTHOLOGICAL MOSAICS

Although I discuss only two of the mythological mosaics, most of those in the House of Dionysos confirm the eastern identity of the Paphian workshop. Throughout the house, the mythological mosaics are surrounded by multiple

10. Michaelides 1986b, esp. 485–86, on the inscription; he notes that the *tria nomina* indicates a Roman citizen and someone of social standing. The most recent compilation of these "signatures" occurs in a study that uses the epigraphic evidence to construct a social history for the mosaicists; see Donderer 1989.

11. Because it is possible to distinguish several styles and hands at work on the numerous surviving mosaics, clearly work should be done to establish whether these differences might be attributed to a variety of workshops.

12. For the different points of view expressed in recent scholarship, see the first pages of Chapter 6, esp. nn. 1 and 2.

borders and treated as independent picture panels, but within each the depiction of landscape tends to be summary, leaving large areas of white ground. The sheer number of legends represented, the use of Greek inscriptions, and the presentation of them in traditional Hellenistic *emblema*-type panels reflect a close alliance with eastern, namely Syrian, workshops. With the exception of the Rape of Ganymede (fig. 83), which is widely represented both in the east and in the west, the Paphian mythological scenes find few parallels in western mosaics. The range of mythological subjects found in Syria is extensive, in contrast to the limited repertoire in North Africa. In fact, the richest stock of mythological themes in the west is found in Pompeian painting and generally not in mosaics. The repertoire of such scenes on Roman sarcophagi is quite extensive and points to an instructive difference in the development of relief and mosaic art. Reliefs provide an important source for comparison throughout our investigation of the Paphian figural subjects.[13]

For the purposes of identifying the character of the workshop, two mosaics in particular stand out for their dependence on Antiochene models: the Narcissus panel in room 1 and the Hippolytos and Phaedra panel in room 7. There are also three mythological mosaics in the west portico—Pyramos and Thisbe, Poseidon and Amymone, Apollo and Daphne—which demonstrate close ties to Antioch, but they will be dealt with as an iconographic ensemble along with the anomalous Ikarios and the "First Wine-Drinkers" composition in Chapter 5. The Ganymede panel in room 10 stands apart from the other mythological representations in that it does not have any particular ties with the east, and its selection might well have been determined by functional considerations; it is fully discussed in Chapter 4. An analysis of the Narcissus and Phaedra mosaics highlights the role of models, the nature of exchanges between ateliers, and the ensuing stylistic and iconographic changes that define the individuality of the Paphian creations. The general evolution of these themes in Greco-Roman art concerns us only insofar as these broad trends may reveal something particular about the Paphian depictions.

NARCISSUS

The Narcissus scene in room 1 is located in the southern wing of the house, that is, flanking the main entrance area and immediately adjacent to the Seasons mosaic.

The square panel (1.26 m. × 1.26 m.) with the melancholic Narcissus (figs. 10 and 11) is set in the center of room 1 and surrounded by a wide field of swastika-meanders in a key pattern. A narrow band of stepped gray diamonds frames the figure scene and separates the polychrome panel from the largely monochrome

13. This is especially true of the Triumph of Dionysos composition at the entrance of the Paphian triclinium; see below Chapter 6.

Figure 10. Narcissus, general view (courtesy of the Department of Antiquities, Cyprus)

surround; the lines of the meander, done in black and red-brown, are read as a continuous dark-on-light pattern.

Although the floor of this room had been seriously damaged during the leveling operations that originally revealed the mosaics, the major parts of the figural panel survived.[14] One fragment portrayed the lower part of Narcissus' body, from the waist to the feet, and another fragment portrayed the upper body, although the face and the right arm were destroyed. These sections were easily joined. Extensive restoration can be noted primarily on the face, but there has also been consolidation work below the waist to join the two fragments and around the lower edges of the drapery below the left leg.

The beautiful youth Narcissus sits on a rocky ledge gazing at his reflection in the pool below him in the lower right corner of the panel (fig. 12). He leans slightly backward, supported by his left arm; his left leg is extended and the right one is bent behind it. On his head he wears a large white hat, gently tilted to his

14. K. Nicolaou 1963, 70, describes the damage to the pavement. See also K. Nicolaou 1967, 121, pl. 21,3. For an illustration of the degree to which the panel was damaged, see K. Nicolaou 1968b, 52.

Figure 11. Narcissus, detail of central panel (courtesy of the Department of Antiquities, Cyprus)

left, with a broad rim known as a *kausia*.[15] His mantle (red and pink), fastened at his neck, falls behind his shoulders and gathers under his left leg and over his right. His upper torso is bare, and the strap hanging across his left breast is evidently for a sword. The pointed left leg is exposed except for the hunter's boot, cross-laced to mid-calf. The reflection mirrors Narcissus' orange-colored hair and white hat. The setting, restricted to the lower half of the panel, consists of a gray, green, and ochre rock outcrop with green grasses growing along the far edge and a pool of blue-green glass tesserae below it. At the far left side of the panel there are a few spiky grasses and the gray-brown ground below the youth's feet.

The upper left area of the panel is damaged, but enough survives of the arm and forearm to indicate that Narcissus' right hand was raised. This one feature immediately distinguishes the Paphian depiction of the myth from the conventional type from which it basically derives. Fortunately, a parallel mosaic exists in Antioch which allows us to reconstruct the position of this lost hand. The Narcissus in the triclinium of the House of Narcissus, now in the Baltimore Museum,

15. On this type of hat see Levi 1947, 39n.21. K. Nicolaou 1963, 70, calls it a *petasos.*

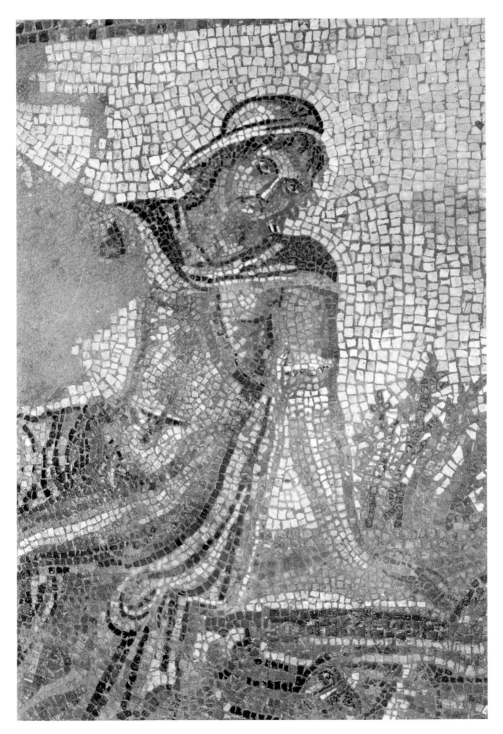

Figure 12. Narcissus, detail of figure (courtesy of the Department of Antiquities, Cyprus)

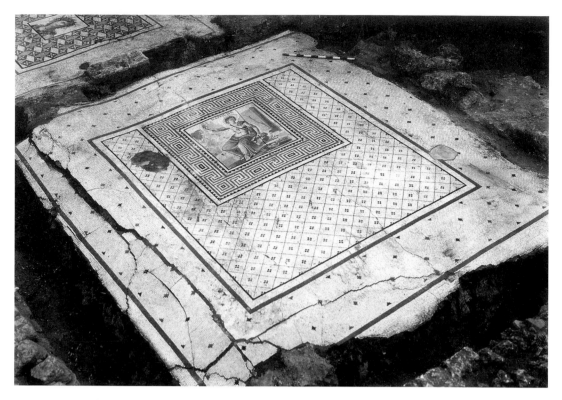

Figure 13. Antioch, House of Narcissus, Narcissus mosaic (courtesy of The Baltimore Museum of Art, Antioch Subscription Fund, BMA 1938.710)

has an attitude and position similar to those of the Paphian youth (figs. 13 and 14).[16] In this example from the second quarter of the second century, the earliest of four extant mosaics of Narcissus at Antioch, the right hand is raised toward the sky, "as if," D. Levi says, "to emphasize the grievous state of mind expressed by the half-open mouth, the sad eyes, and the position of the head."[17] The gesture, however, alludes more specifically to speech and offers a vivid illustration of Ovid's verses describing the boy, distraught with self-love, who raises himself up and stretches his arms to the trees as he cries out his mournful soliloquy.[18] This same gesture, as the youth stretches his fingers and turns out an open palm, was undoubtedly the one intended for the Paphian mosaic.[19]

16. Levi 1947, 60–66, pl. 10.

17. Ibid., 60.

18. Ovid, *Metamorphoses* 3.440–42: "paulumque levatus ad circumstantes tendens sua bracchia silvas 'ecquis, io silvae, crudelius' inquit'amavit?" ("Raising himself a little, and stretching his arms to the trees, he cries, Did anyone, O ye woods, ever love more cruelly than I?").

19. Another variation for the position of Narcissus' right hand is offered by a stucco relief from a Villa Rustica in Petraro-Stabiae and presently in the museum in Castellammare di Stabia. The stucco, dated to the 3d quarter of the 1st century A.D., shows Narcissus holding up his mantle with his right hand; see

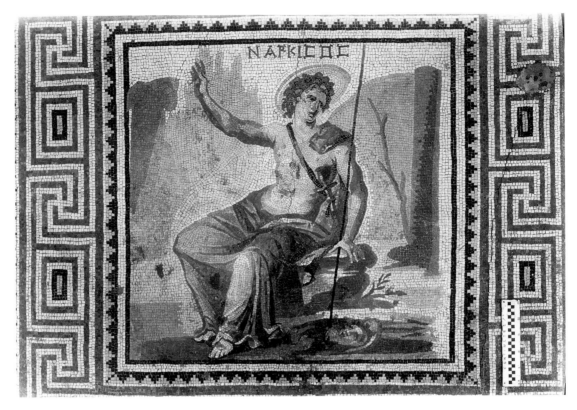

Figure 14. Antioch, House of Narcissus, Narcissus mosaic (courtesy of the Department of Art and Archaeology, Princeton University, no. 2987)

The organization of the floor at Antioch consists of a polychrome *emblema* with Narcissus which is surrounded on three sides by a trellis (red-on-white) of thin dotted lines with a small cross (black or red) in each section and painterly panel. Among the mosaics of Narcissus at Antioch, this arrangement is closest to the one at Paphos, where a two-dimensional pattern (a swastika-meander) with large areas of neutral white ground contrasts with the naturalism of the figural panel, although the latter appears simplified by comparison with the graded tones and highlights of the Antiochene Narcissus. In both cases the all-over patterns are punctuated by small crosses that give to the geometric design a lightly stippled character as opposed to the density of the pictorial zone. These contrasts force the viewer to focus on the mosaic panel as if it were a painting on the wall.

There is indeed a "painterly" consciousness in the mosaic depictions of Narcissus, and this raises the possibility of a painted original. D. Levi in his analysis of

Mielsch 1975, 45–46, pl. 28,1, K 34,1. However, this reconstruction would not be acceptable for Paphos because the cloak in the mosaic is clearly wrapped tightly around Narcissus' body and separated from the arms.

the Narcissus series at Antioch concludes that these mosaics, as well as the Pompeian paintings, were drawn from generic models for the representations of heroes, lovers, and hunters and that they were not necessarily tied to Narcissus.[20] For instance, a painting from the House of Meleager at Pompeii represents Ganymede languidly seated in an oblique position, barely covered and holding a spear in a manner also found in the Pompeian paintings of Narcissus.[21] The only distinguishing features are the youth's Phrygian cap and an eagle guided by an Eros toward Ganymede. Similarly, the Narcissus scene can be recognized by the presence of the pool and the reflected image.

The closest parallel in painting for the Paphian Narcissus is from the House of Lucretius Fronto at Pompeii, where the posture of the slender naked body recalls Ovid's description of the listless youth who can barely lift himself away from his reflection.[22] The painted Narcissus assumes the same position as the youth in the Cypriot mosaic; he is also precariously poised at the edge of a stone ledge on which he supports himself with his extended left arm. Although there are some variations in the positions and in the elaboration of landscape, the Pompeian paintings are fairly consistent. In the paintings, Narcissus' head is crowned with a laurel wreath or his long locks are left uncovered, while the mosaics show him with a *kausia*, or nimbus. The glow of light surrounding his head in two Antiochene mosaics probably refers to the radiance ascribed to him in literary descriptions (fig. 15).[23] In Pompeii, Narcissus' weapon is a long spear, whereas the mosaics also include a sheathed sword strapped across his breast. Otherwise, the general features, that is, a pyramidal composition capped by the head of Narcissus with a strong diagonal underlined by the extended leg and supporting arm held close to the body, are similar in all media. If we allow for standard reversals in positions which do not affect the basic composition, it is reasonable to assume a common model, adapted for the depiction of Narcissus by the addition of certain details, to which painters and mosaicists, including the ones in Paphos, were equally indebted.

Several anomalies do suggest the individuality of the Paphian handling of the inherited prototype. For instance, the ubiquitous presence in mosaics and paintings of a long spear held either in his left or right hand confirms that the source depicted Narcissus as the youthful hunter resting by a brook. The absence of the spear at Paphos indicates an oversight, perhaps due to a lack of familiarity with the model. This observation is reinforced by the muddled execution of the sword. The strap of blue and green glass tesserae is in place across his breast, but the

20. Levi 1947, 61.
21. Rizzo 1929, pl. 105a.
22. Ibid., pl. 126; and Schefold 1957, 86, from Pompeii V, 4, 11.
23. Levi 1947, 64, makes this plausible suggestion and refers to a passage in Philostratus, *Imagines* 23. The nimbus appears in the mosaic from the House of Narcissus and in the mosaic from the House of Menander, Levi 1947, 200–201, pl. 45a. The latter, dated to the mid-3d-century by archaeological evidence, is the latest of three mosaics in Antioch representing the seated Narcissus.

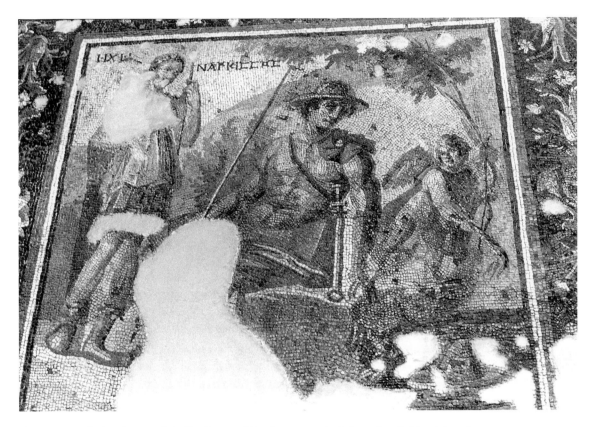

Figure 15. Antioch, House of Buffet Supper, Narcissus mosaic (photo by C. Kondoleon)

sheath of the sword falls down his side and merges with the folds of the mantle. The hilt protrudes into his arm at a right angle instead of hanging vertically, so that it actually could be mistaken for an arm bracelet if one were not aware of the original intention. A comparison with the more precise portrayals found in the House of Narcissus (fig. 14) and in the Severan House of the Buffet Supper (fig. 15) reveals the Paphian confusion. Finally, the downcast creases around his mouth are meant to give him a sad expression, but at Paphos these lines are done with black tesserae and resemble a thin moustache.[24]

The shape of the hat worn by the Paphian Narcissus recalls the *kausia* worn by the Narcissus in the House of the Buffet Supper.[25] At Antioch the brim goes around the entire head and is shaded to give the illusion of a three-dimensional

24. It is important to note that Narcissus' face was seriously damaged by a bulldozer and that the restoration could be misleading; see K. Nicolaou 1967, pl. 21,3, which shows the damaged state of the mosaic quite clearly.

25. The second in the series of three Antioch mosaics with the seated Narcissus dated to the first two decades of the third century on stylistic grounds; see Levi 1947, 129, for the dating argument, and for a description, 136–37, pl. 23c.

object, whereas at Paphos the brim collapses into a flat lopsided band. The Antiochene scene includes Echo and an Eros holding a torch with the flame pointed down. Both accessory figures can be accounted for in Pompeian paintings, but no one painting exactly corresponds to the scene at Antioch.[26] A very similar Eros with torch appears in the Paphian representation of Hippolytos and Phaedra, which is treated below. Like the paintings, this Antiochene mosaic places the figures and scenery in planes receding from the pool in the foreground to the figures in the middle zone to the massive bush and hillside in the background. In contrast, the Paphian example is reduced to a single figure before a plain white background; and Narcissus and the pool are on the same scale and on a single plane. Such discrepancies must again be attributed to the incompetence of the individual craftsman rather than to different models.

In summary, the Paphian Narcissus conforms in its general outlines to a model popular in the early Empire as evidenced by more than forty recorded examples from Pompeii.[27] That this type was popular in the second and third centuries in the east as well is shown by the Antioch mosaics and by a tomb painting found in a second-century hypogeum near Massyaf in Syria, where Narcissus appears, identified by a Greek inscription, in the same manner as in the Pompeian paintings.[28] Even the choice of red for the mantle in the Syrian painting concurs with the coloring in the Pompeian paintings as well as with the Paphian mosaic and the Antiochene example from the House of Narcissus. During this same period (i.e., mid-second through mid-third centuries), Narcissus appears to have been neglected in the mosaic repertoire of the west, with only two examples surviving, one from the Baths at Thina in Tunisia and the other from the Severan floor with the Seven Planets at Orbe in Switzerland.[29] In both, Narcissus is represented standing, apparently dependent on a different model.

The Paphian mosaic can be closely tied to the Antiochene examples by features such as the *kausia*, the strap across the breast with the misconceived hilt and sword, and the right arm raised in the gesture of sorrowful declamation. The overall treatment of the floor at Paphos as if it were a framed prefabricated *emblema* encompassed by a wide field with a monochrome geometric pattern most obviously recalls the arrangement in the triclinium of the House of Narcis-

26. For Echo in Pompeian paintings, see Reinach 1922, 196.4. For Eros, see ibid., 196.3,8,9, and 197.1,2,3,4,6,7.

27. For a complete listing of the Narcissus scenes occurring in Pompeian paintings, including those lost or damaged, see Schefold 1957, esp.51, 53, 86, 112, 157, 258, for those mentioned herein. See also Reinach 1922, 196 and 197, with sixteen illustrated examples. The stucco from Stabia (Mielsch 1975, K34,1) should be included with this Campanian group.

28. Chapouthier 1954, 198–201, pl. 100.

29. For the mosaic from Thina, see Dunbabin 1978, 273, (Thina 1b, caldarium), dated to the late 3d-century. For the Orbe mosaic, see von Gonzenbach 1961, 189–90, pl. 63. The latter example is unique and shows the youth from behind bending over a rocky ledge to look at his reflection. For a discussion of the standing type of Narcissus, see Levi 1947, 62–66. The fourth mosaic representing Narcissus in Antioch from the House of the Red Pavement shows the youth standing and dressed as a hunter with a quiver; see Levi 1947, 89, pl. 14b.

sus (fig. 13). Other similarities between this Antiochene mosaic and our panel include the coloring, the uplifted arm, and the strap with sword. The inclusion of the hat rather than the nimbus in Paphos, however, pushes the Paphian panel closer to the Severan example in the House of the Buffet Supper (fig. 15), that is, toward the late second century. This suggestion fits well with what the analysis of the geometric floors reveals.

The selection of the Narcissus myth at Paphos could be viewed as pertinent to the location of the room it decorates. Because it is sited as it is in room 1 in an entrance sequence followed by the Seasons (room 2) and the peacock (room 3) mosaics, exploring whether there might be a reason behind the choice of imagery is worthwhile. The inextricable association of Narcissus with water and more specifically with fountains may explain the popularity of the image for domestic decoration. In one of the most splendid Pompeiian settings, the House of Loreius Tiburtinus, the painting of Narcissus adorns one side of a *nymphaeum* in the center of an open-air dining area (*biclinium*).[30] The fresco is set adjacent to a decorative fountain fed by a long water channel from the peristyle garden terrace. In another Pompeian house—the House of the Great Altar—Narcissus is placed within a niche above a real fountain in which his painted image is reflected.[31] The illusionistic extension of real gardens by wall paintings is a typical and charming conceit of Campanian decoration. With the Narcissus scene the wall painters go even further in their allegorization of the relationship between reality and art.[32] Just as the ancient beholder could "see" the mythic youth gazing on his reflection in both a real and imaginary pool, so too did the Narcissus scene evoke watery settings. In his *Imagines*, Philostratus describes a Narcissus painting and likens the reflection of the pool to the illusionary effects of the painting. The third-century author goes on to describe the pool, which was roofed over with vines and ivy, and connects it with the Bacchic rites of Dionysos.[33] Certainly Dionysiac gardens and grottoes were not far from the minds of the Paphian inhabitants, given the proximity of the monumental vine carpet in the triclinium.

It is reasonable to assume that Narcissus seated by the pool provided an obvious theme for statues and paintings in garden *nymphaea*.[34] The indoor representations of this subject, both in paintings and mosaics, reflect a Roman taste for evoking naturalistic and idyllic landscapes within their houses. As Levi has suggested, the popularity of this subject at Antioch makes perfect sense for a

30. From Pompeii II, 2,2; also known as the House of Ottavio Quartione. See Spinnazola 1953, 400, fig. 458; Schefold 1957, 53; and Jashemski 1979, 72. A painting of Pyramos and Thisbe adorns the other side of the *nymphaeum* and is discussed below.

31. Rizzo 1929, pl. 127; and Schefold 1957, 157; from Pompeii VI, 16, 15.

32. This concept of allegory, especially in relation to the Narcissus scene described by Philostratus in his *Imagines*, is explored by Conan 1987, esp. 168.

33. Philostratus, *Imagines* 1.23.

34. In a parallel development, aqueous subjects were favored for domestic garden sculpture, especially those used for fountains or pools; see Hill 1981, 83–94; and Jashemski 1979, 34–41.

"town so proud of its wealth of waters, springs, and baths."[35] In the House of the Buffet Supper at Antioch, the location of the Narcissus mosaic directly across from the *nymphaeum* at the other side of the peristyle portico and adjacent to the dining area supports the association of the theme with pleasures of a luxurious garden setting for banquets and receptions. The position of the Paphian Narcissus at the entrance area of the house and adjacent to the Seasons and peacock mosaics underlines the intention of the designer and/or the patron to have the visitor view this as a decorative ensemble of welcome. In this context, the watery habitat of the Paphian Narcissus expresses a delight in the beauty and abundance of the natural world with the attendant implications of the "good life" similar to these other two salutatory themes.

PHAEDRA AND HIPPOLYTOS

The representation of the tragedy of Phaedra and Hippolytos appears in room 7, off the north portico of the peristyle.[36] The scene has been reduced to the two main protagonists and an Eros and a dog, who are placed against a white ground. The figures do not overlap, and only foot shadows mark the ground (figs. 16 and 17). The panel (1.00 m. × 1.78 m.) is bordered by an elaborate series of frames, including the outer surround of a *semis* of red-brown diamonds and half-diamonds;[37] a thick red-brown band followed by a white band; a bold black wave-crest; a swastika-meander with squares;[38] and finally, immediately surrounding the figural panel, a diaper pattern with a dotted trellis of three lines, black-white-black, containing diamonds with a central white cross and black dot in the middle, set in pink and red-brown sections.[39] The overall effect of these multiple borders is to set the figural scene apart as a pseudo-*emblema*, despite the neutral white background of the panel, which negates the illusion of depth that one expects from a "window-picture."

Before we trace the iconographic particulars of this scene, it is important to note that its location—on axis with the west portico—and the format and subject of its composition connect it visually and thematically to the mosaics of the west portico. The figures are oriented north so that those who enter room 7 from the peristyle can easily read the picture. An explanation of its meaning within the

35. Levi 1947, 60.

36. See K. Nicoloau 1967, 68; and more recently in Michaelides 1987a, 17, no. 12, pl. 21; and Daszewski and Michaelides 1988b, 29–30, fig. 12.

37. See Levi 1947, 66, fig. 25, for the same pattern filling the outer border of room 2 in the House of Iphigenia, assigned to the same period as the House of Narcissus, ca. A.D. 130.

38. For an analysis of the types of meander borders found in the Paphian house, see the sections following "Geometric Mosaics" below.

39. A similar pattern occurs in the four geometric panels of the Portico of Nikostratos in the House of the Porticoes; see Levi 1947, 115, pl. 100b.

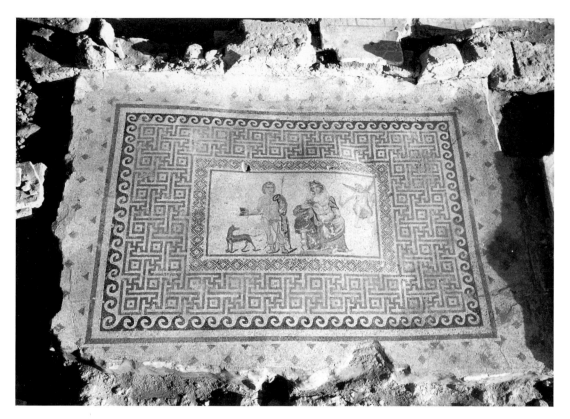

Figure 16. Room 7, Phaedra and Hippolytos, general view (courtesy of the Department of Antiquities, Cyprus)

context of the house plan is best left until Chapter 5, where it is considered as part of the west portico program.[40]

The composition consists of two central figures, Hippolytos standing to the left and Phaedra enthroned to the right. The details that identify the scene are the hound to the left of Hippolytos, and the Eros in the upper-right-hand corner beside Phaedra. The hero is frontal and nude except for the hunter's boots and the mantle covering his left shoulder and arm, in which he holds the spear. Hippolytos, standing in contrapposto, turns his head in three-quarter view toward Phaedra and holds the diptych with her love proposal in his extended right hand. His hound twists his head back toward his master, anxiously awaiting with open mouth and wagging tongue their imminent departure.

Phaedra, seated on her throne, is fully draped in her mantle with yellow and brown folds, and only the hem of her pink and red-brown chiton is visible above

40. Note that room 7 is purposefully excluded from the "reception suite" formed by rooms 8, 9 and 10; see the analysis of the mosaics within the architectural plan of the house in Chapter 1.

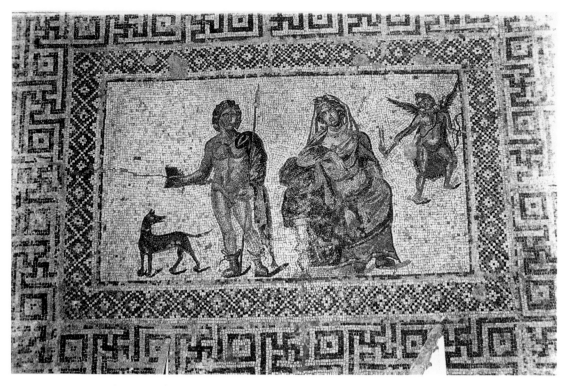

Figure 17. Phaedra and Hippolytos, detail of panel (courtesy of the Department of Antiquities, Cyprus)

her shoes. The anxious queen leans toward Hippolytos, resting her right elbow on the throne, and casts him a glance full of longing. Her head, inclined toward him, is covered in the back by a yellow-and-white veil; the front of her wavy coiffure is neatly parted in the middle and held in place by a white diadem. The angle of her seated position is emphasized by the slant of her body toward the left and by the yellow highlights around the projected right knee. Her left hand rests in her lap. In the upper right corner a winged Eros tilts his head left toward Phaedra and mischievously grins as he rushes off to the right away from this scene of unrequited love. He is naked except for a gray chlamys and holds a bow in his left hand and a torch with the flame pointed downward in his right.

The arrangement of the scene and the selection of the figures do not closely correspond to any single representation. Yet each character, although not necessarily used in depictions of Phaedra and Hippolytos, finds its counterpart in Antiochene mosaics. In its iconography, the composition generally follows the representations on Roman sarcophagi. Largely owing to the inclusion of the diptych and the hound, the subject is easily identified as the tragedy of Phaedra and Hippolytos, but the Paphian representation is a pastiche of figures and details

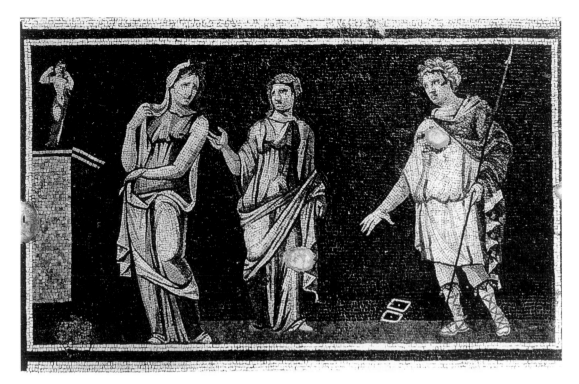

Figure 18. Antioch, House of the Red Pavement, Phaedra and Hippolytos scene (photo by C. Kondoleon)

excerpted from several sources at some stage in the pictorial evolution of this myth.

As the second-known mosaic depiction of this tragedy, the Paphian example is intriguing and merits close study. The first is from the House of the Red Pavement in Antioch (fig. 18).[41] Levi studied the various versions of the tragedy for his analysis and concluded that although there was an original painting from which many of the painted and sculptural representations derived, the Antiochene mosaic has nothing in common with these. The Antiochene mosaic appears to be an ad hoc combination of three different generic figures who are "simply placed side by side in the special action of the tragedy."[42] Despite the firm connections that can be drawn between the Paphian and Antiochene mosaics, their depictions of Phaedra and Hippolytos completely differ—the only feature they share is the diptych.

Unlike the Antiochene example, the Paphian version does correspond to figures found on the series of sarcophagi that apparently reflect the putative original of

41. Levi 1947, 71–75, pl. 11b, assigned a date in the second quarter of the 2d century.
42. Ibid., 75.

Figure 19. Pisa, sarcophagus, Phaedra and Hippolytos (after Sichtermann and Koch 1975, pl. 56)

the Hellenistic period.[43] At the left side of these two-part Roman reliefs (fig. 19), Phaedra is shown seated in a stately manner on the throne opposite her beloved Hippolytos, who appears as the nude hunter standing by his horse and hound.[44] These reliefs also include the intermediary figure of the old nurse, as well as female attendants and Erotes gathered around Phaedra, and hunting companions beside Hippolytos. The most elaborate painting of the subject which survives, a fresco from the Domus Aurea, bears a close resemblance to this sculpted series and points to the existence of a common model.[45]

The Paphian composition, although reduced to the minimum elements and awkwardly arranged, can be traced back to this same original. A comparision with the late-second-century sarcophagus from Pisa makes this point very clear.[46] At the far left side of the relief, Phaedra sits in the same manner as in our mosaic, with her right elbow resting on the arm of the throne. The carving of the throne recalls the decoration of the one visible leg at Paphos and will be taken up below. Her costume—a mantle, veil and diadem—are the same as at Paphos. She turns

43. Ibid., 72.

44. For a recent discussion of these reliefs, see Sichtermann and Koch 1975, 33–36, pls. 55–66, cat. nos. 26–30.

45. Reinach 1922, 209, fig. 4; and Levi 1947, 72n.28.

46. Sichtermann and Koch date it on stylistic grounds to the late 2d century (1975, 33–34, pls. 55.2, 56, 57, cat. no. 26).

in profile and looks directly to the right at Hippolytos, who returns her gaze, unlike the representations on many other reliefs on which they turn away from each other. Not only do the figures of Hippolytos share the contrapposto stance and heroic nudity but, even more specifically, their mantles hang over their left shoulders and arms in the same way. Judging from the other sarcophagi, we can infer that the Pisan Hippolytos once held a spear, now broken off, in his left hand. He is accompanied by a hound at his right. Thus the features of the Paphian mosaic may be found on the Pisan sarcophagus, with their basic arrangement reversed. The same attitudes and positions are present in our mosaic, but the figures are switched so that Phaedra is on the right and Hippolytos is on the left. This reversal forces Phaedra to turn frontally in order to see Hippolytos, so that her body is in full view, but her head tilts to the left. As a result, the two mosaic figures, despite their eye contact, seem to pull away from each other, creating a bifurcated composition and one far less harmonious than the relief.

This brief analysis indicates two different possibilities for the production of the Paphian mosaic. Either the mosaicist clumsily extracted essential elements from a source that reproduced the complete composition, reflected by the Pisan sarcophagus, or another kind of model was available. It is likely that different intermediary sources were in circulation because the paintings, as evidenced by the examples from Pompeii, and mosaics represent a variety of reductions and re-combinations that, at best, only distantly recall the proposed original. Rather than suggest that such compositions were adapted directly from a copy of the original, we might more reasonably assume that these figures were excerpted from the model at an early stage and were transmitted as single-figure types, perhaps gathered in the form of copybooks, which could be recombined with the details and setting suited to a particular myth. The mosaic of the Triumph of Dionysos in the Paphian triclinium reveals the same mechanics of production and points to the role of the sarcophagi workshop in the transmission of these figure types.[47]

In the case of the Paphian scene, the local interpretation is enriched by Antiochene sources as well. Close parallels may be drawn for the general appearance of Phaedra, her throne type, and for Eros with his torch from the Antiochene repertoire. For Phaedra's enthroned position (fig. 20) and courtly bearing there are two similarly dignified ladies, labeled as Deidameia and Thetis, represented in two panels of the south portico of the House of the Porticoes (figs. 21 and 22).[48] Although both panels are damaged, a fusion of the upper torso and head of Thetis with the lower body of Deidameia offers a convincing comparision for the Paphian Phaedra. The broad lap of Deidameia is amply wrapped in the brown and yellow folds of her mantle—the same colors chosen for our Phaedra. The folds

47. See Chapter 6 for a discussion of the Triumph of Dionysos mosaic and what it indicates about workshop practices.

48. See Levi (1947, 110–13, pls. 18e and 18f, respectively), who dates the House of Porticoes to the late 2d century.

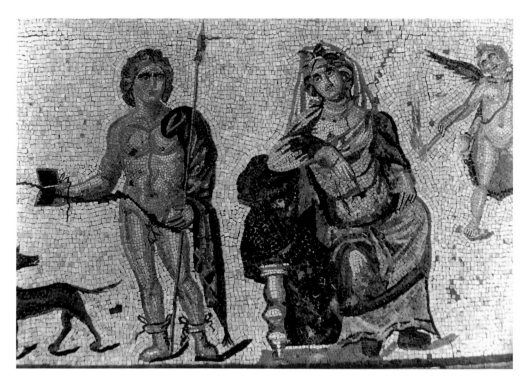

Figure 20. Phaedra enthroned (courtesy of the Department of Antiquities, Cyprus)

around the knees are highlighted with yellow to emphasize their projection and her bent legs. As at Paphos, she turns her body frontally so that her lower body faces right and her upper torso turns left toward Achilles. The heads of both Thetis and Deidameia are covered with veils. The expressive countenance of Thetis provides a compelling comparision for the far less ably conceived face of Phaedra at Paphos. They share the use of strong shadows around the neck and chin to underline the turn of the head; the dark arched eyebrows and creased forehead that express concern; the thin dark slash between the lips and the shadow between the nostrils and upper lip; and the evenly parted hair kept in place by a metallic stephane.[49]

The throne illustrated at Paphos roughly corresponds to a kind common in Antioch mosaics. Again the panel with Thetis from the House of the Porticoes can provide only a clue, because the throne is largely missing. The bottom of the carved foot reveals a large bell-shaped base that rests on a high stem (in lower left corner of fig. 22). For a more complete view of this type of carving, we must turn to the throne depicted in the panel with Aphrodite and Adonis from the earliest house discovered at Antioch, the so-called House of the Atrium, dated to the first

49. Ibid., 112.

Figure 21. Antioch, House of the Porticoes, Deidameia (courtesy of the Department of Art and Archaeology, Princeton University, no. 4814)

half of the second century (fig. 23).[50] The leg consists of a cylindrical upper part of gilded metal, shown by the yellow highlights at Paphos and Antioch, which rests on a bottom part shaped like the calyx of a flower (the bell-shape) set on a high stem. The lower half is rather debased at Paphos, but it clearly relates to this type, also known from Pompeian paintings.[51] The large green cloth wrapped around the left side of the Paphian throne, including the arm on which Phaedra rests her elbow, may be compared with the dark-brown cloth covering the left side of the throne in the House of the Atrium mosaic.[52]

50. Ibid., 24, pl. 2a.
51. See especially the painting of Iphigenia (?) from Herculaneum, now in the Naples Museum (Schefold 1957, pl. 14); and the throne in a painting of Phaedra and Hippolytos from Herculaneum (Reinach 1922, 210.1).
52. Such cloths may also be found in Roman paintings; see Reinach 1922, 209, fig. 4, and 210, figs. 1 and 2.

Figure 22. Antioch, House of the Porticoes, Thetis (courtesy of the Department of Art and Archaeology, Princeton University, no. 4815)

The third point of comparison with Antioch is the winged Eros, who plays a critical supporting role in the Paphian account of the tragedy (fig. 17). Unlike his counterparts on the sarcophagi, who by fawning gestures at Phaedra's feet personify her passion, our Eros signals the fateful outcome of this tale.[53] He does so by pointing his torch, the symbol of passion and life, downward as if to extinguish the flame. This gesture, as well as his contracted brow and his brisk movement away from the scene, alerts the viewer to impending doom. Supporting evidence for this interpretation of the Paphian Eros is offered by the Eros, already mentioned, who appears in the Narcissus panel in the House of the Buffet Supper at

53. For the use of Erotes on sarcophagi with Phaedra and Hippolytos see Sauer 1890, 23; and all the examples cited in Sichtermann and Koch 1975, 33–36, cat. nos. 26–30.

Figure 23. Antioch, House of the Atrium, Aphrodite and Adonis (after Levi 1947, pl. 2a)

Antioch (fig. 15).[54] Our figure, albeit of a far more modest execution, seems an almost exact reproduction of the one at Antioch. Both are at the far right edge of the scene turning their heads toward the victims of love, and each is caught in a running position with his right leg extended and his weight thrown on the turned left leg. They wear similar gray mantles fastened at the neck and each carries his bow upright in his left hand. The facial expression and hairstyle of the Paphian Eros also correspond to those in the Antiochene example. The only difference is the position of their right arms, and this is due to the function of the torch. In the Antiochene panel, Eros stretches his right arm across his body in order to point the torch down toward the reflection, whereas at Paphos the Eros extends his right arm away from his body toward Phaedra on the left. In each instance the torch designates the affliction of love.

There are two other instances at Antioch from the second and early third centuries in which Erotes are used to express love: the early stirrings of passion are signaled in the House of Dionysos and Ariadne, where Eros shows the god the sleeping beauty by rushing with outstretched arms toward her; and in the House of the Red Pavement, Eros is the go-between for Adonis and Aphrodite.[55] Erotes

54. The role of Eros in depictions of Narcissus is discussed by Levi in his iconographic analysis (1947, 60–66).

55. Ibid., 142–50, pl. 28b, dated to the Severan period; and ibid., 80–82, pl. 12b, respectively.

make many other appearances in the mosaics of Antioch, but the examples described here are pertinent to the meaning of the figure at Paphos. Although Pompeian paintings and sarcophagi offer abundant testimony for the use of Erotes as the harbingers of love's joys or sorrows, the resemblances between the Antiochene Eros in the Narcissus panel and our Eros are too specific to be accounted for by a common origin with these other examples.[56] The close similarities between the Erotes at Paphos and at Antioch make a strong argument for connections between these workshops.

These ties can be seen in the use of the diptych both in the Paphian and the Antiochene versions of Phaedra and Hippolytos. In most of the extant paintings and sarcophagi the presence of this device is uncertain, and, in fact, the text of the Euripidean drama *Hippolytos Stephanophoros*, which all the monuments seem to represent, does not mention a love letter.[57] At some early stage, the motif was introduced to encapsulate visually the critical point of Euripides' drama, which was that Phaedra's proposal was made indirectly. The intermediary in the drama is the nurse, but her absence in Paphos makes the diptych indispensable for a correct reading of the scene. Levi notes that the motif was introduced in literature by the *Heroides* in which Ovid recounts the tragedy in the form of a romantic letter by Phaedra.[58] Whatever the source of the device, it was shared by the Paphian and Antiochene workshops.

Finally, a minor but not inconsequential similarity between the Antiochene and Paphian mosaics is their common use of curved stripes for foot shadows. The figures in the nine-part mosaic from the House of the Red Pavement, already noted for its mosaic of Phaedra and Hippolytos, include shadows cast from the feet in a manner similar to those found in Paphos.[59] This technique was popular with the Antiochene mosaicists, being present in many examples.[60]

The Paphian mosaic of Phaedra and Hippolytos demonstrates close ties with Antioch and elucidates the process by which such mosaics were produced. It offers convincing internal evidence that the workshop used a model book, probably consisting of figure types long since separated from their original context, in conjunction with a knowledge of the Antiochene repertoire to produce a condensed version of the tragedy.

56. See especially the Narcissus paintings from the Villa of Diomedes (Rizzo 1929, pl. 128a), where a winged Eros stands to the left with down-pointed torch and looks sadly at Narcissus. For a general discussion of Eros as cupid see Stuveras 1969, 109–21, esp. 111–14.

57. Weitzmann 1941, 233–35, discusses the occurrence of the diptych in paintings and sarcophagi and the relation of these various depictions to the literary sources. He notes that only one sarcophagus, now in Spalato, preserves the letter as a diptych, but he believes that other sarcophagi should be restored to include the diptych (234n.6). See also the sarcophagus in Sichtermann and Koch (1975, 36, pl. 65, no. 30), where Hippolytos holds the diptych; the sarcophagus is dated by its form to the late 3d century.

58. Levi 1947, 72.

59. Ibid., 82, 85, pl. 13.

60. See especially the Seasons from the House of the Drinking Contest in ibid., pl. 33.

GEOMETRIC ORNAMENT

The selection and treatment of ornament in the borders and central fields in the House of Dionysos offer strong internal evidence for dating, for stylistic transmissions, and for the mechanics of mosaic production. Unlike that of figural mosaics, the execution of geometric and vegetal motifs were far less subject to external influence. Although iconographic misinterpretations and stylistic affectations seem to be the common pitfalls in the copying of figural compositions, the execution of patterns reveals the idiosyncratic nature of a workshop.

A survey of the lozenge-star-and-square pattern (room 8) uncovers a broad spectrum of provincial developments, for the popularity of this design provides an index of regional types within a datable series. The inclusion of a multiple-design mosaic in room 14, so unusual in the east, suggests the interdependence of workshops as far apart as Gaul, Tripolitania, Byzacena, and Italy. A close examination of certain border motifs underlines the sources of and influences on the Paphian mosaics. Although the use of multiple frames around central panels (either figural or geometric) is typical of eastern mosaics, the variations of the swastika-meander found in eight borders in the House of Dionysos confirm the use of western models. Border patterns such as the twisted ribbon in rooms 3 (peacock) and 8 offer convincing evidence of an intimate connection with the Antioch workshop(s).

THE LOZENGE-STAR-AND-SQUARE PATTERN

Of all the geometric patterns appearing in the House of Dionysos, the lozenge-star-and-square was the most frequently represented throughout the Mediterranean during the Imperial era. Its form was established in the first century and followed by a series of permutations that can be chronologically linked to regional developments.

A long narrow room (room 8, 10.25 m. × 3.40 m.) directly north of the north portico has as its central design a pattern of tangent stars of eight lozenges forming squares and smaller poised squares (figs. 24 and 25).[61] There are four rows of seventeen large squares; half-squares lie along the sides of the border. The lozenges contain colored fillers of alternately dark-gray and pink, and the poised squares contain crosslets and indented squares of the same colors. The large squares are diversely filled with both geometric and vegetal motifs. A close examination of the Paphian interpretation places it securely within the radius of the Antioch mosaics during the Severan period. The Paphos floor belongs to the

61. The description follows the one given in *Décor géométrique*, 266–67, pl. 173b. The central panel measures about 9.5 m. × 2.0 m.

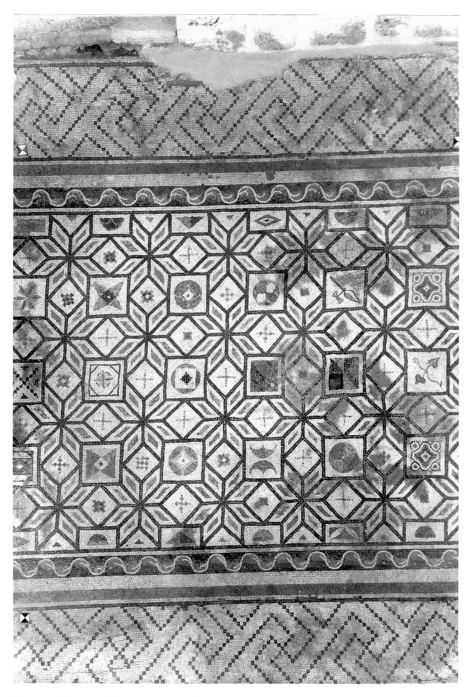

Figure 24. Room 8, lozenge-star-and-square mosaic carpet (courtesy of the Department of Antiquities, Cyprus)

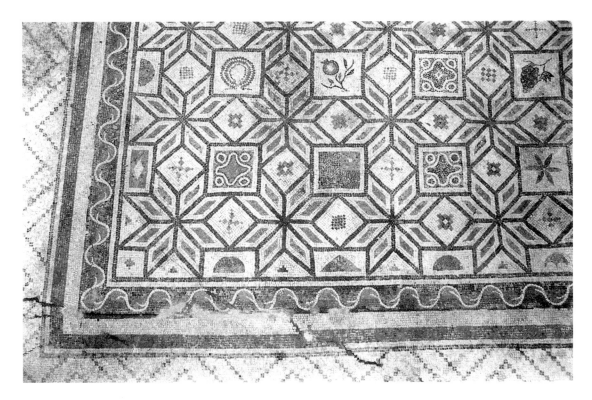

Figure 25. Room 8, detail of lozenge-star-and-square design (courtesy of the Department of Antiquities, Cyprus)

earlier phase of this development and also exemplifies the independence of the Cypriot workshop.

A critical comparison with the Paphos floor is offered by a floor found nearby in Kouklia (Old Paphos) (fig. 26).[62] In Kouklia wide multiple geometric borders frame a central panel decorated by a lozenge-star-and-square pattern. The immediate difference between the Kouklia and Paphos examples can be seen in the relationship between design and background. At Kouklia, the lozenges are delineated by double black lines and left white, and the squares are filled with a relatively simple repertoire of floral and geometric motifs and retain a major portion of white ground. Filling ornaments, such as Solomon's knots, peltae, ivy leaves, fruit branches, and crosslets, function as accents of color in a basically black-and-white design. At Paphos, on the other hand, the pattern is made busy by variously shaded geometric and vegetal motifs set against a neutral white ground. The colored fillers of the lozenges, alternately dark and light, contribute to the polychromatic effects of the Paphian composition. The white ground serves only to unify and balance these disparate parts—it is not a dominant element.

62. Karageorghis 1961, 292–96, fig. 46a and b; and Mitford 1951, 59.

Figure 26. Kouklia, Roman house, geometric mosaic (courtesy of the Department of Antiquities, Cyprus)

The significance of the Kouklia example for the dating and appreciation of the Paphos innovations is great. Fortunately, the date of the Kouklia floor is suggested not only by its style but also by archaeological evidence. A Tiberian coin was found below the mosaic providing a *terminus post quem*, and the contents of a drain in the courtyard contained nothing later than the Severan period. Stylistically, the Kouklia floor shares the austere quality common to the Italian mosaics of the late first century and of the first half of the second century. One close parallel is offered by a mosaic from Imola dated to the last quarter of the first century (fig. 27).[63] Bold geometric fillers including the swastika-meander (instead of the Solomon's knots in Kouklia) alternate with vegetal motifs (an ivy leaf or fruit), but the white ground and the white lozenges remain the predominant features of the design.

The outer border on the floor at Kouklia makes another connection with our house: it contains lozenges inscribed within rectangles (outlined, in turn, by a narrow row of diamonds). The same border, but with boldly colored lozenges, surrounds the multiple-design composition in room 14 at Paphos (fig. 31). This linear composition was used exclusively as a border in Antioch from the early second century.[64]

63. Blake 1930, 112, pl. 35,2; and Salies 1974, 29, 121, K244.
64. E.g., a band of continuous diamonds frames a similar border of lozenges inscribed within squares

Figure 27. Imola (after Blake 1930, pl. 35,2)

The Kouklia floor demonstrates that the pattern of the lozenge-star-and-square had been introduced to Cyprus at least by the first half of the second century and that its representation adhered to the general stylistic principles of the period. The Paphos example is governed by a decidedly different design principle, one that could be called additive.[65] As the filling motifs became increasingly elaborate and polychromatic, they competed with the basic outline of the design. The compositions shifted from those with a central focus to those with the equal ornamentation of all units; variety was favored over regularity. This new style, characterized by an increased elaboration and use of polychromy in the filling motifs, peaks in the post-Antonine period and receives its richest expression in the Severan period.[66]

Seven examples from Antioch illustrate the new type of lozenge-star-and-

in the House of the Calendar at Antioch of the first half of the 2d century; see Levi 1947, 37, fig. 12. For 2d-century examples in Greece, see Packard 1980, 337–38.

65. As M. Blake characterizes the change, "the pattern as a whole [was] sacrificed to the embellishment of the parts" (1936, 192).

66. Ibid., 192; and Salies 1974, 52–53.

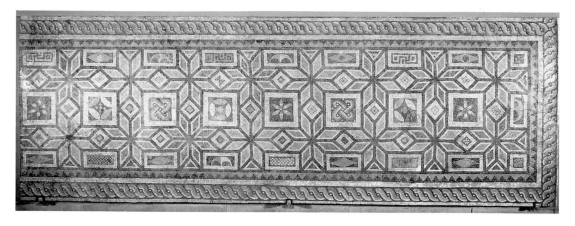

Figure 28. Antioch, House DH 25-L in Daphne, lozenge-star-and-square design (courtesy of The Baltimore Museum of Art, Antioch Subscription Fund, BMA 1937.146)

square in splendid polychromatic technique. As all seven can be dated to the first half of the third century, they provide a remarkably compressed view of the Severan innovations and offer a datable series with which to compare the Paphian interpretation. The proportion of the various units, the treatment of the filling motifs, and the all-over effect suggest the new aesthetic values that took firm root in the region. Levi dated one such mosaic from the courtyard of a house in Daphne (sector DH 25-L) to the Hadrianic period on stylistic grounds, but it cannot be logically separated from the Severan examples (fig. 28).[67] This example, however, does seem to be the earliest in the series at Antioch, largely because the fillers of the lozenges are not yet shaded in an illusionistic manner. A tricolor scheme contains stars filled with alternating light and dark shades of gray, yellow, and red-brown lozenges. In contrast, the filling ornaments in the other Antioch examples are rendered in perspective. In general, the accentuation of plasticity and perspective in the interpretation of the filling motifs in the Antioch series reflects the stylistic trend of the Severan period.[68] For example, the colored fillers in the single lozenges are shaded on two sides in the triclinium floors of the House of Dionysos and Ariadne (fig. 29), in the House of the Drinking Contest (fig. 30), and in vestibule 7 of the House of the Boat of the Psyches.[69] A more extreme emphasis on illusionism can be seen in the House of Aion and in House 5, where

67. The mosaic is now in the Baltimore Museum (inv. no. 1937,146); see Levi 1947, 56, fig. 19, and p. 379.

68. Ibid., 392–412, passim; and Salies 1974, 72. The style of Severan geometric mosaics was the subject of a lecture delivered by V. von Gonzenbach at the *AIEMA* Colloquium, Toronto, Spring 1981. I thank her for generously sharing the unpublished paper with me.

69. See Levi 1947, 141–42, 393, pl. 101a, for the House of Dionysos and Ariadne; 156–57, 396, pls. 30 and 101b, for the House of the Drinking Contest; and 167–68, 399, pls. 38d and 103e, for the House of the Boat of the Psyches.

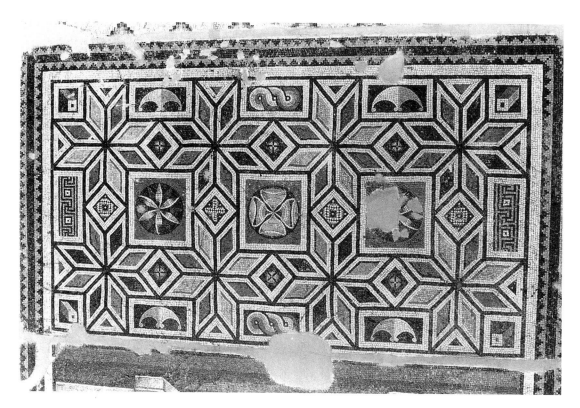

Figure 29. Antioch, House of Dionysos and Ariadne lozenge-star-and-square design
(Photo by C. Kondoleon)

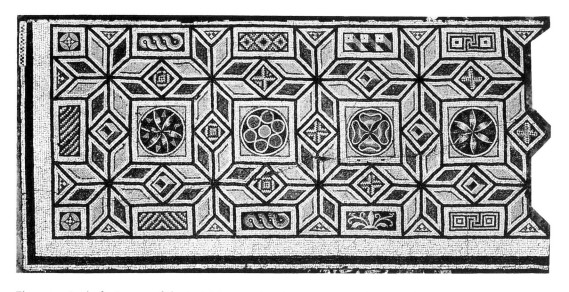

Figure 30. Antioch, House of the Drinking Contest, lozenge-star-and-square design
(courtesy of The Art Museum, Princeton University)

the perspective treatment of the lozenges imitates coffered ceilings.[70] A similar effect—that is, of coffering—occurs on a floor from Mas'udiyah on the Euphrates, securely dated by inscription to A.D. 228.[71] The elaborate shading and outlining of lozenges, along with the introduction of ornaments from the architectural repertory, such as small bosses, characterize the post-Severan interpretations of the pattern.

The Paphos floor stands closer to the earlier phase of this Severan development, as exemplified by the house in sector DH 25-L, because its filling lozenges although colored (alternating gray and dark-pink/rose) remain unshaded. As in Antioch, the Paphian fillers for the lozenge-star-and-square pattern include solids-in-perspective, dotted motifs (crosslets, rainbows, checkerboard), as well as geometric motifs (peltae) that are executed in dark and light shades. Yet the Paphian interpretation differs. A close look at a detail from the triclinium of the House of the Drinking Contest makes it clear that the Antioch artist skillfully uses white highlights and black backgrounds to imbue the motifs with a three-dimensional reality (fig. 30). For instance, the curved petals of the octafoil actually seem to catch and reflect light through the adroit handling of white and graded tones of color. Black-and-white here become the devices of illusionism, pulling the observer in and out of the design surface. At Paphos, white does not highlight, and the gray and dark-pink colors are too close in tonal value to offer any contrast. This lack of contrast can also be easily seen in the treatment of the peltae in the oblong panels along the edge of room 8; they are shaded in dark-pink and gray, and the effect is flat (fig. 24). Similarly, the choice of dark-pink and gray for the lozenge fillers instead of different shades of the same color, as seen in the dark-yellow and light-yellow lozenges of the House of the Drinking Contest, serves to maintain the two-dimensional surface. At Paphos, the absence of shaded fillers allows the eye to travel across the floor surface without the interruption of illusionistic effects. The two-dimensional treatment is reinforced by the fact that the Paphian floor retains more of the neutral white ground than does its Antiochene counterparts by placing most of the fillers on white ground rather than on the dark grounds preferred by the Antioch workshop. The inclusion in the large squares of vegetal fillers (a cluster of grapes, pomegranate, ivy leaf) and the execution of objects (e.g., a spear) or even imitations of marble slabs without illusionism recall Italian mosaics (e.g., at Imola) from the early second century, as well as the Kouklia example. These were conceived as flat, surface-covering designs.

Although these distinctions are indicative of the independence of the Cypriot workshop, they do not invalidate its relationship with the Antiochene workshop(s). It is clear that even within the immediate radius of Antioch there were

70. Ibid., 407, pl. 43c, for the House of Aion; and pls. 106a and b for House 5 (DH 26 M/N) rooms 1 and 2.

71. Ibid., 395, fig. 154.

distinctive developments, as exemplified by a mosaic from Tarsus (Cilicia). Dated on stylistic grounds to the early third century, this lozenge-star-and-square pattern is used as a frame for three figured panels of a triclinium mosaic; it shares with Paphos the unshaded treatment of the lozenge and the flat interpretation of its filling motifs.[72]

A brief survey of the occurrence of this design at other eastern sites, as well as in the west, helps situate the Paphian example within a typological series. The influence of the Syrian innovations may be seen in North Africa, where perspective lozenges are included in a dense, busy version of the lozenge-star-and-square pattern in the House of Jason Magnus at Cyrene.[73] Unique among the North African versions of this pattern, the Cyrene floor with its perspective lozenges closely corresponds to the Syrian versions dated to the late Severan period.[74] The popularity of the Syrian models is also discernable in Greece, where several examples resemble those found in Antioch. In Eleusis, a lozenge-star-and-square mosaic is the central decoration of a room in a Roman house.[75] The inclusion of shaded lozenge fillers and the plastic effects of nine perspective solids in the central square connect this floor to the Severan period and Syria. In Patras, a floor similar to the one in Paphos in its two-dimensional interpretation of the pattern was found in a Roman house, as yet only partially excavated and undated.[76] The familiar filling motifs of rainbows, zigzags, and crosslets appear. A mosaic from the Palace of Nero at Olympia should be included with the Patras and Paphos examples because it too uses unshaded colored lozenges and a similar selection and asymmetrical arrangement of filling motifs for the squares.[77]

Innovations based on the same models are also evident in Greece, where in examples from the first half of the third century the role of white reverses from ground to outline color, thereby eliminating the black outline that was standard throughout the Empire.[78] As a result, the basic element of the star of eight

72. Budde 1972, 121–26, pls. 116 and 117, now in the Antakya Museum.

73. The mosaic is the primary design of room 12; see Mingazzini 1966, 37–41, pls. 16 and 17; and Salies 1974, 59, and cat. no. K284.

74. Other evidence from the house, such as capitals, mosaics, and paintings, suggests a Severan date; see Mingazzini 1966, 88.

75. Salies 1974, 61, 125, K287. See also the related mosaic from Philia Karditsa; Salies dates it to the early 3d century, 62, K288; Waywell dates it to the 2d century (1979, 301, cat. no. 39). In view of the inclusion of perspective solids, a Severan date seems most likely.

76. Papapostolou 1973, 225–26, pls. 188f and 189a. The mosaic was found at the junction of Plateia Psilou Aloniou and Odos Panachaikou.

77. Salies 1974, 125, K289.

78. One example is from a Roman house at Olympia with a *terminus ante quem* provided by the fact that the Herulian walls (A.D. 267) cut through the house; see Salies 1974, 62, pl. 15, K290. The second example is from room 4 of a Roman house in Skala village on the island of Kephallonia; see Kallipolites 1961–62, 26–28, pl. 10; and Salies 1986, 276–78, fig. 19, who dates it to the Severan period. Another comes from the easternmost entrance to the Odeon of Herodes Atticus in Athens, also with *terminus ante quem* provided by the Herulian fire of A.D. 267; see Travlos 1971, 385, figs. 378 and 499. To demonstrate the longevity of this variant in Greece I cite a 5th-century example from Astypalaia; see Pelekanidis 1974, 47, pl. 4a, no. 3.

lozenges no longer dominates, as its dark fillers recede into the dark background. Such variations suggest the tenuous hold of models when local tastes intercede, but it is significant that the variations do not begin until the third century, seemingly after the introduction of the Severan Syrian models.

If we put aside the internal elements and arrangement of the pattern, it is equally instructive to examine the function of the design. In Antioch, the lozenge-star-and-square pattern was assigned a secondary role either as a decorative border for major figural compositions or as a surface-covering for long porticoes or vestibules.[79] In Paphos the pattern is treated as a central carpet with multiple geometric borders; it covers the surface of room 8, which is immediately north of the north portico, and opens onto rooms 9 (interlace with *xenia*) and 10 (Ganymede). In some sense this long and narrow room does function as a corridor space that provides a spatial link between the peristyle and what will be shown to be a reception suite.

In most areas of the west—for example, North Africa and what is now Germany and Switzerland—the tendency was to centralize the scheme and thus reorient the internal order of the design.[80] Because the lozenges are organized around one of the large squares, usually filled with a figural or decorative motif, the pattern itself is relegated to the background. Often limiting the design to four stars surrounding one large square accomplished centralization.[81] Even in the earliest North African examples when the prevailing taste dictated otherwise, the workshops subordinated the pattern to other themes. This subordination is clearly shown in El Jem, where a room in a post-Antonine house is decorated with a simple black-and-white rendition of the lozenge-star-and-square scheme, but colorful *xenia* of fruits and animals fill its large squares, pulling our attention away from the geometry.[82] Gallic workshops, on the other hand, deployed the pattern to cover large floor surfaces and maintained the all-over character of the design.[83]

79. Levi 1947: in House DH 25-L (56, fig. 19), the lozenge-star pattern covers one side of a courtyard; in the House of Dionysos and Ariadne, 141–42, fig. 57, pl. 27a, the design functions as a dado under the figural panel in the triclinium. In the House of the Drinking Contest, (above, fig. 30), the pattern decorates three sides of the figural panel facing the back wall in a typical triclinium arrangement. In the House of the Boat of the Psyches, (Levi 1947, 186, pl. 38d), the pattern covers a vestibule that separates two large rooms.

80. For Germany, see the mosaic in Fliessem (in Parlasca 1959, 14, pl. 20,2), dated to the first half of the 2d century; but Salies (1976, K275) believes it to be early Severan. The central square is filled with a floral motif and given a cable border. In Spain, Blanco Freijeiro (1978, 26–27, cat. no. 2, pls. 8 and 9), dates a mosaic to the second half of the 2d century: a bust of Dionysos fills the central square, yet it is balanced by the many bold geometric patterns filling the other large squares.

81. An example is an unpublished mosaic from Sousse, now in the courtyard of the Sousse Museum, in which Dionysos rides on a panther in the central square of the enlarged version of this pattern. Another example, now in the Sousse museum, from El Jem, Terrain AliSlama Bouslah, Maison I, room 10, ca. A.D. 220 (see Foucher 1960a, pl. 6e) illustrates the related tendency to give a focus to the lozenge-star design through an inserted octagon.

82. See Foucher 1961, pl. 13, for room 14 of the House of the Peacock.

83. For a general discussion and list of examples see Lancha 1977, 152–54. For Switzerland, see von Gonzenbach 1961, 167–69, pls. 18–19, no. 90, from Oberweningen, dated late Antonine.

The Paphos floor does not fall easily into either the eastern or western groups. This same individuality can be discerned in several other mosaics in the House of Dionysos. On the one hand, the Paphian version of the lozenge-star-and-square can be associated with the stylistic developments traced in the Antiochene series of the Severan period. In Antioch, however, the pattern becomes the vehicle for the artist's exploration of illusionistic effects. Especially in the later Severan examples, the plasticity of the filling motifs and their bold colors leap out of the floor and demand our attention. Though they did not centralize the scheme as westerners did, the Antiochene artists succeeded in subordinating the design to the distracting effects of its fillers. Yet at Paphos these internal elements never interrupt the equal patterning of the design. The choice of the muted tones of gray, dark-pink, and olive underlines the intent to balance the scheme throughout. This attention to the surface-covering qualities of the design certainly finds its closest parallels in Italian examples, which also include the stylized vegetal motifs; these are not found in the Syrian examples. The comparison of the Kouklia (fig. 26) and Imola floors (fig. 27) suggests the introduction of Italian models to Paphos earlier in the second century.[84] Although the influence of Antioch is clearly felt, it has been tempered by a strain of Italic taste.

A MULTIPLE-DESIGN MOSAIC

This brief survey of the lozenge-star-and-square pattern suggests that the Paphian workshop had a synthetic approach to geometric ornament. The mosaicists seem to have had access to models that were close to Italian examples from the early Imperial period, but the execution of the patterns bears a distinct Antiochene character. The multiple-design in room 14 off the south portico of the peristyle offers a surprisingly clear case for the use of western models and for the mechanics of production.

The field of the mosaic is divided into sixteen squares by a grid arranged four by four (fig. 31). Each square is filled with diverse geometric schemes, richly colored in light- and dark-pink, reddish-brown, olive- and dark-green, gray, and white (Color pl. 1). There are three separate framing devices. The frame for the entire composition is of a band of alternating outlined squares and rectangles, the squares containing an inscribed poised square (black with white florets as accents), the rectangles an inscribed lozenge (gray with black-and-white inner poised squares).[85] The second border outlines the grid of squares with a row of

84. This view is supported by the correspondence between the motifs used in many early Imperial Italian examples and those found in the Paphian pattern. E.g., see especially a mid-2d-century floor from Aquileia with similar fillers; Salies 1974, 32, 121, K252.

85. The wording of this description follows *Décor géométrique*, 50–51, pl. 18e, except that I deleted the word "horizontal" to describe the disposition of the rectangles and lozenges because they are set in vertically.

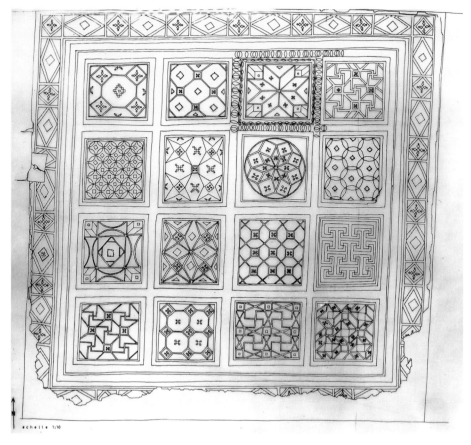

Figure 31. Room 14, Multiple-design mosaic, drawing by M. Medič (courtesy of I. Nicoloau)
The grid is numbered as if viewed by someone standing on the south side of the room
facing north toward the south portico. Square 1 is in the upper-left corner and square 4
is across in the upper-right corner, for square 5 return to the left (east) side, and so on.
The patterns are as follows (for colors, please note that dark-green tesserae are often
interspersed with black tesserae:

Square 1, Décor géométrique (DG), 251, pl. 163a, one unit of an outlined (with
reddish-brown single fillet) orthogonal pattern of adjacent octagons forming poised
squares. Colors: central octagon is reddish-brown with a white poised serrated square
at the center, visible parts of four other octagons are in white; poised squares are in
dark-green/black-with-white crosslets; a white poised serrated square dark-green.

Square 2, DG, 251, pl. 163b, description as for square 1, but five octagons are in-
cluded and the squares are upright. Colors: octagons alternate in rose (dark-pink)
and reddish-brown; squares are olive-green with white poised serrated squares.

Square 3, DG, 266–67, pl. 173b, an outlined orthogonal pattern of tangent eight-
lozenge-stars forming squares and smaller poised squares. Colors: lozenges of stars are
filled with dark-green, reddish-brown, white, and pink; and the squares bear cuboids
in the same color scheme as the lozenges, each unit accented with a white floret.

Square 4, DG, 254–55, pl. 166e, an outlined (with double white fillets) orthogonal
pattern of adjacent irregular octagons (forming squares) bearing an alternately reversed
inscribed swastika that creates the effect of a superimposed key pattern of running

swastikas. Colors: octagons are gray mixed with reddish-brown or dark-green; the squares are pink with white florets at the center.

Square 5, DG, 372–73, pl. 238b, an orthogonal pattern of intersecting circles, forming quatrefoils (saltires of spindles) and concave squares here containing an inscribed white square. Colors: squares alternate in rose and pink; circles are white.

Square 6, DG, 292–93, pl. 186d, an orthogonal pattern of tangent hexagons, forming squares and four-pointed stars; here the stars bear a small inscribed poised square. Colors: hexagons alternate in rose and pink with white florets; stars are white with rose-inscribed squares that bear white crosslets at the center.

Square 7, DG, 266–67, pl. 173b, same as square 3 but inscribed within a circle. Colors: lozenges of gray, dark-green, rose, and white; squares are white, reddish-brown, and dark-green.

Square 8, DG, 390–91, pl. 247b, a pattern of circles intersecting at six points and spaced, forming trefoils and concave hexagons bearing poised serrated squares. Colors: hexagons are either rose or dark-green with white squares; circles are white.

Square 9, DG, 362–63, pl. 232e, an outlined pattern of tangent circles, forming poised concave squares, and a superimposed grid of white fillets with squares inscribed within the compartments of the grid. In our case, the one central compartment shown bears an inscribed poised square. The corner quadrants bear cuboids. Colors: circles are rose; the large squares are reddish-brown; the poised square is rose with a white serrated square at its center; and the cuboids are in dark-green, reddish-brown, and rose.

Square 10, DG, 288–89, pl. 184b, an outlined orthogonal pattern of tangent four-pointed stars bearing an inscribed poised square, forming lozenges alternately recumbent and upright. Colors: stars are reddish-brown; inscribed squares are dark-green with white crosslets at the center; lozenges are either in rose or pink with checkerboard squares of reddish-brown and white at the center.

Square 11, DG, 260, pl. 169a, an outlined orthogonal pattern of irregular octagons adjacent and intersecting on the shorter sides, forming squares and oblong hexagons. Colors: hexagons alternate green and rose; squares alternate white and reddish-brown with red or white florets.

Square 12, DG, 296–97, pl. 188d, latchkey pattern of swastikas with double returns. Colors: alternating fillets of rose and pink.

Square 13, DG, 254–55, pl. 166e, same as square 4 but outlined by single white fillets. Colors: octagons are reddish-brown and rose; squares are dark-green with white crosslets.

Square 14, DG, 251, pl. 163a, same as square 1. Colors: octagons alternate green or reddish-brown; squares are rose with white crosslets.

Square 15, DG, 292–93, pl. 186b, an outlined (with a single white fillet) orthogonal pattern of poised tangent octagons forming four-pointed stars that bear an axially inscribed square. The inclusion of alternately reversed inscribed swastikas within each octagon makes this an unusual adaptation (see squares 4 and 13 for the swastika effect). Colors: the swastika divides the octagon into rose and reddish-brown segments; the squares are in green with small white squares at the center.

Square 16, Basically the same pattern of adjacent octagons forming upright squares as in squares 2 and 14, but here irregular four-pointed stars (?for want of a better name) are inscribed within the octagons and diversely colored lozenges. Colors: stars are white with reddish-brown inscribed squares; lozenges alternate dark-green/black and pink or dark-green/black and light-gray, and each bears a white crosslet; squares are in pink. The whole pattern is outlined by a single reddish-brown fillet.

tangent circles (dark-pink with white centers) and vertical spindles (light pink), the circles shaded to form an inscribed vertical spindle.[86] Each square is individually framed by a classic bead-and-reel in white on a gray ground.[87]

The composition pulsates with the density and diversity of its patterns and colors. The designs include variations of octagons and squares, swastika-meanders, intersecting circles, four-pointed stars, and two eight-pointed stars made up of lozenges.[88] Most of these patterns are standard throughout the Roman Empire, but their execution at Paphos is marked by a bold and original spirit. The treatments of several squares stand out for their unusual interpretation and for the intricacy of the design achieved through the manipulation of color and filling motifs. Two of the most complicated designs occur at the base of the grid in squares 15 and 16.[89] In square 15, the clarity of the basic pattern of tangent octagons forming four-pointed stars is undermined by the superimposition of swastika-meanders in a key pattern that divides the octagons into polygonal sections. These oddly shaped parts are alternately colored in darker and lighter shades of pink, so that it is difficult to see the original octagons.[90] The effects are similar to those found in squares 4 (fig. 32) and 13, where the key pattern is laid over a design of octagons and squares.[91] The decorative effects depend on the juxtaposition of light and dark shades, often in pink, and the use of bright accents in the forms of crosslets, florets, and squares, to punctuate the elements of the design. Square 16 is perhaps the least readable design. Although the underlying pattern of adjacent octagons and squares is common (it is repeated within this grid six times), the choice of colors and filling motifs totally obscures it. The first elements we notice are the irregularly shaped stars inscribed within each octagon because they are colored white with reddish-brown squares at the center. They are also brought out in relief by the dark coloring of the lozenges that fill the interstices between the stars and the outline of the octagons, and form a background.

The creation of such an optically vibrant field accords well with the illusionistic effects favored in the Severan period. Isometric motifs and rich polychromy were favored in Antioch in the late second and early third centuries, as in the lozenge-

86. The wording is taken from *Décor géométrique*, 56–57, pl. 21f, which uses this very border to illustrate the type. One might also describe it as a debased egg-and-dart frieze; see the older *AIEMA* no. 183, where it appears as "ligne d'oves, non-contiguès."

87. *Décor géométrique*, 60–61, pl. 23i.

88. The descriptions provided in the caption of fig. 31 closely follow those found in *Décor géométrique*, in the legend noted as *DG*.

89. See color pl. 1 for square 15 and fig. 31 for square 16 for detailed descriptions.

90. A related and equally confusing interpretation occurs in room 6, where the design is executed in a simple bichrome (dark-gray/black outline against white). Here tangent and secant octagons are so crudely produced that they appear almost circular, and the four-pointed stars and lozenges are also rounded and appear as quatrefoils; see K. Nicolaou 1967, 122.

91. A related interpretation of this pattern occurs in the field surrounding the Ganymede panel in room 10; see the discussion of meander borders below.

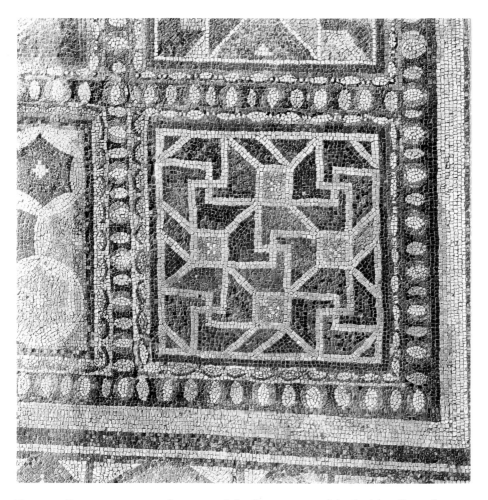

Figure 32. Room 14, square 4 (courtesy of the Department of Antiquities, Cyprus)

star-and-square mosaics illustrated above. In Antioch, the closest relation to our floor is found in the House of the Evil Eye, where a series of geometric panels decorates three sides of a colonnaded portico wrapped around a central pool (fig. 33).[92] The patterns of the panels, including swastika-meanders, four-pointed stars and octagons, intersecting circles forming quatrefoils, and solids-in-perspective, are executed in black, red, yellow, and white. The schemes, filling motifs, and coloring techniques resemble the Paphian geometric style, but the conception of the composition is quite different. At Antioch the geometric panels are spread across the length of the porticoes at widely spaced intervals, like so many separate throw rugs, against a continuous trellis pattern made up of oblique dotted black

92. Levi 1947, 28–29, pl. 93b. The mosaics are dated on the basis of style to the early 2d century (ibid., 375).

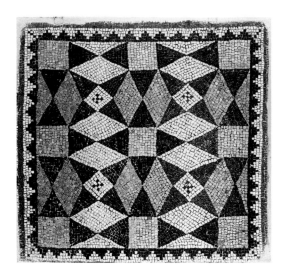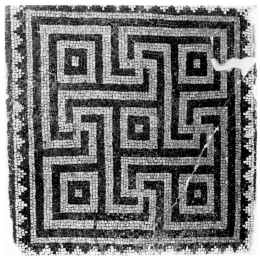

Figure 33. Antioch, House of the Evil Eye, peristyle panels (photo by C. Kondoleon)

lines. In fact, there are no parallels in Antioch or anywhere else in the east for the grid arrangement of geometric panels found in Paphos.[93]

The system of square panels set on an orthogonal grid with diverse decorations including vegetal, figural, and geometric motifs is found throughout the Roman west, where it clearly was one of the most popular compositions.[94] The Paphian example should be placed with this group despite its anomalous appearance in the east. The studies of H. Stern and V. von Gonzenbach initiated much interest in a version of this composition, which they respectively called "à décor multiple" or "Vielmustermösaiken," and which I call multiple-design.[95] It is generally accepted that this type of composition receives its richest interpretation in the workshops of the Rhone Valley in Gaul from the mid-second through the mid-third centuries.[96]

The closest counterparts in terms of composition and geometric schemes for the Paphian floor can be found within the radius of these workshops. The monumental scale—a floor in Lyons is made up of more than ninety squares—and the great variety of motifs which characterizes the Rhone Valley group, however, set

93. Lancha 1977, 55, suggests that the House of the Boat of the Psyches at Antioch offers the only other eastern example aside from Paphos, but I do not agree.

94. For discussion of this pattern in general, see Salies, who discusses the wide variety of regional examples of "Quadratfeldersystem" mosaics (1974, 2–3, 20–25, 38–39, 48–49), and lists them in her "Katalog" 95–104, nos. 1–86. See also Lancha 1977, 17–65.

95. See Stern 1965, esp. 235–38, where he uses the term "à décor multiple" throughout the text; von Gonzenbach (1961, 48–51, pl. 71), uses the term "Vielmustermösaik" in her description of the Avenches mosaic, which she dates to the mid-3d century. On this group in general see Lancha 1977, 19–32.

96. Stern 1965, 236.

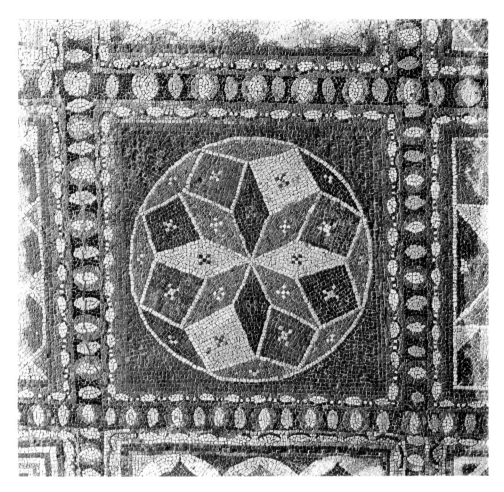

Figure 34. Room 14, square 7 (courtesy of the Department of Antiquities, Cyprus)

these mosaics somewhat apart from the more modest Paphian floor.[97] The Gallic workshops, furthermore, seem to favor a regular alternation of medallions and squares for the panels and a balance between geometric and figural decorations, while the Paphian composition is exclusively geometric and includes only one medallion (square 7, fig. 34).[98] In two spectacular cases, the multiple-design encompasses an *emblema* with, respectively, Achilles in the Court of Lycomedes (fig. 35) and the Drunkeness of Hercules.[99] These sumptuous polychrome mosaics reflect the apogee of multiple-design creations achieved during the Severan period

97. For the mosaic with ninety squares from *Verbe Incarne*, now in Lyons, see Stern 1967, 49–51, pl. 38, no. 53, dated to the first quarter of the 3d century.

98. Lancha 1977, 24, outlines the features of the Vienne mosaics "à décor multiple," which apply to the Rhone workshops in general.

99. For these two mosaic floors see Stern 1969, 13–43. See also the mosaic from Nîmes with an *emblema* containing the Marriage of Admetus; Stern 1967, fig. 5.

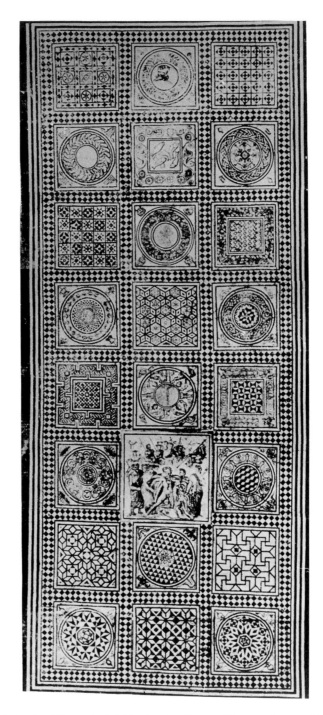

Figure 35. Ste. Colombe (Vienne), Achilles in the Court of Lycomedes, multiple-design mosaic (after Stern 1965, fig. 8)

in Gaul, but there are more restrained examples that remain closer to their sources.

The origins of the ornamental repertoire common to this group and the conception of a multiple-design composition go back to Italian models of the late Republic and early Empire. The discovery of an impressive black-and-white mosaic near Ouzouër-sur-Trézée in Loiret (fig. 36) confirms the dependence on Italian models.[100] The geometric schemes, monochrome treatment, and the use of a continuous border (adjacent black diamonds) to frame each panel and to form the lines of the grid, tie this Loiret floor to Italian floors like those from Gubbio and Reggio Emilia of the first half of the second century.[101] Floors such as these are generally proposed as the probable models of the Rhone Valley mosaics. In fact, they are so close in style and decorative effects to the Ouzouër floor that Stern has dated the Gallic mosaic to the mid-second century.[102]

Of all the Rhone Valley multiple-design mosaics the Ouzouër floor has the most in common with the Paphian mosaic. The prominent, if misshapen, forms of the egg-and-dart border forming the grid lines at Paphos serve a function similar to that of the black diamonds at Ouzouër. With their light coloring on a black ground they are just as effective in unifying the whole composition as at punctuating the individuality of each square. There are four patterns in Paphos which have parallels in the selection of motifs filling the thirty-five squares at Ouzouër. The simplicity of the pink-and-white pattern of intersecting circles forming quatrefoils in square 9 at Paphos (fig. 37) resembles the straightforward black-and-white version repeated four times at Ouzouër and stands in contrast to the complicated treatment of this same motif in the House of the Evil Eye (fig. 33). Similarly, the reddish-brown four-pointed stars and pink lozenges created from secant and tangent octagons in square 10 (fig. 38) at Paphos are nearly as prominent as the black stars and white lozenges found at Ouzouër. At the House of the Evil Eye, on the other hand, the introduction of secondary and tertiary shapes through coloring (black, gray, yellow, and red) distracts attention from the primary forms, the four-pointed stars. Neither the Gallic artists nor their Italian counterparts were devoted to simplicity. At Ouzouër, hexagons, placed in tangent to determine squares and four-pointed stars, are filled with three white lozenges outlined in black.[103] The same pattern at Paphos appears in square 6 (fig. 31) and is easily read as white stars and pink hexagons.[104]

100. Ibid., 49–58, esp. 55–56, figs. 1 and 2.

101. Lancha 1977, 34n.66, fig. 14, dates the Reggio Emilia mosaic to the Augustan period, following the excavation report; however, Salies 1974, 34 and 98/K27, dates it to the early Antonine period with a convincing stylistic argument. For the Gubbio mosaic, see Lancha, 1977, fig. 15, and Salies, 1974, 34, 38–39, K26, who dates it to the second quarter of the 2d century.

102. Stern 1967, 56; and Darmon and Lavagne 1977, 93–99, no. 467, pls. 68–69, who suggest a Severan date but also give the wide range of A.D. 150–250.

103. See the second and fourth squares of row 3 at Ouzouër (fig. 36).

104. A final comparison may be made of the star of eight lozenges in square 3 at Paphos with those appearing in the second and fourth squares of row 2 at Ouzouër (fig. 36).

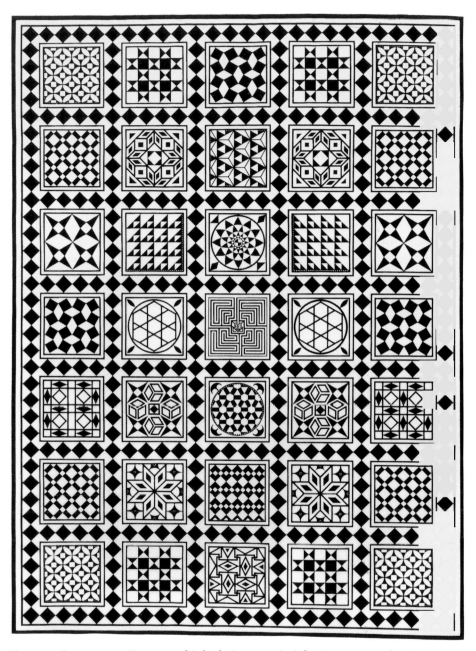

Figure 36. Ouzoüer-sur-Trezée, multiple-design mosaic (after Stern 1967, pl. 69)

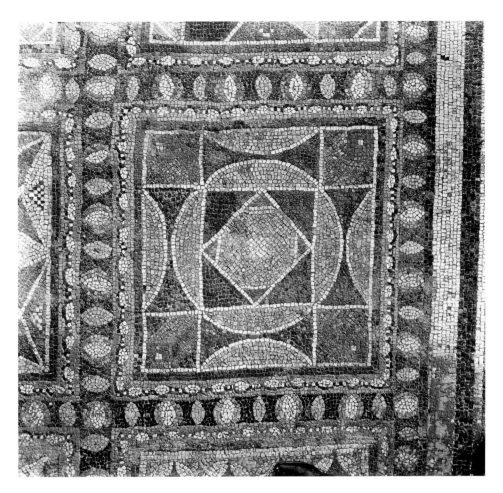

Figure 37. Room 14, square 9 (courtesy of the Department of Antiquities, Cyprus)

The analysis of selected motifs from the Paphian multiple-design floor indicates a connection to Italian models of the first half of the second century, one that has already been suggested in the discussion of the lozenge-star-and-square pattern at Kouklia and at Paphos.[105] At the same time, the application of polychromy, of such accents as crosslets, and of such illusionistic devices as solids-in-perspective link the Paphian floor to the Antiochene workshop. The overall composition, however, indisputedly belongs to the multiple-design group, an association that makes the Paphian floor unique in the east and indicates a knowledge of models common to the Rhone workshops and their Italian antecedents. The exact nature of such influences remains elusive, but the appearance of multiple-design floors in Tripolitania and Byzacena suggests some possible routes.

105. This tie to Italic models is also noted in the discussion of the meander borders below.

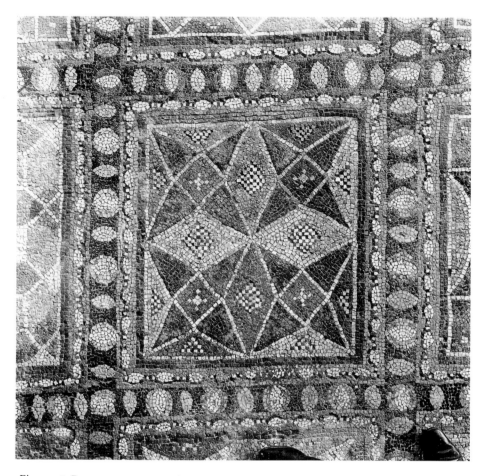

Figure 38. Room 14, square 10 (courtesy of the Department of Antiquities, Cyprus)

Among the several African mosaics that have been categorized as multiple-designs, one at Zliten (fig. 39) and another at the recently discovered villa in Silin (west of Lepcis Magna) (fig. 40) are similar in their organization to the Gallic and Italian examples.[106] In the seaside villa at Dar Buc Ammera near Zliten, an exclusively geometric and basically monochromatic version is arranged in a grid of six-by-four squares decorated with twenty-four different schemes (fig. 39).[107]

106. For a discussion of the African mosaics "à décor multiple" see Di Vita 1966, 39nn.111–15, and Lancha 1977, 50–55. The mosaic found at Sidi-Messri near Tripoli is quite close to the Zliten floor and must have been made at roughly the same time; see Lancha 1977, 51. The mosaic in Silin was only recently discovered and has not yet been included in the studies of multiple-design floors. From the illustrations and description given by Mahjub 1983, 302, figs. 3 and 6, it is clear that this mosaic was made by the same workshop that made the Zliten floor.

107. Aurigemma 1926, 51–59. figs. 23–28, in room N on plan, fig. 11. There are some traces of yellow and red tesserae but it is primarily black-and-white. A similar multiple-design mosaic, also in black-and-white, is in situ in the Theater Baths (also called Baths of Ocean or Small Baths) at Sabratha; see Gozlan 1990, 1006, fig. 25.

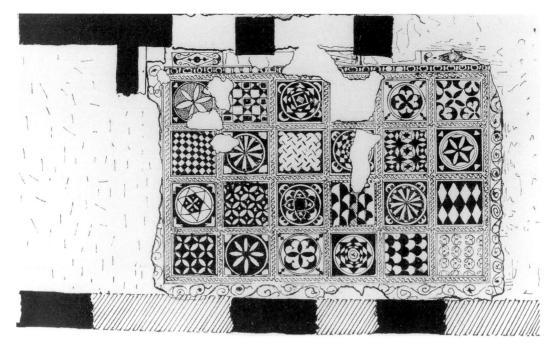

Figure 39. Zliten, Roman villa, room n, multiple-design mosaic (after Aurigemma 1926, fig. 23)

Although the dating of this villa remains controversial, comparisons for its multiple-design mosaic provide persuasive stylistic evidence. The Zliten floor has several features in common with the Reggio Emilia mosaic that has been placed in the Antonine period. Both floors employ the twisted rope (tressed or braided) to outline the grid and frame the panels, a black background to provide the field with more optical contrast, and an alternation of circular and square patterns for the panels. There even seems to be a link between the individual designs, especially the simplified floral forms and scale patterns.[108] The inclusion of peltae in several panels, albeit in a rather haphazard fashion, also recalls Italian examples. With such close Italian parallels it is not necessary to look further afield into Gaul and the latter part of the second century for the inspiration or sources for the Zliten mosaic.[109] Convincing arguments have been made for dating both the Gubbio and Reggio Emilia floors to the first half of the second century, and it seems likely that the Zliten mosaic also belongs to this period.[110] The Ouzouër

108. E.g., the six-and-eight-petaled white motifs. See the first one in the third row from the top placed on a scalloped black ground within a white circle (fig. 39). It has an exact parallel in Reggio Emilia; Lancha 1977, fig. 14.

109. This opinion is also expressed by Lancha 1977, 51, and by Di Vita 1966, 39, but it is in contradiction to the suggestion that the Zliten mosaic results from the direct intervention of the Rhone Valley workshops; see von Gonzenbach 1961, 320n.9.

110. Salies 1974, 34, takes the ambivalent treatment of white and black for backgrounds as a sign of a post-

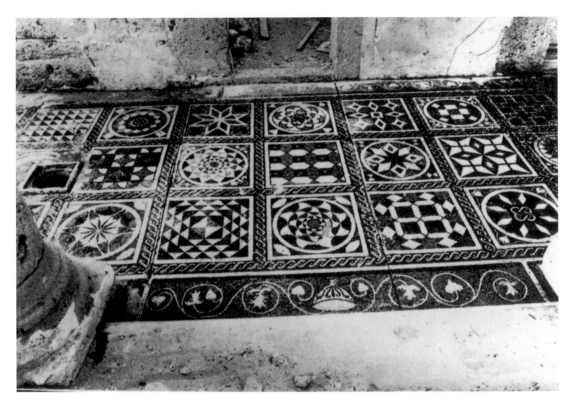

Figure 40. Silin, Roman villa, multiple-design mosaic (after Mahjub 1983, fig. 5)

and Zliten floors share a dependence on the same Italian models, indicating a circulation of these patterns in Gaul and Africa at about the same period.

The Zliten and Paphian multiple-design floors remain true to their Italic origins. The exact relationship between the Gallic, Tripolitanian, and Cypriot mosaics is difficult to determine. The possibilities include the transference of Italian models through Gallic or Tripolitanian intermediaries to Cyprus, or a common dependence on earlier Italian models that were widely circulated. In either case, the Cypriot decorative repertoire must be distinguished from that of the Antiochene workshop in light of the evidence provided by the treatment of the meander pattern throughout the Paphian house and the multiple-design mosaic in room 14. The enrichment of the filling motifs and the polychromatic virtuosity, however, reflect the influence of the Severan style as it was expressed in Antioch.

The anomalous appearance in Paphos of a multiple-design floor in the Greek

Hadrianic date for the Reggio Emilia floor. Implicit in her analysis is a rejection of the excavator's Augustan date, which Lancha accepts without question (34n.66). The controversy around the dating of the Zliten mosaics is reviewed by Dunbabin 1978, 235–37, who indicates a date of ca. 150 for the "ornamental mosaics at Zliten" (esp. 237) which reflect an Italian influence; the analysis given here concurs with her date.

east strongly suggests a work directly influenced by contact with western sources rather than one inspired by models introduced a generation or two earlier. Parallels with the Tripolitanian and Byzacena workshops are recognized in my analysis of the meander types below, and I further explore them in the iconographic discussions. Several mosaics at Zliten and El Jem, in fact, offer compelling analogies for the Paphian mosaics and indicate that the fashionable and influential status of the African centers of mercantile and agricultural wealth should not be easily discounted. This point is taken up again with the discussion of the interlace "cushion" in Chapter 4.

BORDERS: THE MEANDER AND THE TWISTED RIBBON

What immediately becomes clear in a discussion of the Paphian borders is the role they play in organizing the floors into a series of decorated fields. In this sense the workshop follows eastern traditions established in the Hellenistic period. Other features in these same borders can be traced to western developments. One border motif in particular illustrates the interplay of sources within one workshop. Aside from the universal guilloche (braid) and sawtooth, the most frequently used border motif in the Paphian house is the swastika-meander, which appears on eight floors in a variety of combinations.[111] In some cases the meander design functions as a surface composition (color pl. 1, square 12, upper right), while in others it serves as a border or linear composition (fig. 16).[112]

The characteristic the Paphian meander borders share is their relationship to the fields they frame. In each case the restraint in their coloring and decoration offers a strong contrast to the richly colored figural and geometric panels they surround. The variations of the meander found in the Paphian House find their closest parallels in second-century mosaics. Their execution in monochrome scheme, either red-brown or dark-gray on white, with relatively simple filling elements reinforces the comparison with stylistic developments of the first and second centuries. The discovery of many swastika-meander mosaics from this same period in Greece, Tripolitania, and Byzacena confirms a widespread taste for such designs. Although the meander is certainly evident in the borders at Antioch,

111. The eight Paphian meanders are placed in a typological series in a detailed study of the latchkey meander; see Guimier-Sorbets 1983, esp. the table on 212. The author follows the incorrect dating, i.e., 3d/4th century, given in older publications of the Paphian mosaics, and obviously this misdating affects her chronological survey.

112. The three examples of surface designs occur in room 14, where three panels of the multiple-design mosaic are decorated with swastika-meander patterns. The five borders can be found in room 2 around the Seasons mosaic (fig. 46); in room 8 around the lozenge-star-and-square mosaic (fig. 24); in the triclinium or room 1 in the surround (fig. 145); in room 7 as a wide frame for Phaedra and Hippolytos (fig. 16); and in the north, east, and south porticoes of the peristyle (areas 11, 12, 13) as a running surround about the hunting panels (fig. 172). It is important to note that some of the borders are filled with meander types typically used in surface compositions; see Guimier-Sorbet 1983, 196n.5.

it is not as prominent nor is it represented by as many variants. A more precise definition of the Paphian meander types will help characterize the Paphian workshop.

The swastika-meander in room 8 serves as the wide outer frame for the lozenge-star-and-square composition (fig. 24).[113] The swastikas are poised so that the design is set obliquely. The line of the design itself is formed by a series of poised squares made up of four gray tesserae and set point to point. This pointillist treatment of the meander may have its roots in the early technique of *opus signinum* in which pieces of white marble were set point to point in a bed of terracotta-colored cement.[114] The diagonal swastika-meander in *opus signinum* was frequently used in Pompeii for borders, vestibules, and thresholds.[115]

It appears that the oblique dark-on-white meander derived from Italian models that were then transmitted through Sicily and North Africa. The network effect of the *signinum* is imitated in *opus tessellatum* (mosaic technique employing uniform tesserae or cut pieces of stone) in second-century examples from Tunisia, Sicily, and Spain.[116] For instance, one border that is especially close to the execution of the meander in our room 8 occurs in the *tablinum* of an Antonine villa in Castoreale San Biagio on the north coast of Sicily.[117] The central panel of the *tablinum* consists of an *opus sectile* (decoration of cut pieces of marble) pattern of hexagons set in a ground of black tesserae, and this is bordered on three sides by a swastika-meander in *opus tessellatum* set diagonally to the axis of the room. This mixture of techniques reflects an aesthetic preference for arranging the floor design into hierarchical units of threshold, border, and central panel. Although the Paphos floor is entirely executed in *opus tessellatum*, functionally the lacelike effect of the dark-on-white meander border sets off the polychrome central panel as if it were a carpet. Such combinations and contrasts between the borders and the central compositions suit the inherently eastern nature of the Paphian pavements.

The connection between the Paphian meanders and earlier Italian models is most clearly illustrated by the multiple versions of the simple latchkey meander.[118] Five out of the eight meanders at Paphos present variations of this pattern.

113. The frame is about 0.5 meters wide. For the meander type, see *Décor géométrique*, 77, pl. 35g, where it is described as "swastika-meander of poised swastikas with single returns (forming triangles)."

114. This point was also made by Guimier-Sorbets 1983, esp. 197 and 207, where she traces the evolution of the meander from the *opus signum* technique into *opus tessellatum*.

115. About forty examples of meanders in *opus signinum* were found in Pompeii; see Joyce 1979, 255, nos. 17–19; and Blake for Pompeii, House VIII.2,26 (1930, 27, pl. 5,3).

116. In Tunisia, it occurs in corridor 1 of the House of the Masks at Sousse dated ca. A.D. 180; see Foucher 1965, 50, fig. 6; and in corridor C5 of the House of Neptune at Acholla, dated ca. A.D. 170–180; see Gozlan 1974, fig. 11. In Spain, the type is found in the *cubiculum* of the House of the Mithraeum at Mérida; see Blanco Freijeiro 1978b, 39, no. 20, pls. 42b and 43a.

117. Photographs of the *tablinum* remain unpublished; for the other mosaics in the villa, see von Boeselager 1983, 90–97, pl. 51, who dates the villa earlier, to the late 1st or early 2d century.

118. The description from *Décor géométrique*, 79, pl. 37c, reads as "simple latchkey meander, the latchkeys alternately recumbent and upright."

It appears in its simplest form (outlined by a gray double fillet with no filling devices) in room 9 as the monochrome border for the colorful and complicated interlace-"cushion" (fig. 72). This type of meander has also been described as "rectangles linked by swastikas" because it gives the impression that the wide intervals between the narrow points of intersections form rectangles.[119] We need not go far to find the source for this meander type on Cyprus: it appears in nearby Kouklia in the field surrounding the lozenge-star-and-square composition. As already noted, the Kouklia floor can be dated archaeologically to the first half of the second century and closely related to Italian models of the same period.

The simple latchkey meander, outlined by a double fillet, recurs with an elaboration in the expansive field surrounding the Narcissus mosaic in room 1 (fig. 10).[120] The addition of dark-gray crosslets and oblique red squares as filling motifs in the spaces between the swastikas promotes the visual impression of discrete rectangular units. An exact parallel for this treatment with crosslets is found in the second century at Kenchreai in the peristyle court of the Sanctuary of Aphrodite (fig. 41).[121] Their resemblance is suggestive and may indicate Corinth as a place where western models entered into the repertoire of eastern workshops.[122] There are ample parallels in Pompeii and Ostia from the first and second centuries, respectively, which substantiate a well-established Italian series of such meanders.[123]

A denser, more tightly woven effect was achieved by doubling the meander, for instance in the border of the Seasons mosaic in room 2 at the entrance area of the Paphian house (fig. 45).[124] The flatness of this monochrome (dark-pink/red) meander successfully contrasts with the illusionistic cuboids that immediately frame the Seasons panels.[125]

The preference for a dense and intricate border to surround a picture panel is

119. Waywell 1979, 308. Although no rectangles are actually defined, the pattern does visually recall the overlapping squares and rectangles or basket-weave borders often found on 1st- and 2d-century Italian floors; see the border of the *tablinum* in the House of the Boar at Pompeii, in Blake 1930, pl. 27,1.

120. The width of this "border" is approximately 0.22 meters—that is, more than half the width of the central figural panel.

121. The design can be found in the northeast corridor of the peristyle; see Scranton and Shaw 1976–78, 95–96, pl. 38A; and Waywell 1979, 299, cat. no. 29, pl. 48, fig. 24.

122. Although the diffusion of ornament remains a thorny subject, the discovery of the monumental black-and-white marine mosaic in the Baths at nearby Isthmia certainly underlines the links with Italian tastes and models in the Corinth area; this mosaic is examined below in Chapter 6 on the Triumph of Dionysos.

123. At Pompeii, see the atrium mosaic in the House of the Boar (House VIII, 3.8) dated A.D. 50; see Blake 1930, pl. 27,1. A floor dated to A.D. 150 with such a key pattern occurs in the Insula of the Painted Ceiling at Ostia; see Becatti 1961, 64, no. 82, pl. 19. At Ostia, see also the mosaic from the early-2d-century phase of the Domus of Apuleius (ibid., 89, no. 151, pl. 25a); and the "Casette-Tipo," Reg. II, Is. 12–13, dated to ca. 100 (ibid., 139, no. 272).

124. Such a design is described in *Décor géométrique*, 79, pl. 37d, as "double latchkey meander, the latchkeys alternately recumbent and upright." The border is approximately 0.7 meters wide.

125. The same type of meander occurs in a geometric panel on a mosaic found in Bavay (Belgium), which is dated to the 1st or 2d century; see Stern 1979, 80, no. 121, pls. 41–42.

Figure 41. Kenchreai, Sanctuary of Aphrodite, swastika-meander (after Scranton 1976–78, pl. 38a)

clear in the choice of a reverse-returned swastika meander in room 7 (fig. 17).[126] Again, as with the other meander borders for figural scenes at Paphos, the width is roughly half the width of the figural panel. The swastika-meander functions as a concentrated interweave of lines which focuses the viewer's attention on the open space around the figures of Hippolytos and Phaedra in the central panel. A similar effect is achieved when this very same pattern is used to frame an *emblema* in a late-first-century villa at Ptolemais (fig. 42).[127] A lighter version of the same design—that is, one showing more white ground—occurs in the mid-second-century *Horrea Epagathiana et Epaphroditiana* of Ostia.[128]

Another intricate version of the swastika-meander is employed as the surround that wraps the north, south, and east sides of the T-shaped pavement in the triclinium and terminates above the Dioscuri panels at the west end (fig. 145).[129]

126. The design is outlined by a double fillet of reddish-brown tesserae and consists of a double row of "swastika-meander of spaced recessed reverse-returned swastikas with a square in each space"; see *Décor géométrique*, 82–83, pl. 39e.

127. Kraeling 1962, 244, fig. 68, pl. 59c. In Ptolemais the colors are blue and white; in Paphos they are terracotta-red and white.

128. Becatti 1961, 17 and 280, no. 18, pl. 19. A case for regional interpretations can be made with an early Severan example from corridor 11 in the House of Tertulla at El Jem. There, multicolored Solomon's knots on a dark ground fill the squares. The North African taste for coloristic accents and the dominance of filling motifs over the design is evident; see Foucher 1960a, 46, pl. 19b.

129. These long strips border the peltae pattern (shields) that demarcate the three zones for the dining couches; they are about 0.9 m. wide.

Figure 42. Ptolemais, Roman villa, swastika-meander (after Kraeling 1962, pl. 59c)

The design is marked out by a double reddish-brown line and includes lozenges inscribed within the rectangular fields marked by the latchkey pattern (fig. 43).[130] The very same variation appears in the court of the Temple of the Shipbuilders at Ostia, which is dated to the first decade of the second century.[131] Although they are outlined only simply, the lozenges dominate the pattern at Paphos and at Ostia. Such similarities in treatment suggest a rather broad development toward progressively more complicated versions which can be traced throughout the Empire.[132]

There are no fewer than four examples of the insertion of the lozenge into a swastika-meander at Antioch from the Severan period (A.D. 193–235).[133] The simplest one is also the earliest, and it is from the Portico of the Rivers in the late-second-century House of the Porticoes.[134] In subsequent stages of this same version at Antioch more complicated color combinations are used; within a generation the lozenge is turned into an illusionistic device by the Severan art-

130. The design is not described in *Décor géométrique*; it can be found in *AIEMA*, no. 394, as "composition de carrés et lozanges adjacent avec en superimposition méandre de svastikas en pannetons de clé."

131. Becatti 1961, 94 and 332, no. 160, pl. 18a.

132. The earliest dated example is found in the Trajanic Baths of Acholla, where a rectangular segment of the cable motif fills the interstices of the key pattern, giving a strong impression of a basket weave; see Picard 1959, 79, pl. 11; and 1968, 103–4. At Corinth the lozenge-swastika-meander occurs in two rooms of an Antonine villa; see Waywell 1979, 297, cat. no. 17, pl. 47, fig. 16. Color is used to vary the field: a rich texture results from the filling of the lozenges, their interstices, and the swastikas with bright shades of yellow, violet, red, and blue. That this coloristic approach to design variation appears to be peculiar to Greece is seen in the local adaptations of the lozenge-star-and-square above.

133. For a list and discussion of these, see Guimier-Sorbets 1983, table on 210, and 197.

134. Levi 1947, 389, pl. 99b.

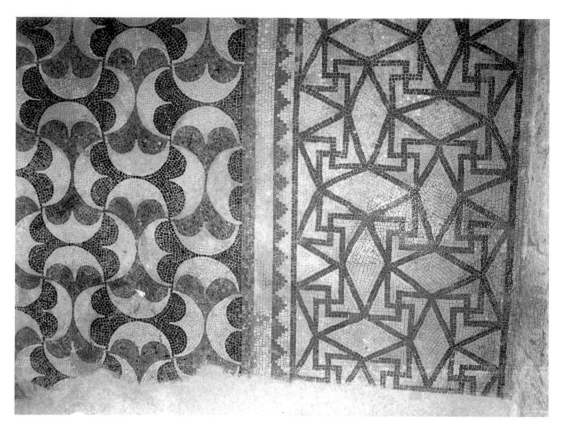

Figure 43. Triclinium, general view (courtesy of the Department of Antiquities, Cyprus)

ists.[135] Although Antioch provides the nearest geographical comparison for our ornamental repertoire, the Ostia mosaic is most like it in its emphasis on simple outline and white ground. It is not necessary to postulate an Italian contact for this comparison, but we should note a Paphian restraint in the adoption of the same motifs that were variously interpreted at Antioch. Perhaps this conservatism was inherited from an earlier phase of the Paphian workshop that produced the Kouklia mosaics. Equally apparent is the eastern compulsion to juxtapose different treatments in terms of style and technique within the same pavement. For instance, in the Paphian triclinium the bold tricolor panels of peltae, or shields, are contrasted with the monochrome surround in the latchkey pattern.

In the field surrounding the Ganymede panel in room 10 (fig. 81) a latchkey of running swastikas is superimposed on a design of tangent octagons and squares; a

135. Immediately following the House of the Porticoes in Levi's chronology is the House in sector DH 23/24N (ibid., 390, pl. 97e). In the post-Severan period, perspective lozenges appear in the House of the Buffet Supper, intermediate level, room 1 (409, pl. 107b).

line of swastikas fills every other line of octagons.[136] The octagons that do not have swastikas in the centers are filled with motifs in dark-pink and gray, including six-petaled flowers, checkerboard squares, and dark-pink circles. The squares are filled with pink diamonds. The pattern visually recalls the common first- and second-century practice of linking octagons with swastikas, but structurally the Paphos floor is quite different, since it consists of two superimposed designs.[137] The closest parallel is found in an early Pompeian floor and in a floor in Amiens from the first or second century.[138]

The inventiveness of the Paphian workshop comes out especially clearly in the execution of the coloristic adaptations of the swastika-meander in four squares of the multiple-design composition in room 14 (fig. 31).[139] In square 12, the same swastika-meander found in the border of the Seasons floor (room 2) is reproduced on a small scale in dark-pink. The other three panels all present variations on the type found in the surround of Ganymede (room 10), but their differences raise the issue of variations that are determined by compositional context. The small geometric panels are highly compact with their white outlines of swastikas and their heavy tones of reddish-brown and dark-green for the octagons. They form units of a geometric patchwork creating a rich and dense polychrome carpet that is effective for the multiple-design composition. In contrast, the dominance of the white ground in the field surrounding Ganymede produces a much lighter effect, one that enhances the polychrome pseudo-*emblema* of Ganymede, as in the case of the Narcissus panel. Working with similar, if not identical models, the Paphian workshop produced two entirely different interpretations by responding to the divergent function and context of each design. These variations within the same house do not necessarily imply a multiplicity of sources, but rather suggest an innovative workshop spirit.

An exhaustive catalogue of the latchkey-meander types assembled by A.-M. Guimier-Sorbets provides an instructive overview of the development of the pattern.[140] From this 1983 survey we can note a widespread use of the meander in

136. For an illustration and description, see *Décor géométrique*, 254–55, pl. 166d, "outlined orthogonal pattern of adjacent octagons forming squares, each alternate octagon bearing an alternately reversed inscribed swastika (creating the effect of superimposed latchkey-pattern of running swastikas)."

137. For some examples of octagons and swastika designs, see the mosaic from vestibule 23 in the Villa of the Contest of the Nereids at Tagiura 1966, 36, pl. 7f; and another related design from the Bath of the Marine Thiasos at Acholla (see Picard 1968, 103, fig. 4); and from the House from Terrain Jiliani Guirat at El Jem (see Foucher 1960a, 41–42, pl. 9e).

138. For Pompeii, see the House of the Centenary; Blake 1930, 98, pl. 14,4. For Amiens, see Stern 1979, 65, no. 93, pls. 36 and 37.

139. These are described in detail above in the section on the multiple-design mosaic. The originality of these panels is commented on by Guimier-Sorbets 1983, 208n.35.

140. A long list of examples, their dates, findspots, and bibliographic references is found in Guimier-Sorbets 1983, 210–13; it must be pointed out that the group from the second and third centuries would be considerably denser if the author had properly dated the House of Dionysos examples to the early Severan period.

the second through the mid-third centuries, especially at sites in Byzacena, Greece, and Syria.[141] Curiously, the monochromatic austerity of many of the Paphian borders places them closer to the Italian examples, largely from Pompeii and Ostia of the first and second centuries. One possible intermediary between the African, Italian, and eastern workshops might have been Corinth.[142] If the early Severan date of the House of Dionysos in Paphos suggested by the archaeological evidence proves to be internally consistent, then this Roman house may disclose important facets of such east-west exchanges.

The border of the lozenge-star-and-square composition in room 8 is a twisted ribbon that provides important evidence for dating the mosaic and for identifying its sources. The ribbon is formed by a thin undulating white line filled with graded hues passing from pink to red and from light-gray to dark-gray (fig. 24). The motif is generally accepted as deriving from painted decoration and does not appear in mosaic until after the destruction of Pompeii. A chronological series of the twisted ribbon is provided by examples from Antioch.[143] The earliest of these date to the Hadrianic period and are characterized by their subtle shading and regular rhythms.[144] The next example dates to the early Severan period and is found in the House of the Porticoes, where it frames the fragmented panel showing Thetis in the so-called Portico (south) of Achilles (fig. 22).[145] This treatment of the twisted ribbon is peculiar for its use of white highlights that dart out in the shape of short, curved white lines from the undulating white ribbon into the graded color area. The effect of these highlights is to interrupt the even rhythms of the ribbon, thereby departing from the standards of the earlier forms. It is precisely this same treatment with white highlights that is found in the Paphos frame. Levi argues that the ornamental style of the House of the Porticoes marks a transitional point in the history of geometric ornament and heralds a new fashion in decoration which will characterize the Severan period.[146]

Some of the features of the "new" Severan ornamental style were noted in the analysis of lozenge-star-and-square mosaic above, especially in terms of the Antiochene comparisons. The addition of the white highlights to the twisted-ribbon border simply underlines the movement toward ornamental complexity which was born in the late second century. It took less than a generation for the new style to become an established tradition that favored schematized versions of the decorative repertoire. This development is easily seen in the twisted-ribbon bor-

141. There are thirteen examples from Antioch on Guimier-Sorbets' list. In addition to the Argos and Corinth examples on this list, see panel 1 of the stoa at the Odeon of Herodes Atticus at Athens (Waywell 1979, 308, cat. no. 8, pl. 46); and the Odeon at Epidauros (ibid., 299,, cat. no. 26). See also the mosaic in a Roman villa at Sami (ibid., 302, cat. no. 44).

142. See the examples listed under Corinth and Kenchreai in Guimier-Sorbets 1983, 211.

143. The many examples of twisted-ribbon borders are discussed throughout Levi 1947, 377–471.

144. This border occurs in the frame for Oceanus and Thetis in the House of the Calendar and in room 3 of the House of Cilicia; see ibid., pl. 6 and pl. 95a, respectively.

145. Ibid., 89, pl. 18f. The mosaic is now at Michigan State University.

146. Ibid., 392.

der found in the House of the Buffet Supper (lower level) at Antioch, dating to the later part of the Severan period.[147] Here the animated effects of the white highlights are eliminated and the ribbon is wider and stretched out toward the horizontal lines of its border, so that deeper loops are created. This exaggerated ribbon is now filled with curved bands of color which are no longer subtly shaded. In the earlier examples, as in Paphos, the juxtaposition of irregular patches of graded color, achieves a natural shading closer to the painted originals. In the succeeding phases the motif quickly becomes more stylized, as the ribbon line is stiffened and the curved bands of color are straightened.[148] It is obvious even in the minute details, such as the darting white highlights, how the artistic response moved from illusionism to an interest in the abstract qualities of the motifs, a trend shown in the advancing degrees of schematization. The preference for patterning and variation begins to make itself felt in the House of the Porticoes, and it is clear that the Paphos ribbon border fits into this transitional phase, as does the lozenge-star-and-square pattern.

Such idiosyncratic similarities between the Paphian and Antiochene mosaics, especially precise in the case of the twisted ribbon, underline the possibility that members of an Antiochene workshop or craftsmen trained by them were present for the production at the House of Dionysos. The mechanics of these exchanges is made clearer by an examination of another twisted-ribbon border framing the peacock in room 3 in the Paphian house (fig. 65). Instead of short curved lines darting out from the white ribbon, several long white lines cross into the colored loops of the ribbon in haphazard fashion, creating a striated rather than a highlighted effect. Although the colors—pinks, reds, and grays—are the same as those used in room 8, they are no longer arranged in an ordered range of tones, and the regular rhythms of the undulating ribbon are also lost. There is a certain looseness, almost a slapdash character to the execution of the motif; it bears no resemblance to any ribbon found in Antioch or to the one in room 8 (fig. 25). It seems logical to assign this twisted ribbon to another, less "trained," craftsman who must have seen the white highlights in room 8 and attempted, with little success, to reproduce its effects. This was undoubtedly a local artisan whose interpretation was unique and provincial and who had little sense of the original form or function of the motif. His ineptitude reveals that several hands of varying skill worked on frames within the workshop and that at least one of those hands, and probably more, were trained or originated in Antioch and set the standards for the workshop.

This examination of the ornament in both the border and surface designs in the House of Dionysos provides a nuanced picture of the Paphian workshop. The impression one gets of its practices in creating designs is not surprising, in that

147. Ibid., 392, pl. 142c.
148. See, e.g., room 3 of the House of the Mysteries of Isis dated to the Severan period, and the border around the eponymous mosaic in the House of the Peddler of Erotes, ca. 240 (ibid., 397, pl. 33a, and 403, pl. 43a, respectively).

much the same approach is seen in the iconographic panels: both are compositions derived from models, with contributions from ad hoc inventions. What the ornament emphatically confirms is the selection of western compositions, such as the multiple-design and the interlace "cushion" (to be taken up below in Chapter 4), that might well have been filtered through North Africa, as witnessed by the numerous parallels in Byzacena and Tripolitania. The restrained interpretations of the swastika-meander and the lozenge-star-and-square pattern point out a close relationship with, or at least a resemblance to, second-century Italian examples. The existence of the Kouklia lozenge-star-and-square mosaic proves that such models were employed in Cyprus in the course of the second century. Undoubtedly, the Kouklia mosaic was executed by the same workshop as the one that made the Paphian mosaics. On the other hand, the idiosyncracies of the ribbon border and the fact that Paphos and Antioch have yielded the greatest number of variations for the latchkey swastika-meander pull the Paphian productions into the radius of Antioch. This association is further emphasized by the series of lozenge-star-and-square mosaics found at Antioch which have guided the stylistic and chronological attribution of the Paphian example. Although the cases of lozenge-star-and-square put forth may seem too few, they do suggest a route of transmission from Italy through North Africa to eastern sites in Greece, Cyprus, and Antioch.

Both the ornamental repertoire at Paphos and the mythological scenes provide a clearer picture of the inventive spirit of the Paphian craftsmen. That they were undeniably steeped in the Hellenism of the Antiochene milieu is demonstrated by both the Narcissus and the Phaedra and Hippolytus scenes, but they were also abreast of stylistic developments in the west. Whether their knowledge derived from a visually astute patron who was deeply involved in the decoration of his *domus,* or from a well-traveled head designer (*pictor*) cannot be determined. Given the evidence from the other mosaics in the house, I suspect that unusual abilities of both patron and designer were needed to produce the innovations found at Paphos.

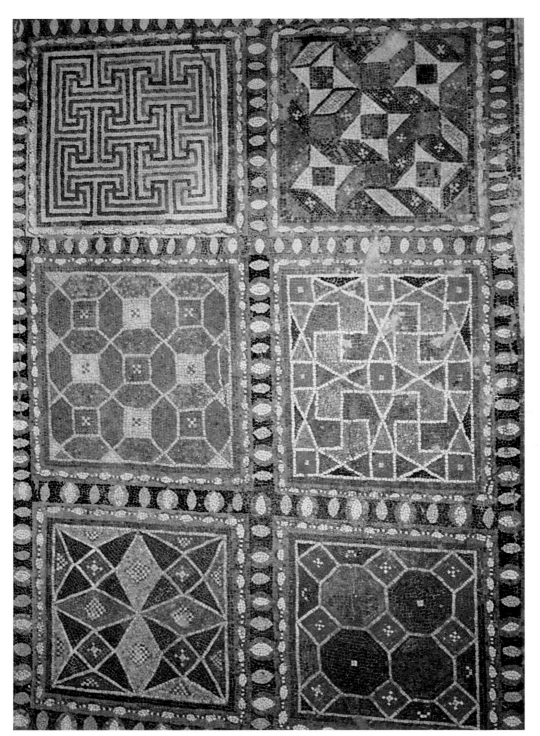

Plate 1. Room 14, multiple design, detail (courtesy of the Cultural Foundation of the Bank of Cyprus)

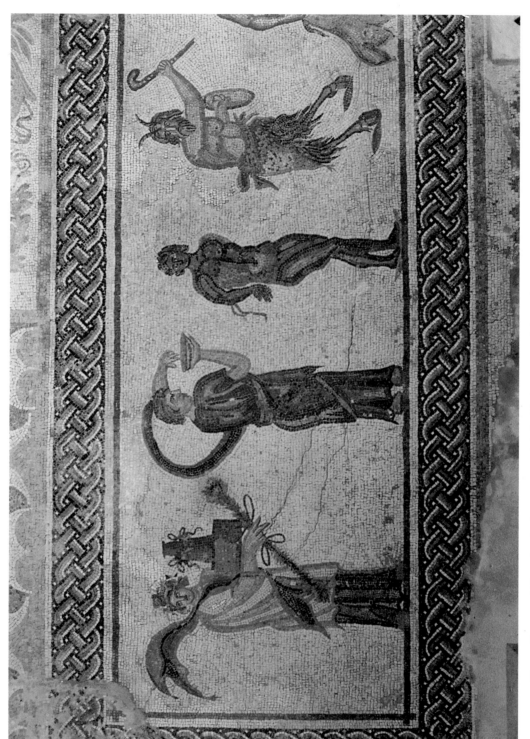

Plate 2. Room 1, Triumph of Dionysos, panel, left side (courtesy of the Cultural Foundation of the Bank of Cyprus)

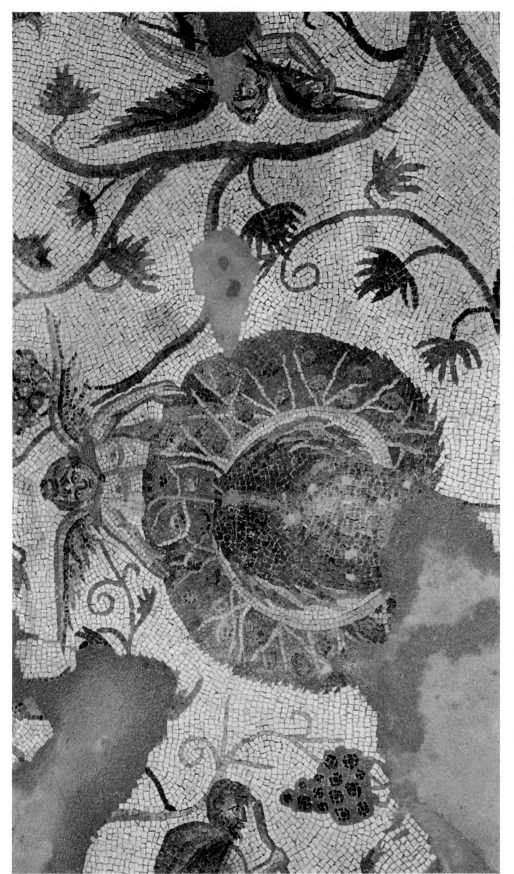

Plate 3. Room 1, vine carpet, detail of Eros and peacock (courtesy of the Cultural Foundation of the Bank of Cyprus)

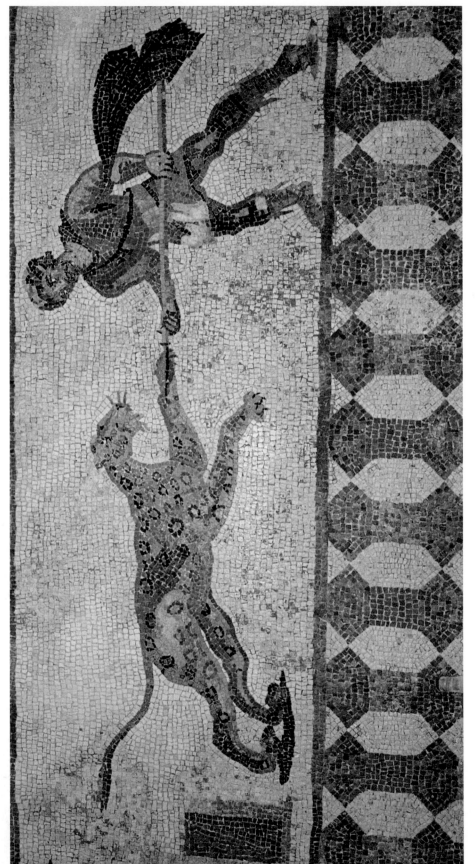

Plate 4. Peristyle, east portico, leopard hunter (courtesy of the Cultural Foundation of the Bank of Cyprus)

The Entrance
Salutations of the Seasons and a Peacock

IN THE HOUSE OF DIONYSOS the rooms flanking the proposed main entrance are constructed with meaningful and appropriate decoration (fig. 1, area A). Three consecutive rooms arranged along the southwest section of the *domus* have pavements with salutatory themes: room 1 with Narcissus, room 2 with the Seasons, and room 3 with a frontal peacock. It is, in fact, the decoration and inscriptions in room 2 which support the hypothesis that the entrance, as discussed in the Introduction, was located somewhere along the south wall of room 2. Although archaeological excavation could not determine the entrance, the greetings "XAIPEI" (Welcome) and "KAICY" (And You) inscribed in mosaic tablets on either side of the Seasons are declarative where the stones cannot speak (figs. 46 and 47).[1] Because these are wishes for those entering or leaving a building, the room might have served as an antechamber of the original entrance. The peacock panel of room 3 is sited on an axis with the west portico and serves as a transition between the entrance area and the triclinium and peristyle (figs. 3 and 4).

This confluence of figural subjects, related inscriptions, and a specific architectural context offers a significant insight into Roman domestic decoration. The absence of a clear entrance axis in the Paphian ground plan should not mislead the modern visitor. Although the Paphian peristyle house does not include the *fau-*

1. K. Nicolaou 1967, 108.

ces-atrium-tablinum arrangement found in the ideal Roman *domus*, the mosaics imply a socially charged use of the entry space.[2] The Seasons and peacock mosaics were undoubtedly viewed by the ancient guest as a visual response to the *salutatio*—a ritual by which the dependents or clients bestowed benefactions on the patron of the household. Just how such Roman conventions were absorbed in the eastern Mediterranean provinces is not well understood, but these Paphian mosaics remain as the symbols of prosperity, *tryphe* (luxury), and well-being which welcomed the guests on their arrival. The greatest number of Seasons pavements have been found in the private homes of Roman Africa, but most of these are decorated rooms for receptions and entertainments.[3] The choice of both the Seasons and peacock themes along the entrance axis at Paphos is unusual and reveals a bold and perhaps local adaptation.

Taken as a group, the Seasons, Narcissus, and peacock mosaics express a delight in the beauty and abundance of the natural world with the attendant implications of the "good life" led by the inhabitants. Their juxtaposition serves to intensify this meaning, and for this reason the Narcissus mosaic in room 1 may also be more broadly interpreted. Although a fuller discussion of the Narcissus panel precedes this chapter, some aspects of its physical context are relevant here.[4] The fact that the scene is set by a reflecting pool might alone have accounted for its presence near the entrance area. Water elements—basins, shallow pools, fountains, and channels—were the sine qua non of elite Mediterranean houses. In the House of Dionysos there is a fish pool and a basin at the center of the peristyle, in addition to a number of mosaics featuring aqueous myths along the west portico. Did the ancient beholder respond only to the narrative of Narcissus? If the *Imagines* provide a guide, then an answer lies in the phrase Philostratus used to describe a painting of the scene: "the pool paints Narcissus, and the painting represents the pool and the whole story of Narcissus." The illusion of a pool becomes a reality for this third-century critic, whose description speaks eloquently about the potential for myth to bear multiple meanings. The representation of a pool serves as a mimetic device to evoke a basin. In other words, water itself was a *topos* of reception and a sign of luxury. That this association was concrete for the ancient visitor is attested by the combination of two mosaic panels at the entrance to a grand *oecus* in the House of Menander at Antioch, where one contains a female bust inscribed as "TRYPHE," and the other two reclining river gods are labeled as "LADON" and "PSALIS" (fig. 44).[5]

2. Two studies integrate social practices and rituals into their analysis of the architecture and decoration of the Roman atrium house; see Clarke 1991b, esp. 2–6; and Dwyer 1991, passim.

3. Parrish 1984, 69, accounts for fifty-three examples in his study.

4. The reader should couple the following discussion with the one at the end of the section on Narcissus above in Chapter 2.

5. Levi 1947, 205–6, pl. 46c and 46e.

Figure 44. Antioch, House of Menander, House 1, room 13, mosaic (courtesy of the Department of Art and Archaeology, Princeton University, no. 4907)

THE SEASONS

The decoration of room 2 ideally suits its location near the entrance, that is, in the southwest corner of the house.[6] The central composition is a grid of nine square panels (roughly 3 m.) with busts of the four Seasons in the corners (fig. 45). Genre motives related to seasonal activities fill the four panels between the Seasons. A long-haired youth is represented at the center in the ninth panel. An uninterrupted band of polychrome solids-in-perspective on a black ground frames the individual panels.[7] A wide band of red swastika-meander in a key pattern surrounds the whole composition.[8] All nine panels are oriented to the west side of the room, ostensibly where the visitor entered the room. On this same

6. The room measures 5.75 m. × 4.85 m.

7. In *Décor géométrique*, 154–55, pl. 99e, they are described as "cuboids." The solids are alternately colored with pink/red and yellow/brown tesserae. The band is 0.19 m. wide.

8. This border is about 0.70 m. wide.

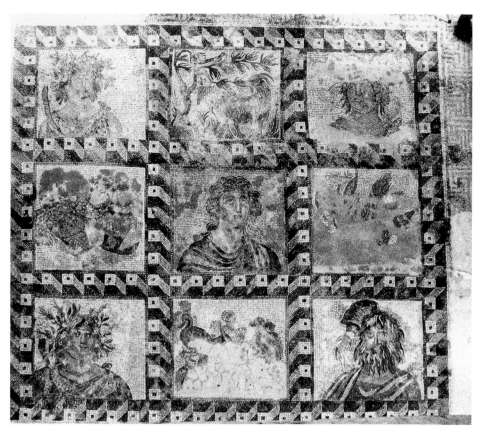

Figure 45. Room 2, Seasons (courtesy of the Department of Antiquities, Cyprus)

side there is a black *tabula ansata* (tablet), set within the geometric frame, with the inscription "KAICY" (fig. 47).[9] A similar device with the inscription "XAIPEI" occurs at the opposite end (fig. 46), facing the east wall (adjacent to room 3 with the peacock). Only fragments of the original floor survived the heavy damage incurred during the leveling operations.[10] As a result, much of what can now be seen is modern restoration, and the precise placement of the panels, details of the busts, and their attributes are not certain. It is clear from photographs taken while the original floor was in situ that the upper left panel (Summer), the adjacent bucolic panel, as well as the central bust are in their original positions (fig. 48). A detailed stylistic or iconographic analysis hardly seems advisable in the light of the broken bits from which these panels were reconstructed, yet there is much to be gleaned from even the most general characteristics of this unusual mosaic.

9. The tablet itself is set within a lozenge that is inscribed in a rectangle; all these forms are outlined by double black or gray fillets; see K. Nicolaou 1967, pl. 21,2; and 1963, 16.
10. See K. Nicolaou 1967, 112.

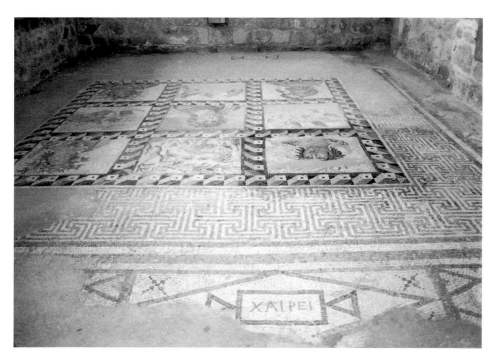

Figure 46. Room 2, Seasons, general view from east side with inscription "XAIPEI" (photo by C. Kondoleon)

The Seasons, which have been reconstructed after leveling, are represented as male busts turned in three-quarter view toward the middle. Three of them wear sleeveless yellow tunics with black spots, suggesting an animal skin, while Winter is wrapped in a woolen mantle. If the reconstruction is correct, the series does not follow a cyclical order. Summer, in the upper-left corner, is identified by the sheaves of grain in his hair and by the sickle at the left shoulder (fig. 48). A pendant panel of vegetables—only artichokes are visible—appears below Summer. Summer faces toward a genre panel in which a goat grazes by a tree with a syrinx hanging from its bough (fig. 49). The bucolic scene leads logically to Spring in the upper-right corner; he is crowned with flowers and holds a bouquet of flowers with a pomegranate and a shepherd's staff (crudely restored) at the right shoulder (fig. 50). Below, two baskets laden with grapes seem to tip over (fig. 51). These are the fruits of Autumn, who appears in the lower-right corner crowned with a wreath of leaves, red buds, and small white flowers (fig. 52). An odd clublike object (a *pedum* again?) is placed at the right shoulder of Autumn.[11] Waterfowl (only parts of the four ducks are still visible) fill the panel between

11. Michaelides describes it as a "badly drawn pruning knife," which would make more sense, but it actually looks more like the *pedum* carried by Spring (Daszewski and Michaelides 1988a, 20).

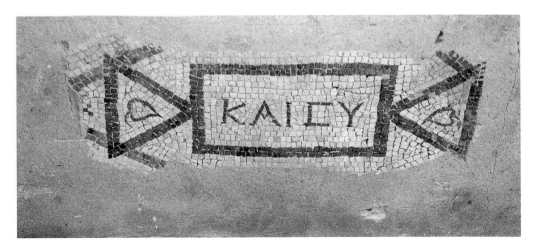

Figure 47. Room 2, Seasons, inscription on west side "KAICY" (photo by
C. Kondoleon)

Autumn and Winter (fig. 53). These seasonal game complement Winter, who
appears in the lower-left corner and is heavily clad in a mantle of dark colors
(gray/black/white) and has long hair and beard of similar shades (fig. 54). Water
flows out of an upturned vessel set to the right of his head.[12] Finally, the youth
in the middle, to whom the four Seasons turn, is wrapped in a yellow and
brown mantle (fig. 55). There are no attributes in his long, wavy locks or else-
where which might help identify him, but he is certainly the most skillfully
produced bust.[13] His wide-eyed gaze commands the immediate attention of the
viewer, as does the fact that this is the only panel with a colored background (gray
and yellow).

For the most part, the Paphian panels follow the standard Roman iconography
of the Seasons in that their attributes are canonical. The exception is Winter, who
is usually shown as a bearded older figure covered in a hood and carrying river
reeds and/or aquatic fowl. At Paphos, the addition of an upturned water jug, an
attribute more typical of river gods, suggests that the mosaicist might have con-
fused or conflated Winter with a river deity. The absence of a hood, de rigeur for
Winter throughout antiquity, underlines this possibility. Although the watery
nature of winter months is illustrated by water flowing from an amphora in the
representation of February in the manuscript illustrations for the *Calendar of 354,*

12. The vessel is oddly shaped, perhaps owing to restoration. It appears curved and pliant so that at first
view this form could be mistaken for a squid. The colors, however, yellow and brown for the vessel and
green and blue glass tesserae for the water, indicate that it is an upturned vessel.

13. Daszewski suggests either Dionysos or Annus, but notes that this head is very much restored, as it
seems also to me; see Daszewski and Michaelides 1988b, 34n.41a.

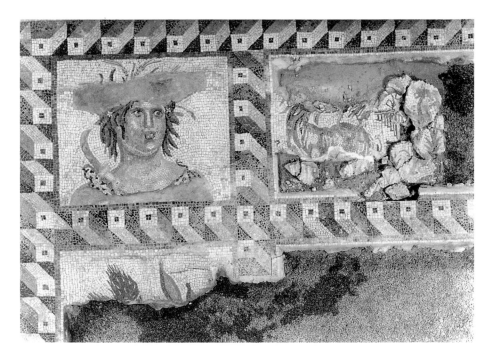

Figure 48. Seasons, Summer and goat, before restoration (courtesy of the Department of Antiquities, Cyprus)

Figure 49. Seasons, goat (courtesy of the Department of Antiquities, Cyprus)

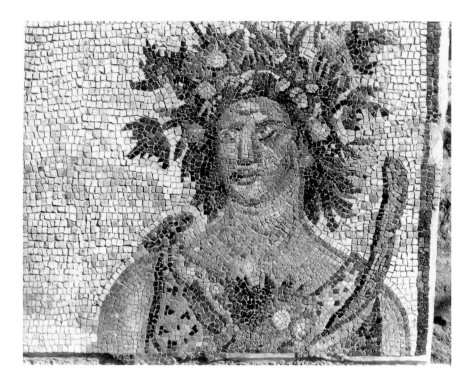

Figure 50. Seasons, Spring (courtesy of the Department of Antiquities, Cyprus)

Figure 51. Seasons, baskets of grapes (courtesy of the Department of Antiquities, Cyprus)

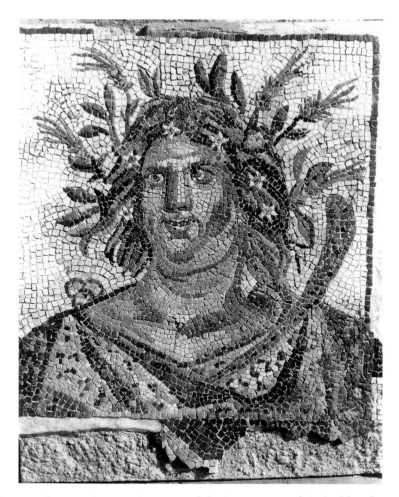

Figure 52. Seasons, Autumn (courtesy of the Department of Antiquities, Cyprus)

this was not the usual attribute of Roman Winter iconography.[14] A similar motif occurs on an early Christian floor from a church in Dair Solaib (Lebanon), where water improbably spills out of an upright vessel at the right side of a female Winter, identified by a Greek inscription.[15] Summer, on the other hand, is absolutely typical with his wreath of grain and sickle. As in many representations of the Seasons, Autumn and Spring at Paphos closely resemble each other, but their leafy crowns and staffs might be similar because of the restoration.

14. See Levi 1947, 87. The *kantharos* held in the hands of the male figure of Winter found in the House of the Red Pavement at Antioch might be considered a related motif (87n.126). Levi suggests that it was inspired by the wine drinking associated with the December festivals of the Saturnalia, but at Paphos water is definitely indicated by the blue glass tesserae and the jug is not a drinking cup or amphora (at least if the restoration is accurate). A squat and wide vessel appears to the left of a hooded Winter bust in a late-2d-century mosaic from Carmona (Spain); see Blazquez 1982, 31–34, no. 15, pl. 12.

15. The mosaic has been dated to the second half of the 5th century and shows the Seasons as female busts accompanied by panels with animals, including two horses; see Hanfmann 1951, 154, no. 192, fig. 121.

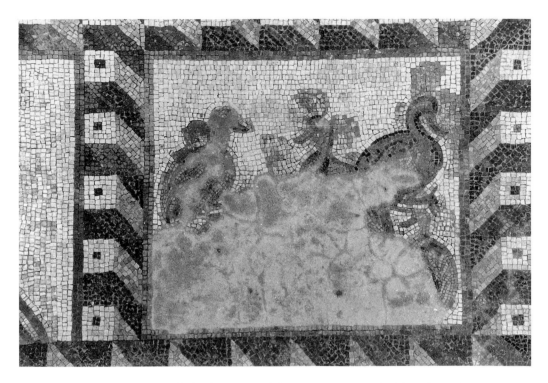

Figure 53. Seasons, ducks (courtesy of the Department Antiquities, Cyprus)

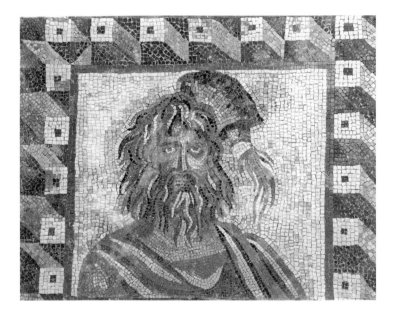

Figure 54. Seasons, Winter (courtesy of the Department of Antiquities, Cyprus)

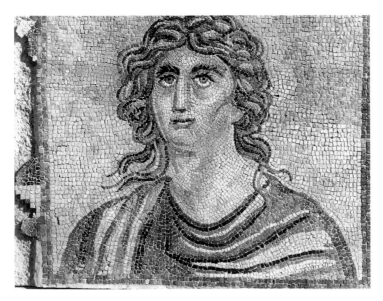

Figure 55. Seasons, central youth (courtesy of the Department of Antiquities, Cyprus)

Despite the availability of comprehensive surveys of the Seasons in art and literature, it remains difficult to categorize the iconographic development, at least of the mosaics, into geographic groups.[16] The scarcity of excavations for the Roman period in the east, especially in Greece, is certainly a factor.[17] It is fair to state, from what has thus far been discovered, that the female bust type predominates in western mosaics for the Imperial period, while male figures, both standing and busts, appear more frequently in eastern mosaics.[18] Whether this division is simply a matter of taste or a natural outcome of diverse origins or interpretations cannot be clearly determined.

Antioch provides an interesting test case for these questions because several types are represented at one site from the Hadrianic period until the mid-third century. A brief list of these examples with the approximate dates proposed by Levi is instructive:[19] winged female busts of Spring and Winter (the other two

16. In an early survey of Season iconography, Hanfmann noted that "the mosaics fail to show any definite development of geographic groups" (1951, 214).

17. Levi raises this point in his critical review of Hanfmann's study of the Dumbarton Oaks Season sarcophagus (1953, 237).

18. In a recent catalogue of these images the female versions are listed separately as Horae, and the male versions as Kairoi; see Abad Casal 1990, "Horae," 510–37, and "Kairoi," 891–920. The most popular form in North Africa, where eighty-two examples have been catalogued, is the female bust; see Parrish 1984, passim. He states that "among the 59 African pavements whose seasonal identity is certain . . . , 43 examples employ female busts or heads, compared to only 5 with Horae, and 14 with males" (ibid., 21). He also notes that a comparable proportion of female-to-male seasons occurs in mosaics from outside Roman Africa (ibid., 21n.32).

19. The dates are taken from the chronological table; see Levi 1947, 625–26. There have been remarkably

Seasons are lost) from the Calendar mosaic in the House of the Calendar (ca. 120);[20] a large male bust (Spring?) from the entrance room of the House of Narcissus (ca. 130);[21] four winged putti from room 1 of the House of the Red Pavement (ca. 150);[22] a similar set of winged male seasons from a corridor in the House of the Drinking Contest (ca. 220);[23] and a bust of Winter of indeterminate gender with a hood and bowl from the entrance panel of the triclinium of the House of Menander (ca. 240–250).[24] Yet another version, that of four full-standing females (Horae) is introduced in the early-fourth-century Constantinian Villa.[25] What this variety demonstrates is that a full spectrum of models was available to the artists at Antioch and that these types were often interchanged according to the decorative demands of the composition. In any case, the introduction of male Seasons seems to have been an Imperial innovation of Trajanic date, as seen on the reliefs of the Arch at Beneventum (A.D. 119–121), and they were obviously circulated among mosaicists and sculptors soon thereafter.[26] The Antiochene series suggests that generalizations along geographic lines may not be useful or advisable.

Elements of the Paphian Seasons floor indicate, as with many other mosaics in the House of Dionysos, a close tie with Antioch. Most notably, the illusionism of the solids-in-perspective that optically jump out from the black ground are a favorite device of the Antiochene mosaicists. A similar application of this design appears around a series of panels filled with theatrical masks in the House of the Mysteries of Isis.[27] In addition, the inscription "KAICY" finds two important and explanatory parallels at Antioch.[28] With Antioch as a nearby source and obvious influence on the Paphian workshop, it is especially curious that there are no parallels there for the Season composition, the *xenia* panels, or the individual busts of the Paphian mosaic.

The Cypriot Seasons are more reminiscent in dress and attribute of their female counterparts in the west; they seem just barely converted from the female types found in North Africa.[29] The closest parallels for the *xenia* panels at Paphos are

few changes to these often stylistic assignments made over forty years ago. In fact, Levi's chronological and stylistic outline for Antioch has been reaffirmed by J. Balty in a more recent survey of Roman mosaics from the Near East (1981, 426).

20. Levi 1947, 36–37, pl. 5b.

21. Ibid., 60, pl. 10a.

22. Ibid., 85–87, pl. 13b–e.

23. From corridor 2b; see ibid., 161–62, pl. 32a–d.

24. The mosaic is from room 2; see ibid., 200, fig. 75, pl. 45b.

25. Ibid., pls. 54–55.

26. Hanfmann made this important observation (1951, 171), and it has been recently accepted by Parrish (1984, 24).

27. The mosaic, dated to the Severan period, is from room 2; see Levi 1947, pl. 102f.

28. The inscriptions will be discussed below.

29. Although there seem to be interesting stylistic parallels with individual African busts, it is risky to engage in this comparative exercise because of the heavily restored nature of the Paphian Seasons.

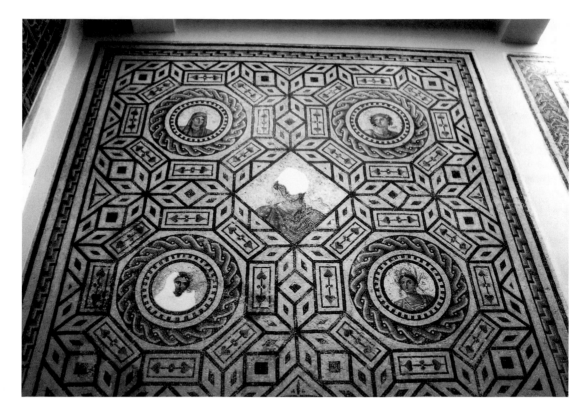

Figure 56. Haidra, Seasons (courtesy of the National Museum of the Bardo)

also found in North Africa. The arrangement around a central bust underscores this analogy inasmuch as there are many instances of a quincunx composition in the African group.[30] Those that are of particular interest here are the mosaics, mainly from Africa Proconsularis, in which the Seasons are associated with a central male bust representing Dionysos or Annus-Aion (fig. 56). The absence of distinguishing attributes leaves the identity of these youthful and beardless busts uncertain, but D. Parrish has convincingly proposed that they represent Annus-Aion, that is, Aion as genius of the Year.[31] Annus, he argues, closely resembles the Seasons, and the crown of fruits he wears on many of these pavements reflects the attribute of Saeculum Frugiferum, the local African cult of Aion.[32] Annus, placed amid the cycle of the Seasons, governs the year and controls its natural bounty.

30. The closest is composition B, type 1; see Parrish 1984, 60, and 61–63, types 4, 5, 6.

31. Parrish most thoroughly presents this idea in an essay (1981a, passim); see also Parrish 1984, 46–50, for a review of these points. For an earlier treatment, see Dunbabin 1978, 158–61; and for the Aion in the Mérida mosaic and on a relief from Aphrodisias, see Alföldi 1979, passim.

32. Parrish 1981a, 11; and Parrish 1984, 47.

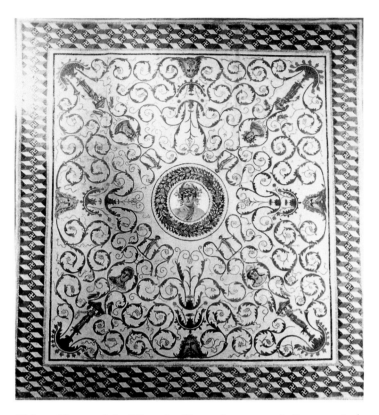

Figure 57. El Jem, House of the Dionysiac Procession, room A, Seasons, Archaeological Museum, El Jem (photo by C. Kondoleon)

One of the earliest representations of the Seasons in North Africa is a late Antonine mosaic from the House of the Dionysiac Procession at El Jem wherein Annus is set in a tondo surrounded by a tracery of acanthus foliage which encircles and upholds busts of the Seasons, figures of satyrs and maenads, and masks of Oceanus (figs. 57 and 58).[33] The concept of abundance is lushly alluded to by his crown of seasonal fruits and by the garland of fruits encircling the tondo. In a slightly later mosaic from the House of the Red Columns at Acholla a basket laden with seasonal fruits, set in the middle of the four Seasons entwined in laurel garlands, functions as the signitive equivalent of Annus (fig. 59).[34] The cosmic and temporal significance of Annus is illustrated by a mosaic from the House of Silenus, also from El Jem but of the mid-third century, in which the Seasons are accompanied by busts of the Sun, Moon, and a bearded visage of Annus crowned

33. The mosaic, now in the Archaeological Museum at El Jem, is from room A of the house; for a full bibliography, see Parrish 1984, 147–49, no. 25, pl. 36.

34. The mosaic, now in the Bardo Museum (inv. 3591), came from a large apsed hall; see ibid., 93–94, no. 1, pl. l. Parrish dates it to the early Severan period.

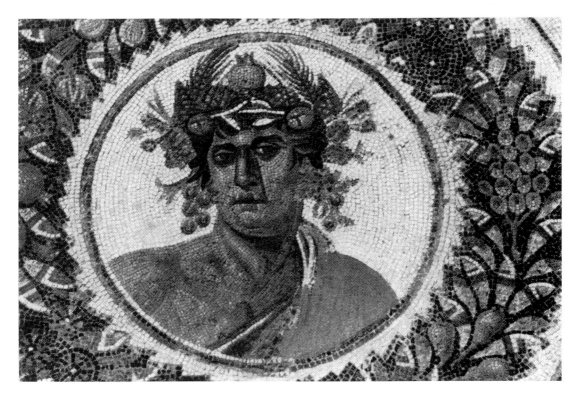

Figure 58. El Jem, House of the Dionysiac Procession, room A, detail of central bust (photo by C. Kondoleon)

only with leaves.[35] Both the Acholla fruit basket and the cosmic deities at El Jem establish the African understanding of Annus as a symbol of fertility throughout the course of the year.

The presence of Dionysos is also implied in many of these pavements. It is reasonable to question whether the central bust in the Seasons mosaic in the House of the Dionysiac Procession may not, in fact, be Dionysos, given the allusions in the composition and throughout that house to the wine god.[36] Dionysos, shown with a *nebris* and a crown of grapes, has been identified amid the lush foliage enveloping medallions of the Seasons in a Severan mosaic from Lambaesis (Algeria) (fig. 60).[37] It is only the difference in their crowns that might lead us to name the latter bust Dionysos and the former Annus. In any case, the

35. The mosaic, now in the Archaeological Museum at El Jem (A.54), was found in room 5; see ibid., 168–71, no. 33, pl. 50.

36. Foucher identifies the bust as Annus as well, but also suggests that this house was the site of a Dionysiac cult (1963, esp. 146–54); see also Parrish 1981b, 51–57, who disputes his interpretation.

37. The mosaic, now in the National Museum of Antiquities in Algiers, was found in a room with an altar near the *scholae* of the military camp; see Parrish 1984, 204–6, no. 50, pl. 69.

Figure 59. Acholla, House of the Red Columns, Seasons (courtesy of the National Museum of Bardo)

combination of Dionysiac and seasonal imagery reveals an early attempt to synthesize these themes and to present a new order, a golden age filtered through local beliefs. The absence of any distinguishing traits for the Paphian bust, and for a series of such busts of Severan date from Africa itself, suggests the neutralization of the type which allowed for interchangeable meanings.

As I noted above, the inclusion of an unidentified male bust and the aspects of the Seasons link the Paphian mosaic with several examples in North Africa. Comparable male busts are evident in at least four (not including the two mentioned above) centralized compositions, three of which date to the Severan period and one to the latter part of the third century.[38] If Paphos is to be dated to the late

38. The four mosaics with Annus (?) are a mosaic of the Severan period from the House of the Muses at

Figure 60. Lambaesis, Seasons, National Museum of Antiquities, Algiers (photo by C. Kondoleon, reproduced with permission of the Service des Antiquités, Algiers)

second century, as the archaeological evidence requires, then it is difficult to postulate that this African series was an inspiration. On the other hand, nothing quite like the Paphian Seasons has been discovered in the east. As indicated by

El Jem, now in the Bardo Museum (inv. 2797) (Parrish 1984, 177–79, no. 37, pl. 55); a Severan mosaic from an unspecified location in Haidra, now in the Bardo Museum (inv. 2812) (ibid., 193–94, no. 45, who identifies the central bust as Dionysos because of the traces of an ivy crown); a late Severan mosaic from the House of the Cortege of Venus at Volubilis, (in situ) (ibid., 234–36, no. 65, pl. 86); and a mosaic firmly dated to the third quarter of the 3d century on archaeological grounds from the House of Dionysos and Ulysses at Dougga, now in the Bardo Museum (inv. 2967) (ibid., 136–38, no. 20, pl. 29b).

several other floors in the House of Dionysos, the Seasons composition appears to mediate between east and west, and between early Imperial and Severan developments. An examination of the overall design and the *xenia* panels addresses this role.

The Paphian design is an assemblage of pseudo-*emblemata* and has the same additive quality that is found in the early floors composed of individually assembled mosaic trays. Among the African series, the closest parallel would be the Seasons floor from Zliten, where a grid arrangement of nine panels features the Seasons and is flanked by four panels with *xenia* (of animals, fish, fowl) and by two Nilotic scenes (fig. 61).[39] Because all the Zliten panels were found in a terracotta casing they can qualify as true *emblemata*, mosaic trays produced in a workshop for export to a site.[40] Although opinions vary for the date of the Zliten mosaics—from the first through the third centuries—the use of *emblemata*, at least for the Seasons pavement may indicate an early Imperial date; if the pavement is Severan or later, then it is purposefully archaistic.[41]

This impression is reinforced by the similarity of the Zliten *xenia* to earlier Campanian paintings and mosaics with the same elements.[42] The discovery in Tripolitania of several other fine *emblemata* with *xenia* that are close to the Hellenistic models suggests a vogue for still-life subjects.[43] While more reduced and less complicated than either their Campanian or Tripolitanian counterparts, the Paphian *xenia* panels certainly belong to this group. Like many of these Tripolitanian examples, the seasonal motifs at Paphos are presented as independent panels. For example, water fowl (at least four are visible) illustrate Winter, and artichokes and cucumbers(?)/courgettes are assembled as the produce of Summer. In Proconsular Africa, such motifs, even in the earliest mosaics, are often excerpted and treated as single units; they are employed as fillers for larger designs.[44] At Paphos, the inclusion of two baskets of grapes with shadows as attributes for Autumn at Paphos underlines the artistic intent to present a composition, in contrast to the more common tendency to employ one basket as repre-

39. The mosaic is now in the Archaeological Museum in Tripoli; see ibid., 243–46, no. 68, pls. 94–95.

40. Aurigemma 1926, 235, 237–41.

41. See Dunbabin 1978, 235–37, on the diverse thoughts about dating; and Parrish 1985, esp. 137–50, who assigns the panels a Severan date but curiously does not discuss the use of *emblemata* as a criterion for dating.

42. For the Campanian examples, see Croisille 1982, 271–89.

43. The large series of such mosaics was the subject of a colloquium and a volume of papers cosponsored by the École française de Rome and the Institut national d'archéologie et d'Art de Tunis in which the North African examples were much discussed; papers published in *Recherches franco-tunisiennes sur la mosaïque de l'Afrique antique: I, xenia. Collection de l'École française de Rome* 125 (Rome, 1990). The two Libyan examples that can be compared to Zliten are the panels from a villa outside of Tripoli dated 1st/2d century and an *emblema* from the villa of Gurgi near Tripoli of 2d/3d-century date; see Balmelle 1990, 55–56, figs. 54–55, respectively.

44. E.g., artichokes, cucumbers, and courgettes appear as fillers for the large circles in the "cushion" pattern that covered a reception room in the north wing of the House of Neptune at Acholla; see Gozlan 1974, 99–103, figs. 32–37, pl. III.

Figure 61. Zliten, villa at Dar Buc Ammera, Seasons (after Aurigemma 1926, pl. 128)

sentative of seasonal fruits.[45] The presentation of the goat within a developed bucolic setting emphasizes this point; the Paphian artist rejected the option of the single animal which abounds in Imperial mosaics.[46] These compositions produce an effect closer to that of the earlier Hellenistic *xenia*.

In Africa, aside from Zliten, only a mosaic from Sousse, dated to the late second century on stylistic grounds, juxtaposes *xenia* with busts of the Seasons in a panel arrangement.[47] Significantly, the thirteen panels at Sousse (ancient Hadrumetum), now destroyed, were also *emblemata*, and the still-life motifs are most like Campanian *xenia*.[48] These *emblemata* reproduced the effects of panel painting but also limited the design possibilities in that an axial alignment (be it stacked or in a grid) of individual panels was the most logical for their display.

45. Ibid., 89, figs. 83–84.
46. Among the innumerable examples, see the seated goat from a triclinium at Shahba (Syria); Balmelle 1990, fig. 65.
47. The mosaic, now destroyed, was found in an apsed building in Sousse. Only some of the ten surviving panels were described and photographed at the time of discovery; see Parrish 1984, 224–26, no. 59, pls. 80–81. The interesting inscription of "MACARI" on one these panels is discussed below.
48. E.g., there is a double register composition of hanging fish.

The grid arrangement of nine pseudo-*emblemata* at Paphos must be seen as an aesthetic choice—no longer a technical limitation—undoubtedly an imitation of a composition with *emblemata*.

An analogous taste for Campanian still-life designs is found in a pavement from a Roman villa at Anaploga near ancient Corinth.[49] Three panels with an array of *xenia* motifs in brilliant polychrome are arranged vertically at the center of a large room, probably a reception room. Each panel is surrounded by an isometric meander frame, which creates an illusionistic effect similar to that of the cuboid border at Paphos. This mosaic, dated on archaeological grounds to the late first century of our era, demonstrates that the imitation of *emblemata* and/or panel paintings entered into the mosaic repertoire in the Greek east rather early. This view is supported by another pavement from a nearby Roman villa at Corinth, where four panels with still-life scenes surround the central pool of the atrium.[50] The panel depicting a goat lying under a tree can be compared to the Paphian Spring tableau showing a goat nibbling on a tree. The mosaics from this area of the villa are assigned a Hadrianic/Antonine date and reinforce the suggestion that the reproduction of *xenia* and genre scenes in pseudo-*emblemata* was practiced in the Greek east in the early Imperial period. The Paphian Seasons can be considered, along with these Corinthian mosaics and the Tripolitanian series, as derivative of the *emblema* tradition and the related Campanian paintings.

Why such trends reached Paphos and were not represented at other eastern sites, for example at Antioch, remains unanswered.[51] The Seasons mosaic, as with other floors at Paphos, can best be compared to mosaics in Tripolitania and traced to Italic models, in this case Campanian paintings. It is not clear that the Tripolitanian mosaics precede the Paphian mosaics. If Severan, the Zliten Seasons would be roughly contemporary or a bit later than the Paphian mosaics. This situation leaves open the question of transmission.[52] Perhaps the models reached Corinth, Paphos, and Tripolitania independently from a major center, such as Alexandria. Unfortunately, we know too little about this period of Alexandrian mosaic art to make any definitive comments. Compelling evidence of itinerant Greco-Egyptian artists is found in two Thracian inscriptions that describe an Alexandrian mosaicist who traveled widely and was responsible for the mosaics in the Tychaeum in Perinthus.[53] Even more appropriate to this discussion are the

49. See Miller 1972, passim, esp. fig. 1 and pls. 65 and 71.

50. For bibliography and brief description, see Waywell 1979, 297, cat. no. 17.

51. Although other Seasons mosaics have been found in the east, they are not comparable to the Paphian Season mosaic; see fragments of female medallion busts in the muse border of the Dionysiac mosaic from Gerasa of Antonine date (Joyce 1980, 308–9, 311, 315–18, fig. 1, pls. 101 [Winter], 105 [Autumn], and 111,2 [Spring]); and three female busts of the Seasons found in Doirani and now in the Archaeological Museum, Thessalonika (see Waywell 1979, 303, no. 52, p. 51, fig. 44, who attributes them to the 3d century).

52. These questions of date and transmission, especially with regard to Tripolitania and Italy, are taken up in the analysis of the multiple-design floor in room 14 and the hunt mosaics of the peristyle.

53. For the text, translation, and discussion, see Toynbee 1951, 43–44.

mosaic panels with still-life subjects from the House of the Faun at Pompeii, dated to the late second century B.C. Scholars have suggested that the *emblemata* from this Pompeian house were products of a workshop founded by Greco-Egyptian craftsmen.[54] Whoever made these remarkably refined stone panels, they reflect the Hellenistic paintings Vitruvius describes as *xenia*; the latter were undoubtedly the inspiration for a series of Campanian paintings and mosaics of the Roman period with the same themes.[55]

Alexandria, it may also be recalled, was the site of the Dionysiac pageant (*Pompē*) of Ptolemy Philadelphus (285–242 B.C.), wherein the *realia* of the personified Seasons accompanied by the Year were introduced to a Hellenistic audience.[56] As I note elsewhere in this book, the visual impact of this prodigious spectacle including thousands of costumed extras and scenic floats must have been powerful. Mythological themes represented in this parade quickly found their way into the artistic repertoire. In fact, scholars have suggested that some of the Dionysiac mosaics from El Jem recall elements from this procession and attest to the continuation of a Hellenistic tradition.[57] Even more to the point, a recent study ties the iconography of the Seasons on Hellenistic metalwork and Republican ceramic wares to figures dressed as Horae and Penteteris in the procession.[58] Representations of Annus-Aion in theatrical dress suggest that the Ptolemaic pageant inspired an artistic tradition that lasted well into the Roman Imperial period.[59]

The extravagance of this public display bore witness to the blessings of *tryphe*

54. For connections between the *emblemata* from the House of the Faun, especially the *xenia* and *symplegma* (embrace of satyr and maenad) panels, and Ptolemaic mosaics and sculptural groups, see Parlasca 1975, 364. More recently, Guimier-Sorbets traces the series of Roman *xenia* of which the cat-attacking-the-bird panel from the House of the Faun is the earliest; she comments on how its double-register composition echoes Hellenistic *pinakes* (panel paintings) (1990, esp. 67–68). See also her relevant comments on how the Anaploga *xenia* cited herein, an Egyptian *emblema* from Kom Truga, another from the Palace at Ptolemais, and a large mosaic with twelve panels from Patras are reflective of Hellenistic *xenia* compositions (ibid., 71nn.97–100). Daszewski, basing his view on an inscription on a late-1st-century relief from Apateira, makes a strong case for the existence of *emblemata* as well-known Alexandrian products produced for export throughout the Mediterranean (1985b, passim); this author also expands on the connections outlined by Parlasca between the House of the Faun *emblemata* and those found in Alexandria (Daszewski 1985b, 15–22, esp. 18–22). The isometric meander that surrounds the Anaploga panels is certainly reminiscent of borders found on a group of Ptolemaic mosaics from Tell Timai in Alexandria.

55. Robertson makes this observation, basing it on their use of identical elements and on the similarities of their two-part compositions; he proposes that we read the upper register, which is shallower, as a kind of upper shelf or step (1975, 580).

56. Athenaeus, *Deipnosophistae* 5.198a-b. For an excellent analysis of the Hellenistic concept of Eniautos (the Cyclic Year) and Penteteris (a Five-Year Span), which were impersonated in theatrical costumes in the *Pompē*, see Rice 1983, 49–50.

57. See Foucher 1963, 137; and Parrish 1981a, 15.

58. See Moevs 1987, 1–36, who provides a very detailed survey of the Hellenistic Egyptian examples that seem to have been inspired by the pageant.

59. The mosaic from the House of the Seasons at Dougga is an example; see Dunbabin 1978, 159n.119, pl. 158. Salomonson, it seems, was the first to point out this connection between the Dougga actor and *Eniautos* from the *Pompē* of Philadelphus, see Salomonson 1965, 63–64n.6.

that Dionysos bestowed on the Ptolemaic rulers.[60] The reappearance of these themes in great concentration in Proconsular Africa during the Severan period (193–235) heralded a golden age in which various provincial towns experienced a burst of economic activity based on their agricultural production. The attendant boom in the building and decoration of private houses is nowhere more evident than in El Jem, where a proportionately large number of seasonal (about 24) and Dionysiac mosaics brilliantly expresses the prosperity of this town situated on the fertile African coast.[61] The good fortunes ensured by Liber were buttressed by the seasonal abundance produced by Annus. This theme seems to be the very essence of the collection of the original and exceptionally refined mosaics of the Antonine period from the House of the Dionysiac Procession.[62] Dionysiac images are accompanied by busts of the Seasons in no less than three grand rooms of the house.[63] It is this same visual and literal symbiosis of Dionysos and the Seasons with well-being and abundance which operates in the selection of themes in the House of Dionysos at Paphos.

Although these domestic decorations openly declared the social aspirations of the Roman provincial class that commissioned them, be they in Cyprus or in Africa, they also served other functions. At Paphos, the Season floor is elucidated by the welcoming inscription "XAIPEI," and the "KAICY" inscription (And You) is an apotropaic formula (figs. 46 and 47).[64] The protective character of "KAICY" is most graphically portrayed in three mosaics from Antioch. Two examples were found one above the other in the vestibule of the early-second-century House of the Evil Eye, where in the upper panel "KAICY" appears with an *ithyphallic dwarf* and the Evil Eye is attacked by talismans; and in the lower panel the inscription is set above an ithyphallic hunchback (figs. 62 and 63).[65] In these Antiochene examples there is no doubt that the formula is invoked as an apotropaic device. Yet coupled with the Seasons and "XAIPEI" as it is at Paphos, "KAICY" bears benevolent connotations, that is, to return the good wishes of welcome visitors.[66] This reading is supported by the fact that "KAICY" was found stamped on dishes and drinking cups, where it was clearly meant to bless the guest.[67]

60. For an excellent discussion on the social and political connotations of *tryphe* for the Greek and Hellenistic periods, see Harward 1982, 57–79.

61. Parrish 1984, 17, says that "somewhat less than one-third of the total number of season mosaics found in Roman Africa comes from there [El Jem]."

62. For a comprehensive publication, see Foucher 1963, passim.

63. See Parrish 1984, 147–56, nos. 25–28, pls. 35–41.

64. For a discussion of both formulas and of the various objects and places in which they appear, see Levi 1941b, esp. 225–26; Dunbabin 1983, 35nn.184, 185; and Engemann 1975, 34–35.

65. See Levi 1947, 32–33, pl. 4a,c; and Levi 1941b, 225–26, pl. 56. A third example is a fragmentary panel with an ithyphallic dwarf from the Colonnade of the Hermaphrodite in the House of the Boat of Psyches; see ibid., 183, pl. 40a.

66. The same combination of formulas occurs on a threshold mosaic from Palermo, where it also was intended as a positive greeting; see Dunbabin 1983, 35n.184.

67. E.g., a small cup found in Antioch was stamped with "KAICY" (see Waagé 1941, 69, fig. 89, no. 2), as were eleven dishes from Tarsos (see Levi 1941, 226).

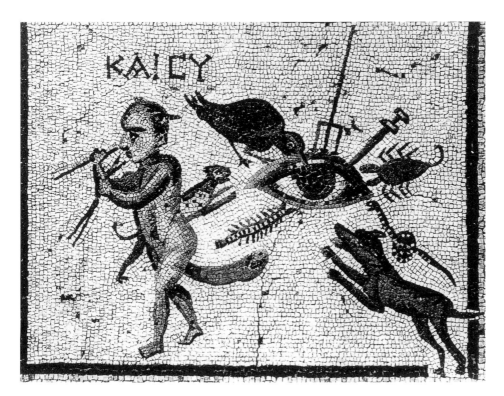

Figure 62. Antioch, House of Evil Eye, "KAICY" with Evil Eye, upper panel (photo by
C. Kondoleon)

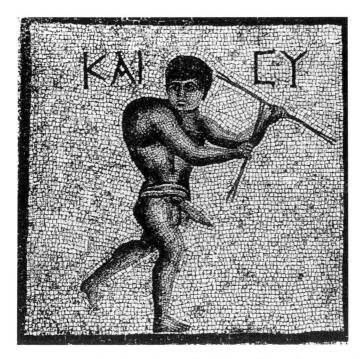

Figure 63. Antioch, House of Evil Eye, "KAICY" with hunchback, lower panel (photo
by C. Kondoleon)

A compelling parallel to the Paphian ensemble of motifs is offered by the Sousse mosaic described above which includes *emblemata* of the Seasons and *xenia*, as well as an inscription "MACARI." It makes sense to interpret this word as "the blessed," implying that the seasonal offerings are a sign of the good fortune of the household, rather than as an artist's signature.[68] The Paphian "XAIPEI" and "KAICY" are the equivalents of the beneficent sentiments implied by "MACARI," which are emphasized by their pendant images of abundance. The nuanced readings of such formulas are underlined by the occurence of "KAICY" above a phallus in a mosaic from a bath at Kôm Truga (Egypt) which is exactly like the phallus that appears next to "CHARI" (delight) on a mosaic from Sousse.[69] Such invocations depended very much on context for their meaning.

The presentation of the Seasons in juxtaposition with beneficent or protective symbols confirms that these personifications were meaningful beyond their obvious temporal associations. The clearest example is provided by a silhouette mosaic from Rome wherein Mercury with a money bag stands beside Abundantia with her cornucopia amid foliage and Seasonal busts.[70] The reception function of the Seasons and their natural pairing with Dionysiac motifs are seen in a dining-room mosaic from the Roman Villa at Ptolemais, where a panel with a pair of tigers drinking out of a large crater abuts a geometric composition with busts of the Seasons.[71] Their magical value is enhanced when they are coupled with a traditional *apotropaion*. For example, the placement of the Seasons at the corners of a large labyrinth in the late Antonine House of Jason Magnus at Cyrene demonstrates their efficacy.[72] In an equally superstitious vein, the Seasons can be found, in the east at Knossos and in the west at Carmona, on the diagonals of the circular shields that surround the Gorgon's head, the most standard of ancient protective devices.[73] In all these instances, the Seasons visually evoke the popular belief encapsulated by Artemidorus, when he declared that to dream of the Horae foretells good luck.[74]

A late-antique gloss on the multiple associations evoked by the Seasons can be

68. Parrish indicates that the inscription is the artist's signature or the name of the mosaic owner (1984, 225, no. 59).

69. For the "KAICY" inscription, see Engemann 1975, 34, no. 91, pl. 11d; and for the Sousse mosaic (Sousse Museum, inv. no. 10.503), see Foucher 1960b, 4–5, pl. 4a, no. 57.011.

70. The mosaic is from SS. Trinità de' Pellegrini; see Blake 1936, 169–70, pl. 39, fig. 3, who dates it to the Antonine period.

71. The mosaic was found in room 5 of the Roman villa; see Kraeling 1962, 250, pl. 60a. In addition to its associations with Dionysos, this image could also be protective; see Dunbabin 1978, 164n.152, on the appearance of this theme on thresholds in North Africa.

72. Labyrinth designs were used at thresholds to ward off the Evil Eye; see Daszewski 1977, 95. The labyrinth mosaic with the Seasons was found in room 34 of the House of Jason Magnus; see Mingazzini 1966, 80, pls. 30.1, 31.1–2, 32.1–3.

73. The example from Knossos comes from room E of a Roman villa, Villa Dionysos, dated to the Antonine period on stylistic grounds; see Waywell 1983, 12. For the example from Carmona, Spain, dated to the late 2d century, see Blazquez 1982, 31–34, no. 15, pl. 11.

74. Hanfmann 1951, 68n.192.

seen in the early-fourth-century triclinium mosaic from the House of the Horses at Carthage. Busts of the Seasons are joined by standing figures of Aion, Venus at her toilet, a frontal peacock, stalks of millet, and other such motifs in an ensemble devoted to prosperity and fertility.[75] The compression of themes in one room— themes usually spread throughout earlier Roman houses—underlines the degree to which such symbols overlapped in meaning and reinforced a general sense of well-being and abundance.

The location of the Paphian Seasons at the probable entrance to the house corresponds to the use of such imagery at the entrances of rooms or houses in Antioch.[76] The fact that none of the many Roman African examples was found at a house entrance suggests an interesting local adaptation of the theme. The pendant salutatory inscriptions confirm that the mosaic composition was understood as a celebration of the earth's fertility and an expression of domestic luxury, at the same time that it served to welcome the visitors and guard the threshold against malevolent forces. As with other reception themes, the Seasons mosaic carries multiple meanings, many of which, it appears from the comparisons enumerated above, were familiar to the Roman guest.

THE PEACOCK

A frontal peacock with a magnificent outspread tail is set in the center of room 3 in the south wing of the house near the entrance area (figs. 64 and 65). This room opens on its north side to both the western and southern porticoes, and therefore connects both visually and physically with the triclinium and peristyle (fig. 3).[77] There is a shallow ground (pink/red) area at the base of the otherwise-plain white square panel. There are two frames: one an internal frame of brownish-red which projects beyond its corners;[78] and a wider border of twisted ribbon with white highlights.[79] This panel is set on top of a large geometric composition of tangent octagons that determine four-pointed stars.[80] The bichromatic scheme of white stars with red and pink squares at their centers, and the reddish-brown octagons filled with white six-petaled rosettes, produces an

75. For a detailed interpretation of this mosaic, see Dunbabin 1978, 165–66, 253, no. 33e, pl. 166.

76. See e.g., the male bust in the vestibule of the House of Narcissus and the panels at the threshold of the triclinium in the House of Menander, both at Antioch; Levi 1947, 60, pl. 10a; and 200, fig. 75.

77. According to the excavator, the western part of the pavement was badly damaged during the leveling operations; see Nicolaou 1963, 16–17; Nicolaou 1967, 121–22. See also Daszewski and Michaelides 1988b, 35; Michaelides 1987, 15–16, no. 9, pl. III.

78. Michaelides suggests that this double-outline resembles the bars of wooden frames which were derived from panel painting (1987, 16).

79. For a description and analysis of the twisted-ribbon border, see the "Geometric Ornament" section of Chapter 2.

80. *Décor géométrique*, 286–87, pl. 183a, described as "outlined orthogonal pattern of tangent poised octagons, forming four-pointed stars (here with an inscribed square)." The example is from the House of the Dionysiac Procession at El Jem; see Foucher 1963, pl. 15d.

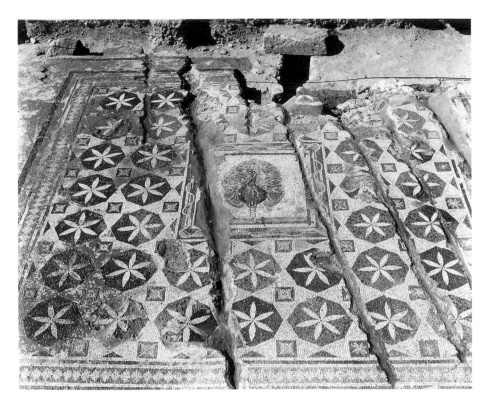

Figure 64. Peacock, room 3, general view showing condition at discovery (courtesy of the Department of Antiquities, Cyprus)

optically vibrant design reminiscent of the Italian black-and-white style.[81] The boldness of the design actually competes with the bird image, despite its tail and body that glisten with blue and green glass tesserae.

Although the geometric mosaics are discussed in detail in Chapter 2, a brief look at the octagon-and-star design surrounding the peacock reinforces the close parallels with the late-second and early-third-century mosaics of Antioch. Bold geometric carpets fill the porticoes of the House of the Porticoes at Antioch; one with a composition of red four-pointed stars within white and yellow octagons is similar to the star-octagon pattern at Paphos in its design and high contrast effect.[82] A twisted-ribbon border almost identical to the one framing the Paphian peacock appears in this Antiochene house dated to the late second century. The arrangement of figural panels inserted in a geometric field is common at Antioch.

81. A rather close version of the Paphian design can be found in a black-and-white mosaic in Bologna of the 2d century, although this pattern consists of hexagons and four-pointed stars with squares; see Mansuelli 1954, 166–68, no. 8, figs. 9–10.

82. The design occurs in the portico of the Pentathalon in the House of the Porticoes at Antioch; see Levi 1947, 106–7, fig. 41, pl. 98.

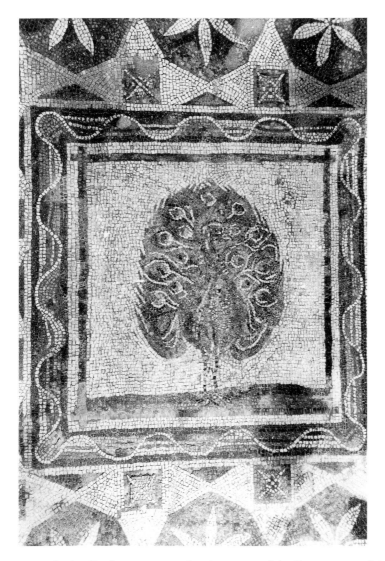

Figure 65. Peacock, detail, after reconstruction (courtesy of the Department of Antiquities, Cyprus)

An early example are the panels of birds and twigs scattered among marine scenes from the House of Polyphemus and Galatea, dated to the first half of the second century on stylistic grounds (fig. 66).[83] These are, in fact, the only true *emblemata* to have survived from Antioch, and the Paphian peacock panel seems to be modeled on such portable panels.

Although several peacocks appear in Antiochene mosaics, they are usually in

83. One of the geometric designs includes darkly colored four-pointed stars inserted into white octagons; see Levi 1947, 25, pls. 2b, c, and 3b, c. For a recent description and review of the archaeological evidence that indicates an early-2d-century date for the house, see Campbell 1988, 30–31.

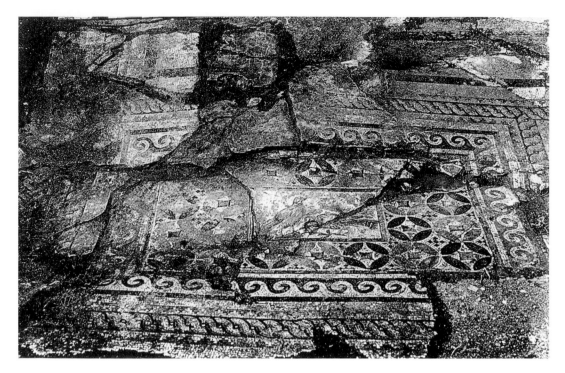

Figure 66. Antioch, House of Polyphemus, bird panel (after Levi 1947, pl. 2c)

the company of other birds and a drinking vessel. In the House of the Red Pavement there are two panels with birds, including strutting peacocks, which decorate a corridor opening on a portico.[84] In both panels the peacocks face the portico, just as the Paphian peacock faces out toward the peristyle. The two other notable examples from Antioch, probably of Severan date, include kraters and decorate triclinia.[85] The suitability of this theme for reception areas was clearly a commonplace of Roman decoration.[86] At the House of the Buffet Supper the addition of Erotes who hunt and catch the birds with cages in the rectangular panel of the apsed dining room animates the still-life theme with narrative; the water flowing out of the metallic krater creates the illusion of a garden, and placement of the birds and figures in registers suggests depth (fig. 67). Despite the fact that the peacock at the center of this dining-room mosaic is frontal, there is

84. The panels were found in room 2 north of the principal room, flanking a central panel filled with peltae; see Levi 1947, 87, fig. 32.

85. One of these examples, a mosaic of the birds and a *kantharos*, was found in the same complex as the mosaic of Megalopsychia, but in a lower stratum. The bird panel is set at the edge of a wide pattern of solids-in-perspective in a way that suggests a triclinium arrangement; see Levi 1947, 90–91, pl. 15a, who dates it too early in the 2d century. The other example is from the triclinium, room 1, of the House of the Buffet Supper; see ibid., 129–30, pl. 23b.

86. Scholars often suggest that the theme is derived from the well-known mosaic composition of two doves on a drinking cup by Sosos of Pergamon.

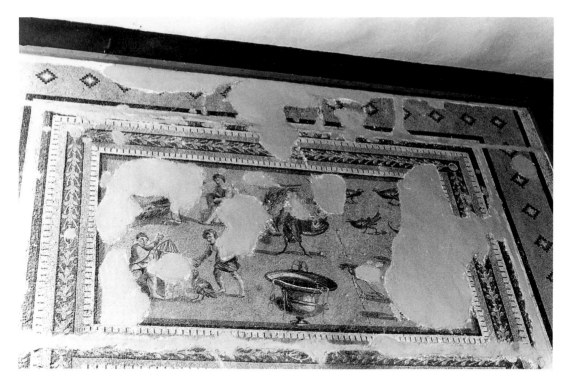

Figure 67. Antioch, House of the Buffet Supper, peacock panel from apsed hall (photo by C. Kondoleon)

no exact parallel at Antioch for the Paphian peacock. Certainly the Paphian pavement conforms to the eastern fashion of wrapping multiple bands around scenic panels, but the treatment of the peacock as an isolated motif does not exist in the east.

The closest parallels for this application can be found in North African houses, where the peacock is shown frontally with spread tail whenever it is the principal subject (fig. 68). Examined individually, each example reinforces the impression that this highly ornamental image could also be symbolic. The feathery arch of the outspread plummage is naturally suited to niches or semicircular compositions that create the illusion of an apse. The physical and iconographic context of the examples found in North Africa suggests that the selection of the peacock went beyond purely decorative considerations. A painted peacock set in a niche at the rear of a grand apsed room commands full attention in a house at Bulla Regia.[87] The floor of this room is covered in part by medallions of marble and in part by mosaics that include apotropaic devices—a snake, spears, peltae, crescent

87. The house was called House of the Trident; see Dunbabin 1978, 164n.151, and 250, Bulla Regia 4; but it is called House of the Peacock by the recent excavators; see Beschaouch, Hanoune, and Thébert 1977, 50, figs. 40–41.

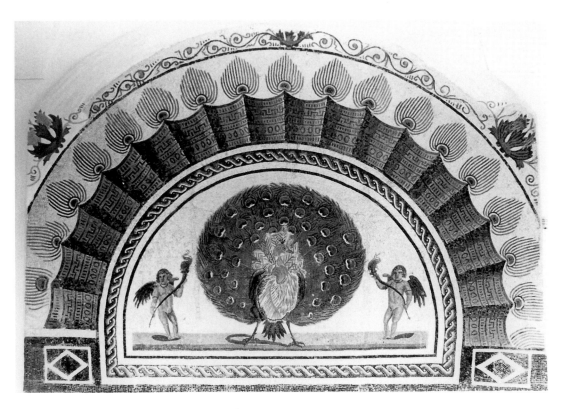

Figure 68. El Jem, House of the Peacock, peacock panel, now in the Archaeological Museum, El Jem (photo by C. Kondoleon)

on a stick. Here the peacock can be numbered among the beneficent signs, the accretion of which ensured the fortunes of the owner. In a late-second-century example from Bir-Chana, a peacock stands above a *thyrsos* (staff of Dionysos) garnered with ivy branches and decorates an exedra that opens on an unusual astrological mosaic.[88] Dunbabin has convincingly proposed that the peacock, the mask of Oceanus in the other exedra, and the mosaic with planetary deities and signs of the zodiac should be read as an integrated design for good fortune.[89] Such an interpretation seems to be demanded by the ensemble of motifs found in a fourth-century mosaic from the House of the Peacock at Dermech in Carthage (fig. 69).[90] In the main room of the house, the plumage of the peacock outlines an arch created by a wide U-shaped band that appears to define a curved dining area. At the base of this arcade-like composition is a horizontal strip with four horses eating seasonal plants out of jewel-encrusted cylindrical containers. The representation of musicians and hunters attacking named bears in the corridor outside

88. Dunbabin 1978, 168, pl. 170.
89. Ibid., 161.
90. Merlin and Poinssot 1934, 128–54; and Dunbabin 1978, 104, 168–69, 252, pl. 92.

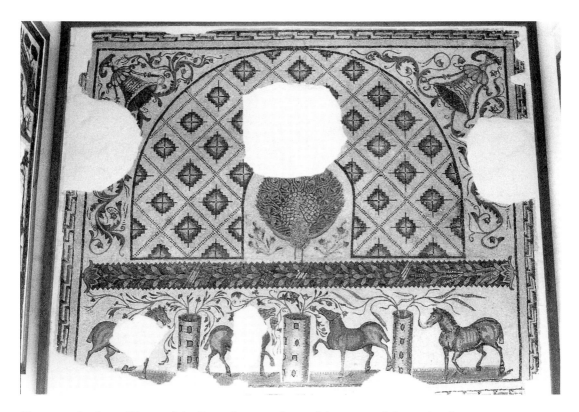

Figure 69. Carthage, House of the Peacock, peacock panel (courtesy of the National Museum of the Bardo)

this room reinforces the impression of a thematic program. The successes of the amphitheater and circus games are invoked as a prophylactic device; the peacock decoratively crowns this arrangement, and must itself connote *fortuna*.[91] Although there is a concentration of symbols and an intensification of meaning which is more typical of late-antique tastes, the Carthage mosaic does provide a gloss on the Paphian peacock. This is especially clear if the adjacent Seasons floor with its salutatory inscriptions at Paphos is considered as a pendant to the peacock mosaic.

The appearance of single peacocks in apsed rooms in the houses of El Jem and of Sousse underlines the fact that this motif could function as a powerful sign in its own right.[92] In fact scholars have pointed out that the "eyes" of its spread tail

91. On the symbolic significance and magical efficacy of the games, see Merlin and Poinssot 1934, 145n.3.

92. This is in contrast to Dunbabin's suggestion that the absence of other significant motives renders such examples decorative (1978, 168). In one late-2d-century example from an apsidal room in the House of Achilles at El Jem, the peacock stands between two rose plants, like those found in the Carthage mosaic; see Foucher 1961, 62, pl. 47a, and Dunbabin 1978, 168, 260. The other example is from an apse of an uniden-

have talismanic value.[93] It would seem that when the bird was depicted frontally with tail feathers spread out, the display of a lot of "eyes" helped to ward off evil powers. In this defensive mode, the motif is particularly appropriate to entrance areas. Perhaps the absence from eastern pavements in general of the isolated peacock in frontal view, noted above, may indicate a particular western adaptation of this motif as an apotropaic symbol. In any case, its appearance along the entrance axis of the Paphian house is a rare example of an eastern adaptation of its protective powers.

Undoubtedly, the most heraldic and imposing composition is found at El Jem in the House of the Peacock, where the bird is flanked by two Erotes bearing torches (fig. 68).[94] This late-second-century mosaic, with a frame that imitates an awning trimmed with peacock feathers, sits in a false exedra within a small room off the peristyle.[95] Although it might seem that the Erotes with torches and the Dionysiac busts and figures that decorate the triclinium seem to indicate a cultic significance for the peacock, the great extent to which other mosaics in the house feature still-life (*xenia*) panels of fruit baskets, foods, and animals implies that a more neutral theme, namely *abundantia*, dominates. Moreover, the location of the false exedra just off the peristyle situates the peacock in a milieu reminiscent of Pompeian garden decoration, in which peacocks perched on illusory fountains in exedrae.[96] In this context, the threshold panel with the hound catching a hare echoes the popularity of animal hunts as subjects for garden paintings in the earlier Imperial period; in fact, they are often juxtaposed with murals of birds, fountains, and ornamental plantings.[97]

The association between peacocks and gardens is also clearly made at Paphos in the vine-carpet mosaic of the triclinium. There at the entrance, directly above the Triumph panel and within the vine arbor (color pl. 3), stands a frontal peacock, his body filled by blue glass tesserae; a winged Eros peers over the brilliant plumage. Although the Dionysiac context of this motif is obvious,[98] the inclusion of this exotic bird in a fantastical garden, in this case a vineyard, equally reflects a

tified building at Sousse: the peacock with many long feathers stands within a polylobed frame; see Foucher 1960b, 62, pl. 33a.

93. According to Ovid, the peacock's tail was decorated with the hundred eyes of Argos (*Metamorphosis* 1.723). Merlin and Poinssot 1934, 134, discuss the magical properties of these "eyes."

94. The mosaic, in room 18, is dated to the last two decades of the 2d century; see Foucher 1961, 11, pl. 14a; and Dunbabin 1978, 259, no. 20f, pl. B.

95. The excavator notes that the floor level of this apsed area, room 18, is raised, and he proposes that a cult statue was housed therein; see Foucher 1961, 6; also Dunbabin 1978, 168, who adopts his suggestion and admits the possibility of religious significance for the peacock because of the Erotes with burning torches.

96. For an example from Pompeii, see the mural with a frontal peacock on a fountain set into the recess of a painted fence; here the painting, which was visible from the atrium, effectively extends the tiny garden in the House of Fabius Amandus (Jashemski 1979, 60, fig. 97). For a mosaic fountain niche with a peacock on the fence from Baiae, see ibid., fig. 108.

97. On the variety of animal paintings found in Campanian gardens, see Jashemski 1979, 68–73.

98. See the iconographic discussion on the vine-carpet mosaic in Chapter 7.

Roman taste for creating miniature *paradeisoi* within their homes.[99] The collection of wild birds and beasts was the privilege of the aristocratic classes, but the appearance of these themes in wall paintings and mosaics throughout the provinces attests to a widespread emulation of such luxurious appointments. In imagined aviaries, gardens, and assortments of *xenia*, the peacock typically struts about in profile with closed tail.[100] It can be generally observed that whenever the peacock is in a collection of birds, Dionysiac symbols, or still-life motives, it is always shown in profile; the outspread tail is reserved for a reception function. In the vineyard mosaic at Paphos, the display qualities of the bird are fully exploited; because of the location, it serves as a sign of greeting. The visitor cannot help but visually connect the triclinium peacock with the one in room 3, and together they reinforce the sense of *felicitas temporum*.[101]

The Paphian peacock is presented in a pseudo-*emblema*; set as it is in a picture panel in the midst of a bold geometric design, it produces the effect of a window cut into the pavement. In this way the peacock is effectively set apart in a hierarchically significant space, and in this respect it is comparable to the placement of single peacocks, either painted or in mosaic, in actual niches, apsed spaces, or simulations of them in the North African examples discussed above. Its physical location adjacent to the Seasons mosaic and the "XAIPEI" and "KAICY" inscriptions suggests that the peacock thematically and spatially extends the salutatory function of room 2 at the main entrance to the house. Aside from the obvious aesthetic appeal of the motif, the peacock, whether or not it is explicitly associated with Dionysos, is a *topos* for luxury, prosperity, and good fortune.[102]

99. Zanker has written extensively on this phenomenon (1979, passim).

100. Among the many examples, see the peacocks in the mosaic surrounding the octagonal pool in the courtyard of the early-3d-century House of the Aviary at Carthage (Lavin 1963, 213–14, figs. 31–33). See also the two peacocks that flank an amphora at the edge of an early-2d-century mosaic of satyrs and maenads from a cubiculum of a house at Sousse (Foucher 1960b, inv. 57.220, 98–101, pl. 50b). For peacocks among still-life subjects, see a mosaic from El Alia (Bardo, inv. 3579) and one from La Chebba (Bardo, inv. 88). An exception to this rule may be seen in the use of a frontal peacock with spread tail as a *xenia* motif in room 11 of the House of the Trifolium at Thuburbo Majus of the second half of the 4th century; Ben Abed-Ben Khader 1987, pls. 20–21 and 59, medallion 33.

101. The association of *felicitas* with the peacock of spread tail occurs on coins and medallions; see Toynbee 1944, 165n.197, pl. 29,8.

102. Geyer rejects any religious interpretation of the peacock, i.e., as a symbol of immortality, and proposes that it be read as a generalized symbol of beauty, fortune, and the good life (1977, 98–102, esp. 102).

The Reception Suite

Xenia and Ganymede Mosaics

THE ASSIGNMENT of room functions by mosaic themes is difficult to establish and rarely supported by archaeological or epigraphic evidence. Yet in the case of rooms 9 and 10, their locations in the architectural plan and their mosaic decorations suggest a relationship to dining (fig. 3). If we embed these mosaic themes in a functional context, an interpretation of their meaning expands into a cultural discourse about Roman notions of prestige and status. An examination of their physical settings within the house and iconographic analyses of the "cushion"-patterned *xenia* (still-life motifs) and of the Ganymede panel disclose obvious site-specific compositions. It is also possible to move beyond the ascription of reception activities to these rooms and consider the nuances of the dialogue between host and guest.

Rooms 9 and 10 are adjacent and set against the north wall of the house not far from the rear entrance (G1), between the kitchen area to the west (F2–F4) and the private quarters (*cubicula* K1–K4), with which they share a latrine (H) (fig. 1). Their proximity to the peristyle through the narrow room 8, off the north portico (fig. 70), echoes the grouping of multiple reception rooms, some more public and others more private, around courtyards throughout the Roman provinces but especially in North Africa.[1] In their access to the utilitarian sectors and to the

1. The architectural parallels are discussed above in the Introduction.

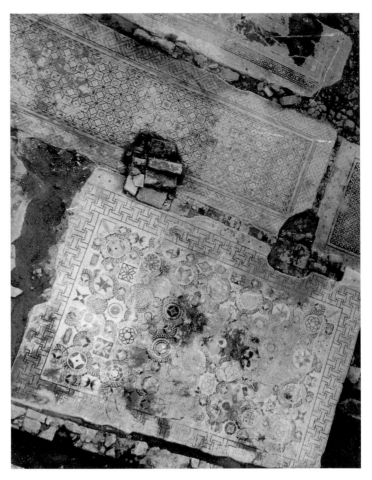

Figure 70. Rooms 8 and 9, overhead view (courtesy of the Department of Antiquities, Cyprus)

public areas of the house, these Paphian rooms are ideally suited to serve as second reception areas.

The location of these rooms offers a key to the interpretation of their mosaic decoration. Although the interlace "cushion" pattern in room 9 could well have been treated with the other geometric ornaments in the previous chapter, the *xenia* that serve as filling motifs are unusual and distinct in their reference to ancient customs of hospitality. Motifs that include a variety of foods and drinks are seen to represent the actual offerings to guests—also called *xenia*. The rarity of *xenia* and of the "cushion" pattern in eastern mosaics attests to an intentional effort at decoration at Paphos, one that presupposes a program of use. The "cushion" pattern was most popular in North Africa, where it typically adorned dining rooms. In this instance, the selection of a geometric design and of its subsidiary motifs can hint at meaning and function.

The presumption that room 9 relates to dining impacts, in turn, on the interpretation of the adjacent room 10 with the Ganymede panel. The obvious allusions to divine banquets and pleasures elicited by the myth of Ganymede were certainly not lost on the ancients. At Paphos we are afforded a rare view of this interplay between myth and social realities. If I had discussed either the interlace "cushion" pattern or the Ganymede mosaic solely in terms of their decorations (in Chapter 2), their roles in constructing a space designed for the social life of the household would be less obvious, along with the intent of the patron and designer.

XENIA IN AN INTERLACE "CUSHION" PATTERN

The character of the design and of some of the filling motifs in room 9 points decidedly to western models and reinforces the indications of western influence in the Paphian geometric patterns, especially in the multiple-design composition in room 14. An unusual interpretation of an interlace "cushion" pattern covers the floor of room 9, one of the largest (8.45 m. × 5.85 m.) in the house (figs. 71 and 72). The design is boldly conceived in the palette of white, black, gray, and pink, with secondary colors (olive, brown-red, and yellow) for the fillers. The geometric field is framed by a black-and-white swastika-meander in a key pattern.[2]

The basic units of the design are "cushions" outlined by bands of interlaced guilloche (plaited ribbons) and by bands of waves; the interlace creates alternately small and large tangent circles and concave octagons. The design appears to be cropped arbitrarily at the edge so that the octagons and smaller circles lose about half of their interlace frames; because there are no internal outlines for the individual compartments, the white background of each unit bleeds into the margins. Each smaller circle, colored half in pink and half in reddish-brown, contains white poised squares with concave sides. Every other octagon has a scalloped border—that is, two reddish-brown semicircles are set at the edge of alternating sides of these octagons. The twenty-eight large circles and forty octagons are filled with a panoply of geometric motifs that range from the simplest elements—such as a single square, an octagon, a lozenge, a solid cross, concentric circles, dotted crosses, a dotted swastika, and Solomon knots—to more complicated patterns, including a swastika-meander, overlapping octagons, solids-in-perspective that surround a lozenge and a square, a circular labyrinth, a variety of stars made of either lozenges, squares, or triangles, a square with a checkerboard, rosettes of different shapes, and networks of loops and circles. Ten of these units contain tableware objects. A floral bud (gray) is set diagonally in each corner.[3]

The closest comparisons in the east for such an interlace design occur much

2. This border is treated as part of the series of swastika-meanders in the geometric section of Chapter 2.

3. For this floral form, see under "elements" in *AIEMA* 1973, 30, no. 102.

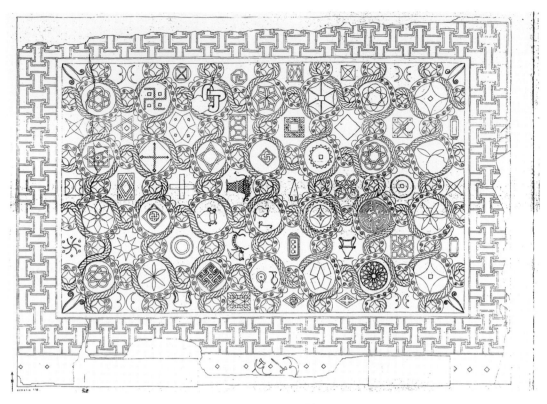

Figure 71. Room 9, drawing by M. Medič of interlace "cushion," room 9 (courtesy of I. Nicolaou)

later than the late-second-century date proposed for Paphos. At Antioch, a comparable arrangement of differently ornamented bands intertwining around geometric motifs dates to the second half of the fifth century.[4] The pattern is also popular in early Christian churches, where it envelops a variety of birds and kraters.[5] In the eastern ornamental repertoire for the Imperial period, the Paphian interlace is an anomaly. There are western examples, both Italian and provincial, of interlacing that form large and small circles and concave octagons; typically, these employ one band, often a guilloche, rather than a mixing of bands as at Paphos.[6] A black-and-white version from Hadrian's Villa presents a re-

4. This design is executed with tangent ellipses and circles; see the description in *Décor géométrique*, 230–31, pl. 150g. The example is taken from a mosaic in Antioch, sector DH 27-H; see also Levi 1947, 317, pl. 130a.

5. E.g., see the guilloche and rainbow interlace found in the mosaic from the Basilica near the Odeion on the island of Kos, dated to the second half of the 5th century (Pelekanides and Atzaka 1974, 66, no. 26, pl. 31a-b).

6. See *Décor géométrique*, 369, pl. 236b, wherein the description of this mosaic is relevant to our design: "polychrome grid-pattern of circles of alternate sizes in simple guilloche interlaced tangentially (the larger circles represent the intersections), forming irregular concave octagonal compartments (the axial sides the longer)."

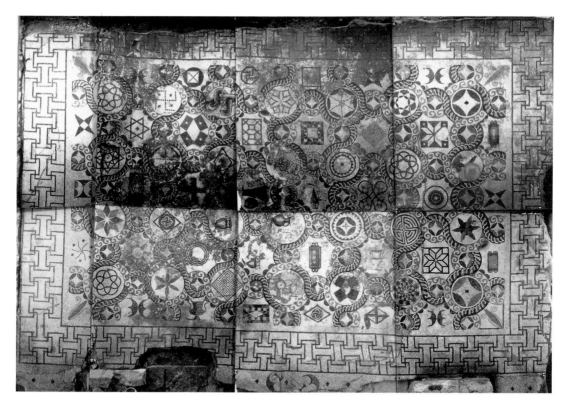

Figure 72. Room 9, composite photo (courtesy of the Department of Antiquities, Cyprus)

strained interpretation with bands of laurel leaves and floral fillers.[7] This type must have inspired the varieties of floral interlace and "cushion" designs found all over Roman North Africa.[8] Although the Paphian interlace is busier, with many secondary patterns not typically associated with interlace designs, there are Italian prototypes for the overall composition.

The lack of contemporary eastern parallels is surprising but is consistent with the overall profile of the Paphian workshop. Just as in the case of the Paphian multiple-design patterns, the interlace in room 9 conclusively indicates the influence of western models. Yet, as elsewhere in the House of Dionysos, the interlace also includes elements traceable to Antioch. The illusionistic effects of solids-in-perspective, which were immensely popular in Antioch but were not part of the western repertoire associated with multiple-designs, appear in two panels of room 9. Even more outstanding are the five medallions filled with a network of loops and circles which can best be compared with the polychromatic loops and circles

7. The mosaic decorates one of the guest rooms of the *ospitali* at Hadrian's Villa; see Blake 1936, 81, 203, pl. 12,2.

8. Among many, see Picard 1968, figs. 12–13, 18–20.

that fill the squares of the lozenge-star-and-square pattern in the triclinium of the House of the Drinking Contest.[9] These few common details serve only to underline the close ties of the Paphian workshop with Antioch, but they do not negate the western tone of the entire composition.

The overall effect of the Paphian composition is that of a dense field with a kaleidoscope of filling devices. In this respect it is quite similar to the multiple-design floors found in the Rhone Valley. Although all these floors are organized by a grid of squares, they share the same compulsion as that demonstrated in this Paphian mosaic: to vary the fillers without regard to symmetry or repetition. The characteristic alternation of medallion and square motifs found in multiple-design mosaics also occurs in the Paphian interlace. A surprising number of the Paphian motifs resemble, albeit in a cruder and more simplified form, those in Gallic mosaics. A floor from Lyons, dated to the first quarter of the third century, offers a large sampling of such devices in its ninety squares.[10]

Of all the Paphian motifs, the labyrinth is the most suggestive of ties to western models.[11] Labyrinth designs appear in several multiple-design compositions in France, Switzerland, and Italy but seem to be nonexistent in eastern mosaics.[12] Curiously, many of these western parallels date to the first half of the third century and cannot be considered anterior to the Paphian mosaics.[13] The earliest floor in the Gallic group, the black-and-white mosaic from Ouzouër (fig. 36), has a labyrinth at its center, and is dated to the mid-second century because of its Italian character.[14] The Ouzouër mosaic has been introduced above as an important parallel for the multiple-design floor in room 14 at Paphos; it indicates, along with other elements in the Paphian geometric repertoire, a dependence on Italian models. Any discussion of the interlace mosaic in room 9 must be related to the character of the multiple-design mosaic at Paphos. Somehow, the Paphian workshop must have received models of multiple-design compositions with their attendant fillers (i.e., the labyrinth) soon after the Ouzouër floor was created. The Paphian interlace can be seen as a local adaptation of a western (Italian?) import—it is interpreted with chromatic exuberance and provincial simplification. The inventiveness of the Paphian workshop is demonstrated by the application of multiple-design effects within an interlace "cushion" pattern and by the combination of motifs from Antioch, Italy, and the Rhone Valley. Exactly how these various sources were brought together is more difficult to determine.

9. The house (S 18-K) is dated to the late Severan period; see Levi 1947, 156–57, pl. 30.

10. See, e.g., Solomon knots, a lozenge with squares or rectangles off the sides, a shield of superimposed triangles, various star-and-cross shapes, in Stern 1967, 49–51, pl. 33, no. 53.

11. For a description of this motif and the attendant dating problems, see Daszewski 1977, 97n.30, and 105, no. 9.

12. See Stern 1967, 56n.19, where he notes that circular labyrinths were introduced into Switzerland through the Rhone workshop. For a detailed study of the labyrinth composition and a catalogue of the motif see Daszewski 1977, passim, esp. 34.

13. On the dating and designs of these floors, see Chapter 2, multiple-design mosaic.

14. Stern 1967, esp. 55–56, figs. 1 and 2.

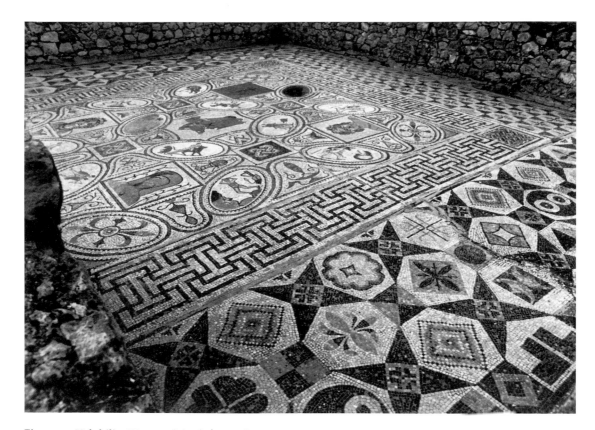

Figure 73. Volubilis, House of the Labors of Hercules, multiple-design mosaic in triclinium (photo by C. Kondoleon)

An analogous application of the multiple-design concept occurs in the triclinium of the House of the Labors of Hercules in Volubilis, dated to the late second or early third century (fig. 73).[15] The wide panels marking the areas for the dining couches are covered with hexagons, four-pointed stars, and squares that are filled with a variety of geometric and floral motifs executed in pink, gray, black, and white—the same palette as at Paphos. Although the Volubilis motifs are flatter and more abstract (less detailed) than those at Paphos, the effect is remarkably similar. The black-and-white swastika-meander in a key pattern which frames the central mosaic with the Labors of Hercules and the Rape of Ganymede is the same as that surrounding the interlace at Paphos. Again, the widespread circulation and appreciation of Italian models sometime after the Antonine period are implied.

What is even more suggestive about the Volubilitan floor is that the Herculean labors are inserted into a "cushion" pattern—a composition favored in North

15. See Dunbabin 1978, 277 (Volubilis 6a), for brief description and bibliography.

Africa from the second through the fourth centuries (fig. 74).[16] The so-called cushions are poised squares with concave sides that are adjacent to ellipses or circles, and determine concave octagons.[17] Although these "cushion" designs are formed by the juxtaposition of independent geometric units, each with its own frame, and as such are distinct from those formed by the interlacing circles at Paphos, they are the closest chronological and formal comparisons for the Paphian mosaic. If the guilloche and wave pattern were more tightly intertwined within the Paphian design, the smaller circles would be less prominent and the concave squares, or "cushions," would be more pronounced; the effect would be one of adjacent "cushions" and large circles.

In this respect the Paphian design is not unlike certain cushion designs found in Byzacena; there, large circles and ellipses are adjacent to the cushions and the concave octagon is eliminated.[18] Eight such mosaics were found in El Jem, where bands of guilloche and wave pattern are also used to outline the "cushions," but they are not interlaced, nor are they in the same design as at Paphos. Two of the examples from El Jem decorate triclinia; they have T-shaped mosaic designs and appropriately include *xenia*, or still-life motifs, as fillers. Both of these mosaics, one from the House of Tertulla and the other from the House of the Months, are of Severan date, and they so closely resemble a third "cushion" design from La Chebba (40 km. east of El Jem; fig. 75) that they must be based on the same model and/or must have been done by the same workshop.[19]

Realistic evocations of fish, fowl, fruits, and vegetables garnish these "cushion" designs and complement the reception function of the rooms they decorate. An earlier (Antonine) but nearly identical version of the El Jem and La Chebba "cushion" mosaics was found in the House of Neptune at Acholla (fig. 5).[20] The food and animal fillers, as well as the size and location of the room with this mosaic, suggest that it was for dining. Although there are two large triclinia in the same house, this room was probably for less public, more familial occasions.[21] The insertion of Dionysiac masks and symbols in these same reception rooms suggests a natural relationship between the bounty of the earth, the prosperity of the host, and the blessings of the deity. Whether there is a religious implication or value to these Dionysiac motifs has not been shown.[22] K. Dunbabin raises the

16. Of the forty or so mosaics with this pattern, over half are from North Africa; see the detailed list provided by Picard 1968, 115–35.

17. *Décor géométrique*, 402–3, pl. 253e,f,g, where it is described as follows: "grid-pattern of adjacent cushions and circles, forming irregular concave octagons . . . (the axial sides the shorter)."

18. Picard records sixteen "cushion" designs for his Byzacena series (1968, 117–25).

19. For a convenient list of these examples, see Picard 1968, 119–21, nos. 5, 6, 9, fig. 15. The mosaic from La Chebba is dated to ca. 230; see Salomonson 1960, 30–31, fig. 5.

20. For a complete description and discussion of the mosaic from "Salon Exedra H," see Gozlan 1974, 99–111, figs. 32–47.

21. The similarity of these *xenia* motifs with those in triclinium M in the same house reinforces my point; see ibid., 93–99, fig. 29.

22. In literary sources the *xenia*-like offerings are made most often to Priapus; see Hanoune 1990, 11. Picard associates the *xenia* and cushion designs with confraternities dedicated to Liber (1968, 134).

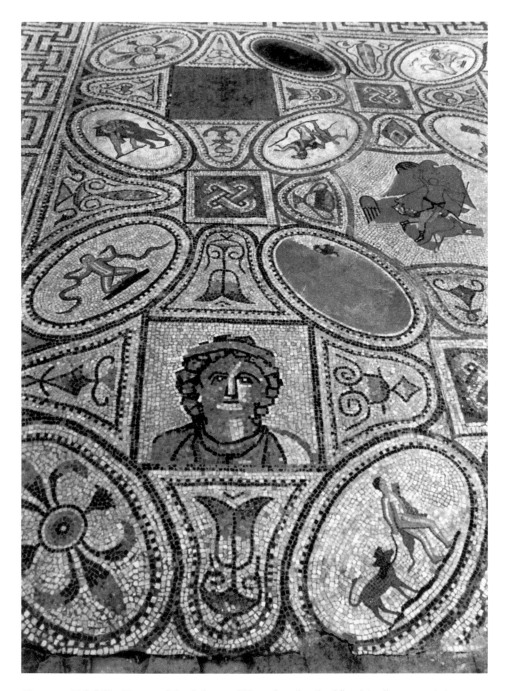

Figure 74. Volubilis, House of the Labors of Hercules, detail of "cushion" pattern (photo by C. Kondoleon)

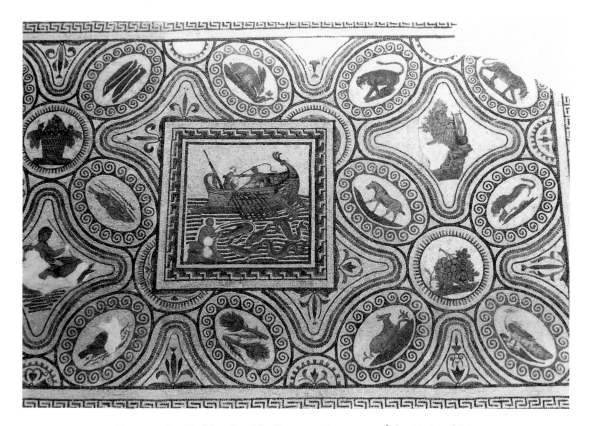

Figure 75. La Chebba, "cushion" pattern (courtesy of the National Museum of the Bardo)

possibility that the mosaics of food might refer to acts of public generosity by rich benefactors, namely the distribution of food (*sportulae*).[23] Such hospitality, whether public or private, certainly enhanced the civic reputation of the *dominus*. These motifs served as graphic allusions to the munificence and wealth of the household.

The eleven different objects of tableware which accent the Paphian interlace are related to this category of gastronomical gifts, which ancient writers called *xenia* and delighted in describing (fig. 76). Their inclusion at Paphos further justifies the comparison with the Byzacena "cushion" designs. Most of these objects are set in the "cushions" and circles at the center and near the entrance to the room. Inasmuch as five of these motifs face the west side of the room, a preferential orientation might be deduced; three motifs are set to be viewed from the entrance

23. Dunbabin 1978, 125.

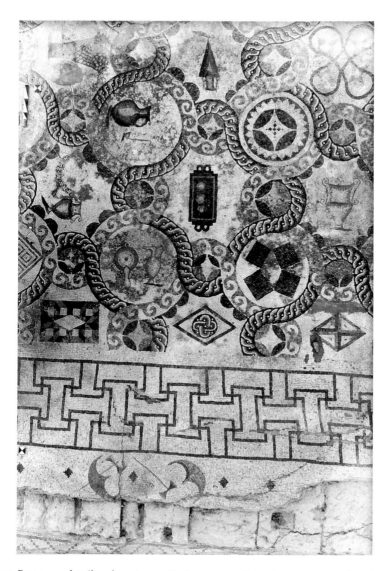

Figure 76. Room 9, details of *xenia* motifs (courtesy of the Department of Antiquities, Cyprus)

(fig. 71). A large basket heaped with grapes and vines, like the one in the *xenia* painting described by Philostratus in the *Imagines* (1.31) of roughly contemporary date, can be found at the center of the composition and facing west. The only other food motif occurs in an octagon closer to the entrance and also facing west—namely, three rose-colored fruits (pomegranates?) on a metal tray (in olive green with gray trim). The other nine objects include two similar trays, but without food, set along the east border of the composition; an amphora with

pointed shoulders oriented toward the north wall;[24] four types of metal kraters;[25] and two types of pitchers.[26] The three subsidiary motifs includea long-handled object attached to a disk—probably a silver mirror (in gray and white)—set next to the silver pitcher and placed immediately at the entrance; a ladle of blue glass tesserae set at the side of the clay pitcher (*oinochoe*) and facing the west wall;[27] a rose garland tied to one handle of a yellow krater and oriented toward the west wall (fig. 76).[28]

These objects might be more properly called *apophoreta*, the nonfood gifts presented to guests "to carry home." The term is used by Athenaeus in his *The Learned Banquet* or *Deipnosophistae* (VI.229) in referring to Cleopatra's practice of bestowing gold and silver crockery on her guests. Martial covers a wide variety of such tableware in the *Apophoreta* section (14) of his *Epigrams*. Among the vessels named are *urceoli ministratorii* (small jugs for table service), *patella cumana* (platters), *ligula argentea* (silver spoons), and *calathi* (tankards).[29] Although none of these corresponds exactly to the selection presented at Paphos, each is close enough in theme to qualify as *apophoreta*. In fact, Martial mentions the garland of roses (*coronae roseae*) in his *xenia* epigrams.[30] The insertion of the silver mirror in the Paphian interlace reminds us that these gifts also included writing instruments, hair and jewelry items, and other personal objects.

Somewhat comparable tablewares are set into square panels in the Hadrianic mosaic in the triclinium of the House of Serapis at Ostia.[31] As with the Paphian objects, yellow is used to indicate gold, and reddish shades clay. One panel is especially close to our Paphian example in that a small ladle leans against a reddish amphora.[32] Each group of objects is set on groundlines that lend an air of realism to the presentation; they are reminiscent of the dark shadows found below most of the Paphian objects. At Ostia, many of the sixty-eight panels, now mostly lost, included food, fowl, and masks, a selection that confirms that these table-

24. The vessel is colored in red and pink to indicate that it is made of clay. It is quite similar in shape to the wine amphorae found in a broken heap in the north corner of the east portico of the house; the production of such vessels is dated to the mid-second century; see above, "Archaeological Evidence" in the Introduction.

25. Three of these, done in yellows and dark-brown, suggest gold or copper vessels, while the one in dark-green and gray tones may indicate a bronze vessel.

26. The gray and white of the one with a longer lip indicate a silver vessel; the other is of clay, since it is made with red and pink tesserae.

27. For the mirrors, see the same object, identified as mirrors, which serve as fillers in the north aisle of the nave of the 5th-century church at Beit Mery in Lebanon; see Doncel-Voûte 1988, pl. 109. A similar wine dipper rests near a jug executed in reds and pinks on a table in the symposium mosaic from room 19 in the House of Menander; see Levi 1947, pl. 45d.

28. A parallel for this motif may be found in panel E, the panel set at the entrance to the triclinium (room 2) in the House of Menander at Antioch; see Levi 1947, 200–201, fig. 75. The *kantharos* is executed in gray-brown with light-yellow and white highlights, and the swaglike garland consists of red flowers.

29. See esp. Martial, *Epigrams* 14.93–121. The translations of the terms are taken from Ker 1920 (Loeb).

30. Martial, *Epigrams* 13.127.

31. For a lengthy description, see Becatti 1961, 143–49, no. 283, pls. 103, 212.

32. Ibid., 147, pl. 103.

wares were conceived as part of the original repertoire of "guest gifts." The numerous drinking vessels (seven in all) among the Paphian *apophoreta* find their closest, although not identical, counterparts in two third-century mosaics from El Jem. Clearly in a tradition illustrated by the Hadrianic Ostian mosaic, these North African examples also use *xenia* motifs to fill the square panels of a grid. The idea of presenting these domestic articles in pairs (e.g., pitcher and ladle at Paphos) corresponds to the wine or water jug cased in woven straw with a glass goblet in a panel from a triclinium mosaic at El Jem (fig. 77).[33] Two bottles (one larger and one smaller) of wine are set in a grid of laurel wreaths along with many *xenia* edibles (fish, fowl, fruits) in the Mosaic of the Dice-Players (fig. 78).[34] Because all twenty-four panels survive, it is possible to observe a purposeful arrangement of the motifs. In other words, each subject is oriented with respect to the viewers' positions as they either walk or are seated around the mosaic. At Paphos the placement is less regular, but a few of the motifs face the entrance and five are oriented to the western side of the room.

My final example of a "cushion" mosaic is from Italy, and it provides a parallel for both the Paphian "cushion" and its variety of filling motifs, as well as for the use of objects as fillers. A monumental "cushion" composition in black-and-white comes from Loano (Liguria) and is dated to the early third century (fig. 79).[35] Although the units of the Loano mosaic are not actually interlaced, their guilloche outlines produce a fluid effect, not unlike that of an interlace. There are many kinds of latticed baskets, kraters, amphorae, and *kantharoi*, all set on black stands,[36] in the corners of the cushions. A bold geometric pattern, in square or medallion format, marks the center of each cushion; these are very close to the patterns arranged in the grid system of multiple-design mosaics. In this respect the Loano floor is closer to that at Paphos than any other "cushion" design mosaic.[37] As at Paphos, peltae are used as accent motifs throughout the mosaic; both mosaics also use the poised square as the preferred filler for the units of intersection (i.e., the smaller circles at Paphos, and the irregular concave octagons at Loano). Their common features—the prominence of vessels and peltae, the flowing braided outline, and the multiple-design effect of the geometric fillers— strongly indicate that the mosaicists at Paphos were working with an Italian prototype. It is equally likely that the Byzacena ateliers, which favored the "cushion" design, received the same models and adapted them according to local tastes. Evidence of this is provided by the *kantharoi*, which are essentially like the ones in Loano, in the cushions of the Volubilis house discussed above. The question of

33. Only six of the original sixty-one panels of the so-called Sadoux mosaic survive, and these are now in the Bardo Museum (inv. A.268–284); see Gozlan 1981, 77; and 1990b, 106.
34. Dunbabin 1978, 125 and 260, fig. 118, dates the mosaic from the mid-to-late 3d century; see also Gozlan 1981, 77; and 1990b, 106.
35. See Restagno 1955, passim, for the preliminary publication; and Picard 1968, 127–29, no. 4, fig. 22.
36. They are too elongated to be read as shadows.
37. Some of the same motifs, e.g., overlapping circles and shield roundels, appear at Paphos also.

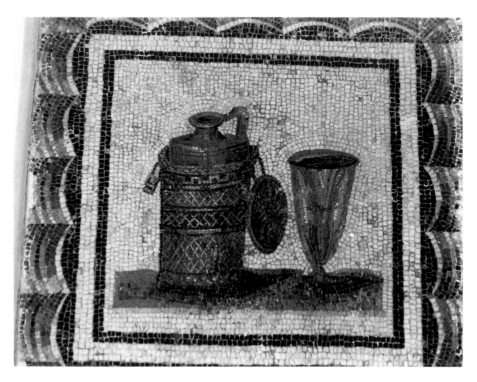

Figure 77. El Jem, mosaic of jug and goblet (courtesy of the National Museum of the Bardo)

transmission for the Paphian interlace is much the same as that for the multiple-design in room 14. Both compositions are anomalous for the east, and their creation at Paphos presents striking evidence of the independence and complexities of workshop practices.

Before we leave this room, we should note the casual placement of a pair of peltae and double-headed axes in the surround at its threshold (fig. 80). They occur at the main entrance and might be considered apotropaic devices, which find their counterparts in the crossed axes and peltae decorated with swastikas in the Loano floor. A quotation from Petronius' *Satyricon* (30) is highly suggestive about the function of the room: "We now went into the dining room . . . astonished to see rods and axes fixed on to the [its] door posts."[38] Perhaps these displays of status objects, in this case attached to the office of the Lictors, provided the initial motivation for such ornaments.

The placement of these symbols at the entrance to Trimalchio's dining room suggests that their presence at the threshold of room 9 may signal a similar context. The fact that the Paphian room is the second-largest room in the house and is situated in a complex of rooms (8, 9 and 10) points to a reception function.

38. The translation is taken from Hesletine and Warmington 1913 (Loeb, 51).

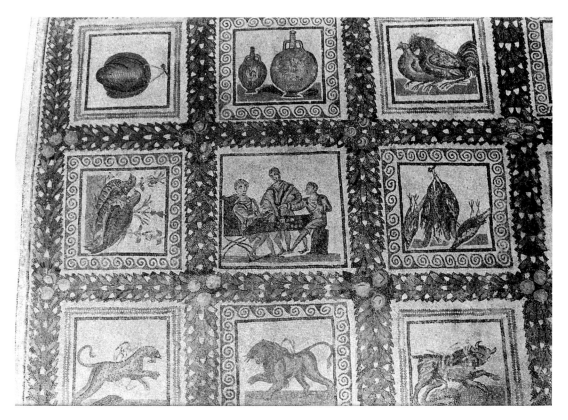

Figure 78. El Jem, Mosaic of the Dice-Players, *xenia* motifs, National Museum of the Bardo (photo by C. Kondoleon)

As noted earlier, it is entered from a long, narrow room (8) decorated with the lozenge-star-and-square pattern, which opens on the north portico; it is adjacent on its east wall with a smaller square room (10) decorated with the abduction of Ganymede. We have already compared the interlace decoration with the "cushion" designs in North Africa, where many such floors cover dining areas. The insertion of *apophoreta* and *xenia* motifs in room 9, so unusual in the eastern mosaic repertoire, makes this the likely location of a second dining area. The architectural and iconographic implications of this suggestion are pursued further as we examine the Ganymede mosaic.

GANYMEDE

A picture panel showing Ganymede taken up by the eagle is the focus of a smaller, roughly square room in the northeast corner of the house, immediately east of the larger rectangular room 9 (fig. 3, room 10).[39] The scene is framed by a

39. The room measures 5.60 m. × 5.90 m.

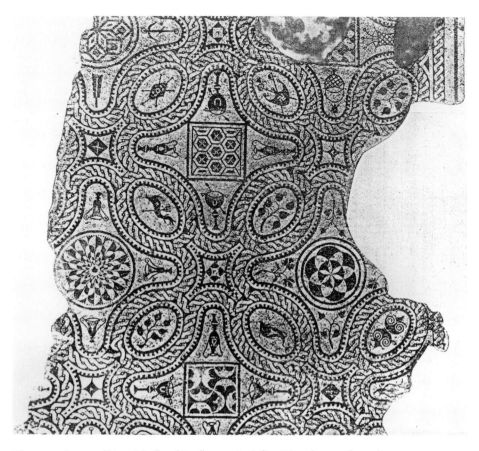

Figure 79. Loano (Liguria), "cushion" mosaic (after Picard 1968, fig. 22)

guilloche and set in the center of a wide design of swastika-meander in a key pattern superimposed over tangent octagons and squares (figs. 81 and 82).[40] The decorative themes and spatial layouts of these two rooms suggest that the northern section of the house may have formed a suite of rooms related by function and design.

The figural panel depicts the handsome Phrygian youth, identified by his pointed red cap, being carried aloft by the eagle (fig. 83). Ganymede, almost in frontal view, gazes upward as he wraps his raised left arm around the neck of the bird. In his lowered right hand he grasps a long, thin spear with the tip (blue glass) pointed down. A shield falls in mid-air off to the left side of the panel. The youth is nude except for boots and a red cloak that falls behind to his waist. His crossed legs—the right one slightly bent behind the left—stretch out to the right side and hang in the air. The outspread yellow-brown wings and wide tail of the

40. See *Décor géométrique*, 254–55, pl. 166d for this very pattern. For a description and discussion of this meander design, see Chapter 3, section Geometric Ornament.

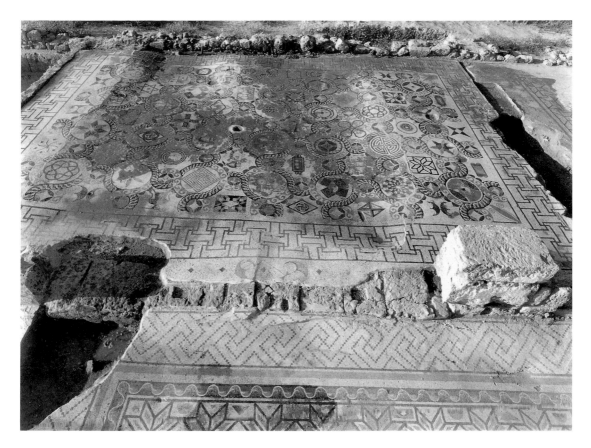

Figure 80. Room 9, view of threshold mosaic (courtesy of the Department of Antiquities, Cyprus)

eagle fill the center of the panel; the tips of the wings, especially at the right, are cropped.[41] The seizure is graphically depicted in the way the pointed white talons clutch the flesh of the youth at his waist and thigh.

The narrative action seems caught in a choreographed moment as the unnatural partners hover above ground. The scene takes place moments after the eagle startles the youth in a surprise attack, as evidenced by the falling shield. In the ascent to the right, the direction of flight is underlined by the extent to which the right wing is cut off. In addition, we follow the gaze of Ganymede to the right as his captor turns left to reveal a fierce profile. The air-bound pair are stabilized by the large V-shape of the bird, which fills the central part of the panel. The heavy vertical axis of the bird, accented by the long, straight spear, forms a counterpoint to the emphatic diagonal established by Ganymede and the more visible left wing.

41. The upper part of the wings are colored in red-brown and shades of yellow, while the tips of the feathers are in gray. The neck and head of the bird are mostly yellow, with red-brown to show shadows; the scalloped tail is several shades of brown with some yellow highlights.

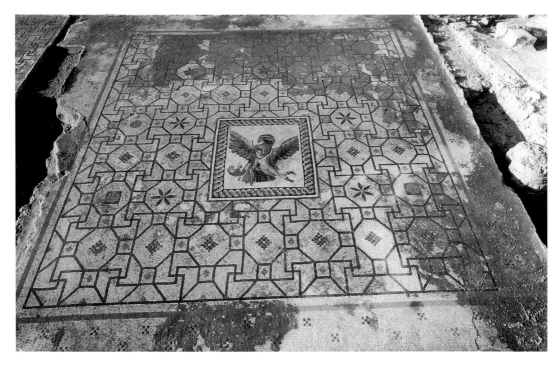

Figure 81. Room 10, full view of Ganymede mosaic (courtesy of the Department of Antiquities, Cyprus)

Whether the eagle is understood to be Zeus or not varies according to the literary sources. Pliny's wording suggests that the eagle acted on the command of Zeus. In the *Iliad*, the earliest literary source for the tale, Homer credits "the immortals, awestruck by his beauty," for snatching Ganymede "to bear the cup of Zeus."[42] It is in Ovid's *Metamorphoses* that the chief Olympian takes the form of an eagle to steal away the Trojan boy for whom he burns with love.[43] Virgil envisions the royal boy with a javelin and cites Mount Ida as the place from which he is carried aloft.[44] Nothing in the Paphian scene indicates that the eagle is, in fact, Zeus, but such associations were surely rife in the viewer's mind. Very few of the Ganymede representations dwell on the erotic aspects of the tale; instead, they dramatize a mythological event.[45]

The literally hundreds of representations of Ganymede in ancient art are often divided into two iconographical groups, those that illustrate the apprehension on

42. The translation quoted here is from R. Fagles, *Homer: The Iliad* (New York, 1990), 511; lines therein appear as 20.268–71.
43. Ovid, *Metamorphoses* 10.155–61.
44. Virgil, *Aeneid* 5.250–55.
45. Compare with the "charged scene of seduction" presented by a marble sculpture group discovered in the House of the Charioteers at Carthage; see Gazda 1981, 172–73. For a recent interpretation of a Ganymede scene in the House of Jupiter and Ganymede at Ostia as homoerotic, see Clarke 1991a, 89–104.

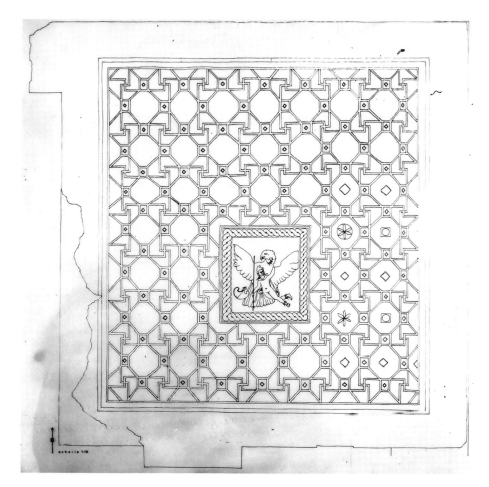

Figure 82. Ganymede mosaic, drawing by M. Medič (courtesy of the Department of Antiquities, Cyprus)

the ground and those that depict the abduction in flight.[46] The Paphian scene depicts the abduction, as do mosaics from sites in the Roman west, namely Volubilis (upper right corner, fig. 74), El Jem (fig. 84), Italica (fig. 85), Vienne, Orbe, and Bignor.[47] All these mosaics are assigned dates in the late second and early third centuries, except Bignor, which probably dates to the late third century.

46. For the standard classifications of the compositional variations, see Sichtermann 1953, nos. 1–414, 73–97; Phillips 1960, 256n.59; Foucher 1979, 155–68; Gazda 1981, 172–73n.89, who cites over 400 examples, including sculptural groups; and Sichtermann 1988, 154–69, who catalogues 267 examples.

47. Foucher lists the following examples (with the addition of the Italica mosaic) of depictions of the abduction and dependent on the Leochares prototype (1979). The Ganymede from Volubilis, much damaged, is set in an octagonal compartment at the center of a large triclinium mosaic in the House of the Labors of Hercules (fig. 74, herein); see also Parrish 1984, 239–43, no. 67, pl. 93. At El Jem, the Rape of Ganymede is at the center of a complicated design, including the Seasons and love scenes, found in the *cubiculum* of the Sollertiana Domus (fig. 84, herein); see also ibid., 165–68, no. 32, pl. 49. Although the rest

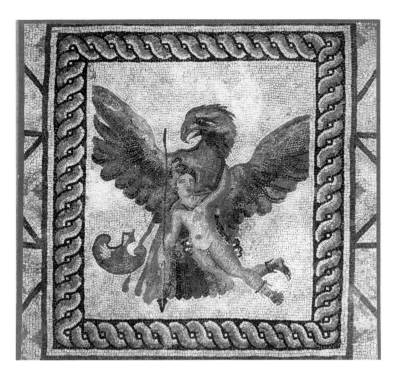

Figure 83. Ganymede mosaic, detail (courtesy of the Department of Antiquities, Cyprus)

A stucco relief from the *tepidarium* of the Forum Baths at Pompeii should also be added to this group, as it replicates the compositional lines of upward and diagonal flight seen in these abductions.[48] Although there are substantial stylistic differences among these mosaics, they follow the same general arrangement. In some cases, however, the legs swing to the left, in others to the right. In most the left hand is lifted with an open palm, but at Paphos and Orbe the right arm is raised. These changes should not be traced to different models but rather reflect reversals common to the process of pictorial translation.

The abduction mosaics quite closely resemble a Roman marble statuette in the Vatican which presumably echoes the celebrated bronze group by Leochares cre-

of the mosaic is mostly restored, the central medallion with Ganymede in the Italica mosaic is authentic (fig. 85, herein); see also Blanco Freijeiro 1978a, 28–29, no. 4, pl. 14. A large medallion with Ganymede is at the center of a design—much like the one from Italica—on a floor from Vienne which includes the four Seasons as well; see also Lancha 1990, 35–37, no. 10, color plate 1, who dates it ca. 175–200. The Ganymede medallion from a grand Roman villa in Orbe, described below, is dated ca. 200–225; see also von Gonzenbach 1961, 184–94, esp. 190, pl. 60. Finally, the Ganymede from the Roman villa near Bignor in West Sussex is dated to the late 3d century on stylistic grounds; see also Johnson 1983, 405–6, fig. 1.

48. Phillips would rather see this stucco relief as dependent on the prototype reflected in a 3d-century Morgantina mosaic, namely an apprehension type, but the physical evidence does not support this suggestion (1960, 259n.67).

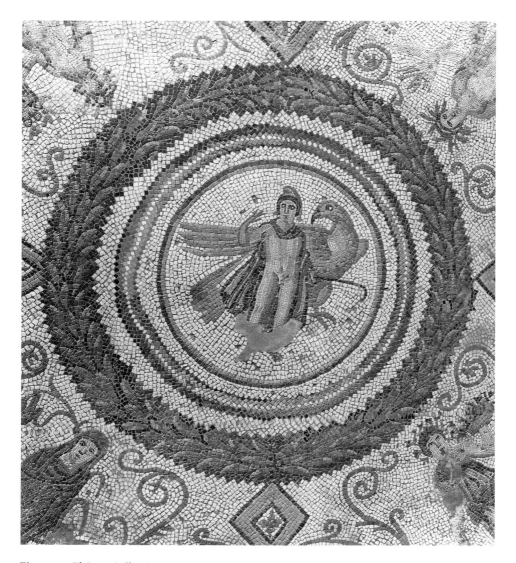

Figure 84. El Jem, Sollertiana Domus, detail of Ganymede mosaic (courtesy of the Department of Antiquities, Cyprus)

ated some time in the mid-fourth century B.C.[49] The Hellenistic sculpture group shows Ganymede's feet barely off the ground and his head lifted upward and to the right, while the eagle turns left with open beak, as at Paphos. In addition to their other shared features, the inclusion of a barking dog in the Italica (fig. 85) and Volubilis mosaics and in the Vatican sculpture attests to a common prototype for the group.[50] The Vatican Ganymede raises the right arm in a gesture that may

49. See Bieber 1955, 62–63, fig. 198. Not all scholars accept this theory; see Phillips 1960, 260, n. 74.
50. Phillips proposed that the 3d-century Morgantina mosaic reflected the original model for both the abduction and apprehension groups (1960, esp. 260–63). Foucher, on the other hand, suggests that there

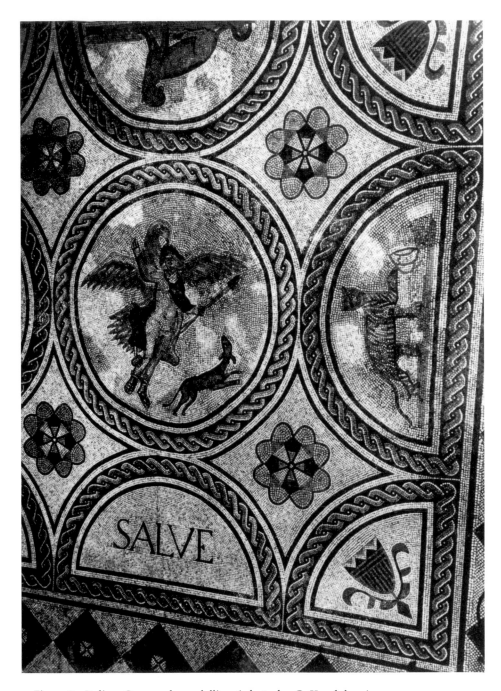

Figure 85. Italica, Ganymede medallion (photo by C. Kondoleon)

indicate either surprise or defense, as well as upward motion.[51] At Paphos this same arm is wrapped around the neck of the eagle. This simple shift of the arm in the Paphian mosaic creates quite a different impression, as the youth appears to acquiesce by holding on to his captor. A similar adaptation occurs in the example from the Severan villa at Orbe, Switzerland. There, Ganymede, set in one of several octagonal compartments filled with divinities, turns his body and head toward the right, a movement led by the hand that reaches up around the bird's neck. The Paphian scene is the only one in the group that contains a shield, although several of them put a spear instead of a shepherd's staff in Ganymede's hand.[52] Most likely, these variants represent misunderstood models or local adaptations.[53] In Pliny's description of the Leochares bronze and from what is depicted in the Vatican statuette, the bird presses its talons where clothing protects the boy, so as not to pierce the skin of its precious charge.[54] At Italica the claws grab at the knees, while at Paphos the eagle clutches at the skin just below the chlamys. Despite such differences, the Paphian mosaic obviously depicts an abduction type that stems from a Hellenistic original but is well attested in Roman sculpture and mosaic.

In the abduction group the figures appear to float against a neutral white ground with no groundlines, and as such they are well suited to compartmental designs, most often medallions. The presentation of the Paphian Ganymede as the sole subject of the mosaic design and of the room itself is unusual for the abduction group. Even at Bignor, where the Ganymede medallion is the single theme of the northern part of the atrium area, it is joined at the southern end by a mosaic of dancing maenads set around a *piscina*.[55] Dionysiac associations can also be detected in the fragmentary remains of panthers and tigers surrounding the Ganymede from Italica (fig. 85). Ganymede might be seen to enhance the felicitous symbols of good fortune, as is certainly the case when the abduction scene is paired with the Seasons, as in Volubilis, El Jem, and Vienne.[56] At Volubilis, the

was a separate model for each group and that the Morgantina mosaic was the source for the apprehension series (1979, passim).

51. The arms of the Vatican Ganymede may have been restored.

52. A shield appears on a Ganymede relief on a Roman ivory plaque found near Alexandria and now in the Walters Art Gallery (inv. 71.596); see Weitzmann 1979, 169–70, no. 148. Both the Volubilis and Italica mosaics show Ganymede with a spear. See also a mosaic from Tarsus in Cilicia which represents a 3d-century conflation of the apprehension and abduction scenes and depicts Ganymede with two spears; see Budde 1972, 149–55. Nearby at Antioch, in the House of the Buffet Supper, a shield and two spears rest to the side of another type of Ganymede scene discussed below; see Levi 1947, pl. 24b.

53. In a similar manner, Ganymede's lifted arm on a marble relief from Baone, A.D. 200, appears to caress the eagle rather than signal his resistance, as on other examples from the group depicting his apprehension; see Sichtermann 1988, 165, no. 226, with illus. in *LIMC* IV.2, 92. Another unusual adaptation occurs on a 3d-century mosaic from Thessalonica wherein Ganymede appears to strangle the eagle; see ibid., 163, no. 179, with illus. in *LIMC* IV.2,89.

54. Pliny, *Naturalis Historia* 34.79.

55. The two mosaic designs were found in room 7; see Johnson 1983, 405, figs. 1 and 2.

56. The Vienne mosaic, discovered in an area called la Chantrerie à Saint-Romain-en-Gal, includes

mosaic with Ganymede aloft at its center forms the T-shape design of a *triclinium* (figs. 73 and 74). A large "cushion" pattern, often found in the reception rooms of North African homes, fills the stem and bar of the T; the Labors of Hercules fill the ovals around the large square panels with the busts of the Seasons. Here we can make a very direct connection between Ganymede, the Seasons, and dining, although the combination of Seasons and Ganymede does not necessarily signal a reception theme, as both elements are found together with love scenes in what appears to be a private chamber in the Sollertiana Domus at El Jem (fig. 84).

Although neither the functions nor the floor plans of the other abduction mosaics can be determined, it would be rash to generalize about the meaning of the Ganymede scene in Roman domestic decoration. It is useful, however, to consult the location of other types of Ganymede scenes. Probably the clearest instance of a direct association between function and design is found in the mosaic of an apsidal room in the House of the Buffet Supper at Antioch (fig. 86).[57] Ganymede, with his shield and spears set to the side, offers the libation to Zeus' eagle in a medallion set in the semicircular space of the apsed room. The depiction of a banquet table replete with food and utensils around this scene effectively echoes the sigma-shaped table that once stood beside it. The guest was meant to associate his host's repast with an Olympic banquet served by Zeus' cupbearer.[58] On a grander scale, we learn from Statius (*Silvae* 1.6.34) that Domitian had cupbearers from Mount Ida (i.e., *ganymedes*) for his public banquet in the Colosseum. Although not as obvious in their connection to dining, the Ganymede compositions used in the reception rooms of other Roman houses must have carried similar evocations. Quite an original conception of the Ganymede myth comes from the triclinium in the House of the Arsenal at Sousse (fig. 87).[59] The mosaic, dated to the early third century, contains a medallion depicting the apprehension of Ganymede, which is placed at the center of the shaft of a T-shaped design and surrounded by medallions filled with beasts of the amphitheater.[60] Also from Sousse, but from a *cubiculum*, is another representation of the apprehension of the handsome youth found in the House of Ganymede (Trocadéro) and dated to the mid-second century (fig. 88).[61] A medallion with Ganymede, inscribed within a multiframed square panel, was originally set at the

marine scenes in the semicircles with the Seasons in curvilinear squares around the Ganymede medallion. It has not been identified with a villa site; see Lancha 1990, 35–37.

57. Levi 1947, 129–36, pl. 24.

58. In a similar mode of domestic encomium through visual imagery, we find mosaic representations of heroes, such as Hercules and Bellerophon, in the reception rooms of late antique houses; clearly, the *dominus* equates his virtues with those of the deities in whose company he appears; see Ellis 1991, esp. 125–27.

59. The shaft section of the mosaic, i.e., the part that includes the Ganymede medallion, is in the Sousse Museum; see Foucher 1960a, 42–43, Sousse C5, no. 57.092, pl. 20a; and Dunbabin 1978, 269, no. 12d.

60. A possible explanation for this unusual combination of themes is given below in Chapter 8, on the hunting mosaics of the peristyle.

61. The mosaic is in the Sousse Museum; see Foucher 1960b, 20–21, pl. 9a; and Dunbabin 1978, 269, no. 6a.

Figure 86. Antioch, House of Buffet Supper, Ganymede detail (courtesy of the Department of Antiquities, Cyprus)

center of a black-and-white geometric design. In its presentation of the myth within a central and isolated medallion in the midst of a bold pattern, this Sousse mosaic is the most like the Paphian floor. It is likely that both these floors predate the more complicated Severan compositions in which Ganymede is found in combination with other motifs.

In all these instances, the Ganymede myth is not only appropriate to the activity of dining but a reminder of the munificence of the host. Ganymede is a mythological sign of hospitality in the same way that the *xenia*, most particularly the inclusion of the *apophoreta*, serve as metonyms of edible and precious gifts to guests and friends, conveying at once the status of the owner/host and the centrality of gift-giving among the Roman elites. Whether such items were actually exchanged among the Paphians is not clear or relevant, but their selection for representation bespeaks a process by which the viewer was to recognize the *Romanitas* of the household. Myth and still-life join in a spatially constructed ensemble for reception, and they also project a Roman concept of culture.[62]

62. In his essay on *xenia*, Bryson discusses these motifs and their ekphrastic texts as expressions of

Figure 87. Sousse, House of the Arsenal, Ganymede medallion (German Archaeological Institute, Rome, no. 64-323)

Ample parallel mosaics exist from the second- and third-century for the Ganymede abduction type at Paphos. There are even a few other examples in which the scene is the sole theme of the floor. The Ganymede mosaics tend to appear in either reception areas or private bedrooms; usually attendant motifs indicate the meaning of the mosaic and the function of the room.

To understand the iconographic intentions of the designer at Paphos, we should view room 10 as part of an ensemble of rooms (8, 9, and 10) physically related within the architectural plan (figs. 1 and 3).[63] The long, narrow room 8

"cultural production" (1990, 55); he suggestively observes that for the milieu of Petronius and Philostratus "cultural work is defined as mediation and artifice, representation and simulation."

63. The archaeological evidence and the discussion of the floor plan in the Introduction support this idea.

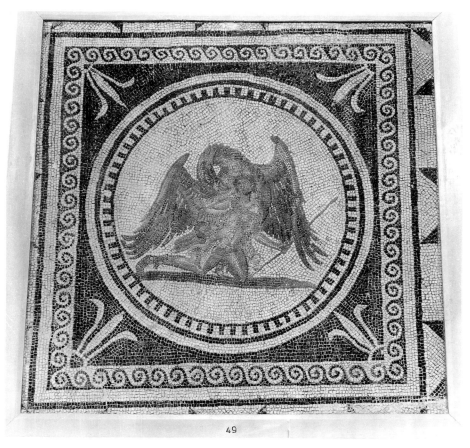

49

Figure 88. Sousse, House of Ganymede, apprehension of Ganymede (German Archaeological Institute, Rome, no. 64-386)

(with its lozenge-star-and-square pattern) served as a corridor-like space that provided access to rooms 9 and 10 through the north portico of the peristyle. On the plan, the square shape and smaller dimensions of room 10 seem visually to lengthen its longer neighbor, room 9. In actual use, communication between the two adjacent rooms would have also allowed them to function as a spatial unit. Several aspects of their locations in the plan determine that these two rooms served the diverse reception needs of the household: their proximity to the latrine (H) and kitchens (F2–4); their juxtaposition, especially of room 10, to the bedroom quarters in the northeast corner; and the closeness, especially of room 9, to the public areas of the peristyle and triclinium. If their physical relationship underlines a shared domestic function, then their decorations should be seen as equally related.

In other words, the *xenia* and *apophoreta* motifs in room 9, with their precise allusions to hospitality, as well as the more subtle reference of the interlace-"cushion" pattern, typically found in the dining rooms of North African houses,

should be seen to complement the abduction of Ganymede. It is then possible to make the association between Ganymede and dining which is known to have existed in many other Roman houses. The large triclinium mosaic in the House of the Labors of Hercules at Volubilis (fig. 73), for example, combines elements from both rooms at Paphos, namely the abduction of Ganymede and the "cushion" pattern in a dining area. In the east, the Ganymede scene set in the apsed dining room of the House of the Buffet Supper at Antioch is another example.

The smaller room, with the Ganymede panel, probably served as a more private entertainment area, perhaps a hierarchically separated space for the master's use, whereas the larger adjacent room served the family reception needs.[64] The juxtaposition of reception rooms and *cubicula*, often arranged around the corners of the house, is a common feature of peristyle house types found in North Africa and in Italy.[65]

64. The size and possible function of the Ganymede room remind us of the *diwan* chambers found in Umayyad pleasure palaces, e.g., at Khirbat al-Mafjar near Jericho; see Grabar 1973, 156, fig. 60.

65. In the plan of the House of Neptune at Acholla (fig. 5), which I cite often for its parallels to the Paphian house, the private apartments are located in the southwestern corner, between the *oecus* and the triclinium. The proliferation of reception rooms—that is, multiple dining rooms—began as early as the 2d century, contrary to what some scholars suggest; see Ellis 1991, 122.

The West Portico

Prelude to a Banquet

THE FOUR MYTHOLOGICAL PANELS that decorate the west portico of the peristyle are, from the south to the north, Pyramos and Thisbe; Dionysos offering the gift of wine to Ikarios and "the First Wine-Drinkers" (the longest panel and the one on axis with the triclinium); Poseidon and Amymone; and Apollo and Daphne (fig. 89).[1] Each panel is individually framed by a tress or braid, and all four panels are surrounded by a wide polychrome band of octagons and crosses that determine oblong hexagons.[2] The figured panels are set apart as *emblemata* by the use of elaborate framing devices in the traditional eastern manner.

The close ties to Antioch which were indicated by the analysis of the Narcissus and of the Phaedra and Hippolytos scenes are underscored by an examination of the portico panels illustrating the legends of Pyramos and Thisbe and of Apollo and Daphne. Although both stories were well known in the Latin west, largely

1. For a description of these panels, see Vermeule 1976, 103–10; Nicolaou 1963, 64–67, who identifies the portico as room II; Balty 1981a, 419n.470; Daszewski and Michaelides 1988b, 23–29, figs. 8–11; Michaelides 1987a, 19–21, nos. 16–19, figs. 16–19.

2. *Décor géométrique*, 280–81, pl. 180b, described as an "outlined orthogonal pattern of adjacent crosses and irregular octagons (the axial sides the shorter)." Some octagons are filled with floral motifs, five with theatrical masks. The colors of dark- and light-pink, grays, and red-brown predominate. For a review of the pattern, its development, and chronology, see Daszewski and Michaelides 1988b, 41–42; also this pattern is discussed in the dating section of "Conclusions" herein.

Figure 89. West portico panels, drawing by M. Medič (courtesy of the Department of Antiquities, Cyprus)

through Ovid's *Metamorphoses* and many artistic representations, their interpretations at Paphos suggest a strong dependence on eastern sources, both literary and pictorial. The three love episodes, including that of Poseidon and Amymone, set out along the west portico, although well attested in the ancient artistic repertoire, contain unusual elements: a river god identified as Pyramos; another river god, unnamed, who reclines beside Daphne; and an Eros with an odd attribute who flies toward Amymone. The labeling of only certain figures is especially curious. Examined individually, each scene reveals the idiosyncracies of mosaic production at Paphos. Despite the obvious parallels with Antiochene mosaics, these panels seem to be fresh creations selected and composed for their particular regional and domestic context.

The Ikarios panel with "the First Wine-Drinkers" has no parallels, and its juxtaposition with the three love scenes is puzzling, but closer examination suggests a programmatic conception for the ensemble. The reasons behind the selection and combination of these four myths emerge most clearly if we consider the three amorous adventures first, and the Ikarios panel last—that is, out of their spatial sequence along the west portico.

PYRAMOS AND THISBE

The panel with Pyramos and Thisbe provides evidence not only for a wide range of influences on the Paphian workshop but also for its individuality (fig. 90). Discrepancies between the literary narrative and the pictorial representation of the story indicate a welding of at least two distinct traditions within this one panel. An analysis of this local variant of the tale will shed light on iconographic exchanges between the Greek east and the Latin west during the Roman Imperial period, as well as on the mechanics of transmission and production.

The Pyramos and Thisbe panel, as well as "the First Wine-Drinkers," contains

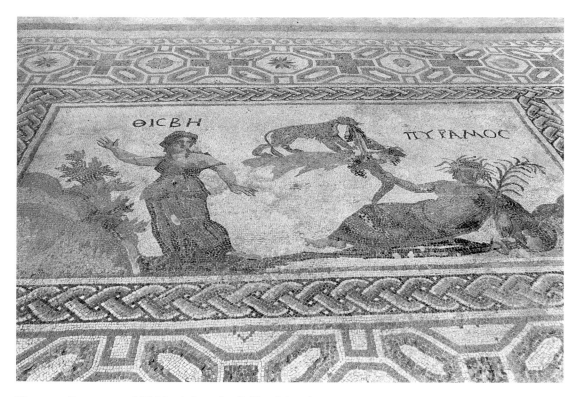

Figure 90. Pyramos and Thisbe (photo by C. Kondoleon)

labels identifying the figures. In both instances the use of labels suggests that these are self-conscious inventions. The Pyramos and Thisbe scene does have anteced-ents, while the Ikarios and Wine-Drinkers panel seems to be a Paphian original. But precisely because the sources of the Pyramos and Thisbe composition are traceable and the combination of figures appears to be ad hoc, it offers a rare insight into the process of artistic production. On the panel (1.15 m. × 2.26 m.), Thisbe stands to the left, Pyramos reclines to the right, and a female leopard stands in the background between them. Thisbe, in a contrapposto stance, lifts up her extended right hand with open palm as she turns her face toward Pyramos, and her other hand extends downward. Her gray sleeveless chiton with red-brown folds falls in three tiers down to her orange-colored feet. The costume slips off her left shoulder, revealing her breast. She wears a caplike headdress, and her hair falls in four long curly locks down to her shoulders. She stands near a rocky outcrop with a tall, leafy bush. In contrast, Pyramos lies on the ground against a rocky hill, propped up by his left arm, which rests on an overturned metallic hydria with water issuing from it (fig. 91). He holds a tall green river reed in the same hand, while his right lifts up an orange and yellow cornucopia filled with fruits. A crown of reeds rests on his head, indicating, along with the other attributes and his reclining position, that he represents a river god. A gray himation with dark-green

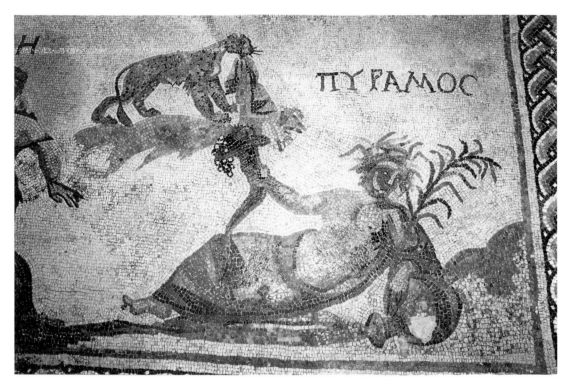

Figure 91. Pyramos, detail (courtesy of the Department of Antiquities, Cyprus)

folds drapes over his left arm and covers him from the waist down. He turns his beardless face away from Thisbe. In the background between the ill-fated lovers, a spotted female leopard stands on a mound of gray earth and clutches Thisbe's cloak in her maw.

The presence of the cloak, leopard, and young maiden recalls Ovid's account in the fourth book of the *Metamorphoses* (55–166), wherein Pyramos and Thisbe are the prototypical star-crossed lovers. The two young lovers, prevented from meeting by their feuding families, arrange a secret nocturnal rendezvous at Ninus' tomb. Thisbe arrives first and is frightened away by the approach of a lion with her fresh kill. She drops her cloak in flight and when Pyramos arrives he sees it bloodied, having been mauled by the lion, and assumes the worst. He kills himself, and when Thisbe returns she finds his body and she also kills herself, after a heart-wrenching soliloquy. Her blood stains a mulberry tree, perhaps indicated by a spiky bush in our mosaic, which henceforth bears dark-red fruit in mourning for the lovers.

The Paphian mosaic portrays the moment when Thisbe flees and the lion, here a leopard, finds the abandoned cloak. Thisbe's fright is persuasively depicted by her gestures—extended arms and fingers, open palms; by her expression of surprise with widened eyes and pursed lips; and by the chiton slipping off her

shoulders and indicating a state of disarray. The figure of a reclining river god at this point in the drama might represent the spring at which the lion quenches her thirst before stalking away (*Metamorphoses* 4.98), but, the label "Pyramos" indicates another intention.

A well-established legend preserved in late antique sources from the east connects Pyramos and Thisbe in a very different way.[3] The earliest of these is Nonnos' *Dionysiaca* (6.346–55), written in fifth-century Alexandria but undoubtedly based on earlier sources, in which Pyramos is a river god. In this poem Pyramos and Thisbe are described as two rivers that, along with the Nile and Euphrates, Alpheios and Arethusa, are likened to lovers who seek and eventually flow into each other. Topographically, Pyramos is a river in Cilicia and is included in Strabo's *Geography*.[4] The presence of Pyramos as river god in Paphos suggests sources other than Ovid for this composition.

The Paphian mosaic appears to be a conflation of the Ovidian and eastern traditions. The lion and cloak can be found in Pompeian paintings that illustrate Ovid's text, and Pyramos occurs as a river god in Syrian mosaics. An examination of the respective sources elucidates the ad hoc process involved in the selection and combination of figures in the Paphian composition. Of the four Pompeian paintings and another from a tomb on the Isola Sacra in Rome depicting Pyramos and Thisbe, three include the lion and two the cloak.[5] The similarities with the Paphian mosaic end here. The Pompeian scenes show the tragic climax of the tale when Thisbe flings herself over him, lifting herself up with her extended left hand and plunging in the sword with her right (fig. 92).[6] The site of Ninus' tomb is designated by a stone pillar with a funerary urn in two cases, and in all but one example the paintings include a young tree.[7] In the instances where the lion is included, she is definitely fleeing in the background and the cloak remains in the foreground hanging on a tree. Quite clearly, from their very similar treatments of the subject, the Pompeian paintings derive from a common model. Despite the presence of the cloak and leopard in the Paphian mosaic, the differences in the representations of Thisbe and Pyramos argue against a dependence on the Pompeian model and, perhaps, even on Ovid.

3. Different accounts of Pyramos and Thisbe are related in Duke 1971, 320–27; Baldassarre 1981, 338n.6; and *RE* 24: 1–11 s.v. "Pyramos" and 7: 286–91 s.v. "Thisbe."

4. For a geographical account of the Pyramos River, see *RE* s.v. "Pyramos."

5. A painting from the House of Lucretius Fronto (V, 4, 11) shows only the rear of the lion as she flees in the upper-right-hand corner (Baldassarre 1981, 341, fig. 2); the lion and cloak are found in a painting from the House of the "Bikini Venus" (ibid., 341, fig. 3); and in a painting from the House of Loreius Tiburtinus (II, 2, 2) the lion is in full view leaping toward the left-hand side of the panel (ibid., 342, fig. 4). The example from Pompeii, IX, 5, 14, now in the Naples Museum (Rizzo 1929, pl. 134a), and the one from the Isola Sacra, a necropolis near Ostia (Baldassarre 1981, 343, figs. 5–6), do not include either the cloak or the lion.

6. The example shown here is from the House of Lucretius Fronto (V, 4, 11); see Rizzo 1929, pl. 134b; and Schefold 1957, 86.

7. The one painting without a tree is from the House of the "Bikini Venus" (I, 11, 6); see Baldassarre 1981, fig. 3.

Figure 92. Pompeii, House of Lucretius Fronto, Pyramos and Thisbe (after Rizzo 1929, pl. 134b)

The representation of Thisbe may be a key to understanding the Paphian version of the legend; her fleeing position with outstretched hand suggests a pictorial source different from that of the Pompeian paintings. Two more illustrations of the Pyramos and Thisbe tale have recently emerged which are closer to the Paphian mosaic; one is a mosaic from a Roman villa in Carranque (Toledo), and the other is a scene from the rim of a large silver plate in the so-called Sevso Treasure. The Carranque mosaic, tentatively dated on stylistic grounds from the mid-fourth century to the mid-fifth century, provides evidence for the circulation of a visual model in the west which differs from the Pompeian paintings and is closer to the Paphian mosaic.[8] On the Spanish floor mosaic, the Pyramos and Thisbe scene (fig. 93) forms one of four lunette panels with mythological scenes that, according to an inscription, decorated a *cubiculum*. Thisbe occupies the

8. See Arce 1986, 365–74, pl. 71a.

Figure 93. Carranque, Pyramos and Thisbe (courtesy of J. Arce)

center of the panel as she runs with an outstretched hand toward the left, away from the frightful sight of the lion mauling the blood-stained cloak.[9] At the far left Pyramos holds a tree with white berries, undoubtedly the mulberry tree, which will later bear red fruits in memory of the blood of the lovers. With the exception of the representation of Pyramos as an adult male rather than as a river deity, the elements in the Carranque mosaic are much the same—stylistic differences aside—as those in the Paphian composition. Certainly, the existence of this scene as far west as Spain and in mosaic underlines the possibility that the Paphian artist could have depended on a visual model—rather than have been familiar with Ovid's tale—which he had adapted according to local traditions.[10] In fact, this physical transmission is most likely, inasmuch as Latin literature was little known in the east.[11] It is possible, however, that craftsmen and patrons were

9. Arce, ibid., 368, identifies the feline as a tiger, but the stripes appear to be stylized shadow lines used by the mosaicist throughout the floor; see especially the figure of Pyramos, who is covered with the same light stripes.

10. Baldassarre 1981, 346, hints at this when she proposes that "the Paphian mosaicist inserted, without understanding it, an element from the Ovidian legend."

11. This fact is emphasized by Knox 1989, 316.

familiar with Ovid's narrative through pictorial models, which traveled more easily and widely than texts.[12]

The Meleager plate from the Sevso Treasure—a large silver plate with scenes of amorous couples chased along its rim (fig. 94)—has been tentatively dated to the fourth and fifth centuries.[13] Thisbe appears with outstretched hands, as she does on the Paphos mosaic, but the body of Pyramos hangs limply in a semi-reclined position beside a fallen sword. A female lion leaps in the center background with a cloak in her jaws. Immediately to the left of Pyramos is a seated river nymph, whose head is cast down and supported by her hand. Between Pyramos and Thisbe is another river nymph; this one, however, reclines with her body facing Thisbe as she turns to look over her shoulder at Pyramos. The attributes of down-turned water jars and reeds identify these two female personifications as water nymphs, but their presence is puzzling. The silver plate relief introduces yet another variant: here the personifications seem to echo the actions of the pro-tagonists, but since both nymphs are female, they cannot be the faithful lovers transformed into streams who appear in the eastern version of Pyramos and Thisbe. Perhaps their inclusion was meant to characterize Pyramos, and possibly Thisbe, as rivers; if so, the Sevso relief would conflate the Ovidian and eastern accounts.

It is possible, as Knox has done, to postulate an eastern source predating Ovid which has a storyline that relates to the Paphian composition.[14] However, the presence of the lion/leopard and cloak in the Paphos mosaic, on the Sevso plate, and in the Spanish mosaic, as well as the mulberry tree in the latter mosaic and the fallen Pyramos with sword on the plate, argues forcefully for the currency of artistic models dependent, albeit indirectly, on Ovid. This explanation follows that proposed by I. Baldasarre, who allows that the mosaicist, drawing on available models, inserted elements from Ovid's tale without necessarily knowing it.[15] Knox, on the other hand, rejects artistic conventions as a means of accounting for these discrepancies.[16]

At least at Paphos, it appears that the representation of Pyramos as a male river god depends on an eastern version of the myth, which the local workshop interpreted. Fortunately, three mosaics survive from Syria which testify to the currency of an eastern version of the legend in art. The depiction of Pyramos as a young, beardless river god occurs twice in Antioch, in the House of Cilicia and in the

12. The role of pictorial models is neglected in Knox's discussion (1989, passim).

13. Sotheby's 1990.

14. Knox 1989, 315–28, esp. 323–24, has recently proposed, on the evidence of the Paphian mosaic, that Ovid adapted a local Cilician myth for his own version of Pyramos and Thisbe. Although we come to different conclusions, Knox makes many of the same observations as appeared in my dissertation in 1985 and most recently in Kondoleon 1990, 109–12. Duke 1971, 322, also suggests that the source for Ovid's version was a Hellenistic author familiar with North Syria and the Pyramos River.

15. See Baldassarre 1981, 346.

16. In response to Baldassarre's proposal, Knox 1989, 325, states that "this appears a very unlikely explanation."

Figure 94. Sevso Treasure, silver plate with Pyramos and Thisbe (courtesy of M. Mango)

House of the Porticoes.[17] In these Antiochene mosaics, however, Pyramos appears as a bust crowned with reeds accompanied by other river gods identified by inscriptions. A key to understanding the genesis of the Paphian Pyramos is best provided by the late-second-century Portico of the Rivers mosaics in the House of the Porticoes, wherein four square panels contain busts of the rivers Alpheios, Arethusa, Thisbe, and Pyramos (fig. 95). Arethusa and Thisbe appear as female busts and confirm the interpretation of these four as two pairs of lovers transformed into the rivers and springs described in Nonnos' poem. In the early-second-century House of Cilicia, only two of the four busts survive, Pyramos and Tigris, and these may be viewed as topographical indicators because of their combination with the personification of Cilicia.[18]

The Paphian Pyramos clearly alludes to the fluvial divinity known to us from Nonnos' poem. Syrian artists outside Antioch were also aware of this tradition because at least one (the Orontes panel) of the four mosaics of seated river gods from the Severan Baths of Ghallineh (district of Lattakia) represents a fluvial couple (fig. 96).[19] The river Alpheios, identified by inscription, is depicted sitting beside his consort Arethusa, the Silician fountain nymph, who puts her arm around his shoulder.[20] He holds a metallic (gold?) cornucopia and she holds a

17. See Levi 1947, 58, pl. 9b, and 109–10, pl. 18c, respectively.

18. Levi, ibid., 58, suggests that the missing rivers are the Kydnos and the Euphrates.

19. J. Balty 1977, 14–15, discusses the pendant river panel with a representation of the Orontes River, now in the Damascus Museum. The other panels are unpublished. Balty assigns them to the Severan period on the basis of style.

20. The mosaic is in the Tartous Museum. I am indebted to T. Allen for the information and visual documentation.

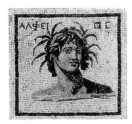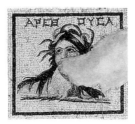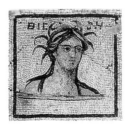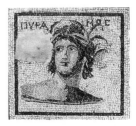

Figure 95. Antioch, House of the Porticoes, rivers gods, Thisbe and Pyramos at right (after Levi 1947, pl. 18c)

(silver?) pitcher in her left hand, providing the only attributes that distinguish this otherwise generic scene of a romantic couple. In this Syrian mosaic these watery lovers were represented as full-length figures. In addition, a mosaic from Antioch, representing two reclining river gods labeled as Ladon and Psalis, from around the mid-third century, attests to the Syrian penchant for such personifications.[21] That there was a geographical tie between Pyramos and Cyprus is evidenced in Strabo's *Geography*; he traces the course of the Pyramos River from the coast of Cilicia to its mouth in northeastern Cyprus, a fact that may well have contributed to a local (i.e., Paphian) formulation of this legend.[22]

The Paphian composition is unique in its combination of the startled Thisbe, the leopard, and the cloak with the river Pyramos, and must be seen as an ad hoc creation. Given the evidence from the Sevso plate and Carranque mosaic, it does not seem likely that the Paphian panel is the key to a long-lost Cilician myth on which Ovid based his text, as Knox has proposed. Rather, it may well represent the attempt of an eastern artist and/or client to reconcile an available western model based on Ovid's tale with his local knowledge of the legend, knowledge reflected in Nonnos' poem. The Paphian Thisbe appears to be a generic type of standing female who uses standard gestures of exclamation.[23] The cloak and leopard necessarily derive from the Ovidian version, while Pyramos as a river god underlines ties to an Antiochene workshop. The mosaicist might have misunderstood the western model, substituting the hero with a river god and a lion with a leopard, because he was unfamiliar with both the pictorial and the literary tradition of the west. The figure of Pyramos attests to the currency of the Antiochene repertoire in Paphos, as well as to the role of local knowledge in artistic productions.

21. The mosaic is from room 13 in the House of Menander, upper level; Levi 1947, 205, pl. 46c.
22. See *RE* s.v. "Pyramos."
23. The pose is very similar to the one Phaedra strikes in the House of the Red Pavement; see Levi 1947, 75, pl. 11b; and her gesture of exclamation replicates the one used by Narcissus in the House of Narcissus; ibid., pl. 10b.

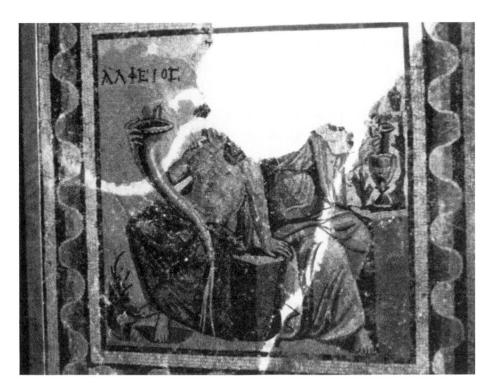

Figure 96. Ghallineh (Lattakia), Severan Baths, the river Alpheios (courtesy of T. Allen)

AMYMONE AND POSEIDON

In the third panel (2.29 m. × 1.12 m.) of the west portico we find a scene depicting the myth of Poseidon and Amymone (fig. 97). At the left side, a bearded Poseidon, identified by the trident slung over his shoulder, rushes toward a seated female, his green mantle swirling about his naked body. The nymph, who appears to have fallen on her knees, rests her elbow on a rocky outcrop. As she turns her body around into a nearly frontal pose, her face is in three-quarter view, and she stretches her hand out toward Poseidon. The neckline of her green chiton has slipped, to expose her breasts, and a reddish-brown mantle is wrapped about her legs and over her left arm. A large yellow golden pitcher is set on a ledge beside her feet. A winged Eros, naked except for a yellow chlamys swung over the shoulder, flies between them holding a torch; he also carries an odd object in his left hand—a rectangular plaque on a staff, possibly a banner.

From numerous representations on Greek vases and in Roman mosaics and paintings it is clear that the scene represents the encounter between Amymone and Poseidon. A comparison of several literary and visual versions of the myth with the Paphian mosaic is instructive. One aspect of the tale which varies, and is ambiguous in our mosaic, is whether the nymph entreats Poseidon for water or is

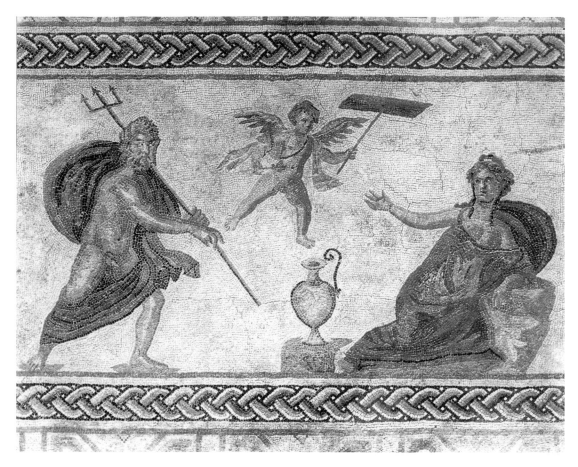

Figure 97. Amymone and Poseidon (courtesy of the Department of Antiquities, Cyprus)

asking him to rescue her from the lascivious attack of a satyr. Or does she invite him to lie with her? The literary accounts provide several versions. Strabo and Pausanias only briefly mention Amymone as the daughter of Danaos who gave her name to a spring at Lerna in the Argolid.[24] Two mythographers, Apollodorus and Hyginus, relate that Amymone, attacked by a satyr on her way to find water in "thirsty" Argos, implored Poseidon for help, whereupon the deity lay with her himself and brought forth a stream of water which was named after the nymph.[25] A most dramatic account is given by the second-century author Lucian in his *Dialogue of the Sea-Gods*, wherein Triton entices Poseidon with a description of the lovely Amymone, and the god responds enthusiastically by calling for his

24. Strabo, *Geography* VIII.6.8 (Jones 1917–32, 160–63); Pausanias, *Description of Greece* II.37 (Frazer 1913, vol. 3: 96).

25. Apollodorus, *The Library* or *Bibliotheca* 2.1.4–5 (Frazer 1921, 137–39), which survives in a 1st/2d-century A.D. edition of this 2d-century B.C. author; and Hyginus, *Fabulae* 169, 169A (Grant 1960, 132) of the Antonine period.

fastest dolphin. Poseidon startles the nymph in her search for water, then offers a fountain with her name in exchange for her favors.[26] It has been suggested that Lucian's amusing dialogue, influenced by mime and comedy, might be a description of a painting.[27] Yet another account is preserved in the ekphrastic passages of the *Imagines* of Philostratus, who describes a painting wherein Poseidon, escorted by his hippocamp, spots Amymone by the waters of the Inachos River and frightens her, so that she drops her golden pitcher.[28]

Not surprisingly, the monumental representations reflect a variety of sources. Two unusual mosaics introduced a satyr into the scene.[29] A third-century mosaic from a Roman house in Chania, Crete, illustrates the legend in two episodes framed within a single panel.[30] At the left Amymone struggles with a satyr, who is attacking her. At the right a more tranquil Amymone is seated on a ledge accompanied by a standing Poseidon, also perched on a ledge, with a trident. Similarly, in a Roman villa of the early decades of the fourth century at Nabeul (Neapolis), Tunisia, both episodes are depicted in mosaic, although in different rooms; one shows a nymph fighting off the advances of a satyr, and the other the same nymph with Poseidon in front of the personification of a water source (fig. 98).[31] Panels with two cocks fighting over gold coins occur in both villas.[32] As an established symbol of amorous rivalries and victory, the combat of the cocks offers a commentary on the love scenes and signals the viewer to read the mosaics as a conceptual unit.[33] This interpretation is especially critical at Nabeul, where the mosaics are located in three separate rooms.[34] Essentially, the Chania and Nabeul mosaics follow the narrative of Apollodorus and Hyginus by linking the satyr's attack to the rescue of the nymph. The fact that the maiden seems to welcome the deity is significant for the interpretation of the scene. Both mythographers recount that Amymone implored Poseidon for help. At Paphos, Amymone gestures

26. Lucian, *Dialogue of the Sea-Gods* 8(6) (Macleod 1961, vol. 7: 205–11).

27. Macleod 1961, 177.

28. Philostratus the Younger, *Imagines* 1.8 (Fairbanks 1931, 33).

29. Simon 1981, 752, notes that the satyr rarely appears in Hellenistic and Roman examples.

30. Berti 1975, passim, esp. figs. 1, 3, 5, dismisses the date of the excavator as absurdly early (ibid., 451) and suggests a date in the mid-3d century on the basis of stylistic parallels with North Africa (ibid., 464–65). See also Saunders 1982, 54, who gives an Antonine date on the basis of a stylistic comparison with the Roman villa at Corinth.

31. For the panel with Amymone and Poseidon (no. 24) found in *cubiculum* C2, see Darmon 1980, 95–98, 160–63, pls. 48–49 and 82; for the panel with Amymone struggling with the satyr (no. 27) found in room X, adjacent to *cubiculum* C2, see ibid., 104–9, 175, 188–90, pls. 52–54.

32. At Chania, the fighting cocks are found within the same mosaic as the Amymone legend; see Berti 1975, figs. 1 and 6. At Nabeul, the cock scene is set in a pseudo-*emblema* along the north portico of the peristyle at a distance from the other two related scenes; see Darmon 1980, no. 19, 79–84, pls. 78–79.

33. For a criticism of Darmon's reading, see Quet 1984, 85–86; Quet suggests that the cocks are a symbol of amorous victory and not desire, and are not necessarily related to the Amymone legend illustrated in the other rooms.

34. Darmon 1980, 188–90, connects these three mosaics and reads them as an ensemble. His observation about the Nabeul mosaics is significant for the programmatic interpretations of domestic decoration in general.

Figure 98. Nabeul, Domus Nympharum, Amymone and Poseidon (courtesy of J.-P. Darmon)

with open hand toward Poseidon, and it appears that he rushes to her aid, but another explanation for this depiction follows below.

Quite a different version occurs in a relief from Side (Turkey) and a mosaic from Carranque (Toledo). In the second, the figure of a winged Eros on horseback is introduced. In the Side relief, from a *nymphaeum* of the Caracallan period, Poseidon rushes toward a kneeling Amymone; between them an Eros flies alongside a rushing steed with the protome of a dolphin in front of it.[35] The existence of this third-century relief clarifies the strange representation in the late-

35. For a full bibliography, see Simon 1981, 745, no. 34.

fourth-century villa in Carranque in which a winged Eros on horseback is about to trample a frightened nymph who kneels beside a fallen pitcher (fig. 99).[36] In the Carranque mosaic, the absence of Poseidon can be explained only as an inadvertent omission or a visual malapropism that was common in late antique provincial art;[37] for a similar oddity we need only glance at the adjacent panel in the same room which shows Pyramos holding a myrtle tree in his arms as if it were a portable prop.[38] The presence of the horse and dolphin seems to reflect the account found in Lucian's *Dialogue*, where Poseidon calls for horses and then decides on a dolphin because it is faster. The sculptor of the Side relief includes both.

One of the most elaborate representations of this legend appears on a marble relief from the early Imperial period now in the Civic Museum in Bologna.[39] The presence of a sea monster (*ketos*) or, more likely, a triton[40] and a nereid at the left side of the relief provides a marine entourage for Poseidon, which seems more in keeping with Lucian's version of the legend. Poseidon is shown striding toward Amymone, who kneels beside a small vase; a third figure, possibly a personification of the water source, stands at the right. A somewhat similar composition appeared on a stucco relief from the Room of Venus at Baiae; it survives only in an early-eighteenth-century drawing by Bartoli (fig. 100).[41] Amymone falls to one knee while trying to escape from Poseidon, who emerges from the sea, as shown by the foreparts of two hippocamps behind him; the reclining woman at the right may be a water personification. In a painting of the legend, as described by Philostratus, Poseidon rides in a chariot drawn by hippocamps said to be "in all respects like dolphins"; the maiden, who visits the waters of Inachos in the Argolid, is so frightened by the sudden entrance of the god from the sea that her golden pitcher falls from her hands. Here, then, are all the elements found in the second group of representations just discussed, even the conflation of dolphins, horses, and hippocamps. Because it has been suggested that Lucian's *Dialogue* was inspired by a painting, it seems likely that this group of images—the relief from Side and the relief now in Bologna, and the Carranque mosaic—as well as other mosaics that show Amymone kneeling beside a fallen pitcher as Poseidon rushes in, are variations on the composition that Philostratus described.[42] A much-

36. Arce 1986, 368, pl. 70b.

37. Despite the ancient title of Poseidon Hippios, I do not think that the mosaic represents Poseidon in the guise of a horse, as Arce has suggested (1986, 368n.6)

38. Ibid., 71a.

39. Simon 1981, 744–45, no. 33; and Berti 1975, 460, fig. 8.

40. Berti identifies the sea creature as a *ketos* (1975, 460); however, on close examination, there appears to be a male bust emerging from the water, and the presence of the nereid would seem to support the identification of this figure as a triton.

41. The drawings are now in the Topham Collection at Eton College; see Ling 1979, 49–50, 4.2; and Simon 1981, illus. 601.

42. One such scene is found in a black-and-white mosaic from the Via Appia and now in the Vatican; it shows Poseidon with a trident rushing in from the right as the startled nymph kneels to catch her fallen pitcher; see Simon 1981, no. 31, 744; and Nogara 1910, 35–36, pl. 72.2. Two other mosaics seem to show only

Figure 99. Carranque, Amymone and Eros (courtesy of J. Arce)

reduced and cruder version of this scene is preserved on a marble relief from Kourion on Cyprus, in which a sea-centaur points toward Poseidon, who is about to grab the nymph kneeling beside her pitcher (fig. 101).[43]

Although there are no references in the Paphian mosaic to the sea, there is a winged Eros—an unusual feature found only on the Side relief and in the Carranque mosaic. The presence of Eros suggests a relation between the Cypriot panel and the Philostratus/Lucian group. Yet there are differences. Amymone, rather than frightened, appears to implore the god for help, as noted above, and the golden pitcher stands upright, undisturbed, in the middle of the composition. In most of the images, Amymone falls to her knees as she runs to the left away from her pursuer, who rushes in from the right. At Paphos, the composition is reversed so that the nymph, here on the right, faces her pursuer, rather than turning back to repel him; likewise, the hand that was held close to her body to ward him off is here stretched out in an extended gesture of welcome. The reversal of the figures alters the meaning of the composition. Yet there is no doubt that the model was

Poseidon and Amymone, but are too damaged to be useful in this discussion; for a mosaic from Amphipolis, see *LIMC* I.1., 744, no. 29; and for a panel from a floor at El Jem, House of the Terrain Jilani Guirat, see Foucher 1960a, 42–43, pl. 17a, who identifies the scene differently.

43. Karageorghis 1975, 844–45, fig. 67; and Simon 1981, 745, no. 35, who assigns it a 3d/4th-century date.

Figure 100. Baiae, Amymone and Poseidon, drawing of stucco relief (The Topham Collection; reproduced by permission of the Provost and Fellows of Eton College)

the one of the startled nymph who falls to her knees. Once again, the Paphian mosaicists seem to adapt traditional compositions and cast their own accent on formulaic scenes.

The presence of the winged Eros with the torch pointed toward Amymone clearly represents *pothos*, that is, Poseidon's amorous sentiments (fig. 102). The use of Eros to personify desire is most obvious on a painted glass vessel found in Kertch (fig. 103) where a winged Eros, labeled as *pothos*, flies between Apollo and a half-transformed Daphne.[44] Although Eros is not included in any of the written versions of the Daphne or Amymone legend, artists have employed him as an animating device, one that became de rigeur in the representation of mythical love scenes in Roman art.[45] Amymone, however, is not usually accompanied by Eros in Roman paintings and mosaics.[46]

Throughout ancient art, winged Erotes inflame passions with their torches pointed in telling directions—upward for successful encounters, downward for the fateful ones. In the Paphian mosaic the torch is pointed horizontally toward Amymone, as if guiding Poseidon to her. On Italian and Attic vases, the inciting

44. The vase is in the Corning Museum of Glass (no. 55.1.86); see Corning 1957, 165–67, no. 324, pl. 7. I discuss it more extensively in my examination of the Apollo and Daphne mosaic below.

45. For a list of the unions of gods and heroes in which Eros has assisted, see Stuveras 1969, 109–21, esp. 111–12. More recently, M. Conan notes the frequent mention of cupids as allegorical representations of man's desires in Philostratus' *Imagines* (1987, 165).

46. It is in Greek vase painting that Amymone, holding a hydria, most often appears with Eros and Aphrodite; for example, see the list of Greek vases in Simon 1981, passim; also, Milne 1962, 305–6; and Trendall 1977, 281–87.

Figure 101. Kourion, Amymone and Poseidon, marble relief (courtesy of the Department of Antiquities, Cyprus)

Figure 102. Amymone and Poseidon, detail of Eros (courtesy of the Department of Antiquities, Cyprus)

Figure 103. Kertch, Daphne ewer, detail of Pothos (courtesy of Corning Museum of Glass, Corning, New York)

Erotes often bear other objects, most commonly crowns, in addition to their lighted torches.[47] Sometimes they bear the attributes of the lovers; for example, Eros with a thunderbolt flies above Europa on a mosaic from Oudna (Tunisia).[48] There are no parallels among the many Amymone representations for the odd object held by the Paphian Eros; it seems most like the *vexillum*, or banner, held by an Eros riding a dolphin in a Pompeian garden painting,[49] and by a wingless Eros who stands on the back of a centaur leading the chariot of Dionysos and Ariadne on a second-century sarcophagus (fig. 104).[50] Because of the military associations of this attribute, such a banner may connote a triumph. By adding Eros with his torch and banner—suggesting passion and marine triumphs,

47. E.g., see a bell-krater from Sydney and a *pelike* from Moscow; Trendall 1977, 282, no. 2, and 284, no. 11.

48. Dunbabin 1978, 39 and 265; and Robertson 1988, 84, no. 144, with illus. IV.2, 43, no. 144.

49. The painting is from the House of Loreius Tiburtinus and shows Venus on a half-shell flanked by two Erotes; see Stuveras 1969, 135, pl. 18, fig. 42.

50. The figure is from a child's sarcophagus in the Vatican; see Matz IV.2, 211, no. 92, pl. 121.

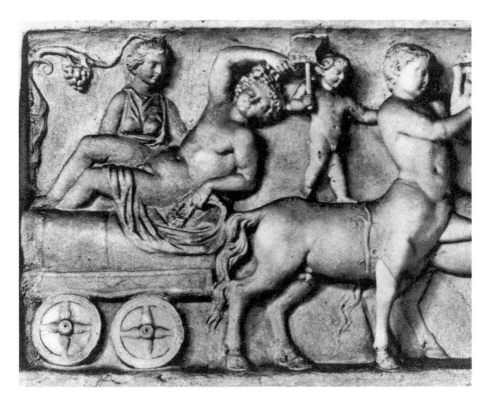

Figure 104. Vatican, child's sarcophagus, detail of the wingless Eros (after Matz IV.2, pl. 121)

respectively—the Paphian artist produced a more nuanced interpretation of the banal couple imagery.

The choice of the Amymone legend as a domestic decoration in Paphos raises an interesting question about the role played by local myths in the selection and formation of artistic compositions. Certainly, the divine couple was a favorite of Greek and Roman artists, but the consistent fusion of Amymone with Beroe in the *Dionysiaca* of the fifth-century writer Nonnos suggests a more specific connection to Paphos. In his poem about the travels of Dionysos, Nonnos lavishes much praise on ancient Berytos (Beirut), and in so doing devotes long verses, nearly two books, to the legend of Beroe, after whom the Phoenician city is named. Therein Nonnos writes that Beroe, "the same they named Amymone," hailed from the "House of Paphia" and was called the daughter of "Cypris," or "Cythereia," referring to the legend that her mother was Aphrodite.[51] This representation of an encounter between a nymph and Poseidon, which looks suspiciously like the one with Amymone on the third-century coins from Berytos, suggests that the two nymphs were interchangeable long before Nonnos wrote his

51. Nonnos, *Dionysiaca* 41. 143–55 (Rouse 1940).

poem.[52] In the east the origins of both nymphs were traced to Aphrodite, a fact significant to the selection of the scene at Paphos. In his panegyric of Berytos, Nonnos puts forth the bold claim that Cypris emerged from her sea birth at Beroe/Berytos, and not at Paphos. The author goes so far as to say, "Those footsteps of the goddess coming out from the sea are all lies of the people of Cyprus."[53] Clearly, these verses reflect a tradition of competition among ancient cities; this was a challenge to the primacy of Paphos in the cult and myth of Aphrodite. Even though the Amymone and Poseidon episode was part of the standard iconographic repertoire, its inclusion at Paphos may well have been a choice of local pride.[54]

APOLLO AND DAPHNE

The composition of the Apollo and Daphne mosaic, the fourth and north-ernmost panel, reveals the influence of eastern sources even more directly than does the Pyramos and Thisbe panel (figs. 105 and 106). Although the figures are not labeled, they follow conventional forms and are easily recognized. There are ample parallels for the two protagonists, but the inclusion of a male river deity is rare.

In the panel (2.33 m. × 1.11 m.) Apollo dashes in from the right toward Daphne, who stands behind a reclining river god on the left side; a small hillock with a leafy bush separates them. Apollo, identified by his laurel crown, his bow, and the quiver just visible over his right shoulder, is nude except for a green and brown mantle thrown over his shoulders and high laced sandals. He steps forward with his cloak flying behind him and points at Daphne with his right hand. The maiden is nude except for a green himation that swings in an arch above her head, as if to indicate a sudden halt in her flight. Daphne, fixed in a contrapposto stance as her legs stiffen into the trunk of a laurel tree with leaves shooting out from the right side, turns to stare at her pursuer. The bearded river god in front of her rests his arm on a downturned jug from which water flows; he holds a cornucopia in his left hand and a reed in his right. He turns his head, crowned with river reeds, away from the scene toward the left.

Among the numerous representations of the legend in mosaic and painting, none includes the figure of the river god. As with Pyramos and Thisbe, the composition of the Paphian version of Apollo and Daphne reveals a certain degree of independence on the part of the mosaicist, who based it on local knowledge. Among the Pompeian painters it seems from the surviving examples

<hr>

52. E.g., see Berti 1975, 462, fig. 9, esp. n. 3; and Simon 1981, 745, nos. 38 and 39, illus. I.2, 601; see also Picard 1956, 227, fig. 6.

53. Nonnos, *Dionysiaca* 41. 117–18 (Rouse 1940, 205).

54. On the use of geography and myth for the expression of intercity rivalries, see Fox 1987, 68–69.

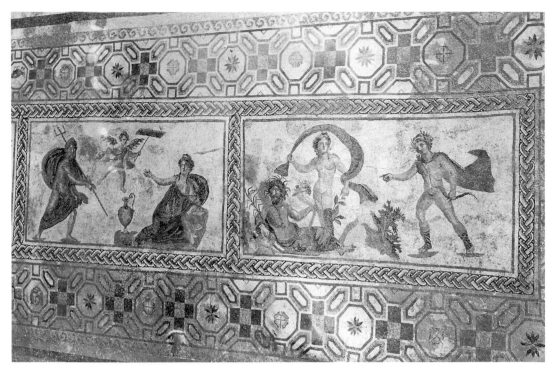

Figure 105. Poseidon and Amymone, Apollo and Daphne (courtesy of the Department of Antiquities, Cyprus)

that two types of scenes circulated: those that illustrate a seduction scene with Apollo and Daphne in conversation, and those that show the god seizing the maiden in a feverish embrace.[55] Although none of these actually portrays her transformation into a laurel, it is assumed that the Pompeian painters were depicting Ovid's account (*Metamorphoses* 1.452–567). Similarly, there are some mosaics—for example, an early-third-century panel from a house in Thessalonika[56] and a late-second-century panel from a house in El Jem[57]—that do not show the transformation. Nevertheless, dramatic presentations of the leafy maiden can be found in several mosaics from the second and third centuries. For example, in a second-century mosaic from Marino near Rome[58] and in a third-

55. For a full discussion of the different versions of the scene, see Müller 1929. The seduction scenes depicting the couple in conversation show either Apollo seated and Daphne standing or the reverse; see Simon and Bauchhenss 1984, vol. II.1, 425, no. 444a and c; illus. vol. II.2, 338. The type in which Apollo falls upon the resisting Daphne is well represented by a Pompeian painting in the House of the Dioscuri; see ibid., no. 444b.

56. The panel, now in the Archaeological Museum, Thessalonika, is one of three figural scenes preserved from a large floor which once decorated a room in a Roman house uncovered on Socrates Street, Thessalonika; see Waywell 1979, 303–4, cat. no. 53, pl. 52, fig. 46.

57. The panel, one of nine scenes featuring the loves of the gods, was found in the triclinium of House A from Terrain Jilani Guirat in El Jem; see Foucher 1960a, 37–44, pl. 15e, who dates the mosaic ca. 180–200.

58. Müller 1929, 62–63, fig. 4; and Simon and Bauchhenss 1984, 425, no. 44658.

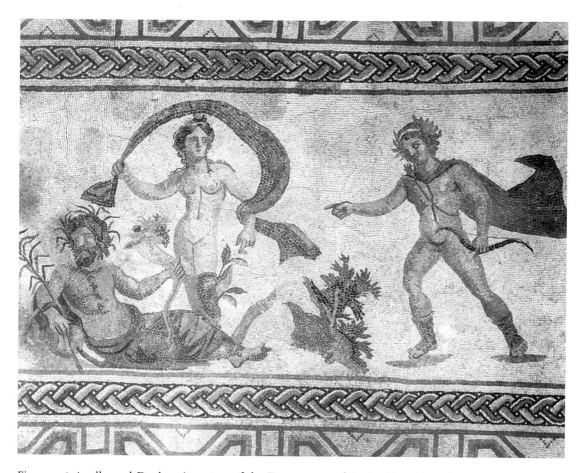

Figure 106. Apollo and Daphne (courtesy of the Department of Antiquities, Cyprus)

century mosaic from Tebessa (Theveste) in North Africa,[59] Daphne appears almost completely converted: her torso changes into a trunk and leaves shoot out of her head, arms, and fingers. These mosaics seem quite literally to illustrate Ovid's verses (1.548–52): "Scarce had she thus prayed when a downdragging numbness seized her limbs, and her soft sides were begirt with thin bark. Her hair was changed to leaves, her arms to branches. Her feet, but now so swift, grew fast in sluggish roots, and her head was now but a tree's top."

It is curious that Peneios, Daphne's father, who plays a critical role in Ovid's account, is left out. After all, it is to the banks of the Peneios River that the unyielding virgin flees for refuge from lustful Apollo, and it is to her father that she pleads for her conversion into a laurel tree. The absence of any fluvial divinity

59. A large crown of leaves is sprouting out of Daphne's head, and several branches issue forth from her hands; the scene forms a picture panel set in the center of a decorative composition of figural medallions filled with animals, Erotes, etc.; see Leschi 1924, pl. 1, passim; and Dunbabin 1978, 272.

in the mosaics and paintings makes it unlikely that Peneios was found in the illustrations of Ovid's tale. The identification of the river god in the Paphian mosaic as Peneios by several scholars[60] therefore presupposes that an eastern Greek craftsman knew the Latin poem—an unlikely hypothesis, as is clear from the Pyramos and Thisbe panel.[61]

The Paphian mosaic also stands apart from the eastern mosaic examples of Greece and Syria. Most surprisingly, in an early third-century mosaic from the House of Menander at Antioch, the legend is illustrated with only two figures: Apollo reaches for the fully dressed maiden, whose lower body has become a tan trunk with long green shoots springing up in front.[62] In a contemporary mosaic from Thessalonika, Daphne is also dressed and fleeing from Apollo's grip.[63] Although the stance and presentation of the Paphian Apollo is similar to those of the Antiochene and Greek examples, the nudity of the Cypriot Daphne aligns her more closely with her western counterparts. And unlike all the surviving mosaic representations, the Paphian craftsmen broke out of the two-person formula by including the river god. The Paphian scene appears to be a pastiche of model book figures adapted to produce a new composition.

A river god, however, does accompany Apollo and Daphne in a version of the legend preserved on a white glass vase found in Kertch and presently in the Corning Museum of Glass (figs. 107 and 108).[64] The figures of Daphne, Apollo, Ladon, and Pothos, identified by Greek letters, are depicted in gilding and enamel colors around the body of the vessel. The figure of Ladon, who appears as a bearded river god holding the horn of plenty in his extended left hand and looking over his right shoulder, recalls the deity in the Paphos mosaic (fig. 109). Although the vase was found in the Crimea, it is said to have been made, along with several other examples of painted glass vessels, at Antioch in the first half of the third century A.D.[65]

The existence of the glass vase with the Greek inscriptions naming the characters offers strong evidence for an alternative representation of the legend, one that follows eastern literary sources rather than Ovid. In a description of the Ladon River in Arcadia, Pausanias states that he will "pass over the story current among the Syrians who live on the river Orontes, and give the account of the Arcadians and Eleans."[66] The Syrian version is preserved by at least three ancient authors

60. In fact, all publications have identified the figure as Peneios; see Nicolaou 1963, 13; Michaelides 1987a, 21, no. 19; Daszewski and Michaelides 1988b, fig. 11; and Daszewski and Michaelides 1988a, 44–45, fig. 34.

61. See Knox 1989, 316n.5.

62. The panel is located in a portico (room no. 16) of the House of Menander, upper level; see Levi 1947, 211–14, pl. 47a, b.

63. See Waywell 1979, 303–4, cat. no. 53, pl. 52, fig. 46.

64. See Müller 1929, 63–64, fig. 5; and Palagia 1986, vol. III.1, 347, no. 39; illus. vol. III.2, 259.

65. The dating around A.D. 200 seems generally to be accepted in the extensive bibliography on these painted glass pieces; see especially Hanfmann 1956, 3–7, and Schüler 1966, 49–50, fig. 4.

66. The Pausanias translation is taken from W. H. S. Jones 1918–35, vol. 3: 436–39; see also the commentary in Frazer 1913, vol. 4: 263, item 20.

Figure 107. Kertch, Daphne ewer, detail of Daphne (courtesy of Corning Museum of Glass, Corning, New York)
Figure 108. Kertch, Daphne ewer, detail of Ladon (courtesy of Corning Museum of Glass, Corning, New York)

from the Greek east. In his *Life of Apollonius of Tyana*, Flavius Philostratus recounts the visit of the sage to the Temple of Apollo at Daphne near Antioch.[67] Herein this Severan Greek author, who based his account on a Syrian source, describes Daphne as the daughter of Ladon, the river that flows near the temple. Predictably, the most elaborate account of the Syrian legend can be found in various passages by Libanius—famed fourth-century orator and citizen of Antioch.[68] In his encomium of Antioch, for example, the legend is given as the background for Seleucus' dedication of the celebrated sanctuary of Apollo.[69] According to this account, Apollo chased the nymph to the banks of the river Ladon (her father) in Daphne, a suburb of Antioch. On reaching the girl in time to witness her metamorphosis into a laurel tree, the god shot his arrows at the

67. Flavius Philostratus, *Vita Apollonii* 1.16 (Conybeare 1912, 42–43).
68. For a discussion of his writings on this legend and the sanctuary of Apollo at Daphne, see Downey 1961, 82n.134; Levi 1947, 205nn.34–35; and Libanius, *Progymnasmata* 17 (Foerster 1921–22, vol. 8: 44–45).
69. Libanius, *Oration XI* 94–99 (Foerster 1921–22, vol. 1: 466–68).

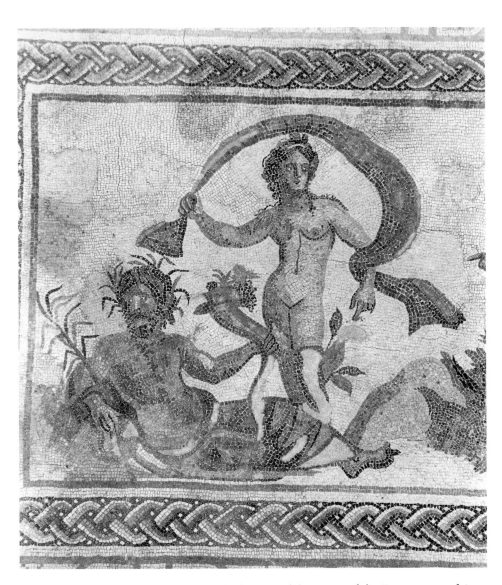

Figure 109. Apollo and Daphne, detail of river god (courtesy of the Department of Antiquities, Cyprus)

ground in frustration. The "discovery" of one of these arrows by Seleucus confirmed the siting of the sanctuary. An abbreviated version appears in the fifth-century *Dionysiaca* of Nonnos, wherein the nymph is alluded to as the "daughter of Ladon that celebrated river."[70] As was shown in the Pyramos and Thisbe discussion, the writings of Nonnos, although later than these mosaics, might reflect an earlier widely known eastern source.

70. Nonnus, *Dionysiaca* 42. 387–90 (Rouse 1940, vol. 3: 254–55).

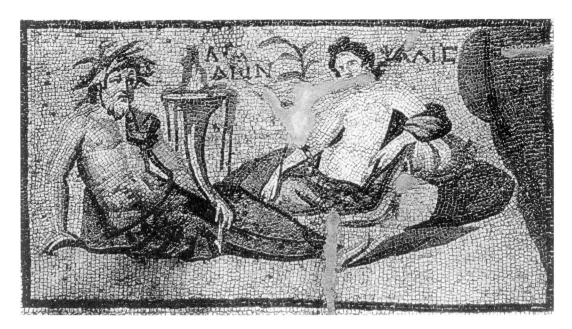

Figure 110. Antioch, House of Menander, detail of river god Ladon (photo by
C. Kondoleon)

The importance of Ladon as a figure in Antiochene geography is confirmed by
his portrayal as a river deity in an early-third-century mosaic from the House of
Menander (fig. 110).[71] Bearded and crowned with reeds, he holds a cornucopia in
his left hand and is reclining opposite a female fluvial deity labeled Psalis. The fact
that the mosaicist labeled him as Ladon and placed him in the same house as the
Apollo and Daphne panel emphasizes the local attachment to the Syrian version
of the myth. The similarities between the Antiochene Ladon and the Paphian river
god, as well as the Ladon figure on the glass vase found in Kertch, strongly suggest
that the fluvial divinity at Paphos might well be Ladon.

Curiously, the Paphian river god looks away from the scene as if to emphasize
his neutral role as an element of the landscape. The function of these river figures
as site indicators, rather than as active participants in the drama, reinforces the
impression that they do not illustrate Ovid's tale; that is, these figures do not
represent the river Peneus with whom Daphne pleaded for her rescue. In the texts
of Philostratus, Libanius, and Nonnos, Daphne is simply called the daughter of
Ladon; she does not address her father. The role of Ladon at Paphos and on the
glass ewer is comparable to the one played by a fluvial divinity in the fourth-
century mosaic of Poseidon and Amymone (fig. 98) at Nabeul (Neapolis, Tu-
nisia).[72] The excavator, J.-P. Darmon, identifies the figure as the personification of

71. The panel is from room 13 of the upper level of the House of Menander, dated in the first half of the
3d century by Levi (1947, 204–5, pl. 44c).

72. Darmon 1980, 95–98, no. 24, pl. 82.

the springs at Lerna produced by Poseidon for Amymone. M. H. Quet, however, has convincingly argued that the figure is more likely to be the river Inachos in the Argolid, where Amymone searched for water.[73] Because the river god is placed in the upper right part of the panel—that is, behind the figures of Amymone and Poseidon, who are also much larger—he seems to represent a place, the river Inachos, rather than the event, that is, the gift of water brought forth by the blows of the god's trident. Similarly, the river god at Paphos appears to be a subsidiary player, a geographic sign.

The Paphian illustration of the Apollo and Daphne legend would seem then to depend on the Syrian version of the tale, which differs from those told elsewhere, as noted by ancient sources. Because none of the other mosaic representations includes a river god, it seems unlikely that Ovid's Peneios would have been included at Paphos. In fact, indirect evidence for the circulation of pictorial models dependent on eastern sources can be found even in the Latin west. In a fourth-century mosaic at Piazza Armerina in Sicily, the metamorphosis of Daphne is juxtaposed with that of the youth Cyparissos.[74] Although these two tales are separated by nine books in Ovid's text,[75] Philostratus, in his description of Apollonius' visit to Antioch, briefly recounts both stories when describing the laurel tree and the cypress tree found at the Temple of Apollo at Daphne.[76] The latter text makes clear the sense of the pairing of the two transformations in the Sicilian mosaic, which would otherwise appear to be a random comparison among many ancient metamorphoses. The existence of the Sicilian mosaic suggests the possibility of representations that followed eastern sources rather than Ovid. The Paphian mosaic strongly underlines this possibility. In any case, the Paphian mosaicists seem to be tied closely to the workshops of Antioch, and they certainly reflect eastern literary sources when they pictorialized this myth, just as with the Pyramos and Thisbe panel.

DIONYSOS, AKME, IKARIOS, AND "THE FIRST WINE-DRINKERS"

The figured panel at the center (4.33 m. × 1.11 m.) of the west portico is nearly twice as long as the other three in the series (fig. 111). The composition is arranged in three parts: Dionysos and Akme are seated at the left of the panel; Ikarios stands in the middle with an oxen-drawn cart at his side (fig. 112); two drunken figures are set in the right (the north corner). Each figure is identified by a Greek inscription, including the two drunks who are called "the First Wine-Drinkers"

73. Quet 1984, 84–85.

74. The mosaic is located in one of the thresholds of the triapsidal *triclinium* in the 4th-century villa at Piazza Armerina; see Carandini et al. 1982, 121–23, fig. 190.

75. Ovid, *Metamorphoses*, 1.452–567 and 10.106–42.

76. Flavius Philostratus, *Vita Apollonii* 1.16.

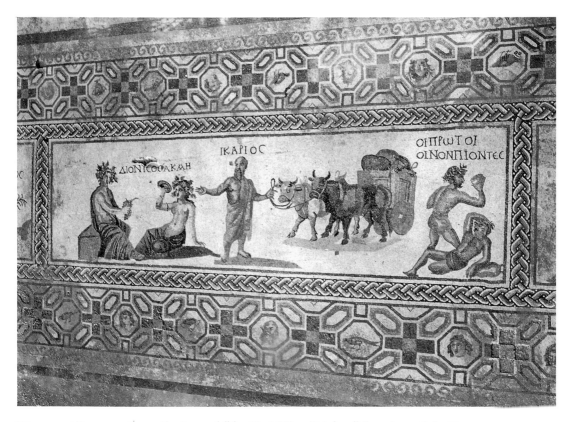

Figure 111. Dionysos, Akme, Ikarios and "the First Wine-Drinkers" (courtesy of the Department of Antiquities, Cyprus)

("ΟΙ ΠΡΩΤΟΙ ΟΙΝΟΝ ΠΙΟΝΤΕC"). The Paphian artist first presents Dionysos' gift of the vine and wine to Ikarios, and then demonstrates the ill-effects of wine on the shepherds to whom Ikarios gave the first drink.

The scene begins with Dionysos ("DIONYCOC"), seated on the edge of a gray bench and holding a cluster of grapes in his two hands. He gazes intently at his companion Akme ("AKMH"), who reclines on the ground before him. Dionysos, crowned with a vine wreath, is nude except for a himation (red, pink) draped around his legs and over his left shoulder. The young woman, also adorned by a vine wreath, is nude but for the drapery (gray, brown, red) wrapped below her waist and around her legs. She lifts a bowl to her lips and leans back on her extended left arm. In the center, Ikarios ("IKARIOC")—bald, bearded, and barefoot—turns toward the seated couple and holds out his right hand with open palm, seemingly to receive their gifts. The Attic herdsman stands in contrapposto and wears a cloak that is draped over his left shoulder and falls below his waist. In his left hand he holds the reins of a two-wheeled cart loaded with wineskins which is pulled from the rear of the picture plane by a pair of oxen (one black and the other natural). At the far right side of the panel, the myth ends with two

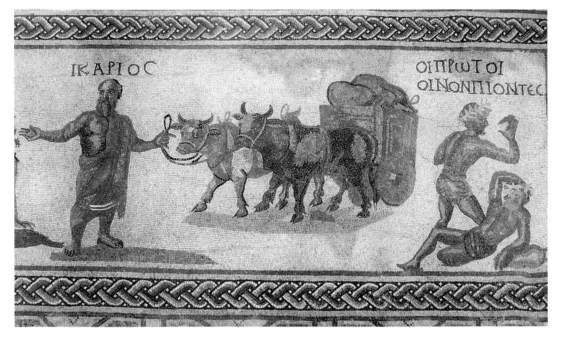

Figure 112. Ikarios and "the First Wine-Drinkers," detail (courtesy of the Department of Antiquities, Cyprus)

figures who are crowned with ivy wreaths and wear only loin cloths. One man is sprawled out in the foreground in a sleeping pose with his left arm resting on a gray wineskin and his other arm held behind his head. His bearded companion stands behind him with his back to the viewer; he leans forward about to drink from the cup held up in his right hand.

The myth, as given by several Roman sources, describes how Ikarios, an Athenian, offered Dionysos generous hospitality and was rewarded with the gift of wine.[77] In his second-century *Bibliotheca* or *The Library* Apollodorus specifies that Ikarios was given a branch of a vine and was taught the process of making wine. In *Fabulae*, another second-century mythological compilation, Hyginus describes the gift as a skin full of wine. Essentially, Dionysos (Liber Pater, Bromios) teaches viticulture to Ikarios, who then offers the new drink to some shepherds. According to Apollodorus, they become inebriated because they drank much wine without water, and imagine they are poisoned. They murder Ikarios; but on coming to their senses the next morning, they bury him. When Erigone,

77. The Roman sources wherein Ikarios and some part of the invention story are mentioned are as follows: Apollodorus, *The Library* 3.14.7; Hyginus, *Fabulae* 130; Pausanias, *The Description of Greece* 1.2.4; Lucian, *Dialogi Meretricii* 7.4; Nonnos, *Dionysiaca* 47.34–55; and Achilles Tatius, *The Adventures of Leucippe and Clitophon* 2.2 (Gaselee trans./Loeb 1917, repr. 1947).

Ikarios' daughter, finds his body with the help of their dog, she swears revenge and hangs herself over his grave, thereby condemning other Athenian virgins to do the same.

The few extant representations of this legend display a variety of approaches to its illustration. The Paphian mosaic is the only one, in fact, which actually follows the narrative—at least, the first part. Our mosaic ends with the drunkenness of the shepherds and omits Erigone, the dog, and the tragedy that ensues. On a Hadrianic relief from the "Phaedrus bema" of the Theater of Dionysos in Athens, figures excerpted from the Ikarios myth represent the Entrance of Dionysos into Attica. In this depiction of the gift of the vine to man, Dionysos is accompanied by a satyr at the left side of a central altar with climbing vines, and Ikarios holds grapes, while his dog, Erigone, and a goat (symbol of tragedy/*tragos*) appear at the other side.[78] The myth is also featured in the midst of a vast vine-carpet mosaic in the *oecus* of the House of the Laberii at Oudna (fig. 113).[79] In the center of this mid-second-century mosaic Dionysos stands near a goat and pours wine out while Ikarios, bearded and in short tunic, offers a cluster of grapes to a seated figure, in Imperial garb and with a scepter, who reaches for them.[80] Neither the relief nor the mosaic attempts to relate a story or illustrate the sources.

This absence of story holds true even into late antiquity: a Gallo-Roman mosaic of late-fourth/early-fifth-century date shows Dionysos, pouring wine from his *kantharos*, and Ikarios, carrying grapes in the folds of his mantle, standing together (fig. 114).[81] This mosaic from Vinon, however, is juxtaposed with two other figural panels that are related by an illuminating epigram from Martial (1.40): *Qui ducis vultus et legis ista libenter omnibus invideas livide nemo tibi*. ("You who scowl, and do not favorably read this, may you envy all men, you livid one, no man envy you!") These other two panels depict the Three Graces and a goat eating the vine beside two shepherds (fig. 115). H. Lavagne has used the inscription to read the three mosaics as a unit, and he has ingeniously interpreted the ensemble as an *apotropaion* against envy (*invidia*). In this context the Three Graces become a *topos* of beneficence and the two wine/vine scenes a moral lesson on the rewards and punishments of Dionysos. The panel with Ikarios and Dionysos begins the series as a kind of hospitable greeting to the guest entering the room. The message is underlined in the next panel by the image of the Charites. These panels are both

78. For a full description and discussion, see Sturgeon 1977, 37–39, fig. 3.

79. The mosaic is from room 32 and is dated to ca. 160–180 (see Dunbabin 1978, Oudna 266m,ii), not to the late 3d/early 4th century, as mistakenly noted by Gondicas 1990, 645.

80. In the first publication of the Oudna mosaics, Gauckler identified the seated royal figure as Ikarios and the man in a short tunic with the grapes as a bearded slave (1896, 209–10). The question of the identity of the royal figure remains unanswered; perhaps it is Amphictyon, king of Athens, who is mentioned several times by Athenaeus in the *Deipnosophistae* (2.38c and 5.179e).

81. The mosaic, probably from a triclinium, was found in Vinon (Var); see Gondicas 1990, 645–46, "Ikarios" no. 3. My discussion is indebted to Lavagne 1994, 238–48.

Figure 113. Oudna, House of the Laberii, Dionysos and Ikarios, detail of vine carpet (courtesy of the National Museum of the Bardo)

set in opposition to the last mosaic, which reflects another epigram of Martial in which a goat eats the vine out of envious sacrilege and is condemned by Dionysos to die (*Epigrams* 3.24). The guest is welcomed just as Ikarios received Dionysos, but warned against beholding the *luxus* displayed in the house (what is understood by *legis ista* in the inscription) with envy.

Although much later in date, and of a far more explicit nature, the Narbonnaise mosaic at Vinon offers a gloss on the Paphian mosaic. In a sense, Ikarios plays the same role as do the Three Graces at Vinon; he serves to unify the two parts of the panel, but also to contrast them. At one end the Paphian Ikarios turns to the divine couple drinking in seemly repose. Because there is no literary source for the inclusion of Akme, she is best understood as a personification. Just as with the Graces at Vinon, she may embody several meanings. In a mosaic from Byblos of the third century a woman labeled "AKMH" is seated on a rock and extends her

Figure 114. Vinon, mosaic panel of Dionysos and Ikarios (courtesy of H. Lavagne)

hand toward another female identified as "XAPIC"; here, paired with the charm of Charis, she might personify the youth and beauty of a woman in her prime years (fig. 116).[82] At Paphos her juxtaposition with the wanton postures of the drunken shepherds suggests a more pointed meaning. In fact, *akme* is defined in an ancient lexicon of rare words as "temperance."[83] Although she is shown

82. The mosaic is dated to the 3d century; see Chéhab 1975, 371–72, pl. 177,2, and K. Nicolaou 1981, 446.
83. This definition is found in Hesychius, a 5th-century Alexandrian lexicographer who based his work on a 1st-century-B.C. lexicon; see Adrados 1980 s.v. *akme*, 117.

Figure 115. Vinon, mosaic panel of a goat and two shepherds (courtesy of H. Lavagne)

actually drinking from a bowl, her composure and *dignitas* seem to be offered as a model that is contrasted with the deleterious effects of wine exhibited by the drunken mortals. The presence of Akme and "the First Wine-Drinkers" makes the Paphian scene unique; the artist went beyond straightforward narrative to create an exegesis of the myth.

The casting of Ikarios as a herdsman can easily be paralleled in the Oudna and

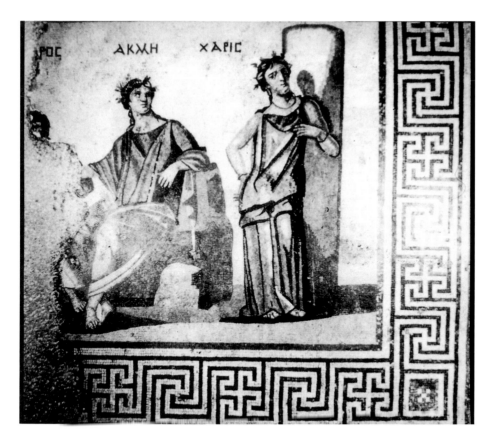

Figure 116. Byblos, mosaic of "AKME" and "XAPIS" (after Chéhab 1975, pl. 177,2)

Vinon mosaics, as well as on the Athenian relief, but the addition of the oxen-drawn cart loaded with wineskins appears to be an ad hoc invention. Although there are parallels for such wagons in the numerous Roman vintage scenes, at Paphos the wagon literally illustrates how Ikarios spread the gift across the Attic countryside. Hyginus even describes Ikarios and Erigone loading a wagon with wineskins (*Fabulae* 130). The *realia* of viticulture clearly fascinated the ancients— they created specific records of wine production and distribution in diverse media. Among the earliest and most naturalistic of these creations were the Labors of the Field and Vintage mosaics from Cherchel, which demonstrate the Severan taste for subjects taken from contemporary life; they include plows drawn by oxen that, although more expertly rendered, resemble the Paphian beasts in their muscular physiques, produced by chiaroscuro effects in both cases.[84] Despite the large number of vintage pavements from Proconsular Africa, most are decorative and fanciful renditions and do not reflect the realism noted in Cher-

84. For a review of these monumental mosaics and their place in the development of realistic genre scenes, see Dunbabin 1978, 114–15, pls. 102–5.

chel.[85] Not until the fourth century when genre scenes, such as vine harvests, dominated the artistic repertoire did grape-laden wagons proliferate.[86] A vivid, if somewhat inept, example is provided by a fourth-century black-and-white vintage mosaic recently found in Mérida. In one part of this three-part ensemble a laborer sits in the wagon drawn by oxen; in the other parts Erotes and men harvest the vines (fig. 117).[87] The combination of the fantastic and the real in this late Spanish vintage mosaic parallels the composition of the vine harvest found in the Paphian triclinium.

The quotidien motifs that accent the vine carpet at Paphos (fig. 144) underline its connection to the Ikarios panel. The degree of realism found in both mosaics is usually associated with developments of the third century or later. This realism is one of the reasons that the Paphian mosaics were initially assigned to the third century and that some scholars remain reluctant to accept the late-second-century date supported by the archaeological evidence.[88] The literal and realistic qualities of the Paphian Ikarios mosaic which make it so distinct from other such scenes in Roman art must be seen in relation to the decoration of the grand banquet hall of the *domus*. What is noted as unique, precocious, even chronologically problematic about both these compositions is a result of their programmatic intent.

The anomalous presentation of the Ikarios panel must be seen as a factor of the architectural context of the mosaic as a whole, as an iconic preface to the major reception hall of the house. In an ingenious formulation, the Paphian artist uses Ikarios to balance the composition in terms of the narrative and the figural arrangement. Ikarios—the ancient paragon of hospitality—turns forward with an open gesture and appears to welcome the guests at the same time that he receives the gift of wine. Nonnos in his *Dionysiaca* (47.53) boasts that Ikarios alone on earth "rivals Ganymede in heaven" as gracious host. It is interesting to note that the handsome cupbearer can be found at the center of what might well be a dining room off the north portico in the Paphian *domus*. There is also a didactic quality to Ikarios' pose; he signals the beneficial associations of wine by pointing to the divine couple. The harmful effects of wanton drinking (i.e., the misuse of the gifts of Dionysos) are disparagingly illustrated at the other end by the drunken

85. Dunbabin lists the major vine pavements in North Africa and notes their lack of realism (ibid., 117–18, esp. n. 28).

86. An exception may be found in the "pastoral mosaic" from Orbe, Switzerland; see von Gonzenbach 1961, 174–76, pls. 49–53, dated to the Severan period. Here an oxen-drawn wagon closely resembles Ikarios' wagon in the Paphos mosaic. Vintage scenes decorate the marble sarcophagi and mosaics and paintings produced for the Christians of Rome, e.g., the 4th-century vault mosaics of Santa Costanza. An exclusively rural depiction of the vintage occurs on a 4th-century mosaic from Cherchel; see Dunbabin 1978, 116, pls. 107–8.

87. The pavement from near the area Travesía de Pedro Ma Plano is a composite of several mosaic panels with various themes (hunting, wrestling, drunken Silenus, Orpheus); see Alvarez Martínez 1990, 37–49, esp. 45, and pls. 8–12, esp. pl. 11.

88. Many early Imperial images can be characterized as realistic—e.g., the silver plate of Flavian date in Madrid which illustrates the collection and transportation of curative waters; see García y Bellido 1949, 467–70, no. 493, pl. 345).

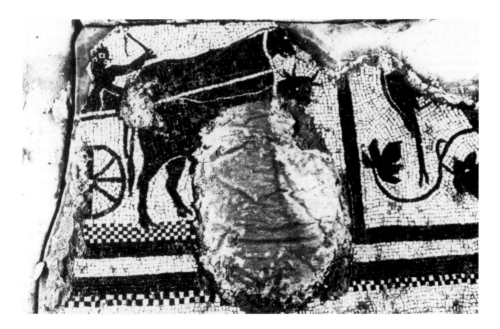

Figure 117. Mérida, vintage scene (after Alvarez Martínez 1990, pl. 11)

shepherds. The inclusion of "AKMH," the personification of temperance in the Greek sense of "nothing in excess," confirms that we are meant to contrast the two ends of the panel. An early Greek precedent for such moral messages are found on red-figure drinking vessels on which images of drunkenness (nausea, vertigo) are placed on the inside of the cup; drinkers are thus reminded of the ill-effects of excess just as they imbibe.[89]

In a broader sense, the wine drinkers also represent an ungrateful, uncivilized response to hospitality; their excesses led them to murder Ikarios. There is a moral lesson in the Paphian Ikarios scene which works on two levels: the blessings bestowed on the followers of Dionysos are celebrated by Ikarios, as well as in the Triumph and vintage scenes of the triclinium; and the scene serves as a cautionary message to the guests—"Do not abuse our hospitality." The fact that the ancients would have understood this moral lesson is emphasized in the Gallo-Roman mosaic at Vinon, in which Martial's verses provide similar juxtapositions.

Further proof that such lessons were part of the intellectual discourse of ancient society can be gleaned from rhetorical treatises citing legendary heroes as paradigms of virtue. In advocating self-restraint when praising a governor, the third-century rhetor Menander instructs rhetoricians to use Hippolytos as an example of temperance (*sophrosyne*).[90] The immunity of Hippolytos to the passions of love

89. For examples and discussion, see Frontisi-Ducroux 1989, 163, fig. 228.
90. Rhetor Menander, *Treatise* IV.10.416 (trans. Russell and Wilson 1981, 166–67). I am grateful to H. Maguire for drawing my attention to this rhetorical text for a description of temperance.

set him up as an ancient *exemplum* of moderation. A parallel for such oral practices is suggested by the placement of the Phaedra and Hippolytos mosaic in room 7 at Paphos (fig. 17). Because it is located on axis with the west portico and its figures face out toward the west, it might be read as a pendant to the other four myths (fig. 4). As an amorous episode with a simple composition, it can be easily associated with the three other mythological panels. Furthermore, the fact that Hippolytos spurns the inappropriate advances of his stepmother offers a coda to the cautionary tone of the Ikarios mosaic, temperance in passion as with drink.

"The First Wine-Drinkers" mosaic stands out among the west portico myths for its length, for the amount of pictorial detail (figures, props, and inscriptions), and for its central and axial placement. This emphasis is obviously intentional and effective in arresting the visitor's progress across the portico, and in punctuating the axial relationship between this mosaic panel and the triclinium (fig. 118). In fact, the selection of the myth and its unusual depiction in three parts was undoubtedly determined by its location. The Invention of Wine makes a perfect introduction to the massive grape harvest spread across the floor of the grand triclinium, for spatially and iconographically, this long mosaic serves as a kind of vestibule for the triclinium.[91] The visitor is invited to unite this scene, both visually and kinaesthetically, with the Triumph of Dionysos and the vintage in the triclinium (figs. 3 and 4) and thereby to single it out from the other three myths. Indeed, the likeness of the other three panels in terms of size, theme, and composition —episodes of divine love—highlights their dissimilarity to the Ikarios panel.

The recipe of sources, both visual and literary, which were required for the interpretation of the west portico panels seems to indicate a fairly complicated process of production. In part, we may see complications because many of the probable eastern sources are lost and must be alluded to through intermediaries, such as mythical compilations or the repertory of ancient art. Yet each scene reveals unusual qualities that cannot be easily attributed or dismissed as banal errors; these certainly seem to be purposeful compositions that reflect the cultural concerns of the *domus* and its audience: a local mentality can be read in the selection, interpretation, and combination of these themes.

The peculiarities of the west portico panels underline an adaptive and innovative approach to their construction. Although the case is weakened by the absence of specific sources, it is possible to suggest that these mosaics represent new pictorial interpretations drawing on local traditions and geographic lore. The inventive spirit of the Cypriot mosaicists is confirmed by the discovery of a mosaic from the neighboring House of Aion, wherein six mythical scenes are

91. Geyer also describes the Ikarios panel as a threshold mosaic for the Paphian *oecus* (triclinium) (1977, 128).

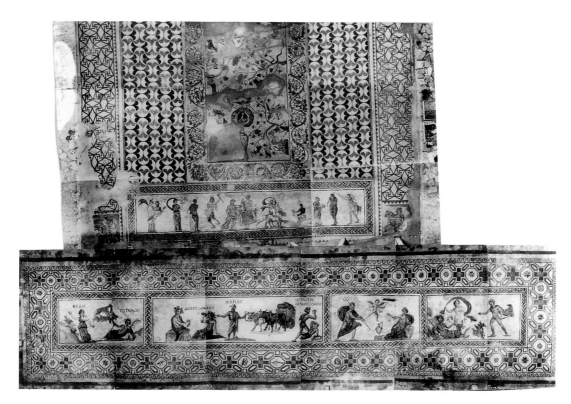

Figure 118. Overhead view of west portico and part of the triclinium (courtesy of the Department of Antiquities, Cyprus)

recast and reflect the cultural and theological shifts of the mid-fourth century.[92] The manic use of personifications, often obscure, and identifying inscriptions on this mosaic imply that these are self-conscious formulations and not prosaic copies. Just as in "the First Wine-Drinkers," the inscriptions in the House of Aion offer an exegesis of their contents, but in a denser and more antiquarian manner.[93]

Paphian mosaics generally, especially those from the fourth century, conform to the traits exhibited by mosaics in other eastern cities (Apamea, Antioch, Palmyra, etc.) in their compulsive labeling and inclusion of allegorical figures. Furthermore, the creation of mosaics according to local legends is attested by two third-century mosaics from Apamea and Palmyra which represent the myth of Cassiopeia. J. Balty convincingly traced these compositions to an eastern variant of the myth with Phoenician and Syrian roots.[94] W. Daszewski, in his interpreta-

92. For a description and illustration, see Daszewski 1985, passim. For an excellent review of Daszewski's publication and an alternative analysis, see Deckers 1985, passim, esp. 155–56, 161, on the use of modified figure types and fresh combinations.
93. For what Deckers called "pseudo-learned," see Deckers 1985, 166.
94. See J.-Ch. Balty 1981, esp. 99; it is interesting that Balty identifies the Amymone in the Apamea

tion of the Cassiopeia panel from the House of Aion, contrasts the Syrian and Paphian interpretations and observes that the scene of the mythic beauty contest follows the Syrian version in presenting Cassiopeia as triumphant but recasts the judge as Aion, rather than as Poseidon.[95] Another commentator notes that the "framing of the new version—what may be called the Near Eastern version—of the Cassiopeia story within the panels of Dionysos" at the House of Aion at Paphos attests to a local and religious transformation.[96]

This parallel evidence from Syria supports the observations made about the Paphian west portico scenes; they too offer variations that seem to reflect local traditions. It is not too far-fetched to state that the west portico mosaics, featured as they are on the main reception axis of the house, were executed with a deliberate regard to their content. Most obvious are the physical and thematic ties between the three shorter panels that feature amorous episodes composed with three figures in minimal landscapes. They follow a popular compositional type exemplified in the nine panels with divine couples from the triclinium of a late-second-century house in El Jem.[97] Although these romances were known to the ancient beholder through literature and performance, there is no single source that accounts for their union on this North African pavement. It is useful to consider that the settings for Roman love poetry were often *convivia*, the dining and drinking parties at which passions were the natural partners to Dionysiac pleasures.[98] The thematic coincidence between poetry and painting has been well documented for the early Imperial period;[99] a similar relationship might be sought a century later for the representation of myth on floor mosaics. The connections between symposiac literature and domestic art will be taken up below.

The placement of love scenes in reception areas, however, was not as typical as their location in private chambers. An explicit example of this fashion was discovered in a late Roman villa in Carranque (Toledo), where four myths of passion are arranged around a bust of Aphrodite in a room identified by inscription as a *cubiculum*.[100] Earlier I cited two of the Spanish scenes—Amymone (fig. 99) and

mosaic as Amymone Beroe, a proposal that fits with the point made above concerning the choice of the Amymone and Poseidon myth for the Paphian west portico; see ibid., 105.

95. Daszewski 1986, 454–72, esp. 466.

96. Here I quote and paraphrase Bowersock 1990, 50–51.

97. The mosaic was found in House A of Terrain Jilani Guirat and dated ca. 180–200; see Dunbabin 1978, 259 (El Djem 18). For illustration, see Foucher 1960a, 39–41, pl. 15e. In the five surviving scenes, the couples depicted have been tentatively identified as Apollo and Daphne, Alpheios and Arethusa, Apollo and Cyrene, Eos and Cephalus, satyr and bacchante. Four other panels with loves of the gods were discovered in room 17 of the same house.

98. See Fisher 1988, esp. 1214.

99. For two recent publications on the links between literature (esp. poetry) and painting in the Republican and early Imperial periods, see Croisille 1982 and Leach 1988; and for two critical reviews of these studies see Wallace-Hadrill 1983, 180–83, and Bergmann 1991, 179–81, respectively.

100. Arce 1986.

Pyramos and Thisbe (fig. 93)—as comparisons for the Paphian panels. The other two—the Rape of Hylas and Diana's Bath—involve bathing and naturally include several nude figures that accent the erotic qualities of such episodes. The context of the *cubiculum* at Carranque determines a different reading for its Amymone and Pyramos scenes than for those at Paphos.

The Roman viewer saw the Paphian panels assembled as a group within a specific architectural context and integrated into an overall program. Because there are no exact literary sources for this particular collection of scenes, we are left to speculate about the possibilities for their selection and combination. Sufficient internal evidence exists for a plausible reconstruction of the ancient response to this ensemble.

The connections between the west portico myths seem to be conceptual ones outside a narrative or cyclical framework. When the mosaics are thus examined, several themes emerge which might account for their union. At first, and I believe inappropriately, metamporphoses seem to be a unifying theme, inasmuch as three of these myths center on transformations: the staining of the mulberries in the tale of Pyramos and Thisbe, Daphne's turning into a laurel tree, and, less overtly in the Ikarios scene, the changing of grapes into wine. Yet I argue above that the depiction of Pyramos as a river god signals that the mosaic represents an eastern version of the legend which had no metamorphosis. In only one account does the gift of wine involve a transformation, and that is in the second-century text of Achilles Tatius, wherein Dionysos visits a herdsman and changes the water to wine.[101] Otherwise, the concept of metamorphosis does not pertain to the Ikarios scene. Although this long central panel certainly can be read separately in conjunction with the Dionysiac themes of the triclinium, its scale and location adumbrate the adjacent myths. In other words, the Ikarios composition provides an intellectual context for the other three scenes.

At the core of the Ikarios story are the gift of wine and the invention of wine making, which were often cited by Greek and Hellenistic authors in their studies of civilization.[102] They presented viticulture as one of the key technologies in the cultural development of man, and they used the role of Ikarios in this discovery as evidence of the Attic origins of human progress.[103] The idea of "the First Wine-Drinkers" conforms to a Greek notion that everything in the natural world was discovered by a first person for the first time.[104] Accordingly, a history of inventors (*heuremata*) became a popular way to explain the causes of natural phenomena. Encyclopedic works that included a series of etymological legends connected

101. See Achilles Tatius, *The Adventures of Leucippe and Clitophon* 2.2.

102. E.g., the tale told by Diodorus Siculus about the discovery of the vine in *Bibliotheke* bk. I.15.7–16.2 (Oldfather/Loeb 1933–). An excellent and lengthy review of the Greek and Hellenistic writers (esp. Philochorus' *Atthis* and fragments of Phanodemus) who mentioned wine in their writings on the origins of culture can be found in Miller 1983, 120–43.

103. Miller alludes to the competitive claims of the Athenians to the earliest and greatest benefactions of mankind, especially with regard to Ptolemaic Egyptians (1983, 87).

104. For an in-depth study of these inventions, see Kleingünter 1933, passim.

to nature (birds, fish, winds), geographic places (cities, islands, rivers), local customs, nomenclature, and rites were popular in the Hellenistic period. The writings of Callimachus of Alexandria, especially the *Aetia*, belong to this tradition.[105] These Hellenistic works reflect an "age of the marvelous" in which intellectual interests interweave myth with scientific curiosity. At Paphos, the inclusion of the phrase "ΟΙ ΠΡΩΤΟΙ ΟΙΝΟΝ ΠΙΟΝΤΕΣ" seems to place this Ikarios composition in the Hellenistic tradition of "first discoveries."

On further examination, the three other panels might also be aetiological in the sense that each myth involves the name of a body of water. In the Pyramos and Thisbe mosaic the representation of Pyramos as a river indicates that the artist knew this was a river in Cilicia and that he was acquainted with an eastern version of the legend. We have seen how the depiction of a river god at the feet of Daphne suggests the presence of her father, the river Ladon. There is no need for allegorical figures in the third panel of the west portico because both Amymone and Poseidon are directly associated with water. The legend itself explains that Poseidon named a spring in the Argolid after his beloved Amymone.[106] The unusual emphasis on river personifications and the fact that each story can be identified with a body of water suggest that the concept of water itself unites these disparate myths.

It is useful to recall here that Nonnos, who throughout the forty-eight books of his *Dionysiaca* displays a detailed knowledge of the local myths and cults of Asia Minor and the Near East, places a particular emphasis on the legendary origins of water sources. The fact that Nonnos identifies Daphne only as the "daughter of Ladon" and describes Pyramos and Thisbe as river dieties, along with Arethusa and Alpheios, offers textual evidence for a developed regional tradition. There is also ample evidence in the early coinage of Asia Minor, and in the Syrian mosaics (especially in Antioch), for the currency of local legends surrounding springs and rivers. The mosaic panels in the west portico at Paphos reveal the same local interest in their presentation of Pyramos as a river god and in the addition of a bearded river god, Ladon, at the side of Daphne.

The Elder Philostratus' descriptions of paintings are closer in date—that is, the first half of the third century—to that of the Paphian mosaics and afford both a literary and pictorial context for the development of geographical themes. Philostratus recounts the Poseidon-Amymone episode along with several other paintings of rivers and their sources from Asia, Africa, Greece, and the west.[107] K. Lehmann, in his reconstruction of the placement of these paintings within a Campanian villa, assigned this group to the "room of the rivers," because other-

105. For a review of his 3d-century writings and their place in Alexandrian scholarship, see Frazer 1972, 454–55.

106. Amymone was one of the widely celebrated water sources of antiquity, as seen in a mosaic from Italica (Spain), where she is identified alongside her companion the river nymph Arethusa; see Simon 1981, 743, no. 3, and illus. I.2, 597.

107. Philostratus, *Imagines* 1.1–13 (Fairbanks 1931, 3–59).

wise unrelated mythological themes are connected through their aqueous settings or subjects.[108] Similarly, the three panels in the Paphian west portico are topographically related. Each scene recalls a specific location near Cyprus—the Pyramos and Ladon rivers of Asia Minor and the Berytos in Phoenicia.

If, in fact, watery associations account for the combination of the three amorous episodes, then their iconography is meaningful both in terms of their location along the main reception axis and in terms of their relationship to the Ikarios and "Wine-Drinkers" scene. In the context of the architectural plan they serve a mimetic function in the sense that they evoke the *nymphaea* typically found in the colonnaded courts facing the triclinia.[109] This relationship is well illustrated by the decoration of a series of spaces in the House of the Arsenal at Sousse, where the T-shaped dining room is paved with a portrayal of Ganymede and medallions of beasts (fig. 87), while a large panel of fishermen in a marine setting is located immediately outside in the corridor of a portico.[110] Although the Paphian myths are more subtlely aqueous, they serve as visual metonyms; they are figural substitutes for fountains and complement the adjacent large pool at the center of the peristyle.[111] Surely, the Roman viewer, who could expect to see ornamental water displays in this part of the house, would have found the watery nature of these stories appropriate to their location within the peristyle and opposite the triclinium.

I suggest another connection between the three myths and the Invention of Wine scene which is even more complex because it involves a more speculative leap into the visual habits of the Romans. The art of wine drinking, as preserved in the texts of symposiac literature, is at the core of my hypothesis. A series of such texts is compiled by Athenaeus in his *Deipnosophistae* or *The Learned Banquet*, one of which contains information relevant to the interpretation of the west portico ensemble. Athenaeus (2.38) quotes the Hellenistic author Philochorus, who relates that Dionysos taught the Athenian king Amphictyon how to drink wine mixed with water so that men might stand upright (i.e., "be civilized" and not stooped over like animals).[112] In gratitude, the Attic king built an altar to the "upright Dionysos" in the shrine of the Seasons, and another nearby to the Nymphs "to remind devotees of the mixing." We then learn that men were to drink only a sip of unmixed wine, in order to recall the power of the "good god," and thereafter to mix water with wine and invoke the name of Zeus *Soter* "as a warning and reminder to drinkers that only when they drank in this fashion would they surely be safe."

108. Lehmann 1941, 36–39, esp. fig. 5.

109. This feature was standard in the houses excavated in Antioch; see Stillwell 1961, 48. It also appears in North African houses; see the Introduction above.

110. Gozlan reproduces E. Sadoux's drawing of 1897, which shows the adjacent room with the Triumph of Dionysos, also in the Bardo Museum (1990a, 1024, fig. 39).

111. In a similar vein, a marine mosaic decorates a pool and effectively evokes the aristocratic appointment of a *piscina* in the House of Orpheus at Volubilis; see Kondoleon 1991, 106–7.

112. A similar story is repeated in Athenaeus, *Deipnosophistae* XV.693. The following translations are taken from Gulick (Loeb 1927–41).

This text can guide our reading of the Paphian mosaics on several levels. First, wine drinking is a benefaction of a divine teacher—Dionysos is presented as such at the left side of the panel. Second, to drink in a civilized manner one needs to mix wine with water. Just as the Altar to the Nymphs reminded the Attic inhabitants to drink mixed wine, so too the three aqueous myths effectively recall water to the minds of the ancient guest.[113] The moral implications of the tale, demonstrated by the symposiac prayer to Zeus, are also applicable to the Paphian mosaic, which presents the deleterious effects of wanton drinking as a lesson.[114] Athenaeus actually follows the Hellenistic text with a discourse of his own on drunkenness (*methē*) and the mystic rites of Dionysos (2.40).[115]

In the same text, Athenaeus goes on to list (2.41–44) the various kinds of water (fresh, salty, spring, well) available to the consumer. In his taster's guide to waters, Athenaeus takes the reader on a tour of sources throughout the ancient world. Might not a similar sequence of ideas be presented in the west portico at Paphos, where various waters (rivers—Ladon and Pyramos; a spring—Amymone; and the sea—Poseidon) are depicted alongside the drunken figures and the gift of wine? While they cannot be said actually to illustrate the text of Athenaeus, the mosaics might well have elicited responses similar to those for the symposiac texts.

The invitational role played by spaces adjoining reception rooms is demonstrated by the mosaic decorating a corridor that leads to the triclinium of the House of Bacchus at Complutum (Spain).[116] There, six servants raise differently shaped wine cups as if to offer libations to the approaching guests. The expressive and realistic qualities of this mosaic are somewhat more expected for the rather late date of the Spanish house—late fourth or early fifth century. The preludial nature of the west portico ensemble for the banquet, although more deeply coded, is nevertheless equally functional.

Seen from this vantage, the mosaics could well have functioned as visual cues for table talk. For instance, in Plutarch's *Table Talk* (3.8–9.657) the guests are directed to mix three parts of water to two parts wine. The mosaics reflect the encyclopedic interests found in symposium literature that, in turn, record the conversational style of ancient banquets. As such, the west portico mosaics form a brilliant and original preface to the grand reception hall, wherein Dionysos is depicted as triumphant over the Indians (the non-Greek, bound, dark-skinned figures in the mosaic), and the numerous activities of viticulture are celebrated in a luxuriant vine-carpet mosaic.

113. Another Hellenistic writer, Phanodemus, notes how water is needed for the vines to grow; see Miller 1983, 122.

114. For a rich discussion of the *heurema* (invention) of wine mixing see Miller 1983, 120–22, and Obbink 1993, 79–86.

115. In a recently discovered mosaic from Sepphoris the theme of drunkenness is treated in at least three of the fifteen panels of the triclinium pavement; see Meyers et al. 1992, 42–53, with illus. In fact, one panel with the drunken Herakles is labeled "ΜΕΘΗ" (Drunkenness).

116. Dunbabin 1991, 128, fig. 19.

The Threshold of the Triclinium
The Triumph of Dionysos

A THREE-PART MOSAIC—a long panel with the Triumph of Dionysos flanked by two shorter panels with the Dioscuri—is set at the entrance to the triclinium. A review of its contents yields insights into the process of assembling a mosaic composition and into the desired effects this combination of themes had on its audience, the inhabitants and their guests. The participants in the Dionysiac procession merit close study because, taken individually, each reveals aspects of workshop production. Taken together, the characters in the Paphian Triumph attest to the use of graphic designs from model books.

Scholars are divided about the exact sources for mosaic images. Many support the notion that stock images circulated from workshop to workshop through the medium of model books; others argue only for the use of cartoons or drawings assembled by the designers for their own use.[1] Mistakes and omissions, often the

1. Recent scholarship has addressed the techniques of mosaic artists with renewed interest. The discovery of an Orpheus mosaic at a neighboring house in Paphos prompted a study of Orpheus mosaics by D. Michaelides, who demonstrates that shared characteristics and certain blunders among the eighty-four examples of Orpheus mosaics prove the existence of copybooks (1986b, esp. 483n.73). Earlier, C. Dauphin had made an interesting inquiry into this question by tracing the frequency of depiction of particular species of animals, birds, and flora which appear within the inhabited scroll motif; she tabulated her finds from a corpus of 116 pavements dated from the 4th through the 7th centuries and concluded that the high percentages of similar depictions could be explained by motifs found in pattern books (1978, 400–

result of careless copying or a misunderstanding of the model, provide evidence for artistic transmission. Although some confusions are inevitably due to the limitations of the craftsmen, certain modifications reflect a dynamic interplay between the designer, his craftsmen, and their models.[2] The Paphian Triumph, in its inclusion of eleven figures, several of them unattested in any other mosaics, offers a valuable test case for the existence of model books.

The second part of this chapter examines the Dioscuri panels with regard to their possible meaning and function. As mosaic subjects they are unusual; they are not typically found as pendants to a Dionysiac Triumph or as motifs for reception rooms. The placement of these panels appears to be an inventive expression on the part of the workshop, which reminds us that certain themes could be endowed with meaning through their physical context.

The Triumph of Dionysos, one of the two Dionysiac mosaics for which the house was named, is prominently placed at the entrance to the major reception room of the house, the triclinium (room I, fig. 119), and on axis with the second eponymous panel, the "Invention of Wine" panel with Dionysos and Ikarios in the west portico (fig. 118). The Triumph is set in a long narrow panel that forms, together with the two flanking panels of the Dioscuroi, the bar of the T-shaped decoration that is standard in Roman dining rooms.

The Triumph of Dionysos derives its iconography from one of the most frequently illustrated themes in ancient art. Most of the eleven figures in the panel have prototypes that occur on a series of Roman Imperial sarcophagi. A far simpler selection of these same Dionysiac types appears on twenty-five floor mosaics as far west as Portugal (Torre de Palma) and as far east as Antioch, but they are, with the exception of a mosaic from Algeria (Setif), creations of a standardized production that seems ultimately to derive from types more fully developed on the sarcophagi.[3] It is in the iconographic repertoire of sarcophagi that parallels for the Paphian figures can most profitably be sought. Although it is impossible to establish a stemma of descent for each member of the triumphal group, the reliefs illustrate a large body of visual formulas that outline the development, interpolation, and

23, esp. 407–8). In his analysis of the scenes in the Great Palace mosaic at Constantinople, J. Trilling offers model books as the source for the collection of classically based imagery (1989, 37). Concerning the related art of miniature decoration, T. Stevenson concludes that "compendiums of traditional motifs must long have been indispensable" and posits the widespread existence of copybooks as a "logical way of explaining the perpetuation of a limited store of motifs" (1983, 109). On the other hand, P. Bruneau rejects the notion of such collections of stock images; he hypothesizes cartoons created by each atelier (1984, esp. 269–72). The use of model books is also denied by Balmelle and Darmon, who argue for a more animated concept of transmission, namely that of master to apprentice (1986, esp. 247).

2. The epigraphic and literary evidence concerning the organization of the mosaic workshop, especially about the designer, called the *pictor*, and the craftsmen, called the *tessellarii*, is reviewed by Balmelle and Darmon 1986, passim; for other views, see the discussion following their article, 248–49.

3. Matz II, 222, lists thirteen Triumph mosaics with their respective references. Eleven other examples are cited in the following studies: Dunbabin 1975; Dunbabin 1978, 181–82; Foucher 1975, 55–61; Blanco Freijeiro 1952, 273–316; and Almeida 1975, 222, pl. 31,3. A Triumph mosaic from Setif, Algeria, is unpublished. The Paphian mosaic is included in the most extensive list of Dionysiac representations; see Augé 1986, III.1, 527, no. 130, with III.2, 418.

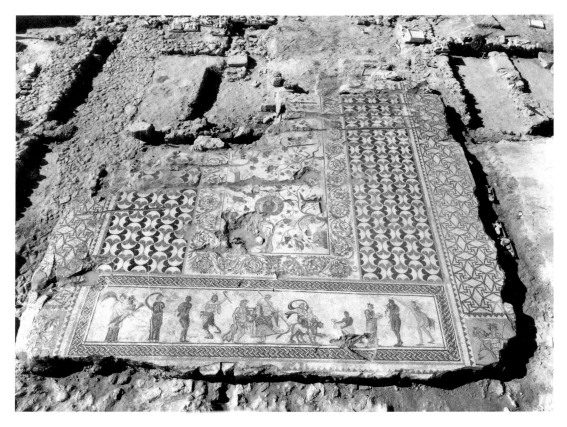

Figure 119. Triumph of Dionysos, triclinium (courtesy of the Department of Antiquities, Cyprus)

misunderstandings that occur in the transmission of figure types. An investigation of these parallels can elucidate the working practices of the mosaicists, as well as of the sculptors, and can suggest criteria for the recognition of levels of competence, patronage, and symbolic intent. We shall look at each member of the Paphian procession separately before considering the entire composition.

In Paphos, Dionysos and his main group are in the center, unlike the more conventional arrangement in which the god comes last or first in the procession. He is seated in a biga drawn by two panthers and led by Silenos, while a satyr laden with a large krater (*kraterphoros*) and wineskin climbs onto the chariot from the rear (fig. 120). The members proceeding from the left toward the chariot include: a maenad bearing the *thyrsos* (*thyrsophoros*) and a cult object; a maenad with libation bowl; a dark-skinned captive; and Pan jumping (color pl. 2). Those approaching from the right toward the center are: a satyr playing a double-horned instrument (*aulistrios*); another bound, dark-skinned captive; a maenad with cymbals (*cymbalistria*); and a third, dark-skinned captive who kneels before the deity. The impression of a procession is somewhat undercut by the fact that the two framing

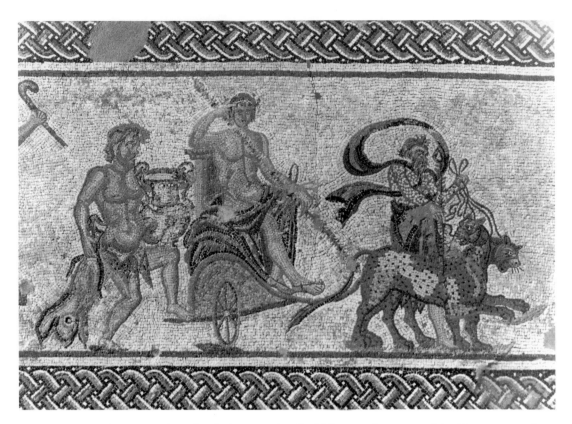

Figure 120. Triumph of Dionysos, detail of Dionysos (courtesy of the Department of Antiquities, Cyprus)

figures and several others at either end turn inward, directing the viewer's attention to the central group. Although the chariot group and several figures move to the right, the whole composition is, in fact, essentially static and centered on the entrance of the triclinium. The placement and the function of the panel as the bar of the T-shaped triclinium affect the formal arrangement of the Triumph so that the members of the *thiasos* face the visitor at the entrance.

F. Matz, in his study of the Dionysiac sarcophagi, divides the representations of the Indian Triumph of Dionysos into three main groups: the largest being the "panther/tiger-Triumph" series, in which either panthers or tigers are the yoke animals for the god's chariot; the "centaur-Triumph" series, in which centaurs—often playing instruments—are drawing the chariot; and the "elephant-Triumph" series in which features of both panther- and centaur-Triumphs are conflated.[4] In

4. For the complete catalogue and treatment of the Triumph sarcophagi, see Matz I, II, III, and IV. Most of the examples listed herein are drawn from the four major versions of the Triumph distinguished by Matz in II: the tiger chariot with the standing Dionysos (212–44, nos. 94–104B, and Matz I, 165–66, nos. 58–58A); the centaur chariot with standing Dionysos (245–66, nos. 105–29, and Matz I, no. 59, 16); the

all three categories Dionysos may appear standing, sitting, or reclining, and in the centaur series he may also appear with his consort Ariadne. The Paphos Triumph seems closest to the panther series by virtue of its central chariot group, but in actual fact it is a pastiche. The eleven members of the procession are drawn from all three groups.

The first figure on the left is the chief maenad, carrying the *thyrsos* (*thyrsophoros*) in her left hand while holding up a problematic object in her right hand (color pl. 2). She turns her head to the left, as if looking at a preceding figure, and is dressed in a green chiton and long-sleeved peplos, part of which flies off her shoulders, indicating her motion forward. Her hair is coiffed in the style described as "pyramidal turban with a flat top" and decorated with a wreath of ivy and vine leaves.[5] This hairstyle was fashionable during the second half of the second century and is decidedly unlike the long flowing locks of her counterparts on sarcophagi and on mosaics. She basically conforms, however, to the standard lead character found on the Triumph group of sarcophagi that are closest in composition and theme to the Paphian mosaic.[6] The sculpted maenads leading the procession on sarcophagi are characterized by their elaborate draperies; most tilt or turn their heads to the left, and all carry the *thyrsos* but, significantly, slanted backward.[7] They are immediately followed by Dionysos standing on his chariot with a *thyrsos* in his right hand, in some cases pointed forward, a stance suggesting that the respective positions of the staffs could easily have been confused.[8]

On sarcophagi the lead maenad carries only the *thyrsos*, but on our mosaic she also holds an enigmatic object, a flat-topped cone (of reddish-brown color) with a fillet (of blue glass tesserae) tied around it and set in or on a wider gray base. It might be identified as a *liknon*, the winnowing basket that traditionally held the phallus that was covered by a veil and revealed at a significant point in the ritual.[9]

elephant chariot with standing Dionysos (267–78, nos. 130–41); and the reclining or seated Dionysos in centaur- and tiger-chariot types (279–300, nos. 142–60). See also Turcan 1966, 238–49 and 441–72; and Lehmann and Olsen 1942, 12–13, 26–33, for an iconographic interpretation, and 70–72; McCann 1978, 86–93; and Levi 1947, 93–99.

5. Levi 1947, 529, discusses this hairstyle in relation to dating the marine *thiasos* from Lambaesis (signed by Aspasios), which in turn is used to date the marine *thiasos* from the House of the Triumph of Dionysos. Levi (1947, 529n.57) associates the turban coiffure with the portraits of Domitia Lucilla, mother of Marcus Aurelius, that is ca. A.D. 160.

6. The majority of examples of lead maenads with *thyrsoi* come from the tiger/panther series: See Matz II: no. 95, pl. 116 (Baltimore: Walters Art Gallery); no. 96, pl. 122 (Rome, Casino Rospigliosi); no. 97, pl. 122,2 (Rome: Museo Capitolino); no. 98, pl. 121 (Rome, Palazzo Giustiniani); no. 99, pl. 124 (Cliveden); no. 100, pl. 126 (Woburn Abbey); no. 101, pl. 127 (Lyons). Others come from the centaur series (no. 105, pl. 134, here fig. 129 [Vatican, Belvedere]) and from the elephant series (no. 141, pl. 158 [Rome, Villa Doria Pamphili]).

7. Matz I, type 45, p. 37, and type 47, p. 38. The type numbers are the designations given by Matz to correspond to the different interpretations of the Dionysiac figures. Type 45 is called the *tropaiophoros* and type 47, the *liknophoros*.

8. See for example, Matz II, no. 95, pl. 116, and no. 99, pl. 124.

9. For the best illustration of this ritual involving the *liknon*, see the 2d-century mosaic from House of Bacchus, Djemila (now in Djemila Museum, Algeria); Dunbabin 1978, 75, 179–80, 256, pl. 179.

In a sixteenth-century watercolor (by Francesco d'Ollanda in the *Codex Escorialen-sis*) of a painting found in the Domus Aurea, a conical form, undoubtedly a phallus, is sheathed in a white cloth, encircled with a fillet, and set into a *liknon* that is carried by two maenads.[10] The scene seems to be one of an initiation ceremony in which the *liknon* and the *cista* (sacred box or basket) are clearly differentiated.[11] Although some scholars have identified the object held by our Paphian maenad as a *cista*, it is most unlikely, for they are typically set on the ground, rarely held, in Dionysiac scenes; the *cista* usually contains a snake.[12] The customary method of carrying the *liknon* is on the top of the head, as attested by many examples found on sarcophagi and mosaics.[13] In an outstanding mosaic from Setif (Algeria) (fig. 121), closely related in composition to the Triumph sarcophagus at the Walters Art Gallery (fig. 122), a maenad holds both a *thyrsos* and a *liknon* filled with several objects on top of her head.[14] One of these, colored in gray seemingly to indicate that it is made of metal (silver?), is a truncated cone set on a wide base with a splayed rim. This object may well represent a stylized phallus in metal or stone. Although there is no exact parallel for the Paphos object, it can be surmised that the craftsman produced an inept version of a cult phallus, thereby combining the function of the *thyrsophoros* with a *phallophoros*, each originally distinct in the hierarchical order of the *mystai*.[15] The appearance of the *liknon* with phallus in mosaics and on sarcophagi is sufficiently rare to suggest that this object retained its symbolic significance.[16] In the case of the mosaic in Paphos, however, the object is no longer fully understood.

There are other examples in which a maenad holds both the *thyrsos* and *liknon*; these occur on sarcophagi and on mosaics, but they are not strictly associated with the Triumph.[17] In the mid-second-century House of the Dionsyiac Procession in

10. Tormo 1940, *Codex Escorialensis*, 28.1.20, folio 14r, p. 76. See also Pace 1979, 141–42, no. 49, folio LIX of Bartoli's drawings in "Pictas veterum tabulas in cryptis Romae repertas."

11. For an explicit illustration of this hierophantic scene in which the phallus is being unveiled, see the 2d-century mosaic from the House of Bacchus at Djemila; Burkert 1987, 95; and Dunbabin 1978, 75, 179–89, 256, pl. 179.

12. Both Daszewski and Michaelides call the Paphian object a *cista*; see Michaelides 1987, 16, no. 10; and Daszewski and Michaelides 1988b, 20. On the differences between the *liknon* and *cista mystica*, see Burkert 1987, 23 and passim. The following sarcophagi reliefs include *cistae* set on the ground: Matz II, no. 85, pl. 105; no. 92, pl. 121; no. 95, pl. 116; no. 105, pl. 134; no. 108, pl. 134.2. For mosaic examples, see the Triumph panel from the House of the Triumph of Dionysos (Levi 1947, pl. 16c); the vintage carpet from the House of Silenus at El Jem (Foucher 1960a, pl. 12c); and the Dionysiac procession panel from triclinium S in the House of Neptune at Acholla (Gozlan 1974, 127–29, figs. 61 and 62).

13. For maenads carrying the *liknon* on their heads, see the twenty examples listed by Matz I, 38, type 47, *liknophoros A*, and 39, type 49, *liknophoros C*. For mosaic examples, see Almeida 1975, pl. 31,3.

14. The Triumph mosaic from Setif is unpublished and is reproduced here with the permission of the Algerian Department of Antiquities. For the Walters Art Gallery sarcophagus, see Matz II, no. 95, pl. 116.

15. Vogliano et al. 1933, 215–70; and Henrichs 1982, 151.

16. Dunbabin 1978, 176, and Nilsson 1957, 21.

17. For example, maenads who hold both *liknon* and *thyrsos* are associated with Dionysos and Ariadne on sarcophagi known as the *hierogamos* series (Matz II, no. 80, pl. 96, and no. 83, pl. 107). They are associated also with the Sleeping Ariadne (Matz III, no. 176, pl. 196); with *thiasoi* (Matz III, no. 173, pl. 191 and no. 209, pl. 220); and with the Childhood and Birth Cycle (Matz, III, no. 199, pl. 211). For mosaics, see

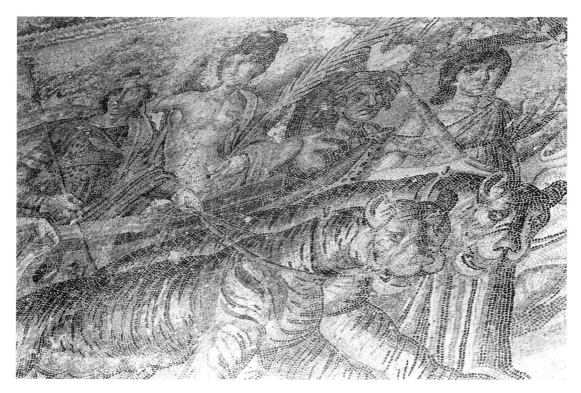

Figure 121. Setif, Triumph of Dionysos, detail of maenad and Dionysos (photo by C. Kondoleon)

El Jem the eponymous panel is located, as at Paphos, at the entrance of the triclinium (fig. 123).[18] A *thyrsophoros* follows the procession from the right, bearing the *liknon* on her head and looking back over her shoulder. Here the focus of the procession is the Dionysos *Pais* (child) riding a lion. The presence of the *liknon* with covered phallus, and of two altars in the same frieze, suggests an illustration of a ritual preliminary to an initiation ceremony.[19]

An alternative interpretation for the strange object held by the Paphian lead maenad is provided by one of the altars in the El Jem mosaic. It is in the shape of a conical obelisk, and although taller and free-standing, it is decorated with a fillet

Foucher 1961, 54, pl. 41c, House of Terrain Hadj Ferjani Kacem (ca. A.D. 200–220), room 2. In one of the curvilinear quadrilobes, a maenad in a long sleeveless chiton holds a *thyrsos* in her right hand and a long flat *liknon* filled with fruit in her left. See also Gozlan 1974, 128–29, fig. 61 (the Acholla procession is illustrated here as figs. 139 and 140), in which a naked maenad holds up a long flat object (a misshapened *liknon?*) with fillet tied around it in her right hand, and a *thyrsos* slanted backward in her left.

18. Foucher 1963, 117, fig. 16a, and pl. 19.

19. Some of the figures, such as the drunken Silenos on the camel, must have migrated from a Triumph group. For a parallel instance of migrations and interpolations on Triumph sarcophagi, see the sarcophagus in the Casino Rospigliosi, Rome (Matz II, no. 96, pl. 122), where a satyr rides a camel and Silenos rides a lion. On the ritual aspects of the El Jem mosaic, see Dunbabin, 1978, 176nn.18 and 19.

Figure 122. Sarcophagus with Triumph of Dionysos (courtesy of the Walters Art Gallery)

and set on a low quadrangular base like the one held by the Paphian maenad.[20] An interesting companion to this hitherto unparalleled altar occurs in the Triumph panel of the triclinium mosaic of the House of Aion at Nea Paphos, situated a few hundred meters from our House of Dionysos (fig. 124).[21] In this remarkably bold mosaic, dated to the second quarter of the fourth century, Dionysos is drawn by a pair of centaurs. The retinue is headed at the right side of the panel by a maenad who holds a pointed conical object colored orange-brown with blue bands (fillets?).[22] The presence of two conical objects held by maenads who lead Triumph processions in houses at such close proximity might well be more than coincidental.[23] If we accept the El Jem conical altar as related, then these three representations attest to an object sacred in the Dionysiac *teletai* (mysteries).

Complementing the ritual nature of her partner, the next bacchante in the House of Dionysos panel holds up a libation bowl in her right hand, while raising her left hand over her head to reach it (color pl. 2). She wears a short-sleeved red

20. When a similarly shaped object is found in a scene with Apollo or Artemis it is called a *baetylos* and associated with a phallus; see DarSag, s.v.*baetylia*, I.642–47. Such an object is carried in a chariot drawn by a pair of griffins in an Augustan painting from the Domus Musae in Assisi; see Guarducci 1979, 278, no. 6, pl. IV.

21. For a description and illustration, see Daszewski 1985, 24–27, color pls. 3–4, but there the author does not identify the conical object.

22. Both Daszewski and Michaelides identify the object as a quiver but do not account for any parallels in Dionysiac iconography; see Daszewski and Michaelides 1988b, 66, and Michaelides 1987a, 31.

23. It is interesting to note that both objects were done in warm shades of a brown, perhaps to resemble wood; in the House of Dionysos the piece is a reddish-brown.

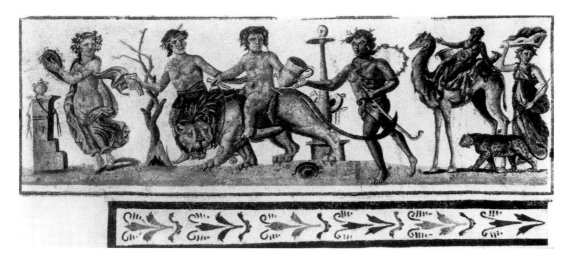

Figure 123. El Jem, House of the Dionysiac Procession, detail of procession in triclinium (courtesy of the National Museum of the Bardo)

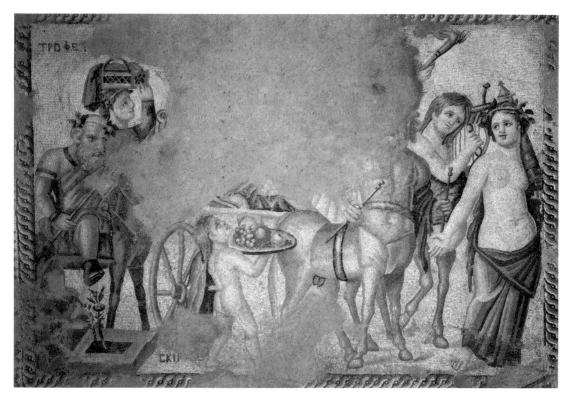

Figure 124. Paphos, House of Aion, detail Triumph of Dionysos panel (photo by C. Kondoleon)

chiton wrapped in a greenish-gray peplos from her waist down to her calves. In the customary technique of showing motion, part of her peplos swings out, forming an arc behind her. Her short-cropped hairstyle is curious and may reflect a failed attempt to reproduce the tight cap often worn by the priestess carrying the lamp (*thymiaterion*), who, as attested on sarcophagi, also held the lamp in the palm of her right hand (fig. 122).[24] The shape of these lamps could possibly be mistaken for a shallow bowl.

A suggestive comparison for such a libation occurs in the Triumph panel from the House of the Triumph of Dionysos in Antioch, dated to the late Antonine period or the third quarter of the second century (fig. 125).[25] Although less than half of the Antiochene Triumph survives, it is critical for our understanding of the Paphian panel. Of the five fragmentary figures in the Antioch Triumph, one reaches into a *kantharos* held up high with the same gesture as that of the Paphos maenad. Because only the hands and *kantharos* survive it is difficult to draw more from this comparison except that the image provides a parallel in the context of a Dionysiac Triumph.

In Paphos, the gaze of the libation bearer is fixed to the right on a gray-skinned nude male who stands with legs crossed and hands bound with ropes behind him (fig. 126). He is best understood when considered with the other two dark-skinned males found in the procession. One stands with crossed legs at the far right end of the panel, and his right hand is bound with a long gray rope (fig. 127). He raises this hand to his forehead in a gesture of submission or distress, while his left hand seems to be folded inside the yellow-spotted skin thrown over his shoulders.

These two bound males can certainly be identified as the Indian captives who accompany Dionysos in his triumphal return. There are several parallels from the Triumph sarcophagi for these two captives, although they usually appear as a group. An early series of Triumph sarcophagi from the Antonine period are distinguished by the absence of a crowded *thiasos* and the inclusion of detailed representations of the bound captives.[26] In this group, drawn from versions of the Triumph with elephant and centaur chariots, the captives are nude males, some with hands fastened behind their backs as at Paphos (fig. 128).

The formula for representing the captives as a standing group differs from the one in which the captives are seated on the elephants and camels laden with the booty, as commonly occurs in the Triumph group with tiger/panther chariot found on the Walters Art Gallery sarcophagus (fig. 122).[27] Studies have consistently

24. Matz II, 232n.75, no. 95, pls. 116 and 240; no. 100, pl. 130,1; Matz III, no. 211, pl. 222,1 (Ariadne series).

25. Augé 1986, III.1, 527, no. 129, with III.2, 418, and Levi 1947, 93, pl. 16c. Levi's dating to the Antonine period on stylistic grounds is challenged by Stillwell 1961, 55n.27, who believes it is too early and would like "to pull the date well into the third century" on the basis of the size of the *triclinium* (8.70 m.), which is as large as the one at Paphos.

26. The series is discussed by Matz II, 268, and includes 255–56, no. 115, pl. 135,2 (centaur chariot); 270, no. 130, pl. 158,1; 271 (elephant chariots), no. 131(lost), pl. 159.

27. Matz identifies the beasts as tigers, but most scholars agree that they are panthers; see McCann 1978,

Figure 125. Antioch, House of the Triumph of Dionysos, Triumph panel (after Levi 1947, pl. 16c)

pointed to this Baltimore sarcophagus as being closest in its composition to the lost archetype, most likely a painting; however, it now must vie with the Setif mosaic for this privileged position.[28] The example of the captives is instructive in the determination of the relationship between these two exquisite creations and their model. The Baltimore sarcophagus shows only one or two bound and clothed captives seated on exotic animals from the east, while in the Setif mosaic these same two captives ride on camels behind a dark-skinned man and woman of stately dress and demeanor, perhaps the conquered rulers. The Setif mosaic seems to remain more faithful to the original or to preserve an even more elaborate model. One sarcophagus from the "Centaur-Triumph" series seems very close to the Setif mosaic and includes both types of captives (fig. 129), a resemblance supporting the proposition that the sculptors and mosaicists depended on a common model.[29]

The evidence of the captives indicates the circulation of at least two Triumph models, one with the panther/tiger-drawn chariot and captives riding or standing,

89n.10; However, the chariots in the unpublished Setif mosaic and several other mosaics are definitely drawn by tigers. In the Paphos mosaic, the spotted coat identifies the animals as panthers.

28. For the dependence of the Baltimore sarcophagus on a lost painting, see Lehmann and Olsen 1942, 72, and Ward-Perkins 1975–76, 213, who calls it "a very close copy of its source."

29. Matz II, 248–49, no. 105 (Vatican, Belvedere Collection), pl. 134,1.

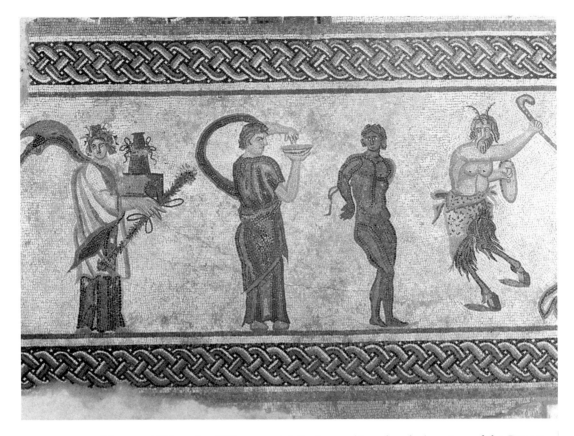

Figure 126. Triumph of Dionysos, detail of gray-skinned male (courtesy of the Department of Antiquities, Cyprus)

and the other with the centaur-drawn chariot and only one group of prisoners standing naked. It could be argued that the depiction of several standing prisoners was an elaboration by the sculptors on the original bound rulers or that the group simply migrated from another source. There are other indications, however, that several versions of the Triumph were known and that at least two basic types were frequently repeated and were eventually interchanged at the will of the artists. The Paphos mosaic is, at best, only distantly related to any of these proposed originals. This distance is underlined by the way the craftsman has excerpted the figures of the captives and randomly placed them throughout the procession.

The third dark-skinned male in the Paphian Triumph kneels before the chariot of Dionysos and proffers a sack(?) with his extended right hand (fig. 119). He is covered from the waist down in a gray cloth and his mouth is open. Although there is no exact parallel for this figure, his pose and reddish-brown skin strongly suggest that he might also be a captive, intended to represent a race different from

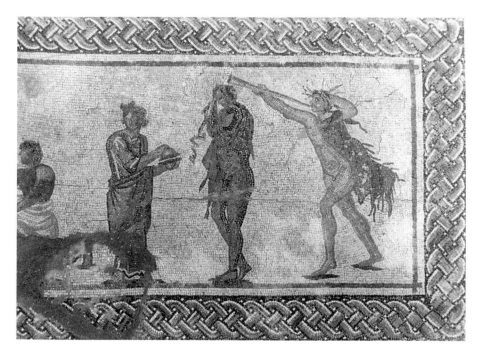

Figure 127. Triumph of Dionysos, detail of right side of panel (courtesy of the Department of Antiquities, Cyprus)

the dark-skinned Indians. The closest comparison for his posture within the repertoire of Dionysiac sarcophagi is provided by a satyr on an early Severan Triumphal sarcophagus in Rome who kneels before a laden elephant while holding a drinking vessel (fig. 130).[30] He disturbs the rhythm of the procession and is undoubtedly a figure borrowed from another Dionysiac scene.[31] Like the Paphos figure, the sculpted satyr wears only a loincloth and kneels on one knee with the other bent for support. Iconographically, the figure of a kneeling captive recalls the act of submission by a vanquished barbarian before his captor which appears frequently in Imperial art.[32] Undoubtedly, the imagery of Roman triumphal art enriched the repertoire of Dionysiac Triumphs, which, in turn, fertilized official art.

One participant who is de rigueur in any Dionysiac scene is an impish Pan. At Paphos he is fourth from the left and visibly more animated than the others (fig.

30. Matz II, 235, no. 96, pl. 122.
31. Matz II, 214.
32. Good examples of this type of figure may be found in the Aurelian relief panels now in the Palazzo dei Conservatori, Rome, where Marcus Aurelius receives two defeated barbarians who kneel before him, and the bound barbarian captives on the Severan arch at Lepcis Magna; see Strong 1980, figs. 135 and 163, respectively.

Figure 128. Florence, Uffizzi, Triumph sarcophagus captives (Alinari no. 1311)

Figure 129. Vatican, Belvedere Collection, Triumph sarcophagus (German Archaeological Institute, Rome, 1937 Foto Faraglia)

Figure 130. Rome, Casino Rospigliosi, Triumph sarcophagus (German Archaeological Institute, Rome, 1937 Foto Faraglia)

119 and color pl. 2). He leaps up on his goat legs, and his distance off the ground is accentuated by the shadows below his hoofs. Swinging his right arm across his chest, he holds up a *lagobolon* (shepherd's staff) and clutches a shield in his left hand. He is horned and bearded and wears the *nebris*, the spotted animal skin of the cult. In the Triumph series with the tiger/panther chariot, Pan is always represented as the leader of the chariot of Dionysos as he walks out in front holding the reins (fig. 122).[33] He often wears a skin loincloth and carries a shepherd's crook. This type of Pan assumes a different role in the Antioch Triumph mosaic (fig. 125).[34] Here he stands with right leg lifted to support the weight of a large metal *kantharos*, closely resembling a satyr *kraterophoros* and similar to that of the fifth member of the Paphos procession. His intoxicated gaze, his leaping goat legs and hoof shadows, his beard and horns, however, all conform to the traditional Pan model. Even though Antioch and Paphos include the tiger/panther chariot group, they do not conform to the model used by the sculptors and other mosaicists depicting this version of the Triumph.

Jumping Pans show up in the centaur-chariot Triumphs, where there is no need for a leader, because the centaurs guide themselves.[35] In these processions, Pan is often dancing in a drunken state, turning and twisting while he leaps. The Pan on the Fitzwilliam Museum sarcophagus (fig. 131) hits a tympanum as he leaps, and this object may be what the designer intended in Paphos, where Pan holds an otherwise incongruent shield. During the process of copying, the craftsman probably mistook a tympanum for a shield. Obviously he misunderstood or was unfamiliar with the attributes of Pan. This suggestion is supported by the occurrence of a similar mistake in the Isthmian black-and-white mosaic of a second-century Roman bath, where a triton is depicted carrying a large shield instead of the tympanum or tambourine typically carried in marine *thiasoi* (fig. 132).[36] The Paphian mosaicist should not be judged too critically on this point because the leaping Pan with tympanum is rare; only three such figures survive in the entire repertoire of Dionysiac sarcophagi.[37]

Set below many jumping Pans on sarcophagi is the *cista mystica* with its lid half

33. Matz I lists examples of Pan as leader of the tiger chariot: type 104, pp. 61–62, and type 105, p. 62. The Pan in Paphos is a combination of the *springende Pan* (type 107, p. 63), Pan with *tympanon* (type 111, p. 64), and Pan with *lagobolon* (type 109, p. 64).

34. In terms of dating, a discussion of the facial type in the Antioch scene is convincingly compared to a Pan from the Genazzano mosaic, located in what is supposed to have been the Imperial villa of Marcus Aurelius (A.D. 161–180); see Levi 1947, 535, pl. 16c; and Blake 1936, 179, pl. 43,3.

35. I cite only those illustrated in Matz (II) and in decipherable condition: no. 106, pl. 144,2; no. 108, pl. 134,2; no. 107, pl. 145,1; no. 123, pl. 149,2; no. 129, pl. 144,1; no. 151, pl. 174,2; no. 152, pl. 168,2; no. 154, pl. 169,2.

36. Packard 1980, 331, pl. 99. It could be argued that the shield occurs in marine *thiasoi* in conjunction with the legend of the armor of Achilles, but this association seems unlikely because the model for the Isthmian mosaic was undoubtedly one of the generic marine scenes popular in the repertoire of Italian monochrome mosaics.

37. Matz I, 64, type 111, and Matz II, no. 92, pl. 121,1; no. 84, pl. 100,2; no. 129, pl. 144,1.

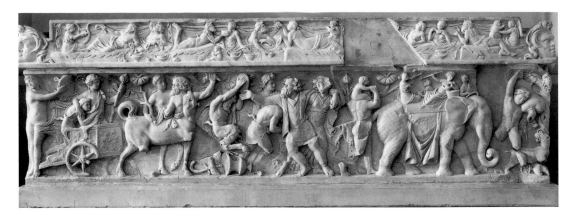

Figure 131. Cambridge, Fitzwilliam Museum, Triumph sarcophagus (courtesy of Fitzwilliam Museum, University of Cambridge)

off exposing the serpent inside (figs. 131 and 133). The consistency of so many examples seems to indicate either a particular ritual action—in fact Pan embodies a Priapic spirit—or an artistic device to draw attention to the cultic importance of the *cista*. In the Antioch mosaic (fig. 125) the *cista* stands between a maenad and Silenos, but the *cista* is not even represented at Paphos. Although the two leaping Pans in these mosaics have parallels in sculpture, either they are not directly modeled on any of these types or they are borrowed out of context. In the case of the Antioch mosaic, the individuality of the figures is clearly due to their being the work of a gifted and original artist, but in Paphos the peculiarities seem more haphazard.

A satyr to the right of Pan carries a large blue krater lifted up on his left leg, which rests on the back of the chariot, and he drags a gray wineskin behind him (fig. 120). He combines the classic role of the *kraterophoros*, known from Neo-Attic reliefs where he appears with his left leg lifted, and the *askophoros* who carries the filled wineskin over his shoulder.[38] Significantly, of the twenty examples of *askophoroi/kraterophoroi* Matz lists, not one is included in a panther-Triumph group, but several are found in the centaur-Triumph series. The position of the satyr behind Dionysos with his foot on the chariot also connects the Paphos group to the centaur series because all these reliefs couple a standing Dionysos with a satyr in the chariot.[39] In these cases the satyr, sometimes holding a krater (fig. 133), supports a drunken Dionysos, who leans back on his companion.[40]

There is a nearly exclusive relationship between the centaur chariot and the drunken Dionysos with satyr, whether the subject is the Triumph or the Discovery

38. For Neo-Attic *kraterophoroi* see Hauser 1889, Hauser 21 in illustrated table of types. For *askophoroi* see Matz I, 46, type 69, and Matz II, no. 79, pl. 97,1.

39. For examples in the centaur series, see above note 4.

40. For a complete list and discussion of the satyr-supported Dionysos, see Matz I, 66, type 116.

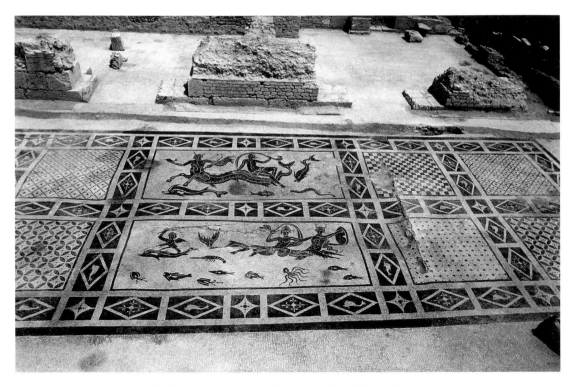

Figure 132. Isthmia, Roman baths, marine mosaic (courtesy of P. Clement)

of Ariadne. The figure of a satyr lifting up a bent leg and holding up a krater occurs on two sarcophagi dated to the sixth decade of the second century and probably from the same workshop (one of these is shown in fig. 133).[41] Both of these also include the jumping Pan, but this is the only other point they have in common with the Paphian procession. These sarcophagi are related by virtue of the satyr-supported Dionysos to centaur-Triumphs that include the band of captives as well as the leaping Pan (fig. 128).[42] In Paphos the panther chariot is joined with the *kraterophoros*, jumping Pan, and the band of captives, all originally part of the centaur-Triumph composition. At some point, before the creation of the Paphian mosaic, a cross-fertilization occurred between the two major types: that is, between the centaur chariot with the satyr-supported Dionysos, and the panther chariot with Dionysos either standing alone or with Victory by his side. Although the Baltimore sarcophagus and the Setif mosaic give a fairly complete view of the panther-Triumph, there is nothing quite so clear in the case of the centaur series. Yet several units recur consistently in the centaur series, and these

41. Matz II, 247–50, no. 106, pl. 144,2, and no. 107, pl. 145,1.
42. For captives in centaur series, see Matz II, 255–56, no. 115, pl. 135,2, and 269–71, no. 130, pl. 158,1, both dated ca. A.D. 150 on stylistic grounds.

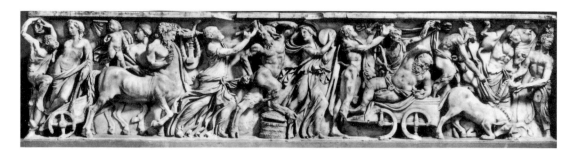

Figure 133. Naples, National Museum, Triumph sarcophagus (Foto Anderson no. 23251)

may be assumed to be part of the original composition. They include the satyr/Dionysos group with centaur-drawn biga; a drunken Heracles or Silenos supported and riding an ass or ass-drawn wagon; lions or panthers with putti riders; *tympanistria* and *aulistria*; a Pan jumping over the *cista*.[43]

The centaur formula appears to be an innovation of the Hadrianic or early Antonine period; evidence is the Fitzwilliam sarcophagus (fig. 131), considered by some to be the oldest representation of the Triumph on a sarcophagus.[44] Matz believes that the "supported Dionysos" group was an invention of the Hadrianic/ Antonine period inasmuch as no Hellenistic models can be found and bronze medallions from the mid-second century first illustrate this type.[45] All the types of Dionysos in the chariot which appear on the sarcophagi occur on the medallions but not necessarily in the same combinations. It is not difficult to imagine how the components of the composition, for example a seated Dionysos in a biga of centaurs or a standing Dionysos with Victory in a biga of panthers, could be interchanged. An Antonine bronze medallion (A.D. 139) provides the earliest evidence of a migration between the satyr-supported-Dionysos formula and the erect Dionysos in the panther-drawn biga.[46] On this medallion a naked Dionysos leans back on his companion standing in a panther-drawn biga led by Pan, a design that combines, as in Paphos, elements of both compositions.

The presence of the satyr stepping onto the back of the chariot in Paphos can be viewed in two ways: either as a simplified frontal version of the twisted contorsions of the springing *kraterophoros* found on some centaur chariots, or as an original ad hoc combination of the Neo-Attic type with the panther-chariot group. The latter suggestion is supported by the appearance of the Neo-Attic satyr type on a mid-second-century sarcophagus fragment of the centaur-Triumph

43. All these elements are included in the first group of centaur-Triumphs dating to the early Antonine period; see Matz I, 167–69, no. 59, pl. 69; and Matz II, 255–56, no. 115, pl. 135,2; 256–57, no. 116, pl. 135,1.
44. Turcan 1966, 140; Matz II, 263–67, no. 129, pl. 144,1, dated to ca. A.D. 145–160 on stylistic grounds.
45. For a discussion of these medallions see Matz I, 68–69, type 116, fig. 1a-f; and Matz II, 245–47.
46. Matz I, 68–69n.263, fig. 1b.

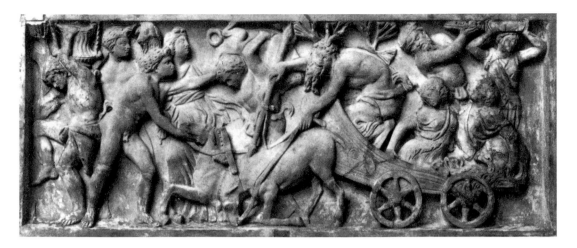

Figure 134. Berlin, Staatliche Museum, fragment of Triumph sarcophagus (after Matz II, pl. 184,1)

now in Berlin (fig. 134).[47] The satyr balances himself on his left leg as he lifts and bends his right leg, while carrying a large krater on his shoulders. While all the other figures form a coherent centripetal group around the collapsing mule-drawn wagon, the *kraterophoros* turns his back on them, unrelated to the action. The same disjunctive placement of the *kraterophoros* can be found in a provincial mosaic of the Triumph from Torre de Palma in Portugal (fig. 135), dated to the fourth century.[48] At the far right of the panel, a satyr carrying a krater (?) stands on one leg with the other lifted and bent, and faces the oncoming procession. Here, as on the sarcophagus, he is obviously taken out of the original sequence, or excerpted from models, perhaps in the form of cartoons, containing isolated figure types. On sarcophagi the *kraterphoros* is consistently associated with the centaur-Triumph series, but he occurs in association with the panther/tiger formula in this and other mosaic versions of the Triumph.[49] It follows that few mosaic Triumphs that are expanded beyond the central chariot group—the Paphos, Antioch, and Portuguese Triumphs—incorporate innovations and conflations. Of the three, the Antioch mosaic is by far the most sophisticated, while the ineptitude and confusions that mar the Portuguese panel cast a more favorable

47. This fragment is considered part of a centaur-Triumph because a 16th-century drawing by Mazzolini includes the centaur chariot of Dionysos; see Matz II, 297–98, no. 157, pl. 184,1 and pl. 184, 3 (the 16th-century drawing). See also an elephant-Triumph in which a *kraterophoros* is placed at the right end of the procession facing away from the approaching group and lifting his left leg; Matz II, no. 139, pl. 160.

48. Almeida 1975; and Blazquez 1980, esp. 125–32, fig. 2; for his dating, see 146–48.

49. For example, see the Triumph mosaic from the House of the Arsenal (Vergil) Sousse; Dunbabin 1978, 182, 269, no. 12d, pl. 182. The satyr, nude except for a panther-hide cape, carries a large krater over his left shoulder.

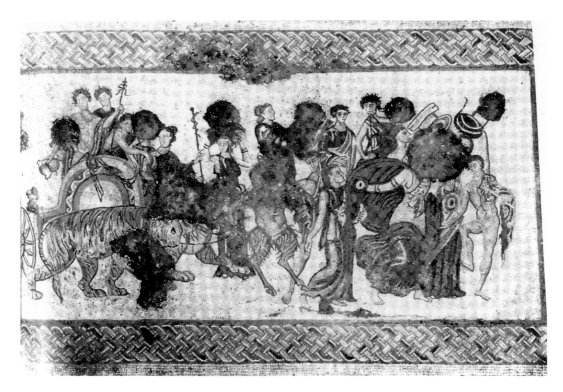

Figure 135. Portugal, Torre de Palma, Triumph mosaic (after Manuel Heleno 1962, pl. 15)

light on the misguided efforts made at Paphos.[50] The presence of the *kraterophoros* stepping up onto the panther chariot of Dionysos at Paphos illustrates once again the ad hoc process of assembling and recombining diverse elements of a well-established theme.

Although Dionysos appears next, I will treat him last in order to complete the discussion of his attendants. At Paphos, Silenos is the chariot leader (fig. 120), another instance of a misreading or ad hoc arrangement of Dionysiac types. The bald and bearded Silenos is placed in the background, walking beside the beasts and holding their reins in his left hand and a *thyrsos* in his right. He wears a gray, spotted, long-sleeved (panther?) skin with a reddish-pink himation and a green mantle that swirls in an arc over his head.[51] There are two problems with his placement: first, the chariot leader should logically be placed ahead of the beasts

50. For some examples of the confusion in this Portuguese mosaic, see the chariot group that includes both a satyr-supported Dionysos and a seated Dionysos in the same chariot, the tigers who walk along unharnessed, and the wheel that is unconnected to the chariot and floats off the left side of the panel.

51. A similarly dressed Silenos with a long-sleeved tunic and a himation knotted around his belly occurs on a Campanian terracotta relief depicting the initiation of the *mysta* and the revelation of the phallus; see Nilsson 1957, 88, fig. 18.

as he is in most Triumphs; and second, the chariot leader is usually a satyr or Pan, but never a Silenos.

In dress and character he conforms to the Silenos in the panther-Triumph series, where he is found at the far right end of the procession, that is, several figures ahead of the chariot group, standing in the foreground beside a lion and holding a *thyrsos* as if it were a walking staff (fig. 122).[52] Although some of the sarcophagi in the panther series introduce minor variations, they are remarkably consistent in the presentation of the Silenos.[53] It is only when the sculptors conflate the panther formula with other versions that Silenos is transposed. A Severan sculptor has fused elements of both the centaur and panther groups with an elephant-drawn biga to produce a refined and complicated composition on the Triumph sarcophapus in the Museum of Fine Arts, Boston.[54] The vigor of this new interpretation is seen in the touching detail of Silenos stroking the lion's mane in the center foreground.[55] Silenos, standing behind the lion, is visible only from the waist up as he is at Paphos, a portrayal which is simply an inversion of his position in the panther series.[56] A similar transformation occurs on the centaur-Triumph from Florence (fig. 128), in which Silenos walks behind the pair of panthers harnessed to the chariot of Semele and guides the group of naked captives.[57] In this sarcophagus the traditions of the centaur and panther series are joined with figures extracted from both and readjusted to the new composition. Silenos is pulled out of sequence and placed beside the chariot group, and he guides the captives with the same gesture he used to hold his walking staff.

In only three other instances does Silenos attend the immediate circle of the chariot group, and in none of these is he the leader as he is at Paphos. Silenos appears in a chariot with Dionysos and Victory on a floor in El Jem, Tunisia, and in a cluster of *thiasos* figures near the panthers on a floor from Portus Magnus,

52. Matz I, 58, type 99, where he cites twenty-three examples of clothed Silenoi with *thyrsoi*/walking staffs. The type is used on early sarcophagi and does not seem to be an invention of the Walters Art Gallery Triumph artist or that of his source.

53. Two of these variations include: a drunken, naked Silenos riding the lion (Matz II, no. 96, pl. 122,1); a clothed Silenos walking beside an elephant because the right side of the procession was abbreviated, thus cutting the lion out (ibid., no. 105, pl. 134,1).

54. The Museum of Fine Arts, Boston, sarcophagus is dated by inscription to ca. A.D. 215–225; Vermeule and Comstock 1976, 152–53, no. 244. Elements of the centaur formula are the Pan leaping over the *cista mystica*, the drunken Hercules supported by revelers, and the dancing *aulistria* and *aulistrios*. The other figures and details are borrowed from the tiger/panther series.

55. The conceit of stroking the mane derives from the model used by the Walters Art Gallery Triumph sculptor for the satyr walking behind the lion that is beside Silenos.

56. For another example of the excerption of the Silenos and lion unit from the tiger/panther formula, see Matz II, no. 139, pl. 160, in which Silenos is placed in front of the elephant *biga* and the accompanying lion is reduced to miniature scale and is practically trampled by the elephants.

57. Matz II, 255–56, no. 115, pl. 135,2.

58. For the El Jem mosaic, see Dunbabin 1971, 55, pl. 13, dated ca. A.D. 250 on stylistic grounds. For Portus Magnus (St. Leu), now Archaeological Museum, Oran, see ibid., 56, pl. 16b, who dates it to the Tetrarchic period on stylistic grounds.

Algeria.[58] In neither case does the arrangement parallel the one at Paphos, except for the close association of Silenos with the chariot.

The third Silenos, from a silver patera handle in the Metropolitan Museum dated to the Antonine or Aurelian period, offers the closest parallel in that he marches beside the panthers and is thus visible only from the waist up, as he is in Paphos.[59] The Metropolitan Silenos holds a branch with three vegetal growths, probably a *thyrsos* like the one held by the Paphian Silenos. In fact, the panther chariot group represented in silver relief provides the closest comparison to the four figures making up the central chariot group in Paphos. In addition to Silenos, the Metropolitan group includes a Pan and a satyr carrying ivory tusks that both closely resemble in posture and function their Paphian counterparts. Pan lifts his left leg and directs his gaze toward his right, just as at Paphos (albeit, a cruder version). The attenuated visage, beard, horns, and intense eyes are especially close to the Pan at Antioch and at Paphos—simply a rougher version. The silver chariot, however, is led by a satyr with *lagobolon*; Dionysos, who remains standing, holds the reins, as is the case in many mosaic representations.[60] Evidently, the Paphos artist conflated the Silenos walking beside the lion with the role of chariot leader who holds the reins of the tethered beasts.

The overriding impression thus far is that the Paphos Triumph does not strictly follow one model or attempt to recompose a famous original. This view is confirmed by the last three figures to be examined. Aside from the central figure of Dionysos, the two remaining members of the procession are the *cymbalistria* who follows the kneeling captive, and the closing figure, an *aulistrios* or trumpeter who faces left toward the group (fig. 127). They both derive from Neo-Attic prototypes and are commonly found as members of the Dionysiac *thiasos* in sculpted and painted representations.[61] Neither of these figures, however, can be exactly compared to figures in the Triumph retinue on sarcophagi or mosaics. The trumpeter occurs in centaur Triumphs but as a female,[62] and the *cymbalistria* does not appear in any Triumph scene. The maenad, dressed in long green chiton and gray himation, looks over her shoulders and lifts up the cymbals in a classic pose paralleled in several mosaics from Antioch.[63] Her closest counterpart in

59. Alexander 1955; and McCann 1978, 88, fig. 79. See also Matz II, 221n.37, who suggests that the silver handle may be a forgery.

60. For several mosaic examples of this arrangement, see Dunbabin 1971, pl. 12 (Sousse, House of the Arsenal/Vergil), pl. 13a (El Jem, House of the Hunt), and pl. 15b (Saragossa).

61. For the *aulistrios* see Matz I, 41, type 54B, type 55C, where he is described as wearing a skin thrown over his shoulder, otherwise naked, and walking in profile with a crown or wreath on his head; for the *cymbalistria*, Matz I, 31, type 30B, where she is described as wearing a chiton and himation, holding the cymbals in her two hands, and turning left, while walking toward the right.

62. Male trumpeters occur on Matz III, nos. 213–14, pl. 223, both of the Dionysos and Ariadne group. For male trumpeters and *cymbalistria* in a Triumph procession, see bronze *tensa* from Rome discussed below.

63. There are two examples from Antioch, one of the Hadrianic period, from the House of the Phoenix, lower level, now in Princeton, and the other of the Severan period from the corridor of Perseus and

Triumph scenes is the *tympanistria*, but they are clearly based on two different models. The absence of the *aulistrios* and *cymbalistria* from any representations of the Triumph, and their presence in Paphos, supports the hypothesis that the craftsmen worked from intermediary models, cartoons, that assembled motifs divorced from their original context and rearranged them at will.

The pivotal figure of Dionysos in his panther-drawn *biga* underscores what has already been suggested by the portrayal of other members of the Paphian procession. He sits with his feet crossed at the ankles on his green-cushioned chariot seat, naked except for a red himation wrapped about his thighs. His head is crowned with ivy and turned in three-quarter view so that all may see his intoxicated gaze. This mood of languor is emphasized by the motif of his right arm draped over the head in the Lykeios pose. The blue glass *thyrsos* is casually held slanted backward in his left hand, which rests on his knee.

In all details this Dionysos corresponds to those found reclining or seated in panther chariots on a group of sarcophagi from the second half of the third century (for the example at Palazzo Doria, see fig. 136).[64] The poses of the panthers, with one turning its head back and growling at Dionysos and the other facing forward, are also found in this group of sarcophagi.[65] The springing panthers and the seated Dionysos go back farther than the mid-third century, as is attested by coins and medallions.[66] On the sarcophagi the reclining god in Lykeios pose is more commonly associated with Ariadne in the *hierogamos* series, dating to the second half of the second century.[67]

A curious feature of the Paphian Dionysos is the way his right arm, the one raised in the Lykeios pose, rests on a pillarlike form, perhaps meant to indicate the back of a chariot seat. There are many examples in the Roman minor arts of the Dionysos Lykeios which show the god resting the unraised arm on some support.[68] What is odd here is that the artist has propped up the lifted arm. This same misread can be viewed on a bronze frieze of the Severan period where the Triumph is depicted in two registers of a bronze *tensa* or triumphal chariot, now in the Conservatori Palace, Rome.[69] Here too a pillar props up the raised arm of

Andromeda in the House of Dionysos and Ariadne; see Levi 1947, 54, pl. 9a and 149–50, pl. 29b, respectively.

 64. Matz II, 279–80, no. 142, pl. 170,1 (Villa Doria Pamphili); no. 143, pl. 172 (Louvre); no. 145, pl. 171,1 (Palazzo Doria, Rome)—the closest to Paphos; no. 146, pl. 171,2 (Villa Doria Pamphili); no. 148, pl. 168,1 (Rome, Villa Savoia).

 65. On the position of the panthers, see Matz II, 229.

 66. For the springing panthers on bronze medallions, see above note 45.

 67. For examples of the reclining Dionysos in the *hierogamos* series, see Matz II, no. 79, pl. 97,1; no. 80, pl. 96, fig. 31; no. 92, pl. 121,2; for panther chariots, nos. 78–82; and for centaur chariots, nos. 83–93.

 68. For a recent iconographic study of Dionysos in the tradition of Apollo Lykeios, see Schröder 1989; for examples on ivory plaques, see Price 1972, 48–57, esp. pl. 34, 2,3 (Museum of Fine Arts, Boston, and Walters Art Gallery) and pl. 35,1 (Louvre).

 69. H. S. Jones 1926, 179–87, cat. no. 13, pl. 70. For another example of Severan metalwork with a similar depiction of Dionysos, see the gilded silver patera from Rennes, now in the Cabinet des Médailles, Paris,

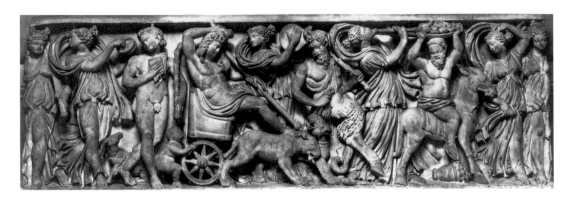

Figure 136. Rome, Palazzo Doria, Triumph sarcophagus (German Archaeological Institute, Rome, Foto MD.2286)

Dionysos, but this posture does not occur on the sarcophagi representations. At Paphos, it seems that the mosaicist selected a Lykeios type for his Triumphal Dionysos, but because he either misunderstood or was unfamiliar with the pose, he supplied a support pillar for the lifted arm. One could well imagine him disturbed by a dangling arm! Not only does the selection process itself seem somewhat arbitrary—supposing the artist had half a dozen Dionysos figures to choose from—but the motifs, once chosen, are subject to ad hoc reinterpretations.

There are no examples of the reclining Dionysos in mosaic representations of the triumphant Dionysos, since nearly all follow depictions of the type presented in the Setif mosaic and Baltimore sarcophagus, that is, the fully dressed standing Dionysos holding the *thyrsos* in his right hand (fig. 122). The two exceptions to this convention underline the observations noted above about the process of assembling a major figural mosaic. First is a bizarre Triumph from a Roman house in Corinth in which a full-faced Dionysos stands in a frontal tiger chariot.[70] The Corinth Triumph is difficult to read as a composition because of its many confusing elements. In it we find a satyr-supported Dionysos in a tiger chariot flanked by two centaurs carrying large kraters on their shoulders; it seems to be a conflation of the centaur and panther/tiger-Triumph series. The strange billowing "clouds" in the lower foreground have no function in a Dionysiac Triumph, but they do resemble the thick coils of the serpentine bodies of the tritons who accompany Poseidon in his Triumph.[71] It seems likely that the Corinthian work-

which is securely dated by its border of Roman coins; see Levi 1947, 23, fig. 5. The *cymbalistria* and *aulistrios* also make their appearance in these two bronze friezes, which bear a closer resemblance to a *thiasos* than to a Triumph.

70. For the Corinth Triumph, see Weinberg 1960, 111–22, pl. 54, north room; see also Waywell 1979, 298, cat. no. 20, who dates it to ca. A.D. 200.

71. For a Triumph of Poseidon, see the House of Neptune at Acholla (Gozlan 1974, 117, fig. 51), where the Triumph occupies the central part of a *triclinium* mosaic and Poseidon holds up his trident in much the same pose as Dionysos holds up his *thyrsos*.

shop was more familiar with the marine Triumph and ineptly borrowed the formula for a Dionysiac Triumph.[72]

The second exception to the conventional Dionysos type occurs in the Antioch Triumph (fig. 125).[73] Dionysos is executed with a skillful assurance that produces a commanding frontal figure, that like the other preserved members of the Antiochene Triumph reflects the positive results of the ad hoc process, that is, a successful fresh combination. As at Paphos, the panel is placed at the entrance to the triclinium, although in Antioch, rather than greeting those entering, the procession faces into the room and the diners at their meal.

Two other mosaics, in Acholla and Gerasa—both in fragmentary condition—include Dionysiac processions that undoubtedly served as greeting panels for triclinia. They share stylistic and compositional features with the Paphos and Antioch Triumphs. Examined as a group, these four mosaic Triumphs (Paphos, Antioch, Gerasa, and Acholla) confirm what has been suggested by our study of the Paphos Triumph. The Dionysiac frieze from Gerasa (Trans-Jordan) is surrounded by an elaborate garland that includes the Seasons and Muses with poets and sages (figs. 137 and 138).[74] The central focus of the Gerasa procession are Dionysos and Ariadne reclining in a four-wheeled wagon drawn by centaurs. Unlike the other two eastern Triumphs from Paphos and Antioch which belong to the panther-Triumph group, the Gerasa composition belongs to the centaur-Triumph series. Just as in Paphos and Antioch, the Gerasa version does not strictly conform to the formula known from the large group of sarcophagi reliefs. For example, the placement of the chariot group in the center of the procession in all three cases is unusual and indicates a similar ad hoc process by which they were assembled. Perhaps the exigencies of their locations at the entrances of rooms, and in the case of Paphos and Antioch, their placement in the bar of the T-shaped triclinia, determined the format of the compositions. In contrast to the more centralized Paphian Triumph, the Gerasa procession moves to the right. In the case of the Antioch floor, one cannot tell, since the right half is lost, although the preserved figures face the front in three-quarter view creating an impression of a static and centralized composition.

The fourth mosaic Dionysiac Triumph is from the great triclinium of the House of Neptune at Acholla, Tunisia (figs. 139 and 140), dated to the last quarter

72. This proposal is supported by the discovery of a 2d-century black-and-white mosaic in Isthmia (Packard 1980) which suggests a familiarity on the part of the Greek workshops with the Italian monochrome mosaic repertoire.

73. For the Antioch Triumph, see Levi 1947, 93, pl. 16c.

74. The mosaic is now split into several pieces: the ten fragments, formerly in the Stark Museum of Art in Orange, Texas were recently in the art market and purchased by a variety of collectors and institutions; twenty-two fragments are in the Staatliche Museum in Berlin. See Joyce, who dates it on the basis of style and the ornament of the garland border to the Antonine period, ca. A.D. 150; she groups it with the Antiochene mosaics from the House of Narcissus, the House of the Red Pavement, and the House of the Triumph of Dionysos (1980, esp. 326, n. 56).

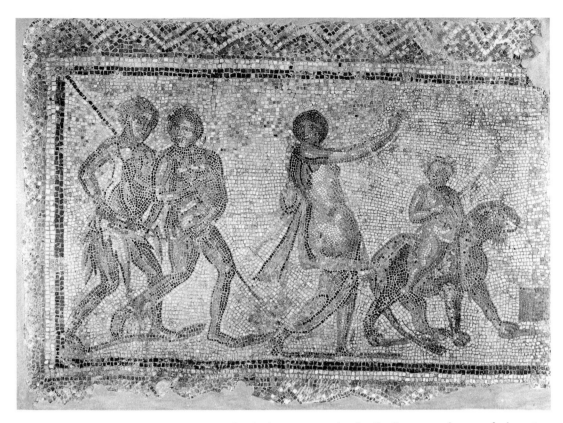

Figure 137. Gerasa, Triumph of Dionysos mosaic, detail of satyrs and maenads (courtesy of Barbara and Justin Kerr)

of the second century.[75] Although it is too fragmentary to permit one to tell whether or not it is a full Triumph, the presence of a maenad *thyrsophoros*, a torchbearing satyr, a Silenos leading a donkey laden with ritual vessels, and finally an altar and *cista mystica* strongly suggests a connection with the Triumph processions. It is not possible to determine which Triumph series was intended because the central group is lost. Once again, however, the arrangement of figures suggests a selection of types which does not follow any particular order; that is, the composition is not dependent on one model.

Before we leave North Africa, one other Triumph requires our attention. The mosaic comes from the center of the *oecus* (room I) of the House of Tertulla at El

75. Gozlan 1974, 127–29, figs. 61 and 62, triclinium S; and Gozlan 1992, 205–8, no. 55, pl. 54. Only two fragments of the panel remain and they are in the storerooms of the Bardo Museum in Tunis; ibid. The mosaics of the house are dated on the basis of the similarities of their motifs and style to the House of Asinius Rufinus, which is securely dated by inscription to ca. A.D. 184. The other mosaic Triumphs discovered in North Africa all follow the panther-Triumph formula.

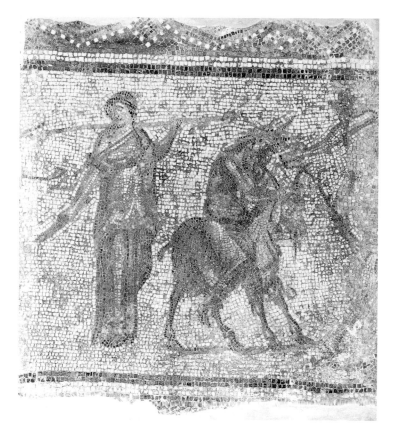

Figure 138. Gerasa, Triumph of Dionysos mosaic, detail of maenad and Pan (courtesy of Barbara and Justin Kerr)

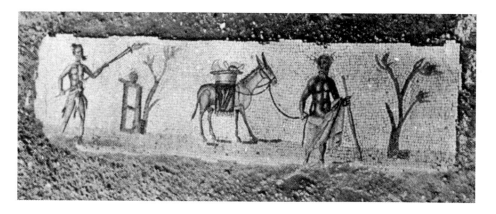

Figure 139. Acholla, House of Neptune, Dionysiac frieze mosaic, detail (courtesy of S. Gozlan)

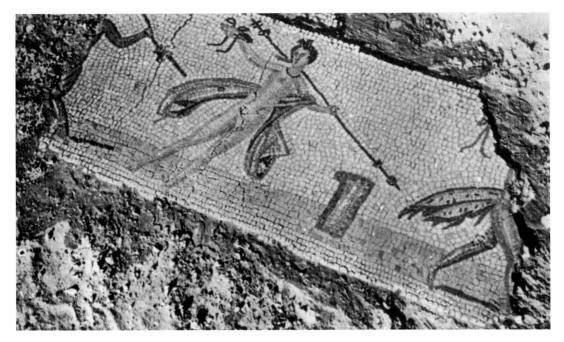

Figure 140. Acholla, House of Neptune, Dionysiac frieze mosaic (courtesy of S. Gozlan)

Jem, wherein the Triumph is composed in a medallion.[76] The medallion was set in a wreath supported by four Erotes who stood on diagonal grapevines. What is interesting about this El Jem mosaic, dated on the basis of style to the Severan period, is the adaptation of the same Triumph types to a different format. Moreover, the fact that the Triumph was physically enveloped by vintaging Erotes in a major reception area echoes the combination at Paphos of the grand vintage carpet and the Triumph panel in the triclinium.

It is worth noting that in the four mosiac Triumphs discussed above the figures are isolated against a neutral ground with wide spacing between them, and with only summary allusions to a naturalistic landscape, such as trees. The groundline in each is established by the use of two-tone foot shadows, and all the figures are isocephalic. When these mosaics were studied individually these features suggested a compositional clarity reminiscent of the Hadrianic and Antonine periods.[77] The Paphos Triumph shares many of these same characteristics and even reflects, although in a much diluted state, the lively gestures and realistic facial expressions of the Antiochene figures, especially Pan and Dionysos. It seems more

76. The mosaic is now in the El Jem Museum; see Parrish 1984, 250–52, pl. 99a, who incorrectly notes it is in situ.

77. Levi notes that these traits are typical of the Antiochene mosaics dated to the second and third centuries (1947, 98). He dates the House of the Triumph of Dionysos on the basis of its marine *thiasos* (corridor 4), which he in turn dates by comparison to the Lambaesis mosaic. A later date should not be excluded, because hairstyles influenced by official fashions reflected in portraiture took time to transfer to the ordinary citizen and into the mosaic repertoire.

likely that these shared stylistic and compositional features point to a common method of production, rather than to an improbably early date. None of these Triumphs follows an established overall model, but rather reflects the practice, well known in sculpture,[78] of repeating conventional types, which, in the case of Antioch, were enriched, and in the case of Paphos, suffered at the hands of an artisan of modest talents. The neutral backgrounds, for example, are indicative of the fact that the mosaicist was unfamiliar with a painted model, and thus of the original setting, and was merely combining, with little understanding of their relationships, separate figure types as he saw fit. It is therefore probable that the four mosaic Triumphs (Paphos, Antioch, Gerasa, and Acholla) belong to the last decades of the second century and that their creation is several steps removed from the original sources, or even from the models used by the Hadrianic and Antonine sculptors in Rome.

The Setif mosaic, on the other hand, bears witness to the contemporary practice of following a painted model very closely, the same one that inspired the Walters Art Gallery Triumph, which in turn fertilized an entire series of Sarcophagi reliefs. Undoubtedly, there were political and religious reasons for the rich production of this scene on sarcophagi,[79] and it seems plausible that the sculptors' cartoons provided some, if not most, of the patterns used by mosaicists.[80] The time lag of at least twenty years between the production of the sarcophagi and the floruit of the mosaic representations of the Triumph supports this hypothesis. At least in the case of the Triumph, it is critical to examine the iconographic development of the theme on sarcophagi. The popularity of the Indian Triumph, featuring exotic beasts—elephants, giraffes, camels, and tigers/panthers—and the Indian captives, reflects a situation in which the sculptors offered a fresh version of an old theme.[81] With the exception of the Setif Triumph, these new elements were not absorbed by the mosaicists. In fact, out of the twenty-five or so mosaic representations of the Triumph, it is only the Paphian mosaic with its three dark-skinned captives which attests to the integration of these elements. The other mosaics follow a remarkably limited path, reproducing the central chariot group from the panther series and varying the sequence in minor ways. As only the fragments of five figures remain from Antioch, where there is surely space for five or six more, it is difficult to know what other figures might have been included. It is clear that the presence of the captives in the Paphian Triumph reflects the trends of Severan exoticism and the conscious Romanization of the Hellenistic model.[82]

The presence of features from the centaur-Triumph series in Paphos is not

78. Ward-Perkins 1975–76, 214–16.
79. Turcan 1966, 441–72.
80. Dunbabin 1971, 64–65.
81. Even on Cyprus itself there is evidence of the development of the Triumph in sculpture: a master sculptor, Titius Antischinus Athenion, of the early third century signed an example of his work "Dionysos and the Indian Panther." This piece was set up in the Salaminian Gymnasium; see Mitford 1980a, 1366–67.
82. Turcan 1966, 460–62.

surprising. By the late Antonine period, the two major versions of the Triumph were interchangeable. A vivid illustration of the effect of these exchanges can be seen in the products of one workshop in the Commodan (A.D. 177–192) period. One sarcophagus, now in the Vatican, unsuccessfully fuses the centaur chariot with the panther/tiger composition (fig. 129), and the other, also in Rome (fig. 130), holds closely to the outlines of the panther formula. The abundant misreadings and ambiguities in the execution of the former—for instance, the captives seated on the elephant are repeated twice and seem to be floating—make it an instructive example of workshop procedures. In one case the model was understood; in the other, illogical placement and overlaps create a confusing composition. The stylistic compulsion to create a packed and complicated surface might excuse the duplication of figures, but the errors can only be ascribed to a second-rate hand. If in a well-established Roman workshop an inept craftsman felt bold enough to make new combinations and remodel inherited forms, why not a Cypriot mosaicist in a backwater eastern province?[83]

If we return to the three mosaic Triumphs that offer the closest parallels in style and composition (not necessarily in iconography), that is, the Antioch, Acholla, and Gerasa panels, a firm impression of Roman mosaic workshop methods emerges. The mosaicist of the House of Dionysos, like his counterparts in Syria, Trans-Jordan, and Africa Proconsularis, drew on models in vogue throughout the Empire, but he used them independently in a semi-ingenious, semi-ingenuous way; they were not quite as sophisticated as the work of the mosaicist in the great metropolis of Antioch, but quite superior to truly rustic provincial productions. It seems likely that the models used for these mosaics were composed of isolated figure types. In other words, the mosaic designer (*pictor*) could concoct a Triumph scene from a variety of motifs that were no longer tied to their traditional context; once selected, these motifs could be modified at the discretion of the mosaicist. Such a process remains distinct from the one that produced the Triumphs on the Walters Art Gallery sarcophagus and the Setif mosaic, which undoubtedly derive from cartoons of an original painting; in these cases the artists attempted to reproduce entire compositions and to adhere faithfully to the source. The Triumph of Dionysos reflects a process, known in sculpture, whereby the artist combines conventional figure types, rather than follows a single model. The development of certain themes as reliefs anticipates their appearance on mosaics by at least twenty years and provides evidence for the dependence of the iconography of mosaics on the products of the sculptors' studios, primarily those of Rome.

The Triumph of Dionysos suggests that both sides of the model book question may be considered accurate.[84] The parallels noted above between the figures on Dionysiac sarcophagi and those on the mosaics presuppose the circulation of graphic designs. Such correspondences between media and geographically dis-

83. For a similar view on workshop practices in Antioch, see Hanfmann 1939, 232.
84. For a review of the recent scholarly debate on this issue, see above note 1.

persed workshops cannot be attributed merely to a "living heritage" of forms passed on from master to pupil.[85] Just as the distant workshops had common methods, so the theme of the Triumph itself and its location in the reception rooms of Roman homes reflect a shared vocabulary for domestic decoration.

As for the popularity of the theme itself, it seems that by the late Antonine age the celebration of a Roman Triumph began to merge with civic religious processions. This phenomenon took hold especially in the Greek east, where the Hellenic elite associated the emperor with divinities.[86] For example, coins for Caracalla issued in Amorium, Phrygia, bear an imperial triumph presented in the guise of the return of Dionysos from India.[87] Many third-century emperors chose elephants to draw their chariots in triumphs in imitation of Dionysos. Elagabulus was reported to have dressed in the garb of Dionysos for his triumphs. The concurrent rise in the popularity of the Triumph of Dionysos for domestic mosaics makes perfect sense, inasmuch as the patrons, often provincial notables, were eager to demonstrate a range of imagery drawn from the civic life they themselves sponsored.

THE DIOSCURI PANELS

The Dioscuri are represented in two square panels at each end of the Triumph of Dionysos procession at the entrance of the triclinium.[88] The twin deities are shown in full military attire standing beside their horses. Although their bodies are frontal, they turn their heads in three-quarter view toward the Dionysiac procession; their horses are posed in profile with one leg lifted (figs. 141 and 142). Each youth, crowned with a wreath, holds a long lance in one hand and a bridle in the other. The golden (yellow) star that appears above each laureate head makes the identification with Castor and Pollux unmistakable.

Both figures wear short-sleeved white tunics with kiltlike skirts in pink, and an overlay of black, gray, and ochre lines indicates the leather and metal strips characteristic of Roman legionary armor of the second century.[89] A long gray cloak is fastened above the breast by a brooch and hangs down below the knees. Each horse is decorated with metal trappings—*phalerae* ring their flanks and a

85. E. Kitzinger offers support for this point in the discussion section that follows Balmelle and Darmon 1986, 248. According to a recent study of the Dionysiac friezes in *oecus* 5 of the Villa of the Mysteries at Pompeii, these unusual frescoes were assembled by the wall painters from a repertory of stock images; see Clarke 1991b, 104.

86. The evidence comes mainly from the coinage of the Greek east and these observations are based on an analysis by Harl 1987, 45–48.

87. Ibid., 48, pl. 18.3.

88. The panels are briefly mentioned in Nicolaou 1963, 11. They are more recently discussed in Daszewski and Michaelides 1988b, 22, fig. 7; and they are cited in Hermary 1986, III.1,571, no. 29.

89. Webster 1969, 126, notes that the strip *lorica* was replaced after the 2d century by the scale-and-mail armor. The kiltlike garment is close to the centurion's uniform; see ibid., pl. 1.

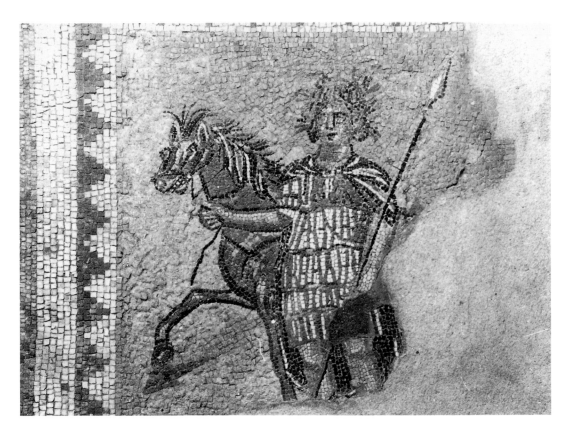

Figure 141. Dioscuri, north panel (courtesy of the Department of Antiquities, Cyprus)

torque hangs below each neck. Although the two panels are quite similar, some variations in technical execution should be noted. For example, the color scheme of the Twin in the north panel (fig. 141) is much brighter, employing orange tesserae in the upper chest area and in the cross strips of the skirt. In addition, his wreath is a brighter green, and the grays are darker, providing a higher contrast to the white fabric of the costume. The horse bares his teeth, so that he has a fiercer and more animated expression than his counterpart in the south panel.

The use of a dark (bluish-gray) background distinguishes these panels from the other figural mosaics in the house, which all have white grounds.[90] Curiously, the youths are given bolder expressions and appear stiffer and more blocklike than the other figures in house. In fact, they presage a late-antique figure style and could easily have been dated in the late third century if they were taken out of their archaeological context. The representation of the Dioscuri in the uniform

90. The coloration might be meant to suggest a sky—especially appropriate for the Dioscuri. An analogous treatment exists in the neighboring House of Orpheus at Paphos, wherein a mosaic with an Amazon is set against a striking blue ground; see Michaelides 1987, 12–13, pl. 19, no. 5, who sees these mosaics as stylistically and chronologically close to those of the House of Dionysos.

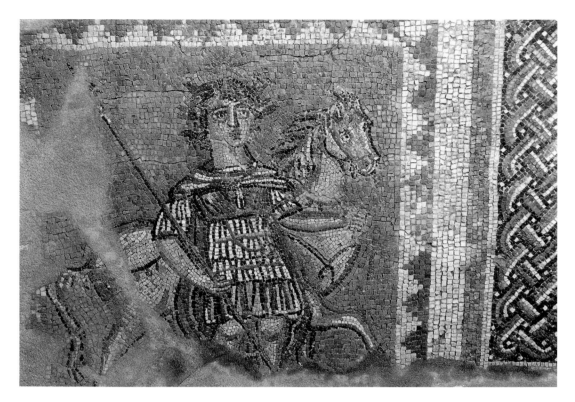

Figure 142. Dioscuri, south panel (courtesy of the Department of Antiquities, Cyprus)

of Roman officers is telling on several levels. First, it reflects a markedly Imperial Roman taste, for the Twins were depicted as heroic nudes throughout the classical Greek and Hellenistic eras. In fact, there is virtually no representation earlier than the second century A.D. that shows them in military attire.[91] Second, the preponderance of these examples, many of them on coins, comes from Egypt.[92] Several coins issued by the mint of Alexandria bear reverse images of the deities in frontal pose with heads turned toward one another.[93] They are outfitted in cuirass and leather skirts, and carry a lance in one hand and a bridle in the other. Typically, they don conical caps (*piloi*), but some coins, especially from the Republican period when the Dioscuri were a favorite type, show them crowned with laurel wreaths and stars, as they appear at Paphos.[94] Insofar as any generalization is

91. Kantorowicz 1961, 368–69.

92. Ibid., 369n.5. A monument that should be added to those cited by Kantorowicz is a limestone stele now in the Egyptian Museum in Turin (N1321) which is dated to the late Hellenistic period, but seems to be Roman; see Hermary 1986, III.1, 570, no. 17, with III.2, 457, no. 17; their costumes and poses, as well as their horses, are similar to those in the Paphian panels.

93. For a Trajanic coin, see Gury 1986, III.1, 572, no. 44, with III.2, 460, no. 44; and for a Hadrianic one, see Chapouthier 1935, 63, no. 54, pl. 11.

94. See e.g., several denarii from Rome; see Crawford 1974, 316–17, no. 307, pl. 41. See also the laureate

possible, it seems that the Paphian panels follow the same model as the Alexandrian coins.

The presentation of the Dioscuroi in contemporary uniforms follows the late Roman vogue for the militarization and imperialization of divinities and may explain the stylistic discrepancies between these two figures and the other mythological figures in the Paphian house.[95] Perhaps the single richest find that attests to this fashion is the mosaic of the horses in the *oecus* of the House of the Horses at Carthage. Among the many square panels that constitute this checkerboard mosaic, dated to the early decades of the third century, are a series of circus horses accompanied by divinities dressed in various types of military uniforms.[96] A figure identified as Mars wears a costume that is closest to the one worn by the Paphian Dioscuri.[97] Two figures that resemble the Twins are also found in the Carthage mosaic, and they are attired in Phrygian costume—long leggings, tunics, and pointed caps (fig. 143).[98]

The Twins appear in similar eastern attire at the center of a fifth- or sixth-century earthenware relief dish from Egypt with wild beasts around its rim.[99] The presence of several kraters, most prominently the large one set between the youths on the dish, as well as two stelelike forms,[100] indicates the agonistic milieu of the games. The association of the Twins with hunting and circus games is alluded to in both the Carthage mosaic and on the display dish, but the Christian inscription on the dish leaves no doubt that these deities were "stamped" with new meaning, one related to a Christian victory—salvation.

The example of the relief dish makes clear that the Dioscuri were culturally movable. In fact, the representational history of these twin images suggests that they were polyvalent motifs that could imply several meanings depending on their context.[101] At Paphos, the physical location of the panels—that is, at the entrance of the triclinium, at either end of a Dionsyiac procession, adjacent to a vine-

heads of the nude Twins on two terracotta amphorae from Gotha of the mid-3d century; Gury 1986, III.1, 572, no. 42, with III.2, 460.

95. Again, Kantorowicz traces this development in the late-antique period back to Egypt (1961, 384–90).

96. Among these figures are Jupiter, Neptune, Mars, and Vulcan; see Salomonson 1965, 59–65.

97. Ibid., 111, fig. 33, panel 29, pl. 41,3.

98. According to Salomonson these two figures form a pictograph of the name of a circus horse in that they allude to the Phrygian festival of the Hilaria, and should not be read as the Dioscuroi; see ibid., 104, fig. 20, panel 16, pl. 59,2. I find this less convincing than his readings of the other panels, largely because the inclusion of the Dioscuri in a circus milieu is normal (see Humphrey 1986, 256, 260; and Kitzinger 1951, 114nn.135–36), and not every panel in the Carthage mosaic identifies a horse.

99. The fragments of this rectangular dish are now in the Benaki Museum, Athens; see Salomonson 1962, 67–72, fig. 4, pl. 21, 1–2.

100. The object appears to be a rectangular block with a triangular pediment mounted on a stepped base; it is quite similar to an arena monument depicted on the glass sports cups; see the one from Colchester illustrated and ambiguously identified as pavilion/*aediculae*(?) in Humphrey 1986, 189, fig. 92.

101. Ambiguous images, i.e., those charged with multiple meanings, from the early Byzantine period are the focus of a study by H. Maguire; his method is useful in regarding the Dioscuri at Paphos (1987, esp. 10–12).

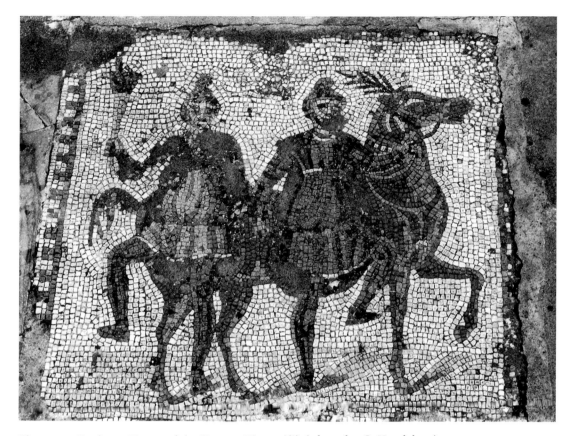

Figure 143. Carthage, House of the Horses, Dioscuri(?) (photo by C. Kondoleon)

carpet floor, and facing into the peristyle with the hunt panels—determines a variety of possible readings.

In the most general sense, they serve a protective function, as scholars have noted.[102] More specifically, the Twins, as constellations, were associated with sea voyages and were invoked to safeguard trade ships.[103] In trying to establish that the Paphian home belonged to a merchant, A. Geyer emphasizes the maritime role of the Dioscuri[104] and uses a comparison with a fourth-century mosaic from the House of the Dioscuri in Ostia to support her view.[105] In this late

102. Daszewski (Daszewski and Michaelides 1988b, 22) follows Geyer's suggestion (1977, 128 and 134) without qualification.

103. The most often quoted source to support this interpretation is a description by Ammianus Marcellinus of a sacrifice made to Castor and Pollux at Ostia so that they might quell a storm and let the grain ships pass into port; see Meiggs 1960 (rpt. 1977) 343–45.

104. It is interesting to note that it was the Greeks who celebrated the Dioscuri as maritime divinities; the Romans were far less apt to do so; see Taylor 1912, 25–26.

105. Geyer 1977, 128.

Roman mosaic the Twins are represented nude, without their horses, in a central panel surrounded by motifs, such as kraters (*kantharoi*), peltae, Solomon's knots, and a fruit basket.[106] Although possibly the Ostian house belonged to a merchant, the depiction of the Dioscuri does not confirm this identification.[107] The fact that this mosaic was set at the entrance to the Ostian house,[108] and that Castor and Pollux are juxtaposed with beneficent symbols, especially three large kraters, connoting good fortune and prosperity, emphasizes their prophylactic function and not the class or profession of the *dominus*.[109] The context of the mosaic, in terms of location both within a plan and within a decorative scheme, must be considered. Inasmuch as there are no overt marine themes in the Paphian house,[110] let alone abutting the Dioscuri panels, it seems beside the point to stress their navigational ties or those of the owner.

Set as they are at the entrance to the most important room in the Paphian house, they stand guard at the threshold where the guests are to be received and the malevolent forces expelled.[111] As domestic decoration, their closest parallel can be found in the two paintings of Neronian date set at either side of the vestibule of the House of the Dioscuri at Pompeii.[112] It is easy to understand from this example how the equation of the Dioscuri with the Republican household deities, the Lares and the Penates, took hold in Roman practice.[113] Their association and resemblance to one another resulted in an intensification of their meaning so that each could evoke the protection of crossroads, entrances, and travelers, as well as of private cults with their domestic shrines. In representations (painted altars, statues, coins) these deities are often subordinate to a central divinity.[114] In this respect, the placement of the Paphian Dioscuri at either end of a Dionysiac Triumph fits the visual traditions of the group.

106. Becatti 1961, 117–19, no. 216, pl. 201.

107. Geyer 1977, 128, takes the Marine Venus mosaic found in this house as further proof that the owner was a merchant, but the composition was far too popular in the 4th century to be taken as a social document about profession; see Dunbabin 1978, 157–58. If anything, it is the polychrome style of the Marine Venus which speaks of North African trade connections; ibid., 215. Meiggs suggests that the owner may have been Volusianus, an urban prefect who had property in North Africa (1960, 212). As the protectors of sea voyages, the Dioscuri were naturally tied to Neptune, and their cults were especially active in Ostia (Gury 1986, 610); but Neptune is not represented in this house.

108. For a plan, see Meiggs 1960, fig. 20.

109. Single kraters appear at the entrances of several buildings at Ostia; one is accompanied by an inscription that invites thirsty guests to drink; see Becatti 1961, nos. 9, 17, 77–80, pls. 192–93, esp. 63, no. 80.

110. There is a panel of Amymone and Poseidon in the west portico, but it lacks the marine qualities typical of such scenes.

111. Early evidence for their apotropaic use comes from Delos, where the *piloi*, as well as the phallus and club of Hercules, appear inscribed in relief on Hellenistic buildings; see Bruneau and Ducat 1966, 117, no. 58, and 120, no. 64. Geyer 1977, 134, emphatically concludes that their strategic location at the threshold of the Paphian triclinium reinforces their protective function.

112. The 4th-style paintings were found in vestibule 33 of House VI,9,6; for a full list of references, see Gury 1986, 615, no. 34.

113. On the conflation of these deities, see Waites 1920, 256–61; Chapouthier 1935, 313–20; and Gury 1986, III.1, 609.

114. A large selection of divinities, as well as serpents and eggs, appears on the painted *lararia* from

Although an explanation for the relationship between the Dioscuri and Dionysos is not immediately obvious from literary or visual sources, there is one possible link through yet another group of deities who were often confused with the Dioscuroi, namely the Cabiri. At many centers, the worship of the Cabiri was connected to the cult of Dionysos.[115] According to certain Greek traditions, they were even regarded as guardians of the vintage.[116] Although much earlier, this tradition certainly is consistent with the layout of the Paphian triclinium, where the Dioscuroi oversee a monumental vine harvest. The exact nature of the overlap between Dionysos, the Cabiri, and the Dioscuri may not be ascertainable; however, the tenacity of these connections is evidenced by a late-fifth- or sixth-century bowl from North Africa wherein the busts of the Dioscuri flank Liber Pater.[117] The eclecticism of Roman religious traditions indicates that these conflations were a commonplace, and may even account for the ambiguous nature of these images.

Greek literature and art, although chronologically early, may provide an interpretation appropriate to the setting of the Paphian mosaics. Although rare, representations of the *theoxenia*, a festival for the gods which involved a banquet, feature Castor and Pollux as attendants. For example, on a red-figured hydria they lead their horses toward a table and couch assembled for a banquet.[118] Such images seem to echo a third-century drinking song in their honor: "O Castor, and you, Polydeuces, . . . tamers of horses, protectors of the homeless and guides of the guests."[119] Callimachus quotes these verses in a poem "The Night-Festival" (*Pannychis*), and the verses are accompanied by phrases from the texts of Pindar and Euripides which attest to the hospitality of the Twins at both divine and mortal banquets.[120] It is tempting to see the Paphian Dioscuri, situated as they are at the threshold of a dining room covered with a vine carpet replete with

Pompeii; see the corpus by Boyce 1937, passim. On the grouping of the Dioscuroi with Helen, Juno, etc., see Chapouthier 1935, passim. Scholars have also linked Dionysos and Liber Pater to the cult of the Lares; see Waites 1920, passim.

115. For a discussion of the Cabiric cult and its various assimilations, see Waites 1920, 256–61. The facts that the Ptolemies promoted the worship of the Cabiri at Samothrace, the historic center of their cult, and that the Dioscuroi were among the most popular Greek gods in Alexandria (Frazer 1972, 207) are worth noting in view of the Ptolemaic control of Paphos.

116. They were assigned this role at Lemnos; see Waites 1920, 257.

117. The bowl is in the Lavigerie Museum (inv. 47.38), Carthage; see Salomonson 1962, 71, pl. 22.5. Starred caps are set in a field around a chariot carrying a divine couple—possibly one of the pair is Dionysos—on a terracotta disk from Brindisi, but here the signs of the Dioscuri serve as constellations, along with the busts of Sol, Luna, and a zodiacal ring (see Gury 1986, III.1, 625, no. 136, where it is dated to 3d century A.D.). See also the nude Twins, who stand beside their horses on either side of Sabazios, another deity associated with Dionysos, on a bronze plaque of the 3d century A.D.; see ibid., 617, no. 51.

118. Interestingly, the banquet area is set off by two Ionic columns so that the Twins appear to approach it from the outside. They each wear a petasos and carry lances; see Chapouthier 1935, 133, fig. 7.

119. Callimachus, *Diegesis: Pannychis* (Trypanis 1975, 160–63, no. 227).

120. For a discussion of these sources and the role of the Dioscuri in the *theoxenia*, see Chapouthier 1935, 132–34.

allusions to abundance, as hosts to a celebration; certainly the central panel with the Triumph of Dionysos expands on this reading.

The architectural context of the Twin panels should also be considered in relation to the peristyle, which opens onto the triclinium and is decorated on three sides with hunting scenes. As the patron gods of horses and horsemen, Castor and Pollux were the protectors of the *equites,* a class that in times of peace was entrusted with commercial transactions.[121] Once again, a reference to the entrepeneurial concerns of the owner might be indicated, but the close proximity of the hunt panels suggests another meaning. In Greek tradition the Twins drove chariots; in Italy they presided over the races of the hippodrome.[122] Among the appointments—statuary, turning posts, lap markers—of Roman circuses, scholars have found many references to the Dioscuri. For instance, the triad of conical obelisks that were turning posts (*metae*) might have recalled Castor, Pollux, and Helen to the ancient viewer.[123] I alluded to their connection to the circus with regard to the horse mosaic at Carthage and to the late Roman earthenware dish on which the Twins appear with wild beasts on the rim. A suggestive allusion to Dionysos and the circus is made in a fourth-century mosaic from Mérida: a medallion filled with Dionysiac dancers and motifs is flanked by two panels, each with a charioteer in a quadriga; the accompanying inscriptions are victorious acclamations.[124] Dunbabin has proposed that charioteers in a domestic setting can be read broadly as good-luck symbols, with their connotation of success.[125] Similarly, the Dioscuroi might signify victory through their association with the circus and, in the case of Paphos, with the triumphant Dionysos.

The leap from circus spectacles to hunts in the amphitheater is a natural one. Oppian in his *Cynegetica* credits Castor with the invention of hunting on horseback, and Pollux with the introduction of hounds.[126] This late-second-century-A.D. text by a Cilician author reinforces the impression that the ancient visitor might have seen a connection between the panels with the Twins and the hunt scenes in the adjacent peristyle. In this sense, the Paphian Twins are ideally suited to their location, for they visually and thematically link the two most public areas of the house—the triclinium and peristyle—and underline their reception function.

Admittedly, in an attempt to determine the significance of the Dioscuri in the Paphian house, the discussion has covered a wide chronological span and em-

121. DarSag s.v. Dioscuri, 263–64.

122. DarSag s.v. Dioscuri, 264, where it is noted that in Rome their statues were carried on the day of the games from the Capital to the Circus Maximus; see esp. the celebration of the Transvectio Equitum celebrated on July 15.

123. The interpretations of these circus devices is reviewed in Humphrey 1986, esp. 256, 260, and 281; see also Quinn-Schoffield 1967, 450–53.

124. Blanco Freijeiro 1978b, 45–46, no. 43, pl. 77.

125. As domestic decoration, anonymous charioteers can be read as signs of victory in the sense of *felicitas*; see Dunbabin 1982, 82–86.

126. Oppian, *Cynegetica* II.14, II.18–19; see also Chapouthier 1935, 283n.1.

braced a diversity of traditions. The simplest explanation of this pair may just be that in ancient art they were the preferred escorts for divinities, in this case Dionysos, and that like Tyche, whom they sometimes accompanied,[127] they conferred abundance, good fortune, and in a general sense protection on the owners and their visitors. Yet the architectural and iconographic context of these panels demands a more nuanced reading where multiple meanings are possible and even desirable. It is difficult to know which of the many possible connotations were intended, but there is no doubt that these panels mediate between the triclinium with its Triumph of Dionysos and vine harvest and the adjoining peristyle with its spectacles of the hunt.

127. For examples of Dioscuri with Tyche, see Chapouthier 1935, 310–11, nos. 71–72. See also a clay medallion with Dioscuri and Helen in relief which was found in the House of Dionysos at Paphos; K. Nicolaou, "Archaeology in Cyprus, 1966–69," *Arch Reports* (1969), 51, fig. 20.

The Triclinium
Dining in an Arbor

VINE COMPOSITIONS are among the most versatile and exuberant themes of antiquity. They moved as easily between ceilings and floors as they did from pagan to Christian settings. The introduction of the vine repertoire into mosaics and Christian art inspired new creations that originated in these contexts. Their abundant representation in all media provides an excellent example of stylistic and iconographic changes within relatively precise geographical and chronological bounds.[1] The vintage scene (figs. 144 and 145) decorating the long stem of the T-shaped triclinium (room 5) occupies a critical position in the vine series because its composition is rare for the eastern mosaic repertoire (figs. 3 and 4). The Paphos vine carpet is surprisingly close to a type lavishly produced in North Africa from the mid-second century through the fifth century[2] and relatively unused in Italy and the other western provinces.[3] In sculpture, on the other hand, the figured vine scroll flourished in the east, perhaps

1. The most detailed study organized by region and date remains Toynbee and Ward-Perkins 1950.

2. Dunbabin 1978, 117n.28, lists chronologically, in conjunction with vine schemes related to rural themes, thirteen vine mosaics from North Africa. The example from the Small West Baths in Banasa is omitted in her note but included in her catalogue (no. 1, 249) and dated to the late 2d and 3d centuries.

3. Exceptions are the peopled acanthus scrolls that did appear on earlier Roman mosaics (see Toynbee and Ward-Perkins 1950, 17 and 22) and the Lycurgus mosaic from Vienne to be discussed below.

Figure 144. Vine carpet mosaic, triclinium, drawing by M. Medič (courtesy of
I. Nicolaou)

owing to the active exchanges fostered by the marble trade which brought about
common elements of taste and craftsmanship.[4]

The Paphos vintage scene is thematically connected to the long rectangular
panel with the Triumph of Dionysos, at the entrance of the room and to the panel
with Ikarios and Dionysos (figs. 118 and 119) set on axis with it in the west portico.
The extraordinary size of the panel (2.02 m. × 7.13 m.), not to mention the entire
triclinium (11.50 m. × 8.50 m.), produces an imposing ambience. As the guests

4. For an analysis of the marble trade, see Ward-Perkins 1980, 23–69. Carved vine scrolls occur in Rome
and Gaul; see Ward-Perkins 1952, 28–29; and Toynbee and Ward-Perkins 1950, 24.

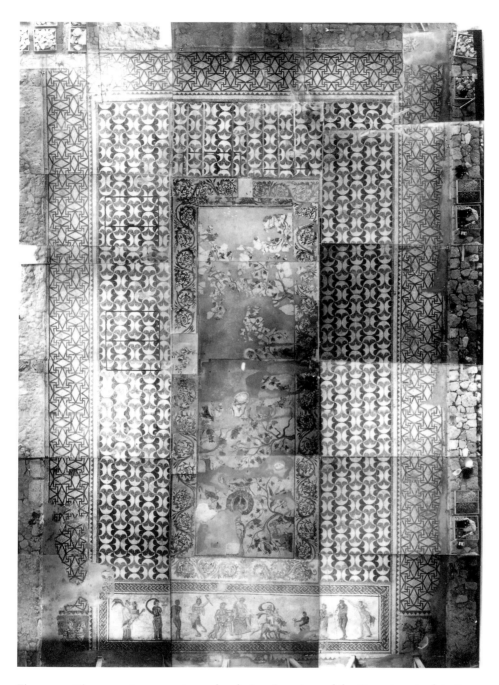

Figure 145. Vine carpet pavement, overhead view (courtesy of the Department of Antiquities, Cyprus)

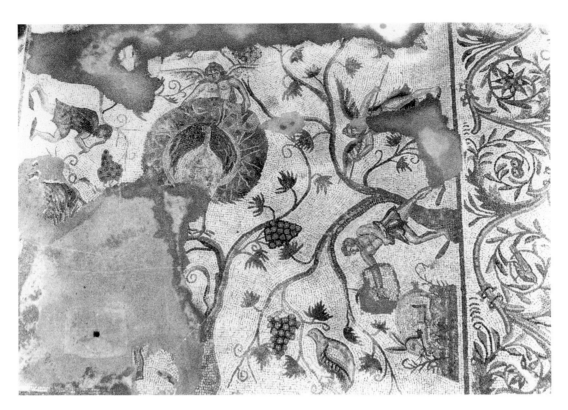

Figure 146. Vine carpet, detail from south side (courtesy of the Department of Antiquities, Cyprus)

proceeded past the Triumph panel at the entrance and took their places on the three couches, presumably set over the geometric panels decorated with addorsed peltae,[5] they were confronted with entertaining vignettes of the vine harvest (fig. 146). The vine pavement is arranged so that each group of guests, those entering and those reclined, could enjoy their own particular views of the composition. The designer accomplished this variety of views by grouping figures into discreet units of activity between four vine stalks placed at right angles with the border, at intervals of 1-1/2 meters along the north and south sides, and around one stalk in the center of the east and west sides. Of the nineteen extant figures, some are in fragmentary condition (fig. 147),[6] seven can be certainly identified as winged putti,

5. Levi illustrates this tradition with the net pattern used to cover the three sides of the T-shaped triclinium in the Atrium House at Antioch (1947, 15, fig. 2).

6. The vintage panel was badly damaged during the leveling operations that originally revealed the mosaics in 1962. A large portion of the southwestern part of the room was completely destroyed; see K. Nicolaou 1963, 62–63, and 1968, 50. A section halfway up the south side of the vine panel is lost as well as the south corner of the east side, i.e., to the left below the frontal peacock. Although much of the west side is lost, it is possible to reconstruct the scene; see the description below of satyrs pressing grapes (fig. 168). More recent descriptions can be found in Michaelides 1987a, 17, no. 11, pls. 4–5; and Daszewski and Michaelides 1988b, 20–22, figs. 4 and 6.

Figure 147. Vine carpet, detail from north side (courtesy of the Department of Antiquities, Cyprus)

and eight as adult males who are vintagers, herdsmen, and hunters. In addition to this unusual combination of the real and ideal world, this delightful vineyard bustles with an assortment of fowl and fauna.

The all-over treatment of the Paphian vine composition strikingly recalls the North African vine carpets, which offer the richest series of vine creations and are also the precursors of the early Christian vine carpets found throughout the Mediterranean from the late fifth century on. Although our view of vine-carpet development is dominated by the North African series, represented by sixteen extant vine pavements, the Paphian vintage panel offers important new evidence for the derivation and evolution of these floors. The upright arrangement of the vine shoots distinguishes the Paphian composition from the entire North African series. The vines in Paphos grow out of stalks firmly rooted along the groundline, rather than spring from kraters or acanthus clusters set in corners as they do in all the North African carpets. The diagonal orientation that is de rigueur for the North African vine compositions is notably absent in Paphos. A familiarity with the North African oeuvre is suggested, but not the direct influence of a model. The

Figure 148. Lambaesis, Dionysiac vine mosaic, detail (photo by C. Kondoleon)

Paphian vine carpet reveals at once the originality of its conception and its obvious debt to a rich tradition of vine compositions in classical art.

The origins of the vine-carpet tradition are best sought in the earliest of the North African group, that is, in the lush vintage scene from Lambaesis (fig. 148), dated to the third quarter of the second century.[7] The vine shoots emerge from

7. Dunbabin 1978, 263 and 117, n. 28, cat. Lambaesis 5; and *Inv. Alg.* 191. For a discussion of the date, see Lavin 1963, 221n.183, where he notes its discovery with the mosaic of the Nereid Hippocamp signed by "ASPASIOS" and dated by the hairstyle of the Nereids to the late Antonine period.

Figure 149. Hermoupolis, silver goblet, vines and Dionysiac figures, Greco-Roman Museum, Alexandria (after Adriani 1939)

acanthus clusters and form boughs under which Dionysos and Ariadne and their retinue recline, while vintaging putti scramble in the vine. The manner in which the Dionysiac figures repose within the spreading vines and are attended by putti is strongly evocative of the design on an Alexandrian silver goblet of the Flavian period from Hermoupolis (fig. 149).[8] The goblet is decorated in gilt relief with a

8. The silver goblet is now in the Greco-Roman Museum in Alexandria (inv. no. 24201); see the monograph by Adriani 1939. The piece is dated by the similarity of its vine scheme to those in other media dated to the late 1st and early 2d century (ibid., 19–25). Further corroboration for this dating is provided by the Vespasianic stucco decoration found in Pozzuoli, Fondo Caiazzo, which includes reclining figures similar to those found on the goblet; see Mielsch 1975, 148–49, k58III, pl. 61, and 149–50, k59III, pl. 63,1. Toynbee and Ward-Perkins 1950, 24n.118, argue that the goblet provides "important evidence for the east-Mediterranean origin of such compositions" (i.e., all-over vine schemes).

sprawling vine within which reclining Dionysiac figures (satyrs, maenads) are interspersed with Erotes busily engaged in vintage activities. It is tempting to view this goblet, along with reports of the famous Dionysiac pageant of Ptolemy Philadelphus (285–242 B.C.) as evidence of the Alexandrian origins of mythological vintages.[9] Hellenistic painting would seem the likely inspiration for such Dionysiac compositions, but, at least in the Roman period, vine schemes appeared in mosaics and sarcophagus reliefs only after their introduction into the metal and ceramic repertoire of the early Empire. The Egyptian goblet, produced at least seventy years before the earliest North African vine mosaic, provides strong evidence that the luxury arts, closely linked to Alexandria, were intermediary sources for Roman vine compositions.[10]

The Lambaesis floor is distinct in the North African series for its integration of mythological figures within the decorative setting of the vine arbor. More typical of the North African series is the vine carpet from the Antonine House of the Laberii at Oudna, where the mythological subject is set apart as a framed panel within an enveloping vine decoration (fig. 150).[11] The sinuous tendrils of four major shoots issue from *kantharoi* in the corners, leaving an open area in which Dionysos introduces wine to the Attic Deme Ikarios—a scene that occurs in the west portico in the Paphian house. The encircling leafy network is peopled with vintaging Erotes who, although thematically related, are essentially secondary to the mythological scene.

The majority of North African vine carpets follow the Oudna example, whereby the vine decoration is subordinate to an enclosed mythological scene. By far the greatest concentration of vine pavements occurs in the area of the Byzacena workshops, that is, in Thysdrus (El Jem) and Hadrumetum (Sousse), where a rich selection of mosaics survives from the private residences of the African elite. The predilection for Dionysiac subjects and the North African talent for coloristic carpet mosaics provided optimum circumstances for the application of vintage themes, especially in the reception rooms of the homes at El Jem. Unfortunately, the earliest of these, the *oecus* (room 3) of the House of Tertulla, dated to the early Severan period, survives in only fragmentary condition. What remains fills in the basic outlines of the composition: vines, peopled by nude Erotes and Dionysiac figures, issue from kraters in the corners and surround a central medallion and four rectangles placed along the sides, all five of which contain Dionysiac scenes

9. Schreiber 1894, 427–28, is convinced that the type originated in Alexandrian metalwork and argues that the Hildesheim krater had an Alexandrian model. On the *Pompē* of Philadelphus, see Athenaeus, *Deipnosophistae* 5.197C.

10. E.g., the majority of Gallic wares were exported through Alexandria, and there could easily have been reciprocal exchanges between ceramic and metalwork producers (Oswald and Pryce 1920, 24–25). For Alexandrian exports, see Comfort 1937, 406–10.

11. Gauckler 1896, 207–10, pl. 21, room 32. For a review of the various dating arguments and a suggestion of ca. 160–180 for the Ikarios panel, see Dunbabin 1978, 112n.18, and 240–41 (app. 3); Lavin 1963, 221n.180; and Levi 1947, 522n.25, who dates it "not before the Hadrianic age."

Figure 150. Oudna, House of the Laberii, room 32, vine carpet (courtesy of the National Museum of the Bardo)

(see panel in fig. 151). Two later floors from the second half of the third century at El Jem simplify the composition by returning to a single figural theme, but they retain the diagonal orientation marked by the corner kraters and vine shoots. In the earlier House of the Hunt, the Triumph of Dionysos dominates one long side of the rectangular panel, while smaller Dionysiac figures populate the spreading

Figure 151. El Jem, House of Tertulla, detail of the Dionysiac procession (photo by
C. Kondoleon)

vines into which it is set.[12] In the third quarter of the third century, the drunken
Silenos appears in a central hexagon embedded in a densely covered surface
overrun with vine shoots, vintaging Erotes, and Bacchic exotica in the House of
Silenus (fig. 166).[13] The neutral ground of the figural panel and its centrality barely
offset the *horror vacui* of the surrounding vegetation, an arrangement anticipating
the development of the all-over carpet mosaics of a later generation.

 The combination of the Triumph with a vintage scene in El Jem has an earlier
precedent in the Severan mosaic from the House of Virgil at Sousse (fig. 152).[14]
The even convolutions of a peopled vine scroll surround a central scene of the
Triumph with half-life-size figures. Like its later counterpart, which undoubtedly
shared the same model, it is unframed.[15] In fact, the vine completely intrudes into

12. For the House of the Hunt at El Jem, see Yacoub 1970, 62, fig. 63, inv. no. A.287; and Dunbabin 1978,
181–82, 117n.28, 257–58 (El Djem 1c), pl. 181, where it is given a date of ca. 240–260.
 13. For the House of Silenus, see Foucher 1960a, 27–30, pls. 11 and 12; and Dunbabin 1978, 117n.28, 180–81,
and 259 (El Jem 16d/room 10), pl. 106, who assigns a date of ca. 260–280.
 14. For the House of Virgil, see Foucher 1960b, 47–48, pl. 23, inv. no. 57.099; Dunbabin 1978, 181–82, 269
(Sousse 12d) pl. 182, with a date of ca. 200–210; and Dunbabin 1975, 53–54, pl. 12.
 15. Dunbabin 1975, 55.

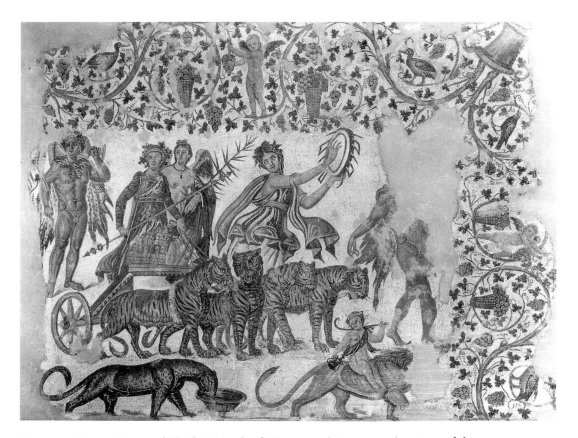

Figure 152. Sousse, House of Virgil, Triumph of Dionysos, vintage scene (courtesy of the National Museum of the Bardo)

the figural scene in the Triumph at El Jem so that there is no clear separation between them. Even in the earlier stages, the distinction between the mythological and the decorative began to get blurred in the face of the strong thematic attraction between Dionysos and the vintage. The Oudna and Lambaesis examples clearly represent two approaches, both introduced in the third quarter of the second century. Once introduced, they fused. The Triumph mosaics of Byzacena indicate that such a fusion was possible by the early third century and that the Dionysiac repertory entered the koine of the North African workshops and could be adapted at will.

The major elements of the triclinium decoration at Paphos—the Triumph, the vintage, and the acanthus-scroll border—were well established in the Byzacena workshop by the early Severan period.[16] In Paphos, however, these are presented as independent units, a separation that may suggest that the Paphos floor was laid at a

16. The acanthus-scroll border of the Paphos vintage resembles the frame around the vine carpet in the House of Silenus at El Jem; see fig. 166.

time when the Triumph and the vintage were closer to their original models—that is, in the late second century—before combinations like that at Sousse took place. This hypothesis is weakened by the factor of regional tastes. Despite the demonstrated synthetic spirit of the Paphian workshop, the arrangement of the triclinium strictly follows the eastern taste for individually framed panels, best illustrated in Antioch.[17] Nevertheless, as an ensemble the Triumph and vintage scene, although both independent creations of the Paphian workshop, echo the repertoire of Byzacena. The connection between the Byzacena vine-carpet mosaics and the Paphian vintage is, at best, indirect: they are not based on the same models, as is most clearly shown by the different ways their vines grow. The tradition of the diagonal vine compositions remained vigorous in Africa. These same themes were perpetuated well into the late fourth century, undergoing minor workshop changes, but essentially remaining faithful to their source (fig. 153).[18]

Quite another pictorial method was favored in the east. There, almost without exception, vine tendrils grow naturally from treelike stalks, like those in Paphos. These plantings recall real vine arbors and stand in marked contrast to the decorative fantasies of their North African counterparts, which can be traced to ceiling decorations. It is this simple but telling difference that places the Paphian vine carpet apart along with the few isolated examples of vine schemes preserved in the east, all of which favor naturalistic upright vines. The most outstanding vine scheme in the east covers three sides of the San Lorenzo sarcophagus, an Attic product of the early third century (fig. 154).[19] Six wide trunks with multiple vine shoots are firmly planted along the front side of the marble *kline*, forming a dense growth in which winged Erotes pluck succulent grapes and caper with various birds. The flat-relief style and all-over character of this thickly settled vineyard cut in stone points to textile and/or mosaic sources.[20] In fact, the frolicking Erotes are closest to those found on the Oudna mosaic (fig. 150), but the vines are completely different.[21]

Further evidence for a regional preference for upright vines is found in a series

17. Kitzinger 1965, 342–46.

18. Three other North African mosaics with vintage schemes attest to the popularity of the type in the 3d and 4th centuries. The first is dated in the early 3d century and is from a villa at Hippo Regius (Marec 1953, 102–7, fig. 4; and Dunbabin 1978, 262, [Hippo Regius 5b]). The second mosaic is from the Small West Baths in Banasa in Mauretania Tingitania (Thouvenot and Luquet 1951, 40–49, pl. III; and Dunbabin 1978, 249 [Banasa 1]). The date of the mosaic is given by a *terminus ante quem* of the last quarter of the 3d century when the town was abandoned by the Roman administration (ibid., p. 249n.1). The third example (herein fig. 153) is from the House of the Protomes at Thuburbo Maius (Poinssot and Quoniam 1953, 153–68, fig. 10; and Lavin 1963, 222n.188, fig. 58). Most recently a date in the second half of the 4th century—i.e., later than the Piazza Armerina mosaics to which they are so often compared—is given by A. Ben Abed on the basis of her excavations at the site (1983, 291–98).

19. Rodenwaldt 1930, 116–89, pls. 6 and 7. One of the author's arguments for the Attic origins of the sarcophagus is its upright vine scheme, which he compares with one lightly cut into the reverse of an Athenian sarcophagus dated by a portrait to the early 3d century (ibid., 163–64, fig. 46).

20. Rodenwaldt suggests an imported Syrian textile as a model for the decoration of the sarcophagus in San Lorenzo (1930, 182).

21. Ibid., 171.

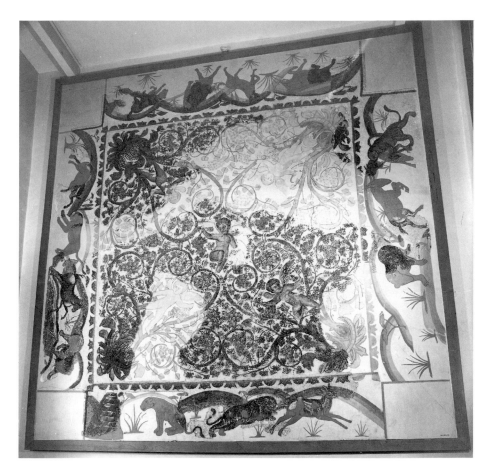

Figure 153. Thuburbo Maius, House of the Protomes, diagonal vine composition (courtesy of the National Museum of the Bardo)

of carved spiral columns. Best known are the twelve spiral columns that formed a screen around the burial site of the Apostle in Old St. Peter's (fig. 155).[22] On the Vatican columns, in the zones between the spiral fluting, vines grow directly out of the acanthus clusters. The most recent addition to this series is a column discovered in the area of the Nymphaeum of Trajan in Ephesus.[23] On the Ephesian column the carver allowed some space between the decorative acanthus ring and the vine trunks in order to give the illusion of a groundline from which the stalks grow. The Vatican columns are said to have been brought by Constantine from the east to adorn the Apostle's tomb, as noted in the *Liber Pontificalis*, and so scholars have concluded that these columns were of eastern workmanship.[24] What is signif-

22. Ward-Perkins 1952, 21–33, pls. 1–7, esp. sets 1 and 2, pls. 2 and 4; he dates the columns to the early 3d century and attributes them to eastern Greek workmanship.
23. Wegner 1976–77, cols. 48–64. The column is presently in the Selçuk Museum, inv. no. 15555.
24. Ward-Perkins 1952, 22n.9 and 28.

Figure 154. Rome, San Lorenzo Sarcophagus, vine scheme (after Rodenwaldt 1930, pl. 6)

icant about these spiral columns is the treatment of the vines as naturalistic; their stalks grow upright and their shoots spread freely. Such natural vines stand in marked contrast to their decorative alternative, the medallion scrolls that enclose hunting and Dionysiac motifs within leafy circles formed by the even convolutions of interweaving vine stems.[25] Although the medallion scroll was favored in the west from the first century onward and associated with official building programs, naturalistic vines are uncommon in the west.[26]

As for eastern vine-carpet mosaics, the meagerness of the remains is somewhat mitigated by an interesting example from Melos in the Cyclades, where a vine carpet is one of five mosaic panels decorating a long hall (fig. 156).[27] An altar stood on the vine panel at the eastern end of the hall, a fact that, along with several inscriptions, led scholars to interpret the room as a Baccheion or Dionysiac meeting hall.[28] A panel adjacent to the vine scheme shows a fisherman enclosed within a circular sea teaming with fish and busts of the four winds in the outer corners. It seems likely that these two pendant panels should be read as a cosmographic

25. Ward-Perkins 1980, 66, describes various medallion scrolls. Undoubtedly of Hellenistic origin, such scrolls were a feature of Augustan building decoration and thereafter became a hallmark of classical revivals throughout the Imperial period.

26. E.g., the Flavian tomb of the Haterii (von Blanckenhagen 1940, 99–105); for the Hadrianic period, see the Temple of Hadrian at Cyzicus (Ashmole 1956, 179–91) and the Hadrianic Baths at Aphrodisias (Toynbee and Ward-Perkins 1950, 34, pl. 24). For the Severan period, see the scrollwork pilasters of the Basilica at Lepcis Magna (Toynbee and Ward-Perkins 1950, 38, pl. 24).

27. Bosanquet 1898, 60–80, pls. 1–3; and Geyer 1972, 140–41, n. 815, pl. 12.

28. For a discussion of the Melian *mystae*, see Bosanquet 1898, 65 and 77–79.

Figure 155. Rome, Old St. Peter's, vine detail of spiral column (after Ward-Perkins 1952, pl. 2)

scheme, that is, as the representation of the earth and the sea. Such a theme would not be incompatible with a Dionysiac cult building.[29] It is the format of the Melian vine panel, not its meaning, which pertains to this discussion. The rectangular panel is given a diagonal orientation by the four hefty vine stalks that grow from its corners. Unlike the North African vines, these emerge directly from the ground-line. The Melian panel illustrates that even when a diagonal scheme was chosen in the east, the treelike vine growths were preferred over those emerging from kraters or acanthus clusters. The Melian vineyard is occupied solely by a few scattered birds, a rooster, and a hare; there are no vintaging Erotes, peasants, or Dionysiac figures.

29. Geyer 1977, 141.

Figure 156. Melos, long hall, vine panel (after Bosanquet 1898, pl. 1)

There are two other vine mosaics from private homes from the east, both now in the Antioch Museum, dated to the first half of the third century: one, found in Tarsus, shows Ambrosia swirling through a leafy tangle; and the other, from the House of the Boat of the Psyches in Antioch, shows Lycurgus ensnarled by the shoots.[30] In both cases the stalks grow naturalistically out of the groundlines or clumps of earth.

These mosaics represent a Dionysiac myth by means of what Levi calls an "excerpt with a single protagonist" isolated against a ground of vines.[31] A similar format is found in the depiction of Lycurgus on a spectacular floor from Vienne of the late second century (fig. 157).[32] The condemned king stands alone brandishing an ax against the engulfing jungle of vines into which Ambrosia has been trans-

30. For Tarsus, see Budde 1972, 121–26, esp. 123, figs. 118 and 146. For Antioch, see Levi 1947, 178–81, pl. 38a, room 3 of The House of the Boat of the Psyches, dated to the late Severan period.

31. Levi 1947, 180.

32. Ibid., 511, fig. 188; and Lancha 1977, 185–87, pl. 4, fig. 98, inv. no. 236, dated to the late 2d century because by the early 3d century the area of Sainte-Colombe, on the right bank of the Rhone, where the mosaic was found, was destroyed.

Figure 157. Vienne, Lycurgus mosaic, drawing by R. Prudhomme (after Lancha 1977, fig. 98)

formed. The vine is an integral part of the myth and not simply a landscape setting for Dionysiac revels. Yet when the artist could easily have justified an imaginary vine creation, he chose a naturalistic arrangement. The sprawling vines, weighted with ripe fruits and mature leaves, grow out of three thick stalks placed vertically on each side and set into a black border, clearly meant to give the illusion of the ground.

The Vienne vine carpet, unique in the west, shows several ties to eastern art. Not only is the composition of the myth similar to those of the Antiochene examples, but its lush illusionism is close to the eastern pictorial style.[33] The choice of a realistic vine composition in Vienne corresponds to the vine designs chosen by the makers of the Gallic *terra sigillata*, and together they point to an eastern influence on Gallic art. The sculptural evidence is equally suggestive: the application of vine scrolls peopled with vintaging putti as architectural decoration was common in Gaul.[34] It is likely that the Gallic series reflects Gaul's frequent contacts with the east Roman world. The Vienne carpet, like the one in Paphos, raises the question of exchanges between east and west. Both appear to be original hybrid creations that were independently conceived but drew on sources outside their geographical confines.

The visual perspective of the Paphian and Vienne vine-carpet mosaics could best be described as "katoptic" in the sense that they invite the viewer to look down over an entire vineyard or, in the case of Vienne, a vine forest. In this sense, the mosaic is perceived as a whole and the composition is successful as a surface-covering device. In addition, the treelike arrangement divides the composition into individual units along its borders, and so keeps pace with the movements of the guests around the room.[35]

A unique application of this compositional device that uses trees instead of vines occurs on an early-third-century floor in the House of Orpheus in Volubilis (fig. 158).[36] The viewer is invited to look down into a circular forest where Orpheus sits calming the beasts. The forest is divided into radial units by seven trees that grow up from the circumference toward the center, where their curving branches form an octagonal compartment around the seated Orpheus. A great assortment of beasts and birds, set in the spaces between the trees, form rings around the curvilinear octagon. It is likely that the room, given its layout and the subject of the mosaic, was a large triclinium that served as an entertainment pavilion.

33. Similarly, the Lambaesis mosaic exhibits a rich polychromy and illusionistic style (fig. 148) that suggest an eastern hand. This observation is reinforced by the signature of "ASPASIOS" on the Nereid mosaic found with it.

34. Toynbee and Ward-Perkins 1950, 28–30, suggest that it might even have been through Gaul that the Hellenistic motif was introduced to the west because the earliest example of peopled scroll with *protomai* thus far discovered in the west is on the entablature of the Theater at Arles.

35. For North Africa, see Dunbabin 1978, 255 (Cherchel 5), pls. 107–8, dated to the late 4th or early 5th century; and ibid., 255 (Cherchel 10), dated to ca. 320–340.

36. Thouvenot 1941, 42–66.

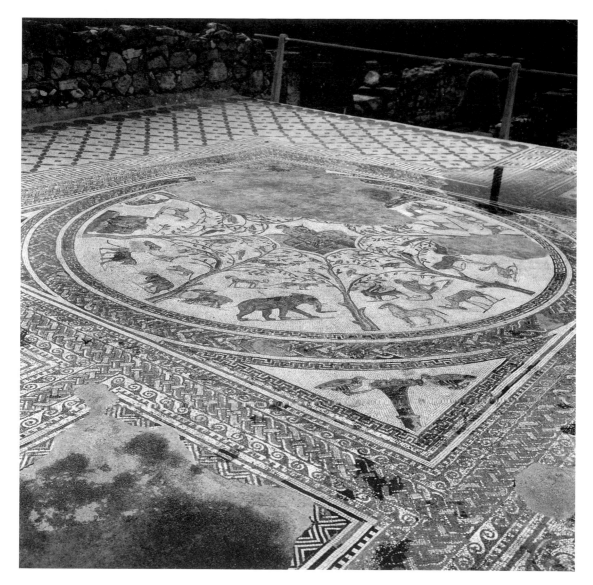

Figure 158. Volubilis, House of Orpheus, tree pattern (courtesy of Roger Viollet, Paris)

The convention of decorating dining areas with lush vine foliage and Dionysiac scenes ties in with both domestic and cult practices. The connections between decoration and function are amusingly posed by a Severan mosaic from the apsidal dining room in the House of the Buffet Supper at Antioch (fig. 86); here the format of the mosaic follows the outlines of the horseshoe table, and dishes and food are set out with culinary realism.[37] The actual table settings are reflected onto

37. Levi 1947, 127–36, pl. 24, dated to the middle Roman period.

the floor, below where the guests would sit and gaze at Ganymede in the central medallion. Ganymede was steward of Olympian banquets, and his image effectively elevates the guests and hosts into a divine realm. At Vienne, the apse mosaic adjoining the monumental vine carpet suggests a similarly nuanced relationship between theme and function (fig. 157).[38] The designer filled the curved space with four Dionysiac figures who recline in a grotto covered by vines (in the apse part of the pavement/drawing). The merrymaking of the mosaic revelers was clearly meant to set the tone for the guests who actually dined in supine positions at a *sigma*-shaped table. The lush arbor-like setting for the mythical diners also stirs a cultural memory in its evocation of the ritual origins of such domestic repasts. The prevalence of such settings can be seen in an early-fifth-century mosaic from the House of Bacchus and Ariadne at Thuburbo Maius, where Dionysos and Ariadne recline under a vine arbor accompanied by revelers in the two registers below.[39]

The recreation of a grotto for the dining area derives from a popular Roman custom. At the highest levels, we learn from Athenaeus in his *Deipnosophists* that Mark Antony visited Athens and "erected a scaffold in plain sight above the theater and roofed [it] with green boughs, like the 'caves', built for Bacchic revels; on this he hung tambourines, fawnskins, and other Dionysiac trinkets of all sorts, where he reclined," and spent the night drinking and feasting with friends.[40] Athenaeus in the same work also describes one of the elaborate carts in the Dionysiac *Pompē* of Ptolemy Philadelphus which was surrounded by nymphs and was drawn by five hundred men, carrying a deep cavern, covered with ivy, from which issued two springs of wine and milk.[41] The Lambaesis mosaic (fig. 148) and the Hermoupolis goblet (fig. 149) fit the image conjured by the float in this passage. Thus the fashion for portraying grottoes either in cult dining halls (*stibadia*) or in private residences goes back to the Hellenistic age, was taken up by Roman emperors, and was passed on down through the Empire.[42]

Turning from the written accounts and mosaic reflections to the archaeological record, we find abundant evidence for the existence of outdoor vine-covered settings in both the domestic and cult buildings of Pompeii. The major source for this material is a publication of Pompeian gardens which catalogues masonry triclinia in the gardens of Pompeian private houses.[43] These are U-shaped struc-

38. Lancha 1977, 186.

39. The mosaic is in the Bardo Museum; it will appear in the forthcoming vol. 2, fasc. 4, of *Mosaïques de Tunisie: Thuburbo Majus*, ed. M. Alexander and A. Ben Abed, as no. 376.

40. Athenaeus, *Deipnosophistae* 4.148c (trans. Gulick/Loeb, 177).

41. Ibid., V.199a. It is interesting to note, in relation to mosaic vine schemes, that this cart was followed by a float with a winepress bearing sixty satyrs trodding the grapes. Three satyrs press the grapes in the center of a third-century mosaic vine carpet in the House of the Amphitheater at Mérida; see Blanco Freijeiro 1978b, 44, no. 39, pl. 73. The vines emerge from four kraters in the corners and divide the composition into four even sectors, thus echoing the neighboring North African taste.

42. Stewart 1974, 76–90, on Imperial dining in grottoes.

43. The following sites are discussed as examples of masonry triclinia with vine pergolas in Jashemski 1979: House of the Centenary (IX.vii.6) 32; House of Menander (I.x.4) 92; House of the Ephebe (I.vii.1) 92, fig. 145; Inn of the House of Sallust (VI.ii.4) 168; west of the Great Palaestra, 176, fig. 261; Garden of the

tures consisting of two parallel couches joined by a third couch and shaded by a vine pergola supported by stucco-covered masonry columns. Just such a structure must have surmounted the raised dining area at the rear of the largest peristyle garden in Pompeii, that of the Villa of Diomedes, where six supporting columns still stand.[44] Some of these masonry triclinia were shaded by the spreading branches of large trees, as shown in the traces of the planting patterns.[45] This variation in plantings is significant in light of the vine-tree arbor represented in Paphos and popular in eastern art. Masonry altars were also found accompanying these outdoor triclinia, an indication that ritual activities took place at the outdoor feasts.[46] The link between Dionysos and outdoor dining is confirmed by the discovery of two large masonry triclinia on either side of a stone altar in the front of the Temple of Dionysos.[47] This is the first time an actual setting for a ritual banquet has been discovered, although other evidence had led scholars to assume their existence for some time.[48]

The construction in Pompeian houses of garden dining areas accompanied by sculpture and reliefs related to the cult of Dionysos supports P. Grimal's view that every garden was regarded as a Temple of Dionysos and was meant to evoke a sacro-idyllic grove.[49] It is not surprising, therefore, to find in these same houses paintings representing sacred gardens for indoor dining.[50]

Aside from the many wall paintings in Pompeii, there are the rare extant fragments of painted ceilings which attest to the tradition of projecting vine arbors onto vaulted ceilings.[51] The flexibility of vine schemes is demonstrated by the paintings in the triclinium of a Roman house below SS. Giovanni e Paolo, called the Hall of the Ephebes.[52] On the wall of this room elegant nude youths, after whom the room is named, stand in contrapposto in front of spring garlands, with

Fugitives (I.xxi.2) 243–44; House of Albucius Celsus/Silver Wedding (V.ii.i) 92. For a catalogue of all known outdoor triclinia in Pompeii, see Soprano 1950, 288–310, who lists thirty-nine examples in all.

44. Jashemski 1979, 315–17, figs. 491–92. See also Rakob 1964, 182–94.

45. Jashemski 1979, 253–54. This triclinium was found in a large orchard located west of the Garden of the Fugitives in insula I.xxii.

46. Ibid., 254.

47. Ibid., 123–24, and 157–58, fig. 244.

48. Nilsson 1957, 63–64. On the sacred character of symposia and domestic cult practices, see Harward 1982, 82–83.

49. Grimal 1943, 317–30. On the presence of Dionysiac themes in garden sculpture, see Dwyer 1982, 263 and 265. For a vivid illustration of the combination of the sacred and garden themes, see the apsidal exedra (no. 24) off the large garden peristyle in the House of Menander at Pompeii; there a sacro-idyllic painting of Venus and Cupid in a rustic temple is capped by a stucco vine scroll spread across the vault of the niche (Clarke 1991, 184–85, fig. 101). The association of ceilings with vine decorations is obvious here and significant for the following discussion. For the archaeological evidence of a wooden triclinium shaded by a vine pergola set up within the interior of this same peristyle, see Jashemski 1979, 92.

50. See Jashemski 1979, 73–79, on garden paintings inside buildings; Grimal 1943, 442–58, describes thirty-seven garden paintings from Pompeii.

51. Such fragments were found in the House of the Fruit Orchard (I.ix.5), dated to ca. A.D. 50; see ibid., 79, figs. 123–25.

52. See Joyce 1981, 62–63, fig. 64, who suggests that the triclinium was decorated at the same time that the courtyard was made into a *nymphaeum*, ca. A.D. 250–75.

various birds surrounding them. Enough of the fragmentary vault above this wall frieze survives to show that the ceiling was originally covered with vine tendrils that grew from clusters of leafy acanthus in the corners and that were peopled with vintaging putti and birds. Season sarcophagi offer the closest thematic and stylistic parallels to the painted program of this dining room, paintings that can be dated to the second half of the third century.[53] The subject of the Seasons and of such occupational themes as the grape harvest came into vogue for the decoration of sarcophagi, primarily in Rome, in the early third century. Such themes are also found painted on the vaults and walls of second- and third-century sepulchral chambers throughout the Empire.[54] The same patrons who wished to evoke the blessings of the Dionysiac vineyard in their dining areas aspired to bliss and abundance in the afterlife. In this sense, the ritual banquets in domestic and cult buildings were a prefiguration of the rewards awaiting these followers of Dionysos. The popularity of the vintage theme in funerary art may well have been inspired by its use in domestic settings.

If we assume that certain ceiling designs preceded their mosaic twins, then it is natural to see the development of diagonal vine-scroll compositions in mosaic as a reflection of groin vaults.[55] In such arrangements, the diagonals are marked, as on the painted ceilings, by vases or acanthus clusters set in the corners from which spring vine tendrils that envelop a central subject.[56] One alternative favored in the east was the use of the trunks of vine trees set along the diagonals of a vaulted ceiling or of a floor, as in the mosaics of Antioch.[57] Recent research on Roman interior decoration has shown that the form of the ceiling rarely influenced the choice of the decorative system, so that diagonal schemes appeared on barrel vaults and flat ceilings as well as on cross-vaults.[58] The interchangeability of these systems suggests that the selection of themes was determined by other considerations. Such ceiling decorations might well reflect "katoptic" views of gardens transferred from floor mosaics.

Just as the original inspiration for these vine schemes, on both the ceilings and floors of Roman reception halls, derived directly from dining practices in domestic and cult settings, the appearance of several types of vine arrangements

53. Ibid., 63; and Hanfmann 1951, 64, fig. 2.

54. An excellent example survives from an early-3d-century tomb in Rome, on which the banqueters are seated at a *stibadium* set below a vine arbor; see Tran Tam Tinh 1974, 71–72, no. 50, fig. 57.

55. See note 49 above for the example of the stucco vine scroll that adorns the apsidal exedra in the House of Menander at Pompeii.

56. For an overview of these interchanges between ceilings and floors, see Lavin 1963, 219–21. A North African example of a diagonal vine composition can be found in the mosaic from Kourba now in the Bardo Museum (Dunbabin 1978, 263, Kourba 1a), with a date of ca. 250–300; and Lavin 1963, 221n.184, who dates this floor to the early 3d century). For an eastern example, see the vine mosaic from Argos with maenads (Kritzas 1973–74, 230–46, pl. 159b).

57. In a domestic context, there is the barrel-vaulted niche covered with vine branches springing from the four trees placed in each corner of a house in Ephesus; see Jobst and Vetters 1977, 64–74, figs. 110–21, who date it to the early 5th century.

58. See Joyce 1981, 93.

undoubtedly reflects the diversity of these settings. Similarly, as the pergolas shading the masonry triclinia, in both the outdoor gardens and the peristyle gardens, were covered with varied plantings, so too were the vine mosaics diversely arranged.[59]

The Paphos floor combines two types of vine compositions and represents a conflation of eastern and western traditions. The all-over treatment of the floor as a vine carpet links the Paphian creation with the North African series, which almost exclusively uses the pergola-type composition ultimately derived from ceiling decoration. The use of real trees as the dividers, however, is inspired by a "katoptic" view of a garden that originated on floors and was explored primarily in the east. The Paphian vine arbor with its realistic upright vine trunks vividly illustrates a fashion for representing vine schemes by a series of upright trees that divide the composition into discreet units without imposing a dominant central focus.

ICONOGRAPHY

The treatment of the Paphos vintage scene as an all-over vine carpet offers provocative evidence of the possible ties of the Paphian workshops to the North African workshops. Yet we can determine that the mosaicists at Paphos clearly did not base their composition on North African models, for two major reasons. One is the choice of the upright vine plantings, already discussed. The second is the inclusion of rural activities performed by adult figures within the context of the Dionysiac vineyard. The imaginary world of the winged Erotes is surely meant to evoke Dionysiac associations and, as such, offers a colorful complement to the Dionysiac Triumph at the entrance. The addition of rural figures attests to the conflation of a mythological vintage with rustic realism and distinguishes the Paphian vine carpet as an original product.

In North Africa, the distinction between fantasy and genre was maintained even when the vogue for realistic subjects intensified during the Severan period. Generally, vine carpets are inhabited by Erotes and linked to Dionysiac themes (fig. 150), while rural scenes are filled with peasants engaged in the occupations of country life (fig. 159).[60] This differentiation is complicated by the involvement of Erotes in rustic activities. The compositional development of vine carpets and rural scenes was separate until the fourth century, when some overlapping took

59. For a discussion of the varied methods of vine training employed by the ancients, see Jashemski 1979, 210–14. The author draws on studies of Roman viticulture made by Varro, Cato, Columella, and Pliny. For a recent publication on all aspects (both cultural and technical) of viticulture based largely on classical authors, see Hagenow 1982.

60. Both types of compositions are represented within the same house in the House of the Laberii at Oudna; for the vine-carpet floor (herein fig. 150) and the rural scenes (herein fig. 159), see Dunbabin 1978, 266 (Oundna 1m) and 265 (Oudna 1f), pl. 101.

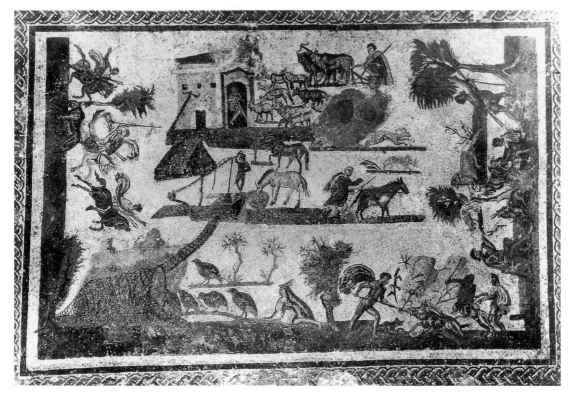

Figure 159. Oudna, House of the Laberii, room 21, rural scenes (courtesy of the National Museum of the Bardo)

place, but the conflation of real and ideal figures remained an anomaly.[61] Their combination in Paphos confirms the independence of this Cypriot workshop and its creative adaptations of the artistic koine of the Mediterranean.

An examination of the various scenes and the extent to which their details conform to established types provides a measure of the iconographic originality of the Paphos vintage scene (fig. 144). At the east end of the north side of the triclinium we find an adult male wearing a green loincloth; he reaches with his right arm (restored) for a large hare resting on red-brown turf and feeding on the grass that grows on it (fig. 146). That the hunting of hares traditionally involved baskets is attested by several illustrations of this technique[62] and was associated with the seasonal occupation for Autumn.[63] The solitary hare peacefully nibbling

61. See, e.g., the two vineyard scenes from Cherchel in Dunbabin 1978, 254, pl. 105 (Cherchel 5), 254 and 255 (Cherchel 10,ii).

62. A well-known example of a hare hunter comes from the Great Palace mosaic, in which a young boy is about to trap a hare with his basket; see Brett 1947, 71, pl. 28.

63. The seasonal association of captured hares and grape vines with October is made in a Latin tetrastich in *The Calendar of 354*, which states, "October offers you the captured hare and the grapes within vine-leaves"; see Levi 1941a, 268.

on grapes or leaves commonly appears as a decorative motif within the compartments of geometric or floral patterns in textiles, mosaics, and sculptural friezes.[64] Diverging from these standard representations, the Paphos mosaic shows the hunter about to catch a hare with his bare hands. A close parallel for this type exists in one of the earliest North African vine carpets from the House of the Laberii at Oudna (fig. 150). Along the mid-point of the right side of the composition (i.e., to the right of the mythological panel), a winged Eros steps forward with both hands extended toward an animal that appears to be a hare hunched on a small piece of grass; unfortunately, it is difficult to verify the animal's identity because its head is damaged. To one side of this group stands a large bird (partridge?) with a striped underbelly.[65] Although there are other close similarities between the Paphos and Oudna vintagers, the African harvest is populated exclusively by Erotes.

The four male vintagers and herdsman who appear along the north and south sides attest to the appropriation of the traditional fantasy garden as part of the real world. This design is realized by the placement of all earthly creatures at ground level—that is, around the edges of the composition and parallel to the vine stalks—while Erotes appear both on the ground and in the air. The rural figures are conventional: most wear short tunics, carry baskets laden with grapes, and hold shepherds' staffs (fig. 160). They are accompanied by a snake (fig. 161) and a saddled donkey; a donkey picking grapes on his hind legs (along the north side); a pair of tethered donkeys on the side of the room, also on the south; a lizard and goat (fig. 160). The bearded herdsman in short tunic runs after a wayward ram with a club (fig. 162).

There are no exact parallels for these vintagers, but they conform in dress and occupation to the genre figures that were popular in North Africa by the mid-second century and proliferated in the fourth century (fig. 159).[66] The rural realism of the Paphos scene is unusual because mythological figures and personifications typically abound in eastern mosaics of the second and third centuries.[67] One chronologically early exception comes from Kos, where the quotidian activities of bird hunters and fishermen are depicted on an early-third-century mosa-

64. For hares nibbling on grapes or leaves as singular and repeated motifs on textiles, see Liapounova and Mat'e 1951, 61, pl. 27. For mosaics, see the hare nibbling on grapes set in a medallion along with other *xenia* subjects in a mosaic from Orbe, Switzerland, dated to ca. 200–225; see von Gonzenbach 1961, 177–82, cat. no. 95 (Orbe III).

65. A similar bird, called a partridge in the description, appears in the Seasons mosaic of the Villa of Dar Buc Amméra; see Aurigemma 1926, 115, cat. no. 22, fig. 67, pl. 128.

66. For example, the mosaics of La Chebba, Oudna (herein fig. 159), Zliten, Utica, and Cherchel offer close parallels in dress and type; see "Rural Scenes" in Dunbabin 1978, 109–23.

67. In particular, there is a noteworthy absence of such rural scenes in the mosaics of Antioch until the 4th century, with the exception of a panel with an olive harvest scene from the House of Menander, upper level, room 13, which is dated to the mid-3d century (Levi 1947, 204–6, pl. 46d); and a set of border panels with topographical scenes from the House of the Mysteries of Isis of the early 3d century (ibid., 166).

Figure 160. Vine carpet, detail of a vintager with baskets, lizards, and goat on south side (courtesy of the Department of Antiquities, Cyprus)

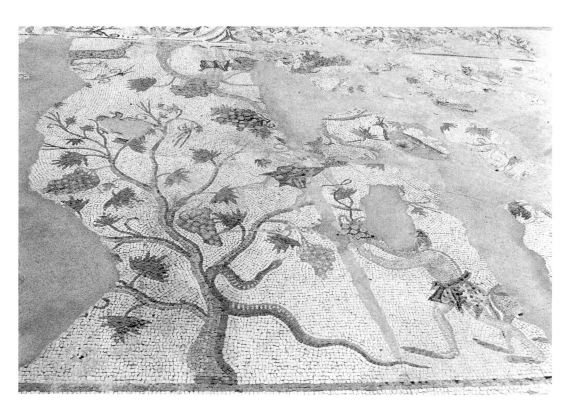

Figure 161. Vine carpet, detail of vintager with snake on north side (courtesy of the Department of Antiquities, Cyprus)

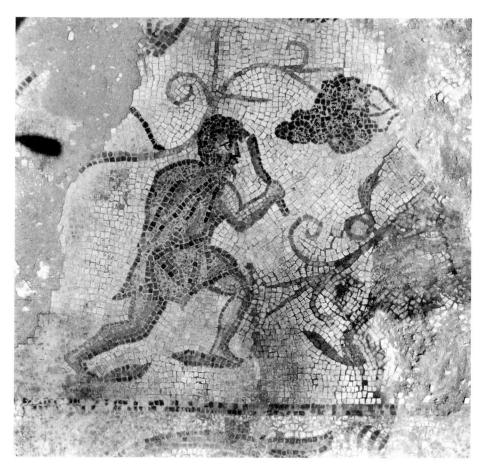

Figure 162. Vine carpet, detail of a shepherd with club on south side (courtesy of the Department of Antiquities, Cyprus)

ic.[68] The discovery at the same site of a mosaic panel with gladiators and their inscribed titles reinforces the impression of a keen interest in genre scenes which is in keeping with the Severan date assigned to these mosaics.[69] The Kos mosaic, like the Paphian vintage, also breaks from the eastern habit of employing picture-panels (*emblemata*) with spatial illusionism. Instead, the designers placed isolated vignettes against a plain ground. This system was more flexible because it did not demand a one-point perspective; such compositions could also be expanded according to the size and shape of the room. Even in Corinth, where western models were well known, the Greek artists chose to decorate the atrium of a

68. The mosaic was discovered in the western area of the city near the small port; see Jacopich 1928, 98–99, fig. 81, and Atzaka 1973, 34, no. 30a, pl. 17a.

69. The amphitheater scenes are now in the Archaeological Museum, Istanbul; see Atzaka 1973, 234, no. 29, pl. 16b. These mosaics are dated on stylistic grounds to the early 3d century.

Figure 163. Orbe, frieze of genre scenes (after von Gonzenbach 1963, pl. 49)

Roman villa with four illusionistic panels of pastoral subjects.[70] The unusually early appearance at Kos and Paphos of the expandable formula wherein single rural episodes were set into a neutral matrix is significant.[71] Such methods were more typically applied to areas that required long narrow panels—that is, corridors, porticoes, or strips of borders—around larger compositions. For instance, on one early-third-century mosaic from Orbe in Switzerland a frieze of genre scenes frames a lost central composition (fig. 163).[72] Here also, minimal landscape elements, a simple white ground, and a few shadow lines highlight single figures enacting seasonal activities (e.g., bird catching, the delivery of the stocks).[73] It is interesting that another mosaic from Orbe with hunting scenes provides a compelling contemporary comparison with the Paphian hunting mosaics. In the Cypriot vintage all the groundlines are dissolved except for the foot shadows, and all spatial relationships are subordinated to the vine plantings that correspond to the seating arrangements in the dining room.

Aside from Paphos, only one other eastern site has produced a rustic vintager in a vine composition. The vintage mosaic discovered near the excavations of a Roman villa in Kastelli Kisamou, western Crete, includes a fragment with a plump young boy reaching up to cut a bunch of grapes with his sickle (fig. 164).[74]

70. See Shear 1930, 19–26, pls. 3–5; and Waywell 1979, 297, cat. no. 17, who dates room A (atrium) of the Roman villa found to the northwest of Corinth in the Hadrianic or Antonine period. For the currency of western models in Greece, see Miller 1972, 353–54; and Packard 1980, 344–46.

71. Other points of comparison between the mosaics of Kos and Cyprus are discussed in Chapter 8 on the hunt mosaics.

72. Von Gonzenbach 1961, 174–77, no. 95 (Orbe II), pls. 49–53.

73. In its realism the oxen-drawn cart recalls the cart laden with wineskins and led by Ikarios in the central panel of the west portico in our house.

74. Tzedakis 1972, 637–38, pl. 599c and d. This mosaic is dated by the excavator to ca. A.D. 100–150 by its technique and style. It was discovered at a distance of 200 meters northeast of the Roman building decorated with mosaics from the late 3d or early 4th century (Tzedakis 1969, 431–32, and Atzaka 1973, 224–25, no. 15, pl. 10a). These later mosaics do not seem to differ greatly in style or technique, at least not in reproductions, from the mosaic of a boy plucking grapes discussed here. The early-second-century date is too early for the style, subject, and geometric borders used on this mosaic. It seems likely that it belongs to

Figure 164. Crete, house of Kastelli Kisamou, boy picking grapes (after Tzedakis 1972, pl. 599a)

Although awkwardly rendered, this figure is clearly not an adult or an Eros. Children of Eros-like proportions are often represented performing adult activities, a rendering that follows the Hellenistic habit of substituting Erotes for men in realistic scenes.[75]

The playful Erotes that scamper in the Paphian vineyard attest to a taste for the fanciful in addition to a liking for rural and everyday features. One of the more imaginative creations is the winged figure that stands to the north of the hare hunter (fig. 165). This Eros (right leg and torso damaged), naked except for the green mantle thrown around his shoulders, stands ready to spear a bull (head and foreleg preserved). A hunt scene, typically associated with the amphitheater, is here enacted in a vineyard by an Eros in the guise of a *venator* (Roman hunter). This one episode epitomizes the synthetic spirit of the Paphian workshop. Several related but traditionally distinct themes are conflated: the playful substitution of Erotes for humans; the motif of hunting Erotes within the convolutions of the vine and acanthus scroll; the hunt within all-over carpets; and finally, the popular representations of the amphitheater. Although the Severan period marks an increase in the use of all these subjects in new combinations, there is not a single parallel for the overlapping of all four elements; and, in fact, several seem to be

the same period as the first phase of the Roman building (i.e., when it was a Roman house), that is, the second half of the 3d century.

75. Dunbabin 1978, 85–87; and Kitzinger 1951, 111–12.

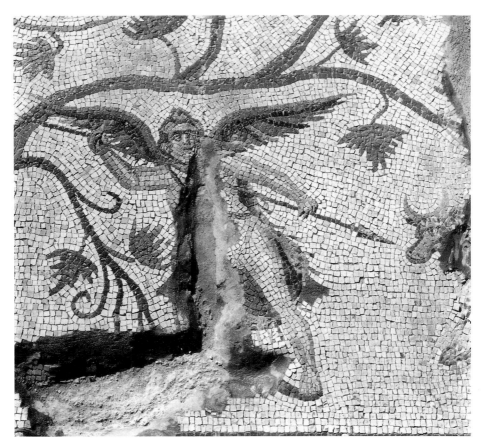

Figure 165. Vine carpet, detail of an Eros and the bull (courtesy of the Department of Antiquities, Cyprus)

mutually exclusive. For instance, although vine carpets include the hunt of hares and birds amid other bucolic activities, wild prey are rare. Exotic beasts such as camels, lions, and elephants do appear in two vine carpets from El Jem, but there they are associated with the Dionysiac cycle (fig. 166).[76] The hunting of exotic beasts by Erotes can be found in the peopled scrolls of decorative friezes and mosaic borders that were the ornamental hallmarks of classical revivals from the Flavian through the Constantinian periods.[77] In the earlier periods, only the foreparts of the beasts and their miniature hunters are visible within the vine convolutions, but in late antiquity, as the scroll becomes looser and less leafy, full

76. The earlier mosaic (ca. A.D 250) is from the House of the Hunt (Dunbabin 1978, 257–58, El Djem 1, and *Inv. Tun.* 67, and plate). The second mosaic is from the House of Silenus (Foucher 1960a, 27–30, pls. 11 and 12).

77. Examples for each period can be found in Toynbee and Ward-Perkins 1950, passim.

Figure 166. El Jem, House of Silenus, detail of vine carpet (photo by C. Kondoleon)

figures appear within the intertwining stems.[78] The appearance of an Eros spearing a bull in the Paphian vine carpet suggests an early migration of hunting motifs from the peopled scroll borders into the area of the primary panel. A similar instance occurs in a second-century mosaic from Chalkis in western Euboea, where an Eros, about to spear a stag, is contained within the central square of a nine-panel grid.[79]

Such playful conflations were also adopted as decorative motifs for friezes and frames without scrollwork. In the border of a Severan mosaic from the House of the Mysteries of Isis at Antioch, winged Erotes dressed as *venatores* combat ferocious beasts.[80] In Paphos itself, an early-fifth-century version of this same theme is found surrounding scenes from the Life of Achilles in the House of Theseus next door (fig. 167).[81] Models for Erotes as hunters were abundant in the east, but the majority of these figures, even in late antiquity, were relegated to the borders. The designer of the Paphos vine carpet extrapolated the hunting Eros, rather than invented it.

In addition to introducing the motif of a hunting Eros into the landscape of the vineyard, the Paphos mosaicist included two other uncustomary figures: a tall Eros, covered by a mantle and holding a bouquet of flowers, stands in the far northwest corner (fig. 168); and in the upper part of the east side, a wide-eyed Eros peers over the brilliant plumage of a frontal peacock and faces the entering guests (color pl. 3). Both belong to an established lineage in Hellenistic and Roman art, but they are displaced from their usual surroundings. The former is easily identified as a relation, if not an actual quotation, of the winged genius that personifies Spring. The closest parallels for the Paphos Eros are found in the mosaics from Antioch. In a corridor of the House of the Drinking Contest, an Eros, naked except for the mantle thrown over his shoulders, is designated by the bowl of flowers he carries as Spring.[82] His dress, stance, and attributes compare with those of the Paphian figure and suggest once again a borrowing of a type typically found in the repertoire of seasonal personifications.

The charming conceit of the Eros and frontal peacock seems to be a fresh

78. The inhabited rinceau functioned as a border motif in the east; see the scrolls peopled with Erotes in the mosaic from Mariamin, now in the Hama Museum (J. Balty 1977, 100–101, no. 45, who dates it rather late, i.e., the end of the 4th century); and the border from a mosaic at Nablus dated to the second half of the 3d century (Dauphin 1979, 11–33, pls. 1–8). In the 6th century the peopled scroll becomes a field design, e.g., the vine scroll carpets produced in Gaza; see Avi-Yonah 1975, 377–83, esp. pl. 182,1, for the Church of Lot and Procopius, El Mukhayyat.

79. Waywell 1979, 296, cat. no. 14, fig. 12, room 5, dated to the 2d century; Atzaka 1973, 251, no. 67, pl. 30a and b. For the initial report on this group of mosaics found in a Roman villa in Gyphtika, a hill in Chalkis, see Andreiomenou 1953–54, 303, 307–11, 313, pls. 2 and 3.

80. Levi 1947, 164–65, pl. 33b, the Navigium Isis, room 1, dated to the late Severan period.

81. See the border of room 40 with the Infancy of Achilles mosaic, dated to the 5th century (Dazewski 1972, 210–17, pls. 36 and 37); Vermeule 1976, 82–83, fig. 15, agrees with the date of ca. A.D. 400 on stylistic and iconographic grounds.

82. Levi 1947, 161–62, pl. 32a, corridor 2b, dated to the late Severan period. See also an Antonine example of the same type in the House of the Red Pavement, room 1 (ibid., 85–87, pl. 13b).

Figure 167. Paphos, House of Theseus, an Eros as hunter in detail of border of Birth of Achilles (photo by C. Kondoleon)

Paphian creation derived from Hellenistic art. Its most dramatic prototype is found in the sculptures set up along the *dromos* of the Sarapeion at Memphis in the early Ptolemaic period. Two of these portray a young boy riding on the back of a peacock with a fully spread tail.[83] The grape clusters and vine leaves scattered at the base of each suggest, as do the dress (*mitrephoros*) and demeanor of the boy, that this might be Dionysos *Pais* (Child Dionysos).[84] The sacred image of the child-god merged with picturesque representations of Erotes in the Hellenistic period, a conflation that created an ambiguity between genre and religious scenes.[85] This ambiguity is easily demonstrated on the short sides of the San Lorenzo sarcophagus, mentioned above, on which Erotes who ride peacocks in a sepulchral context can be interpreted as paradisiacal motifs.[86] Yet they are very similar to those appearing in an early-third-century marine mosaic decorating the

83. Lauer and Picard 1950, 194–209, figs. 95, 99–102.
84. Ibid., 1950, 195–96.
85. Stuveras 1969, 90.
86. Rodenwaldt 1930, 116–89, pls. 6 and 7.

Figure 168. Vine carpet, west end, detail of grape treaders and an Eros with bouquet of flowers (photo by C. Kondoleon)

grand hall of the baths in Utica.[87] Clearly, such images were interchangeable, but their meanings varied according to their settings. They do share a common heritage in the Dionysiac repertory, most fantastically embodied in the *Pompē* of Ptolemy Philadelphus held in Alexandria, where peacocks were carried in cages along with other birds and animals captured in the conquered lands of India.[88] It might be inferred that the capture and riding of the peacocks represent the taming or subduing of the captive peoples and their land, in much the same way that the exotic beasts were included in the Indian Triumph on sarcophagi.[89]

Although the Paphian peacock and Eros are placed above the Dionysiac Triumph and in the ambience of a Dionysiac vineyard, their meaning is less specifically mythological or symbolic of triumph. Two factors indicate a more neutral reading of the image: first, the Eros does not ride the peacock, but rather stands behind it displaying the bird's sparkling plumage; second, it must be seen as a

87. Alexander et al. 1974, 51–58, pl. 33, nos. 205–6; see also Dunbabin 1978, 276, pl. 146 (Utica 4). The mosaic, now in the Bardo Museum, is dated to late 2d century or early 3d century.

88. Athenaeus, *Deipnosophistae* 5.201B.

89. Horn 1972, 28–29. On the missionary context of the Triumph and its civilizing aspects, see Turcan 1966, 448–56.

Figure 169. Hermoupolis, design of goblet (after Adriani 1939)

greeting, given its location at the entrance of the room. The selection of an equally majestic frontal peacock with outspread tail as the sole decoration of room 3 on the south-entrance axis of the Paphian house reinforces the salutatory interpretation of the vintage peacock (fig. 64).[90]

Dionysiac associations are affirmed at the opposite end of the room, on the west side, where two satyrs press the grapes with their bare feet (fig. 168). Although badly damaged, both males clearly wear the *nebris*, are horned, and seem to be balancing themselves by holding onto the vine branches above their heads. This exact pose is duplicated by three satyrs who appear in gilded relief on the Flavian silver goblet from Hermoupolis discussed above (fig. 169). In the early Imperial period the preference seems to have been for satyrs to tread the grapes. For example, several Gaulish potters, producing *terra sigillata* relief wares from the mid-first through the mid-second centuries, developed vivacious scenes of putti vintaging but persisted in using adult males/satyrs for the pressing scenes.[91] The continuation of this tradition is evinced by a third-century mosaic from the House of Amphitheater at Mérida, Spain, in which three men hold hands and tread grapes, their feet lifted in unison (fig. 170).[92] While wine is shown flowing into three vats below them, nude boys (without wings) busy themselves with the harvest by climbing ladders and bearing laden baskets. The vines emanate from acanthus calices in the four corners of the panel that decorates a reception room

90. On the salutatory function of the peacock mosaic in room 3, see Chapter 3.

91. In particular, see the work of the potter Satto; see Delort 1948, 95–127; and Oswald 1936, 48, pl. 24, nos. 489, 494, and 494A (marble prototype).

92. From room 39 (a triclinium?) off the peristyle; see Blanco Freijeiro 1978b, 44–45, no. 39, pl. 73.

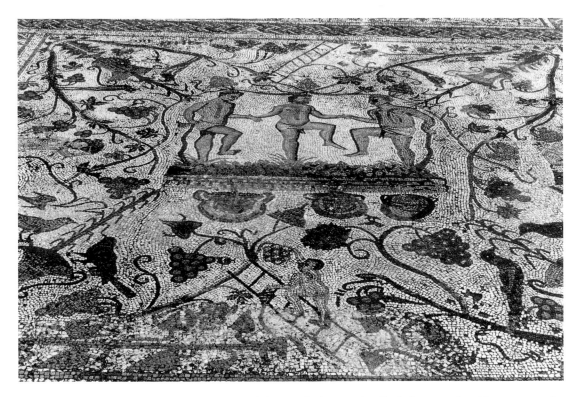

Figure 170. Mérida, House of the Amphitheater, detail of vine mosaic with grape tread-
ers (photo by C. Kondoleon)

directly off the peristyle. Despite the inclusion of *kantharoi* along the diagonals,
the composition is closer in spirit to a genre scene and, like the Paphian vintage,
combines the Dionysiac heritage with a Severan taste for realism.

The transformation of the entire cast of Dionysiac vintagers into genre figures
occurred during the Severan period, when a surge of naturalism dictated a new
style, perhaps one inspired by the tastes of North African patrons.[93] This alter-
ation was so complete that late-antique and early Christian artists felt free to
appropriate vintage scenes and substitute Erotes for adults without implying
paganism. For example, on the sides of the Junius Bassus sarcophagus, dated to
A.D. 342, Erotes tread the grapes and harvest, although the front bears explicit
biblical scenes.[94]

Six other figures can also be identified as Erotes engaged in the harvest. Al-
though they evoke representations of such figures in all media throughout Helle-
nistic and Roman art, they bear a remarkably close resemblance in their acrobatic

93. Dunbabin 1978, 114–18.
94. Deichmann 1967, 279, no. 680, pl. 104. Hanfmann (1951, 184–85, cat. no. 540, fig. 148) discusses the
two compartments on the left as illustrations of the seasonal occupation for Autumn, i.e., the vintage.

positions to the twenty-eight Erotes encircling the Ikarios panel in the great *oecus* of the House of Laberii in Oudna (fig. 150).[95] As in Paphos, these Erotes balance themselves precariously on vine branches in order to reach the fruit and lower laden baskets to those waiting below. An Eros on the right-hand side of the Ikarios panel (directly above the Eros catching a hare? cited above) strikes an unusual pose by stretching out horizontally and clinging to a vine for support as he reaches for a cluster of grapes. Just such a position is reproduced in Paphos by a clothed figure that hands down black grapes to another figure, wrapped in a green cloth and seated cross-legged in the bough of the next vine. Unfortunately, the upper parts of the bodies of both are defaced, but they undoubtedly belong to winged vintagers. This identification is confirmed by the presence of three other nimble Erotes in similar positions who, although damaged, retain their wings. A pair of Erotes occupy the branches above the shepherd and donkey on the north side: the naked one grabs a tendril in the midst of his leap; the clothed one sits with crossed legs in the higher vines. To the east of this pair, a tunic-clad Eros swings between the branches and lets down the rope tied to a grape-filled basket that is received by a male wearing the *nebris* (fig. 171). The final vintaging Eros has both feet on the ground, stands behind branches, and is followed by a donkey along the south side of the room. The Paphian Erotes are comparable in their feats of aerial harvesting to those in Oudna, but the inclusion of adult males sets the Paphian vine carpet apart. The mixture of figures in the Paphos vintage places it between the purely imaginary creation in Oudna belonging to the Antonine period and the heightened realism of Severan art. Typologically, the Paphos vintage seems to be a hybrid of several trends current in the development of vine schemes.

Possible intermediary sources for compositions that combine rural and mythological aspects of the vintage may be sought in metal and ceramic wares. By the Augustan period, the vintage was a popular subject for luxurious drinking vessels.[96] The consequent appearance of vintages with genre elements on the relief wares of Gaul in the first and second centuries, long assumed to be imitations of toreutic designs, suggests that the motif gained wide currency through the medium of metalwork. The decorations on the *terra sigillata* represent the whole gamut of Greco-Roman genre figures, often as repeated motifs divorced from their original context. Not only does the diverse selection of vintagers from Paphos find counterparts on these wares, but so also do the nibbling hare and the hunters and beasts from the peristyle.[97] Like the vintage at Paphos, the vine

95. Gauckler 1896, 207–10, pl. 21, room 32. For a review of the various dating arguments and a suggestion of ca. 160–180 for the Ikarios panel see Dunbabin 1978, 112n.18 and 240–41, app. 3; Lavin 1963, 221n.180; and Levi 1947, 522n.25, who dates it "not before the Hadrianic age."

96. Toynbee and Ward-Perkins 1950, 27.

97. Oswald and Pryce 1920, pl. 17,4, a vessel signed "SATTO FECIT" with an image of a hare, from Mainspitze; for the vintagers, ibid., 101, pl. 19,5, a vessel signed "BIRACILLUS," from Rottweil; and for the hunters, ibid., pl. 20.5, from Lezoux.

Figure 171. Vine carpet, north side, detail of an Eros lowering basket of grapes (courtesy of the Department of Antiquities, Cyprus)

schemes on this red-glazed pottery are comprised of thick stalks set upright, a position perhaps reflecting the technique of supporting vines by means of wedding them to trees,[98] and they show equal intervals between harvesting Erotes. These compositions are distinguished by the *realia* of the harvesters, such as ladders, baskets, and sickles, and by the exclusion of mythological figures. Although the Paphian Erotes are closer to those in the mythological vine tradition, the adult figures are taken from the repertoire of genre scenes.

The Paphos vine mosaic represents a unique creation, conceived within the framework of the vine-carpet tradition but drawing on a wide range of motifs. Elements from the related worlds of pastoral *realia* and the mythical realms of the

98. Jashemski 1979, fig. 309, no. 6 (*arbustum* method of vine training). On this method see Cato, *De re rustica* 1.7, and Columella, *De re rustica* 5.6; on the diverse methods used in the provinces, see Varro, *De agricultura* 1.8.1.

Dionysiac cult were adapted and rearranged at will with equal disregard for, or ignorance of, their respective traditions. (This eclecticism helps to explain the criss-crossing of my investigation here.) Once freed from their sources, artistic themes such as the vine harvest only dimly recall their models and often acquire regional peculiarities. In the case of the Paphian vintage, they are the vertical vine trunks and the separation of the vintage and the Triumph into two adjacent compositions. At the same time, the proliferation of all-over vine carpets in the reception and banquet rooms of North African houses undoubtedly reflects the decorative standards for the homes of wealthy merchants, a preference that might well have accounted for the selection of such a floor at Paphos. The popularity of a theme did not, however, guarantee a familiarity with its original context or source, so that the vintage, just as the pendant Triumph panel, is an ad hoc production. The combination of these two related and often conflated themes as independent units indicates an early stage in their development as mosaic subjects. The use of an expandable vine scheme and the combination of rustics and Erotes, usually associated with the third century, characterize the Paphos vine carpet as a precocious and provincial creation of the early Severan period.

The Peristyle
Public Spectacles in the Private Sphere

 HUNTING MOSAICS offer a broad and profound view of both the stylistic evolution and the cultural develop ments that accompanied the Romanization of the east. Scholars have analyzed the implications of their compositional varieties and have generally located their iconographic sources in the contemporary practices of Roman society.[1] An examination of the hunting scenes that decorate three porticoes of the Paphian peristyle provides compelling new evidence for the theoretical schemes of development outlined by these studies. A consideration of the location of the Paphian hunting mosaics within the plan and overall decoration of the house, along with an inspection of the analogies for their composition and iconography, yields insights into the complex dialogue between form and function, aesthetic taste and communal practice.

Like the vine pavement in the triclinium, the hunting mosaics are unusual for the eastern mosaic repertoire, especially for the proposed late-second-century or early-third-century date for the House of Dionysos. Although the subject of the hunt, drawn both from the rustic genre and from staged events in the amphitheater, was known in the east, it is the composition of the Paphian hunts that is so surprising for its early date. In fact, it is unlike any other composition in the house

1. For an analysis of the various hunting compositions, see Lavin 1963, passim. Detailed iconographic treatments can be found in Dunbabin 1978, 46–87; and Aymard 1951, passim.

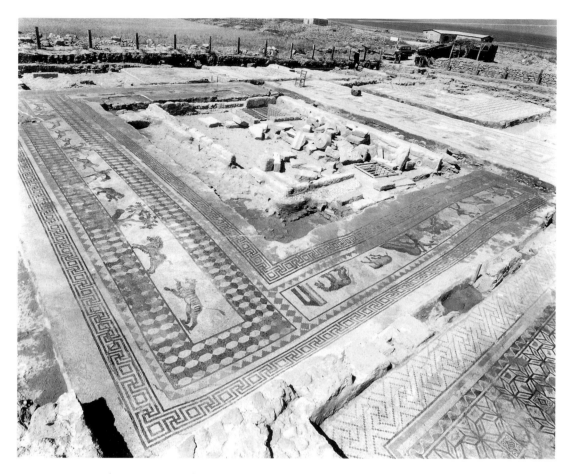

Figure 172. Peristyle, general view (courtesy of the Department of Antiquities, Cyprus)

itself, with the possible exception of certain features of the vintage floor. The hunt scenes, comprised of six hunters and eighteen beasts, unfold in a frieze composition in three porticoes of the atrium peristyle (fig. 172). The fourth side, the west portico, is decorated with four mythological panels that correspond to the decoration and arrangement of the triclinium and are not obviously related to the hunting themes. The rhythm of animals and hunters, placed one after another against a plain ground with only schematic allusions to landscape and setting, guides the visitor around the grand peristyle (measuring 15.2 meters along the north-south axis and 11.75 meters along the east-west axis).[2] Because the peristyle is central to the architectural design, the guest is thereby introduced to the overall splendor of the house. The significance of the hunt scenes is emphasized by their location in the three long porticoes linking major areas of the house, and by the sheer magnitude of their surface area.

2. A detailed description of these figures appears below.

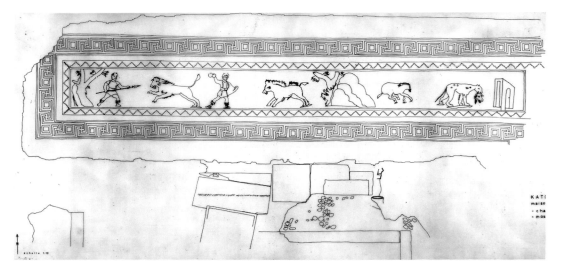

Figure 173. Peristyle, north portico panel, hunt scenes, drawing by M. Medič (courtesy of the Department of Antiquities, Cyprus)

As the guests or inhabitants ambled about the naturally lit peristyle, they encountered various episodes of the hunt. The three panels are divided into eleven distinct scenes consisting of *venatores* pursuing and attacking exotic beasts, and each unit includes landscape elements, comprised of trees on rocky hillocks, or architectural elements, such as an arch (e.g., north portico, fig. 173).[3] The action is lively and these scenic devices encourage the viewer to move in stages across the floor and, in this sense, recall the effects of the vine trunks in the vine pavement of the triclinium. The orientation of the figures themselves varies from portico to portico, so that the south and east panels are meant to be viewed from the outside, the west and north porticoes from the inside.[4] These changes of orientation affect the manner in which the hunting panels are read by the visitor. Taking the actions of the human figures as a guide, one reads the north panel from left to right (fig. 173) and the east panel from right to left (fig. 182). But the south panel reads partly from left to right, partly from right to left (fig. 186). The action is continuous on the north and east sides, while the south side is interrupted by the changes in the direction of the hunters.

COMPOSITION

The Paphian hunting mosaics clearly belong to that category of figure carpets which, like their geometric and floral counterparts, was favored for covering long

3. The hunts at Paphos recall the wild-beast shows of the amphitheater, as is shown in the iconographic discussion below.
4. Nicolaou 1971, 143–44, notes the multiple orientation of the portico mosaics but cannot "offer any satisfactory explanation."

narrow surfaces—corridors and porticoes.[5] Such compositions are characterized by the even, continuous effects of their repetitious patterns or figures, typically set against a solid ground. The absence of any spatial illusionism liberates the design from perspectival constraints, thereby guaranteeing its adaptability. For example, the Paphian hunters and beasts form divisible units that could be adapted to any space. The inherent logic of such compositions is their flexibility and obvious suitability to the function of covering floor surfaces.

The style and arrangement of the Paphian hunting panels, with their summary allusions to setting, white backgrounds, vividly colored beasts and hunters, and extendible formats, have contemporary parallels in the west. This type of hunt does not appear in second- or third-century Antioch, the center to which the Cypriot mosaics have been most closely linked by their style and technique. It appears that the Paphian hunting mosaics anticipate the development of large-scale hunt carpets in the east by as much as two centuries. What then is the explanation for the precocious appearance of such a progressive composition, outside of the eastern mainstream, in provincial Cyprus?

The treatment of the Paphian hunting panels parallels formal solutions favored for covering elongated surfaces, such as frames and corridors, in the Latin west. The porticoes of the peristyles present essentially the same format for decoration as a frame. In the west, portico designs, whether geometric or figural, were executed without interruption around all four sides.[6] At Antioch, extensive surfaces were covered with all-over geometric patterns, but these were divided up into separate panels.[7] When figural scenes were used as frames in Antioch they were treated as individual picture units that adhered to the illusionism preferred by eastern artists until the mid-fifth century.[8] The appearance in Paphos of long, uninterrupted panels filled with figural scenes treated in a two-dimensional, nonillusionistic manner is surprising.

The stylistic antecedents for such hunt porticoes can be found in the black-and-white mosaics of Italy. An early-second-century mosaic from Castel Porziano once framed a grand quadriporticus of a bath building and includes representations of staged hunts that resemble those at Paphos (fig. 174).[9] The *venationes* of the amphitheater are displayed on two sides, while mythological marine creatures frolic on the other two sides of the peristyle.[10] The arrangement of these scenes in long panels covering immense surfaces (365 sq. meters), the use of widely spaced

5. Lavin 1963, 218.

6. Ibid., 219 and 230.

7. Kitzinger 1965, 343n.6.

8. E.g., the border panels with pastoral scenes found in room 1 of the Constantinian Villa; see Levi 1947, pl. 59a-d.

9. Blake 1936, 156; Aurigemma 1974, 76, pl. XIX, no. 166; Lavin 1963, 252, figs. 117 and 118; Becatti 1961, 302. The mosaic is currently in the Cloister of the Ludovisi Collection in the National Museum, Rome, inv. no. 61649.

10. For the marine scenes, see Blake 1936, 147; and Becatti 1961, 319, who compares the marine creatures to the analogous repertory in Ostia and dates the entire Roman peristyle to the first half of the 2d century.

Figure 174. Castel Porziano, hunt mosaic frame, Ludovisi Collection, Terme Museum (after Lavin 1963, fig. 117)

figures with minimal groundlines, and the large expanses of white ground correspond to the treatment of the Paphian hunts. At Castel Porziano there are two types of amphitheater hunt figures—the *venatores* who attack the animals and the *bestiarii* who incite the beasts to fight each other. The Roman menagerie differs from the Paphian one only in its inclusion of ostriches. The hunters assume similar offensive positions with their spears, and although there are no *bestiarii* in the Paphian hunt, there are indirect references to this type of spectacle in the episodes in which beasts ferociously attack each other. Both mosaics portray the use of hounds to assist hunters in the chase. The arrangement in the Castel Porziano hunt, of some hunters and animals in two registers, indicating spatial depth, sets it apart from the Paphian hunt, which strictly adheres to a sequential

frieze composition. The Roman example also differs in the absence of any indication of setting except for minimal groundlines and foot shadows. These discrepancies can be explained by the differences between Italian silhouette-style and polychrome mosaics. A mosaic with the black-and-white technique in effect was a reduction of the Hellenistic polychrome type of composition: it eliminated elaborate picturesque settings in favor of neutral, and therefore more unifying, white backgrounds.[11] Just as the silhouette figures could be plastically conceived through expert draftsmanship, depth could also be figuratively carved out of the solid ground by the skillful arrangement of figures. As polychrome mosaics, the Paphian hunts could have made use of the Hellenistic repertoire of illusionistic settings, yet they are unmistakably influenced by the Roman vogue for silhouette mosaics.

Excavations at Ostia Antica revealed a group of eight datable black-and-white mosaics with representations of activities related to the *venationes*; they range in date from the Hadrianic to the early Severan periods.[12] The Castel Porziano mosaic has been dated with the early examples from this Ostian group, that is, from the first half of the second century.[13] The grandest and liveliest of the Ostian series is found in the circular *frigidarium* of the Baths of the Seven Sages, wherein fifteen hunters and eighteen beasts chase one another in and out of an acanthus scroll that unfurls in a radial pattern.[14] This mosaic composition seems to have been inspired by the arena hunts, with its diversity of beasts, including growling hounds; bears, lions, and leopards who spring in mid-air; determined boars and bulls; gracefully leaping deer; and hunters who stand ready to hurl their lances. If it were possible to dissolve the scrollwork, a continuous frieze, albeit in a circular arrangement, would emerge and present a plausible Hadrianic predecessor for the Paphian hunt. The foliate framework and the nudity of the hunters immediately signal a fantastic interpretation, but the hunts nonetheless derive from the *realia* of the arena. The convolutions of the black scrolls optically dominate the field and qualify the Ostian mosaic as one of the earliest floral carpets, and its floral

11. Becatti 1965, 22 and 24.

12. The Ostian hunt pavements are the following, according to Becatti's chronology and catalogue: the fragmentary no. 62, with leaping horse, bear, deer, and tiger, from the Baths of the Cisiari dated to ca. A.D. 120 (1961, 40–41, pl. 90); no. 268, with hunters and beasts inhabiting a foliate scroll, from room C ("Rotonda") of the Baths of the Seven Sages dated to ca. A.D. 130 (134–36, pls. 84–86; 94–95); three from about the mid-2d century: no. 18 of a tiger and panther from the *Horrea* of *Epagathiana et Epaphroditiana* (17–18, pl. 92) and nos. 28 and 109 from the Piazza of the Corporations, *statio* no. 52 with a venator and bull, and *statio* no. 128 with an elephant, stag, and boar (82, pl. 101, and 76–77, pl. 93); and finally three from the Severan period in the first half of the 3d century: no. 359, showing hounds attacking Actaeon from the Insula with Viridiana (189–90, pl. 97); no. 76, the depiction of the slaughter of bulls for sacrifice from the Barracks of the Vigiles (61–62, pl. 100); and finally no. 408, with fawn, tiger, panther, and wolf, from the House of Fortuna Annonaria of the late 2d century (213–17, pls. 97–99).

13. Becatti 1961, 319; and Ville 1965, 150n.26, who compares the beasts of Castel Porziano to those found in the *venatio* mosaics from Ostia.

14. A Severan date is suggested by Toynbee and Ward-Perkins, 1950, 22. Becatti dates it to ca. A.D. 130 for stylistic reasons (1961, 301 and 339).

character also distinguishes it from the Paphian figural frieze.[15] The remaining Ostian examples do not pertain to this discussion of composition and are considered later with iconography.

Recent archaeological discoveries suggest an eastward path for these western techniques and designs. In Asia Minor, the Italian excavations of Iasos have revealed a series of monochrome geometric floors in the House of the Mosaics, dating to the Hadrianic period or possibly earlier, which indicate a wholesale importation in the first and second centuries of the Italian black-and-white style.[16] A dramatic illustration of the ambitious scale of such importations can be seen in the unique find of a black-and-white marine mosaic in the second-century Roman Bath at Isthmia near Corinth (fig. 132).[17] There is little doubt that this composition of Nereids and Tritons surrounded by sea creatures was inspired by the monochrome fashions of Italy, well documented in the marine series from Ostia.[18] The organization of the Isthmian mosaic into multiple panels and frames that create a hierarchy of decorated zones underlines the fact that its black-and-white design was imported but that the mosaic was executed by a local Greek artist.[19]

This same combination of eastern and western characteristics is also evident in the frames of the Paphian hunts, in which both a border of gray stepped triangles and a wider band filled with a reddish-brown swastika-meander-and-square pattern appear.[20] In addition to these, the east portico is enclosed by an even wider frame of adjacent and secant octagons that determine squares flanked by oblong hexagons (fig. 172).[21] As at Isthmia, the multiple borders emphasize the central design and create three separate panels, individually framed. The Paphian hunt

15. Lavin 1963, 217–18.

16. Levi 1969–70, esp. fig. 74. See also Berti 1983, 235–46.

17. Packard 1980, 326–46, passim; she gives a tentative date of the first half of the 2d century for the marine mosaic on the basis of its style; see esp. 344–45.

18. A general comparison may be made with the Triton and Nereid from the *calidarium* of the Baths of Buticosus, of around A.D. 115; Becatti 1961, 29–30, pls. 129–30, 133, no. 52. A precise date is indicated by the late Trajanic brick stamps.

19. Packard 1980, 345–46. He also notes the iconographic and stylistic peculiarities in the Isthmia mosaic and decides that they indicate a lack of familiarity with the monochrome style and marine themes (328–35).

20. For the stepped triangles, see *Décor géométrique*, 38–39, pl. 10g ("serrated saw-tooth pattern"). This border is about 24 cm. wide. For the meander, see *Décor géométrique*, 80–81, pl. 38c ("swastika-meander of spaced single-returned swastikas with a square in each space"). This border is about 34 cm. wide.

21. The squares and the horizontal hexagons are dark-brown and reddish-brown respectively, while the vertical hexagons remain white. This bold contrast of light and dark resembles the optical effects of the black-and-white borders in Isthmia. For this pattern, see *Décor géométrique*, 260, pl. 169d ("outlined orthogonal pattern of irregular octagons adjacent and intersecting on the longer sides, forming squares and hexagons"). The border is approximately 45 cm. wide. For a detailed analysis of this pattern, see Lavagne 1978, 8–11, who cites the Paphian example in his group B, which is distinguished by the fact that the size of the square is equal to that of the hexagon. It is represented by ninety-nine examples with a wide regional distribution. The early-3d-century example from Vienne, unusual in its role as a filling motif for a grand multiple-design floor, bears some similarity to the Paphian pattern in the balance between the colored areas and the white ground (ibid., 9, fig. 3).

scenes are inherently connected by their subject, and in this way they are transitional. Their designer appears to have experimented with new concepts, such as figure carpets, but relied on traditional methods, such as multiple frames, for the execution.

The compositional principles of the Italian silhouette style anticipated the stylistic effects of the polychromed hunt mosaics of North Africa, and later those of Antioch. Isthmia makes clear that black-and-white designs, highly fashionable under the Antonines, were available in the Greek east and that their use depended largely on the tastes and pretensions of the patrons. Might it be possible to explain the adoption of the all-over carpet format for the Paphian hunts and for the vine carpet in the triclinium by the influence to the putative patron? Unfortunately, the potentially decisive role of the patron often eludes historical documentation and must be surmised indirectly from the mosaics themselves. A close study of a number of mosaics depicting amphitheater events begins to shape our understanding of how the tastes of the inhabitants were reflected.

The spectacular mosaics from the seaside villa at Dar Buc Ammera near Zliten in Tripolitania are as disjunctive in style as those at Paphos.[22] The confusion arises from the cohabitation of classically conceived *emblemata* with atmospheric landscape settings, and abstract paratactic compositions with absolutely no suggestion of space. The latter type is found in the amphitheater mosaic that surrounds a central checkerboard field comprised of circular *emblemata* containing fish, alternating with panels of *opus sectile* (figs. 175 and 176).[23] A detailed account of arena activities forms a frieze that unfolds in a series of episodes similar to the sequence in which the games themselves were performed. The colorful figures are placed against a solid white ground without shadows or groundlines. This two dimensionality is striking in contrast to the realistically depicted costumes and other technical paraphernalia.[24] It is precisely this combination of subject matter taken from contemporary Roman life with a figural style liberated from spatial illusionism which is found on the large-scale figure carpets so popular throughout Roman North Africa from the third century onward. It appears then, if the Flavian date is accepted, that the Zliten amphitheater mosaic precedes the African series by an entire century. This observation and other features of the Zliten mosaics trouble scholars and have led to arguments for dates ranging from the late first through the late third century.[25]

22. Aurigemma 1926, passim; Aurigemma 1960, 55–60, pls. 116–74; Dunbabin 1978, 278, cat. Zliten 1a-f, pls. 12, 46–69, 95–96.

23. Aurigemma 1926, 131–201, figs. 75–126, 152–54, from room D on plan, see fig. 11; Dunbabin 1978, 278, pls. 1, 46–49, cat. Zliten 1e.

24. The technical aspects of the Zliten mosaic are discussed in the following: Ville 1965, 147–54; Auguet 1972, 75, fig. 3. For the *venationes*, see Toynbee 1973, passim; and Hönle and Henze 1981, 60–62, pl. 8. For the most exhaustive account, see Aurigemma 1926, 131–201.

25. For a thorough and well-considered presentation of the dating arguments, see Dunbabin 1978, 225–37, app. I. She proposes several stages for the decoration of the villa: her first phase belongs to the late-1st or early-2d century and includes the agricultural scenes, the inhabited acanthus voTutes, the amphitheater

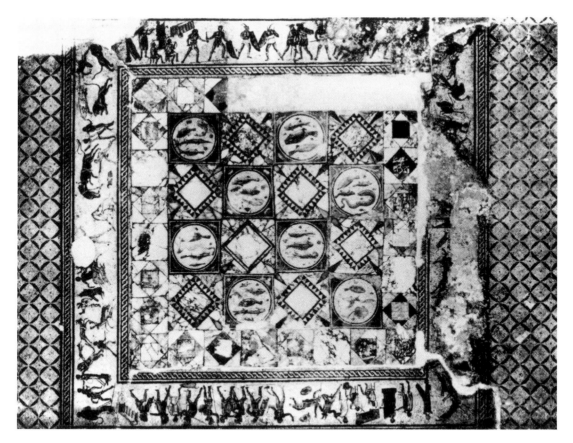

Figure 175. Zliten, villa at Dar Buc Ammera, room D, amphitheater frieze (after Aurigemma 1926, fig. 78)

The Zliten amphitheater mosaic offers suggestive analogies to the Paphian hunts: in theme—the *venationes* of the amphitheater; in composition—an extendible frieze of figures on white ground; and in arrangement—long narrow friezes framing a central area. Both of these compositions are "precocious" for the

scenes, and the unusual Seasons; her second phase occurs around the mid-2d century and can be seen in the Italianate geometric mosaics; and finally at some unspecified later date a restoration project from which much of the scholarly confusion ensues. Dunbabin does not make clear why the Italianate geometric mosaics must be later than the figural mosaics and assigned to the mid-2d century. The date of the multiple-design pattern of room N is critical for the chronology of the Zliten mosaics and yet has never been satisfactorily resolved (see the discussion of multiple-design in Chapter 2). The acanthus volutes could also be more precisely dated if they were analyzed in relation to the development of acanthus scrolls on decorative relief sculpture. For example, one could successfully compare the treatment of the spiral columns in the Chapel of the Holy Sacrament in St. Peter's, dated to the Hadrianic or possibly Flavian period. Tiny creatures including birds, lizards, and mice play among the vine-scroll foliage and resemble the inhabitants of the Zliten volutes; see Ward-Perkins 1952, 26, pl. 5. The description of the relief as relying for its effect "not on contrasts of light and shade, but on the gradation of the gently modelled surfaces and on the delicacy of the detail" (ibid., 26), could easily be applied to the Zliten acanthus mosaic. For the dating in general, see also the informative debate following Ville 1965, 152–54.

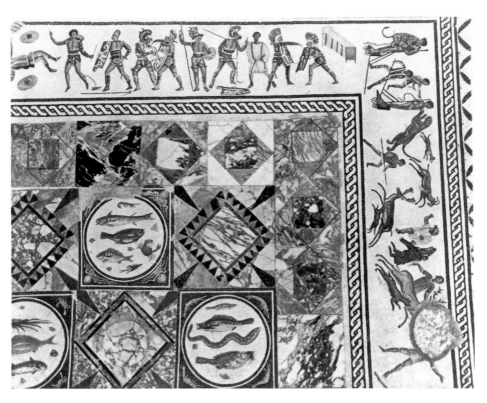

Figure 176. Zliten, villa at Dar Buc Ammera, room D, details of amphitheater frieze (after Aurigemma 1926, table D)

early dates suggested by archaeological evidence in the case of Paphos, and by the style of the other villa mosaics in the case of Zliten. The explanations proposed for the creation of the unusual Zliten mosaic point directly or indirectly to the influence of the hypothetical patron. For example, Aurigemma's Flavian date for the villa depends on the supposition that the Zliten amphitheater mosaic is a record of games held in celebration of the defeat of the Garamantes in A.D. 70.[26] Even if this particular event is not commemorated, the mosaic does seem to be based on firsthand experience of such events rather than on intermediary sources. The amphitheaters in Lepcis Magna, Sabratha, and Oea were all within a day's journey from Zliten and could easily have provided the model *munus* (Roman games) that inspired the patron to commission the Zliten mosaic.[27] The mosaicists, possibly immigrant craftsmen from the eastern Mediterranean, accommodated the commission and treated the composition as a frieze to frame the expensive *opus sectile*.[28]

26. Aurigemma 1926, 269–78.
27. Hönle and Henze 1981, 62.
28. Dunbabin calls the amphitheater composition "a previously unexampled type" (1978, 237). Signifi-

Whatever the final explanation might be for the creation of the Zliten amphitheater mosaic, it is certainly the earliest and most thorough in its documentation of arena spectacles in a series of such mosaics. The digression into the puzzle of its "precocious" nature sheds light on the critical question of original and transitional works that are not easily posited in an established chronology of style. To push the date of the entire Zliten villa later on the basis of the supposed anachronism of one composition seems questionable, especially since the role of patronage is so vaguely understood.[29]

It is with a view informed by the earlier Zliten model that the creation of the Paphian hunt may be better understood. The Paphian hunts do not conform to accepted notions of eastern stylistic development for either the second or third century, nor do they form a group coherent with the other mosaics in the house. Probably they were concocted in response to the patron's desire for fashionable Roman themes and styles. The mosaicists, prompted by the patron and undoubtedly inspired by the actual games performed in the Cypriot amphitheaters, combined such classical devices as multiple frames and narrative illustrations with the idea of a figure carpet.[30] As at Zliten, the mixture of two traditions produces something quite original. The Zliten mosaic serves as more than a parallel model; it leads us to consider the possible routes for the diffusion of western fashions. Tripolitania was certainly an active trading center for sea commerce with Rome, Alexandria, and the east, and it is not difficult to imagine wealthy traveling merchants exchanging hospitalities and influencing one another's tastes in much the same way that the Art Deco revival is carried from Manhattan apartments and antique shops to Paris and back again. Fortunately, other amphitheater mosaics survive from the Greek east that corroborate the evidence from Zliten and Paphos.

Several mosaics with scenes derived from the arena at sites in Greece and Turkey join a larger body of evidence in the form of funerary stelae and reliefs that attest to a pronounced interest in these distinctly Roman entertainments in the eastern provinces. At Patras, a prosperous urban center of Achaea during the second and third centuries, there are a number of remains, including those of an amphitheater, which reflect the citizens' active involvment in the *munera gladiatoria*.[31] A combat between professionals identifed by their Greek names occurs in a mosaic of the late second or early third century from a Roman house there.[32] The figures, although plastically modeled and arranged with some spatial naturalism, are set against a white ground with only foot shadows to indicate a setting.

cant is the fact that the *emblemata* found in the Zliten villa testify to the influence of the Hellenistic tradition at the site (ibid., 236).

29. This is the view of Parlasca 1954, 111.

30. This point is discussed further below.

31. See Papapostolou 1989, 351–401, for a detailed discussion of gladiatorial monuments from Patras.

32. Ibid., 393–400, figs. 36–37, who dates the mosaic on the basis of the style of its peopled scroll border (400).

Similarly full-bodied hunters and pugilists are found in six mosaic panels from one room in an unidentified and undated Roman building on Chios.[33] The separation of these episodes into individually framed units stacked into two vertical rows of three panels breaks from the frieze sequences typical of arena representations, but they do share other features with such mosaics. Among the Chian scenes are: two hounds that chase hares; a hunter who spears a lion by a tree; another spears a boar; two other hunters hide behind a hill and throw rocks at a tiger; and boxers from the palaestra. These scenes are set against a neutral white ground with only a tree or hill as landscape. The positions of the hunters and beasts, as well as aspects of their costumes and their actions, recall the Paphian hunts. Indeed, the latter could easily be broken up into independent episodes and presented in the Chian arrangement.[34]

Even more in the spirit of the Paphian hunts is a mosaic from the triclinium of a Roman house in Miletus, wherein a frieze of four winged hunters with spears forms the bar of the T-shaped decoration.[35] This long narrow panel is placed below a square panel with Orpheus at the center surrounded by wild life that are divided into eight compartments. The hunters, beasts, and hounds are placed one after another along the edge of a frame with extended shadows that could be mistaken for groundlines. This animated sequence of leaping figures, which has been assigned a late-second-century date, recalls the friezes at Paphos. The three arena-inspired mosaics from the Greek east just described are composed in a nonillusionistic fashion and should be considered as a group, along with the Paphian hunts; they illustrate the pictorial Romanization of domestic decoration by the late second century.

Further confirmation of this trend can be found in a Roman house dated to the early third century on the island of Kos in the Dodecanese. In a great hall (13.80 m. × 6.55 m.) near the Western Bath area is a mosaic with three large square panels with mythological scenes in the central field (only two survive). The panels are framed by a continuous frieze of acrobatic and hunting scenes derived from the amphitheater (figs. 177 and 178).[36] The Kos frieze consists of boar, bull, and bear hunters and a leopard hunter; several of these are mounted on horseback and some engage in acrobatics in their attacks. The inscription of the names of the hunters and beasts in Greek provides vivid testimony that such episodes were indeed rooted in actual events, perhaps even local ones.[37] The highly specific

33. Mastoropoulos and Tsaravopoulos 1982, 4–7, figs. 1–5.

34. Although the preliminary report of this find does not offer any information for dating, the pendant geometric mosaics, especially the lozenge-star-and-square pattern, indicate a date in the early 3d century.

35. The house was found between the Byzantine church and the south city wall in Miletus; see Kriseleit 1985, 14–17, no. 72.

36. Morricone 1950, 227, figs. 37–40; Atzaka 1973, 231–32, no. 23; Robert 1940, 191–92, no. 191a; Robert 1948, 89–90. The excavator, Morricone, assigns the Kos mosaic a late-2d-century date on the basis of the technique and because these mosaics had been lifted in the 3d century, probably for the construction of the Baths.

37. See Dunbabin 1978, 66, who believes that the amphitheater scenes from Zliten and Smirat are rare

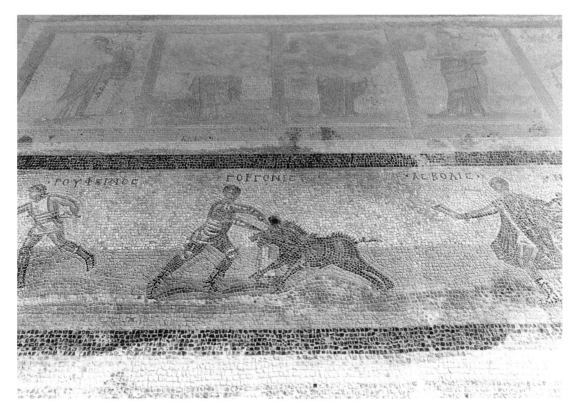

Figure 177. Kos, great hall in western excavations, detail of border with boar fighter (photo by C. Kondoleon)

nature of the Kos scenes, the absence of any setting except for a brown groundline and some cast shadows, and the function of the frieze as a frame for figured panels, place this Greek-island mosaic close in concept to the Zliten mosaic. The inclusion of the names recalls another Tripolitanian hunting frieze. This one, however, is painted along the north and south walls of the *frigidarium* of the Hunting Baths at Lepcis Magna, dated to the Severan period.[38] The names are inscribed in Latin beside the hunters, lions, and leopards that comprise these two long friezes. They were undoubtedly meant to recall the arena and would have particular significance for the proposed patrons of the Baths, an association of merchant-hunters.[39] Once again, as at Zliten and Kos, these scenes seem to reflect actual social practices rather than formulaic imagery.

The Roman counterparts for the narrative realism and originality exhibited by

examples of the representation of actual events in mosaic. Some hunting mosaics include the names of hounds and horses; she suggests that these names may identify the patrons' own hounds and horses (61).

38. Ward-Perkins and Toynbee 1949, 181, and pls. 41–43. The Severan date is based on archaeological, architectural, and stylistic evidence (191–93).

39. Ibid., 194–95.

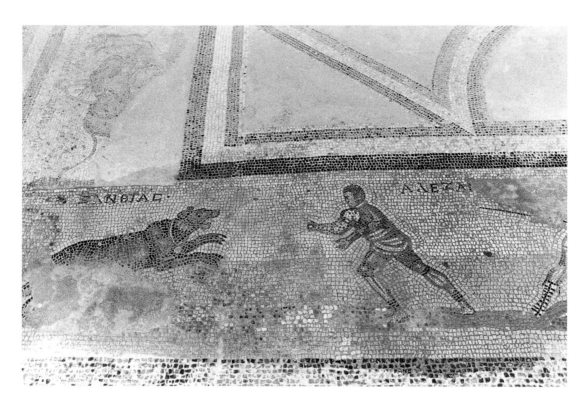

Figure 178. Kos, great hall in western excavations, detail of border with bear (photo by C. Kondoleon)

these amphitheater friezes are a set of polychromed mosaics found in the Roman house below S. Sabina on the Aventine.[40] The Aventine design, as it is preserved in five rectangular panels, includes musical performances and several types of *venationes*. Along with the gladiatorial combats and the hunt with spears, it includes the spectacle of *bestiarii* goading beasts with their theatrical acrobatics, often while riding other beasts.[41] For example, a mahout forces his elephant to charge a bull head-on, and in another panel a *bestiarius* pursues a bull on horseback. Entire acrobatic stunts can be seen in the Koan frieze, where bull-jumping (*taurokathapsia*) is enacted by the performer Aitheris and the bull Stadiarchis.[42] In this sport the rider pursued the bull in order to tire him out, then dismounted and jumped over the bull's head, grabbing the horns.[43] Such spectacles were especially popular in the first century, as documents attest, but are curiously

40. Blake 1936, 174; Blake 1940, 115, pls. 30,6 and 31,1–4.
41. Robert 1940, 311–20.
42. Ibid., 192. A recently discovered mosaic features a bull and acrobats enacting a *taurokathapsia* from room 14 in a villa at Silin, Libya and is dated to the Severan period; see Mahjub 1983, 303–4, fig. 8.
43. Robert 1940, 318. See also the relief from Apri in Thrace (90–92, pl. 24, no. 27), where the scene is extremely close to the one depicted in Kos.

absent from the elaborate arena mosaics that proliferate from the late third century onward.[44] Several elements point to a similar date for the Kos and Aventine mosaics—that is, the late second or early third century—including representations of these acrobatic performances, the small-scale figures placed freely against a plain ground within large panels, minimal settings, and the animated actions and lively gestures.[45] The conception of the Aventine composition as several separate panels recalls the Paphian hunts and underlines the transitional aspect of such mosaics in that they combine traditional designs of framed panels without backgrounds.

A hunt frieze from Orbe in Switzerland, dated to the first quarter of the third century, balances our series with a second example from the west (fig. 179).[46] Once again the theme of the *venatio* is extended in a paratactic arrangement to decorate four long panels framing a central design of thirteen medallions filled with the divinities of the week. The figures are placed one after another against a white ground with only foot shadows as a concession to setting. Just as at Paphos the panels are individually framed, but far more simply in Orbe with plain double bands. Of the five or six figures in each panel, two of which are fragmentary, there is only one *venator* and the rest are beasts, including a leopard, lion, bull, horses, bears, and deer. The hunter holds a spear in one hand and the leash of a huge hound that pulls him forward in the other. The leaping poses of all the beasts and this type of hunter emphasize the chase of prey, rather than actual combat, slaughter, or provocation by stunts.

The nearly exclusive use of pursued animals, as in the Orbe mosaic, represents an important stage in the development of amphitheater scenes. Once excerpted from the realism of the arena, these ferocious beasts are neutralized and easily made into decorative devices (i.e., for frames and the like). In no less than four rooms of the House of the Laberii in Oudna, individually framed panels of two or three animals, depicted in pursuit, combat, or standing peacefully, fill the spaces

44. Ibid., 319n.44, where it is stated that Caesar introduced these bullfights and that they remained popular throughout the 1st century. On the bullfights, see also Auguet 1972, 91. The absence of this event from the remarkably realistic mosaics from a peristyle at Torre Nuova, now in the Borghese Museum, dated to the early 4th century implies that the vogue for such spectacles did not last through the 3d century; see Blake 1940, 113–15, pl. 30.

45. The same characteristics apply to the Zliten frieze also, but the proposed dating for these mosaics is earlier; see Dunbabin 1978, 225–37. Blake originally suggested a 2d-century date for the Aventine mosaics on the basis of technique and style (1936, 174), but she revised it to the early 4th century because of the decorated *segmenta* on the tunics of the hunters (1940, 115). There is no absolute evidence, however, that these costume decorations did not occur earlier, and, in fact, *segmenta* appear on the tunics of the sowers and reapers of the Cherchel mosaic (see Dunbabin 1978, pl. 40) for which a date A.D. 200–220 has been generally accepted. The details of costume therefore do not justify Lavin's claim that "an early fourth century date seems beyond any serious doubt" (1963, 257). He also places the Borghese mosaic, which is reasonably assigned a 4th-century date, together with the Aventine mosaic, but I see no points of comparison, either in style, composition, or costume. Dunbabin correctly observes that the Aventine figures are closer to 3d-century style (1978, 214n.77).

46. Von Gonzenbach 1961, 184–94, esp. 185, pls. 60, 64–65. The mosaic is dated by the iconographic details and the ceramic finds (192).

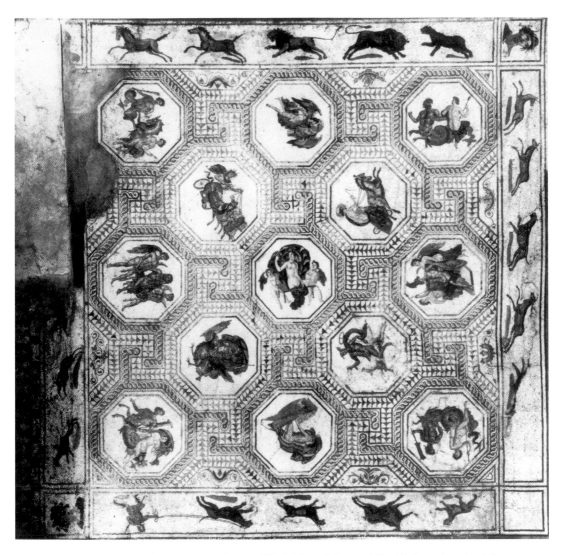

Figure 179. Orbe, Roman house, "divinities of the week" with hunt border (after von Gonzenbach 1961, pl. 60)

between the columns that decorate each of these rooms (fig. 180).[47] The suitability of animal combats and chases for intercolumnar spaces might well have derived from an earlier precedent in which revetments painted with similar scenes decorated spaces between the columns of Campanian peristyles.[48] In such garden

47. Gauckler 1896, 193–96, "Atrium" no. 7, figs. 3–4; 197–99, "Atrium" no. 17, fig. 5; 200–202, "Atrium" no. 21; 205–6, "Atrium" no. 30. See also Dunbabin 1978, 265–66 (Oudna 1b,c,f, and j) dated to ca. 160–80.

48. See, e.g., the low wall screen that ran along between the columns of the large peristyle in the House of Menander at Pompeii, where two panels include a hound chasing a deer and a lion confronting a boar; see Maiuri 1933, 82–83, figs. 38–39, pl. 9a.

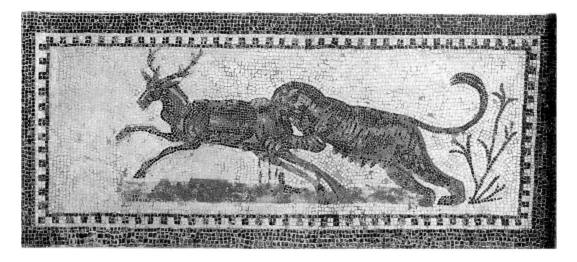

Figure 180. Oudna, House of Laberii, room 7, hunt panel (courtesy of the National Museum of the Bardo)

settings these motifs evoke, albeit on a miniaturized scale, the great game parks that were the appointments of Italian aristocratic estates. In two of the porticoed rooms in the House of the Laberii the columns and animal panels surround large marine compositions that are pictorial substitutes for great fountains.[49] The ensemble of porticoes, hunt, and marine scenes underlines the inherent connection of such arrangments to garden designs. At Oudna, the absence of any sort of hunter and the repetition of the theme as secondary to central compositions confirm the decorative status of these motifs as early as the mid-second century, the accepted date for Oudna. Animal friezes like these continued to be used, especially as frames, throughout late antiquity.[50]

Arena scenes are also taken out of the realistic sequence provided by the frieze format and adapted as inserts to fill geometric designs. In the central reception hall of the Severan villa at Nennig near Trier, eight octagonal medallions and one square insert contain episodes from the amphitheater, including gladiatorial combats, musicians, *venationes*, and animal combats.[51] These compact, lively scenes indicate more spatial depth by the overlapping and foreshortening of figures than do the frieze compositions, but they keep the white backgrounds and summary groundlines of the frieze. It is clear that the arena repertoire also traveled east in the form of such medallions. Each of four subsidiary panels of a vault-design mosaic discovered near Korone in the Messenian Gulf features a *venator* confront-

49. The two are found in room 7 and room 17; see Dunbabin 1978, 265 (Oudna 1b and c).

50. For example, a frieze of exotic animals in a hilly landscape surrounds a scene of vintaging Erotes from the so-called *frigidarium*, actually a colonnaded room of the House of the Protomes, Thuburbo Maius; see Poinssot and Quoniam 1953, 166, fig. 10.

51. Parlasca 1959, 35–38, pls. 36–39, dated to ca. A.D. 230–240.

ing a beast.[52] The single episodes are placed on white backgrounds with only thin curved strips for groundlines, just as they are in the related frieze compositions. The *venatio*, juxtaposed in the Korone design with symbols of the Dionysiac cult, is reduced to a filler motif that does not correspond to the continuous flow of event in a real performance. Herein lies the essential difference between the hunt friezes and the medallion excerpts. The latter do, however, provide a rich source of iconographic analogies for the study of the friezes and must ultimately have depended on similar sources for their details.

The illustration of amphitheater scenes and hunts in friezes seems to reflect the narrative sequence in which the actual events were seen. Such scenes were easily appropriated as frames, as in Antioch, or as frieze decorations for long narrow surfaces, as in Paphos, Zliten, Miletus, Kos, Aventine, and Orbe. It is possible to argue for a Severan date for all these examples with the exception of Zliten, which most likely dates to the first half of the second century. Although they form a small group, these examples confirm the existence of a Roman koine for the representation of arena spectacles, which is supported by the evidence of Italian monochrome mosaics, especially the Castel Porziano mosaic, contemporary painting (e.g., the Severan Baths at Lepcis), and reliefs.[53]

These hunting friezes are a prelude to the widespread adoption of figure carpets in the form of hunting scenes in the Greek east during the fifth and sixth centuries. The appearance of these monumental two-dimensional compositions marked a significant change in style. In fact, I. Lavin contends that the production of figure carpets at Antioch determined a radical break with classical tradition and ushered in a medieval style in the east. The fact that the eastern hunt carpets strongly recall earlier North African compositions led Lavin to suggest that the latter exerted "an influence of considerable importance" on the eastern mosaics.[54] The North African preference for "carpet" designs over the more traditional alternative of illusionistic *emblemata* favored by their eastern contemporaries presaged the transformation of the Hellenistic pictorial legacy into an international abstract style.

According to Lavin, an importation from the Latin west to the Greek east occurred only at a particular time early in the fifth century; otherwise the two cultural centers remained polarized.[55] The Paphian hunts, however, along with the other recent finds of mosaics in the Greek east already noted, challenge Lavin's theory. These discoveries suggest an eastward path of western artistic taste at least

52. Atzaka 1973, 230, pl. 13a, no. 22; Waywell 1978, 200, pl. 49, fig. 27, no. 30; Picard 1941, 159–63, fig. 1; and Parlasca 1959, 116n.4. A date in the mid-2d century was indicated by the discovery of a Trajanic coin in the setting-bed; however, Parlasca suggests a date ca. 175–200 as more likely for stylistic reasons. The mosaic is presently in the Kalamata Museum.

53. A fuller discussion of the evidence from reliefs follows in the iconographic analysis.

54. Lavin 1963, 244.

55. Lavin suggests the Vandal conquest of North Africa as the event that allowed for such importations (ibid., 273)

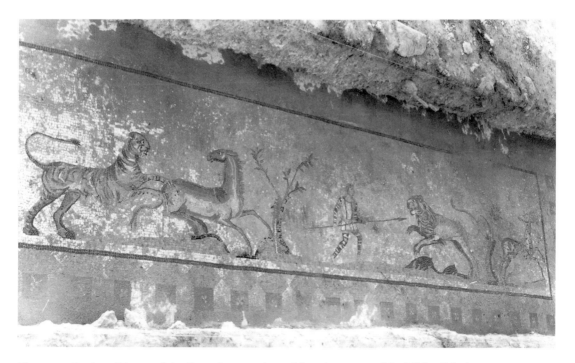

Figure 181. Paphos, House of the Four Seasons, hunt frieze (courtesy of D. Michaelides)

by the mid-second century. Cultural ideas followed and even, at times, outlined a path for Romanization. At the elite levels of society, which included the patrons of such mosaics, there was an active, indeed manic, trend to imitate the domestic appointments of the "rich and famous." Homes of Italian aristocrats set the pace, and the ripple effects can be found throughout the Mediterranean. The hunt scenes could have connoted the benefaction of the amphitheater spectacles, and even their representational presence in the household might have served to associate the owners with a Roman style of life and *civitas*.

In terms of composition, the Paphian hunts are certainly no more "precocious" than their counterparts within this group from the late second or early third century in both the east and the west, and together they argue persuasively for a much earlier adoption of the figure-carpet style in the eastern provinces than Lavin allowed. Indeed, the recent discovery of a new hunting mosaic in Paphos from the House of the Four Seasons, dated stylistically to the early third century and undoubtedly produced by the same workshop that created our Paphian hunts, underlines the likelihood that other such compositions will be found in the Greek east (fig. 181).[56] The taste for them was set in the cultural consciousness, and their particular style is predicated on the nature of the subject itself, namely a

56. I am grateful to the excavator of this new house, D. Michaelides, who generously shared his initial report on this discovery and some photographs (one of which is reproduced here).

reportorial realism. The location of the panels in peristyles contributed to forging the combination of traditional panel pictures with continuous friezes of freely disposed figures and flat backgrounds. The success of these transitional compositions in effectively covering large surface areas with animated sequences of arena spectacles anticipates the widespread adoption of the carpet formula in late antiquity.

ICONOGRAPHY OF THE HUNT

The search for parallels of the formal arrangement of the amphitheater mosaic at Paphos required the casting of a wide regional net. It appears that the iconographic details point to many of the same examples. The common language shared by this group of amphitheater hunt mosaics is marked by the types of activities depicted, by the details of costume, equipment, and props, and by the portrayal of the beasts. Yet the ways in which the Paphian panels differ can point to observations on the relation of visual representations to the life of society and on the possible significance of such scenes. Unique features of the Paphian hunts suggest that actual performances were the inspiration for the patron's selection and for the originality and realism with which the mosaics were conceived.

I have used the terms "hunt" and "amphitheater" interchangeably, but it is now necessary to distinguish the hunts practiced in nature for sport or for the procurement of exotic beasts for the arena from those hunts performed by professional *venatores* within the amphitheater.[57] Although they represent diverse events, the Zliten, Kos, Paphos, Aventine, and Orbe mosaics all reflect the realm of the arena.

The Paphian hunts represent an interesting variation on the *venatio* spectacle. A careful description illuminates how the Cypriot hunts differ. The six *venatores* and eighteen beasts, representing ten different species, are grouped into eleven hunting incidents, each punctuated by natural and architectural features. Each of the three long panels begins with a landscape element, a truncated tree on a high rocky ledge.

The east portico, the longest and most elaborately framed, consists of four separate episodes (fig. 182). At the south corner, a hound passes in front of the tree and bites at the ankles of a wild ass, which he cruelly leads toward the spear of the huntsman (fig. 183). A small grassy hill separates the hunter and onager. The next scene also includes a hound, this time in determined pursuit of two ibices (or moufflon?) that leap in fright toward a high rocky hill with grasses along its edges (fig. 184). The hound emerges from a curious conflation of architecture and natural landscape: on the left, a truncated tree on a grassy hillock, and on the right, two vertical pillars, drawn in perspective and resembling the posts of a gate

57. For a thorough study of Roman hunting, see Anderson 1985, 83–153.

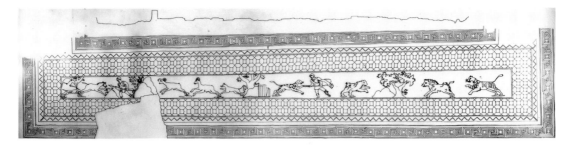

Figure 182. Peristyle, east portico panel, drawing by M. Medič (courtesy of the Department of Antiquities, Cyprus)

(fig. 185). From this stone gate, a leopard attacks a *venator* with ready spear, constituting the third scene (color pl. 4). A bear runs toward a boar, seemingly headed for confrontation (fig. 185). They are separated by a gnarled full-leaved tree and adjacent hillock. And in the final scene, rushing leftward toward the boar, a boldy striped tiger leaps with its forepaws in mid-air.

The south portico includes three scenes separated by three landscape motives. Just as in the closing east panel, the opening south scene excludes human intervention: a tiger (head damaged) bounds in the direction of a stag that is hemmed in by a fierce hound attacking from the opposite side (fig. 186). One strip of ground connects all three animals and indicates that this is a continuous scene, despite the narrow table (?) or altar (?) and tree (damaged) dividing the tiger and stag.[58] Behind the hound is a young tree. In the central scene a bearded hunter stands prepared to thrust his spear into an approaching lion (fig. 187). The final scene is separated by a rocky outcrop with a tree and shows a bull standing on his hind legs charging a beardless hunter who lunges forward on his deeply bent right leg, while his left leg stretches behind him to the corner of the panel (fig. 188).

The three scenes of the north portico frieze begin with the typical unit of landscape (fig. 173). If we read left to right from the west corner; we see a bearded hunter with a pointed spear standing poised to confront the lion that leaps toward him with an open mouth and hanging tongue (fig. 189). The next scene follows immediately without any topographical divider. A beardless hunter raises a round object that he seems to aim at the approaching boar (fig. 190). A three-tiered hill with truncated tree separates the final scene, wherein we witness the bloody finale of a combat between a leopard and a wild ass. In this particularly gruesome depiction, a headless ass with blood dripping from his neck stumbles behind a leopard carrying the onager's bloody head in his mouth (fig. 191). The leopard walks toward a structure drawn in perspective with its foreside arched and backside trabeated.

58. K. Nicolaou 1963, 67, suggests that this mysterious object is a hut, but this proposal is not convincing.

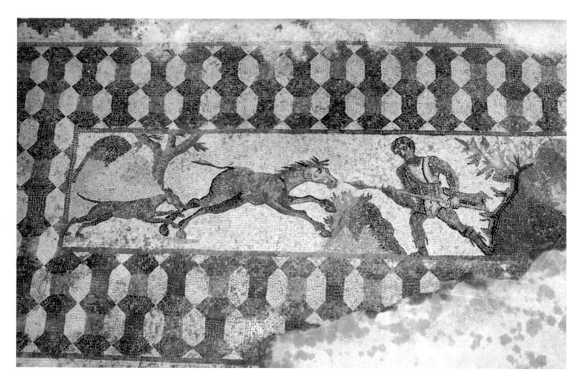

Figure 183. Peristyle, east portico panel, detail of south end with wild ass and hunter (courtesy of the Department of Antiquities, Cyprus)

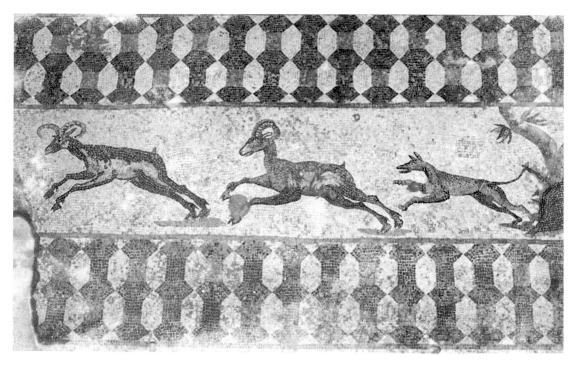

Figure 184. Peristyle, east portico panel, center with hounds chasing moufflon/ibices? (courtesy of the Department of Antiquities, Cyprus)

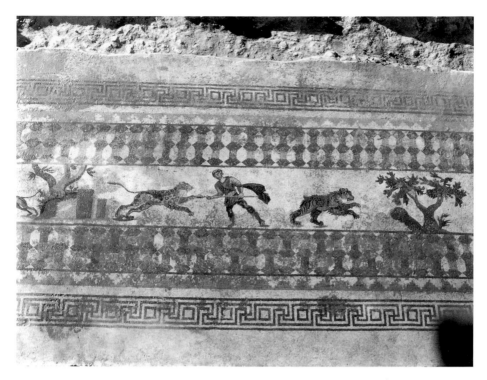

Figure 185. Peristyle, east portico panel, north end with leopard hunter and bear (courtesy of the Department of Antiquities, Cyprus)

The six huntsmen, all in three-quarter view, are represented in two basic positions: facing left and leaning the weight on the advanced right leg (fig. 188);[59] and facing right with the weight on the advanced left leg (fig. 189).[60] Five *venatores* carry a spear reinforced by an iron point, called a *venabulum*.[61] They are dressed in short, long-sleeved tunics—except for the lion hunter of the south portico, who has a short-sleeved tunic—and their thighs and knees are covered with tights.[62] Their calves are protected by spiral puttees, that is, leather leggings secured by laces and wrapped from the ankle to just below the knee.[63] This simple

59. See the leopard and wild-ass hunters of the east portico and the bull hunter of the south portico.

60. See the lion hunter of the south portico and the boar and lion hunters of the north portico. This position is close to that of the hunter in the *frigidarium* mosaic of the Baths of the Seven Sages; see Becatti 1961, 135.

61. For discussion of the *instrumenta venatoria*, see Robert 1940, 324; and Aymard 1951, 119 and 201–5.

62. Their costume colors are as follows: in the east portico the wild-ass hunter wears a gray tunic with yellow sleeves and belt and a gray mantle and leggings; the leopard hunter wears a brown tunic with yellow belt and sleeves and dark-gray tights and mantle; in the south portico the lion hunter wears a pink tunic with red highlights, gray sleeves, and yellow belt and tights; the bull hunter wears a dark-gray tunic with mauve sleeves and yellow tights; and in the north portico the boar hunter wears a yellow tunic with black *clavi*, a green belt, and pinkish-gray mantle and sleeves; and the lion hunter wears a mauve tunic with short green sleeves and yellow belt and tights.

63. Ville 1965, 149.

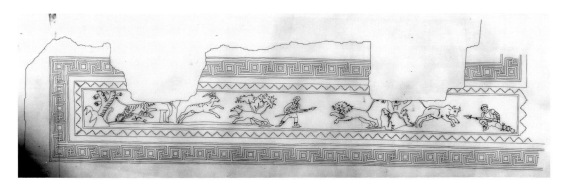

Figure 186. Peristyle, south portico panel, drawing by M. Medič (courtesy of the Department of Antiquities, Cyprus)

costume of short tunic, tights, and leggings or puttees, which left the *venatores* rather unprotected when compared to the gladiators, who wore more elaborate uniforms, was popular during the first and early second centuries.[64] The wide belts worn over nearly all the Paphian tunics and the leather strapping around the arms and knees of the bull hunter (fig. 188) and the leopard hunter (color pl. 4) reflect a more complicated fashion current in the late second and third centuries.[65] The addition of bands above and around the knees, known as *fasciae crurales*, can be found in the Castel Porziano mosaic of around the mid-second century.[66] This Roman mosaic also includes the simpler, earlier type of costume and thus represents a transitional phase in the depiction of the costume of the *venator*.[67] The costumes at Paphos are not as simple as those of the Zliten *venatores*, some of whom are even barefoot, but closer to those depicted in the Kos amphitheater frieze of the late second century (figs. 177 and 178).[68] Again, as with the composition of the Paphian hunts, the closest parallels for the costumes in Paphian hunts are the second-century frieze mosaics.

The Paphian beasts present few problems of identification in that they represent the most popular animals selected for amphitheater performance. Analogous pavements from Castel Porziano, Ostia, Zliten, Kos, and Orbe include the same animals, with some additions such as ostriches, antelopes, and horses. There is

64. See the costumes of the east side of the Zliten amphitheater; ibid., 148–49; and Aurigemma 1926, 189–201.

65. Ville 1965, 149n.17.

66. Aurigemma 1926, pl. 19, where a *bestiarius* standing by a lion and bison wears a short-sleeved tunic with *clavi*, wide belt, and *fasciae crurales* above his puttees, a fashion closely resembling the Paphian costumes.

67. Ville 1965, 150, suggests a chronological scheme for the evolution of the costumes and uses it to date the Zliten mosaics in the early 2d century.

68. For example, the *venator* attacking the bear named Andromache wears a short green tunic with black *clavi*, wide belt, leather straps around his arms, and lattice-work puttees. See Robert 1940, 192, no. 191, who mistakenly identifies the bear as a leopard.

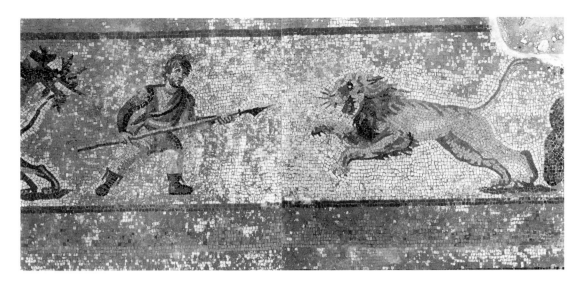

Figure 187. Peristyle, south portico panel, center with lion hunter (courtesy of the Department of Antiquities, Cyprus)

little evidence of local preferences or geographic restrictions in the selection of a particular species, either for the actual performances or for the mosaic representations. In fact, all the animals portrayed in these mosaics appear in the lists of the great Imperial collections for the *ludi* held in Rome.[69] That the Roman games clearly set the standard for an Empire-wide taste in the gathering and presentation of such menageries is indicated by the procurement of *Libycae ferae*, that is, African game, for cities as far east as Hierapolis.[70]

Aside from the ferocious felines associated with the African continent in the sources, the shows featured the *bestiae herbaticae*—that is, bulls, a variety of deer, equines, and wild sheep and goats. The sheep and goats present some difficulties for identification in the Paphian panels. The horned creatures chased by the hound in the penultimate scene of the east portico have been identified as moufflon, wild sheep native to Cyprus.[71] Their curled horns do, in fact, resemble those of the moufflon; however, the smooth, short-haired coat, short tail, and bold transverse rings marking the horns identify the Paphian beasts as ibices.[72] This classification is confirmed by a mosaic from Carthage which conveniently provides a visual catalogue of amphitheater beasts in which moufflon are shown

69. For a thorough discussion of these Imperial displays, see Jennison 1937, 60–98.

70. Robert 1940, 313–14, lists the animals included in eastern reliefs and inscriptions; see esp. p. 314n.1, where he cites references to the term *Libycae ferae*.

71. K. Nicolaou 1963, 68; and Eliades 1980, 35, who says that they are "similar to those found in the forest of Stavros tis Psokas."

72. Toynbee 1973, 147.

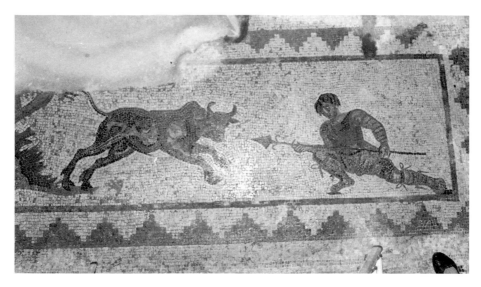

Figure 188. Peristyle, south portico panel, north end with bull hunter (courtesy of the Department of Antiquities, Cyprus)

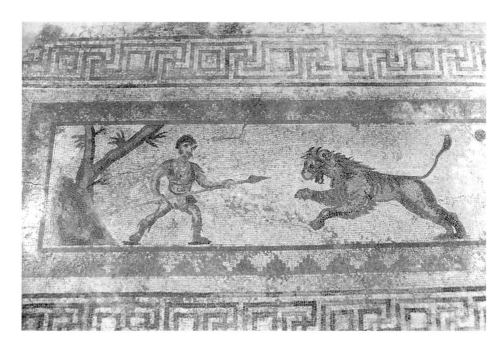

Figure 189. Peristyle, north portico panel, west end with lion and hunter (courtesy of the Department of Antiquities, Cyprus)

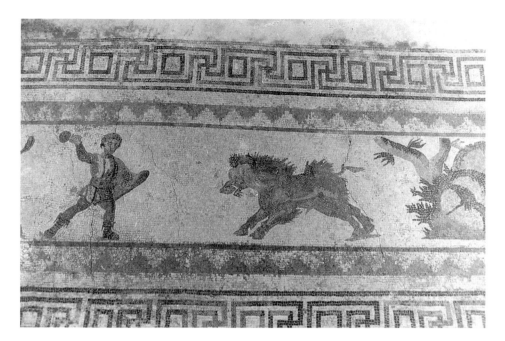

Figure 190. Peristyle, north portico panel, center with boar and bull (courtesy of the Department of Antiquities, Cyprus)

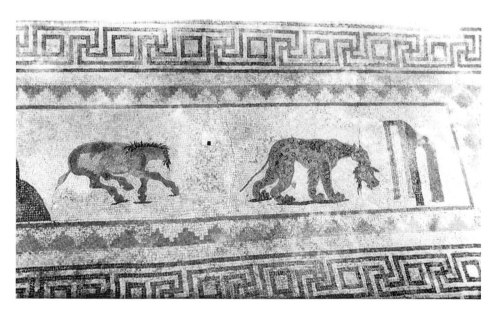

Figure 191. Peristyle, north portico panel, east end with leopard and wild ass (courtesy of the Department of Antiquities, Cyprus)

to have shaggy coats and long tails.[73] The accuracy of these representations is ensured by the fact that the pavement commemorates a real *munus*, as evidenced by the numeral markings on the beasts, referring to the number of animals of each species that was exhibited.[74] The ibex also appears in several animal panels decorating the intercolumniations of the House of the Laberii at Oudna, where felines do the chasing, rather than hounds.[75] The Oudna scenes seem to allude to the amphitheater.

The use of hounds to harass herbivores is well documented and the appearance of hounds in the amphitheater is attested by the narrative realism of the Zliten mosaic (fig. 176).[76] In the extreme left corner of the eastern frieze two hounds assist a *venator*; the upper one chases an antelope and the lower one nips at the thighs of a stag that charges in the direction of the hunter's spear.[77] The eastern and western (badly damaged) friezes at Zliten describe the *munus venationum*, while the other two sides illustrate the *munus gladiatorum*. The eastern frieze offers several parallels for the Paphian hunts. For example, in the left-hand corner of the south portico in Paphos, a hound attempts to stay the flight of a leaping stag that flees from the fierce tiger behind him. The stag is accurately depicted with a white-spotted, reddish-brown coat and antlers.[78]

The Paphian hunts also include animals in combat, as we saw in the graphic depiction of the leopard with the head of an onager in its jaws (fig. 191). All the analogies for this scene appear as isolated incidents showing a lion or tiger either mauling or carrying in its maws the head of an ass, stag, or bull.[79] All serve as fillers for single panels or medallions and therefore are excerpted from the narrative of arena spectacles portrayed in the frieze mosaic group.[80] In several single

73. The mosaic is from the House of Scorpianus in the western region of Carthage; see Dunbabin 1978, 71, 250, pl. 57 (Carthage A3,a); and Poinssot and Quoniam 1952, 129–53. The dates assigned vary from the improbably early date of the second quarter of the 2d century to the more likely mid-3d century; Dunbabin 1978, 71n.31.

74. See Poinssot and Quoniam 1952, 140n.51; and Dunbabin 1978, 71–72.

75. Gauckler 1896, 202 (room 21) and 205 (room 30).

76. On the techniques and types of hounds used for hunting, see Aymard 1951, 235–74; and Toynbee 1973, 102–6. Martial in *De Spectaculis* XXX describes a swift Molossian hound chasing a hind in the *munus venationum* given by Titus in Rome.

77. Aurigemma 1926, 186, fig. 112, esp. fig. 116.

78. Again identification may be confirmed by the Carthage "catalogue"; see Poinssot and Quoniam 1952, 139–40, fig. 6, where the stag is described as having a red-brown coat and the customary white spots. For a similar stag, see a mosaic from the "villa romana" at Marsala (Lilybaeum); Marconi Bovio 1940, 389–91, fig. 25; and von Boeselager 1983, 144.

79. The mosaic parallels are as follows: a tiger carrying an ass's head from the Baths at Philippi (Waywell 1979, 301–2, pl. 50, fig. 38, cat. no. 41); a lion holding an antlered head of a stag, from Verulamium (Toynbee 1973, pl. 16); a tiger pawing the head of a bull, from *Horrea of Epagathiana et Epaphroditiana* at Ostia (Becatti 1961, pl. 92); and a lion pawing an ass's head in one of the Nennig medallions (Parlasca 1959, pl. 39).

80. This observation is underlined by the inclusion of the headless ass within the same medallion as the tiger with its head in the Baths at Philippi; see Waywell 1979, fig. 38.

incidents, similarly used as fillers, a feline ferociously claws an ass, an attack that might be seen as a prelude to the same fatal end.[81]

The tradition of depicting pairs of beasts in murderous contests as isolated motifs developed concurrently with narrative friezes of the same themes, and the two approaches undoubtedly enriched each other. The depiction of felines at Paphos follows the patterns of felines in contemporary mosaics throughout the Mediterranean. This uniformity can be attributed not only to the circulation of model books but also to common firsthand knowledge of these carnivores from local spectacles. The presence of two lions, two leopards, and two tigers—that is six out of eighteen beasts—in the Paphian panels is interesting when we consider that there was a decline in the number of felines appearing in the arena, while the number of herbivores increased in the second and third centuries.[82] Tigers were especially rare in the arena repertoire, even in Rome, and it is interesting to note that they appear infrequently in mosaics as well.[83] They are found most often in the context of animal combat and as single motifs (fig. 180) rather than in narrative friezes, except in Paphos. The leopards and lions, however, have many parallels in the amphitheater friezes discussed above. The lions of both the south and north porticoes (figs. 187 and 189) with their hairy manes and tawny pelts closely resemble the lion in the east frieze at Zliten and the north frieze at Orbe.[84] A lively naturalism characterizes these stalking leopards and springing lions, which, in this sense, are comparable to their monochrome counterparts in Ostia and Castel Porziano, although the delineation of anatomical details and the modeling differ.[85] A close counterpart to the lion, as well as to the large spotted leopard, appears in a mosaic fountain basin of the late second century from Sousse (fig. 192).[86] A mosaic frieze of four beasts from the amphitheater, set against a white ground with foot shadows and with tufts of grass and trees scattered between them, covers the wall of the basin. It is not only the treatment of the beasts which is similar, but the type of composition as well.

The boar on the Sousse basin (fig. 193), although more plastically conceived,

81. The examples are from Ptolemais; see Kraeling 1962, pl. 58A, from room 11 of the villa assigned to the 1st century A.D.; and from the House of Terrain Hadj Ferjani Kacem, in El Jem, dated to ca. 200–220; see Foucher 1960a, pls. 44 and 45. See also another medallion in the Severan villa at Nennig showing a tiger seizing a *pulcher onager*; Parlasca 1959, pl. 38.

82. Jennison 1937, 83. Compare, for example, the Ostian mosaic from the Baths of the Seven Sages, in which four out of eighteen beasts are felines. The absence of felines in the amphitheater mosaic from the House of the Ostriches in Sousse of the mid-3d century illustrates this point very clearly; see Dunbabin 1978, 271, pl. 60, cat. Sousse no. 32(c).

83. On the rarity of tigers in Rome, see Jennison 1937, 77; and Toynbee 1973, 81.

84. See Aurigemma 1926, 190, fig. 120; and von Gonzenbach 1961, pl. 65.

85. The descriptions of the eighteen beasts from the *frigidarium* of the Baths of the Seven Sages could easily apply to the Paphian beasts; see Becatti 1961, 135–36, and 300–301.

86. Foucher 1960b, 23–24, pls. 10c and 11, inv. Sousse no. 57.049, dates it to the late 2d century; and see Dunbabin 1978, 269 (Sousse 7). The Sousse leopard's spots are large open circles like those on the Paphian beast, unlike the solid black spots on the Zliten leopard.

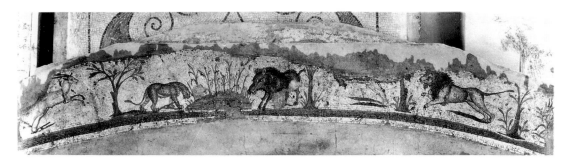

Figure 192. Sousse, fountain-basin frieze, four beasts (courtesy of the German Archaeological Institute, Rome, no. 64.312)

recalls the pugnacious character of the two boars in Paphos, particularly the boar of the east portico which is chased by a tiger (fig. 194). The latter shares with the Sousse boar the dark lines used to delineate the bristles along the upper ridge, haunches, neck, and chin, as well as the bulging eyes, protruding snout, and open mouth with tusks. The absence of dark lines to highlight the bristles of the boar in the north portico and the difference in its coloring reveal the variety of hands involved in the creation of the Paphian hunts. Boars appear in all the comparable frieze mosaics, but the boar Gorgonis from Kos is probably the closest to the Paphian examples (fig. 177).[87]

The curious boar scene in the north portico (fig. 190) in which the hunter holds a dark spherical object in his raised right hand might be clarified by a comparable image in the eastern frieze at Zliten (fig. 176). The Zliten boar stands on its hindquarters balancing a spherical object between its snout and forehead, while a dwarfish figure stands opposite and holds another spherical object in his raised right hand.[88] The little man takes aim as if he were throwing a ball. It is likely that this episode represents the type of comic trick or juggling which was interspersed with the more life-threatening *venationes* in the amphitheaters.[89] The identical manner in which the young (beardless) Paphian hunter takes aim at the boar suggests a similar theatrical moment.

Another Paphian beast is the brown bull of the south portico; the hump above its shoulder distinguishes it as a type of Asiatic ox called a zebu (fig. 188).[90]

87. See also the gray-blue boar with black bristles speared by a naked hunter in the atrium of the House of Silenus of the late 2d century from the western excavations at Kos; Atzaka 1973,232, pl. 15a; and Morricone 1950, 240–41, figs. 75–76.

88. See Aurigemma 1926, 186, and 189, fig. 117, who suggests that the spherical objects are fruits. Support for his interpretation is offered by a panel in room 7 of the House of the Laberii at Oudna in which two amphitheater bears gather oranges from a tree; see Gauckler 1896, 195, fig. 3.

89. Levi 1947, 276, interprets the Zliten scene as a clown playing ball with a bear. The animal at Zliten, with its snout and white tusks, is certainly a boar, but Levi is correct to identify these round objects as balls. Although there was a tradition of performing bears, playing with boars was unusual.

90. Toynbee 1973, 148.

Figure 193. Sousse, fountain-basin, detail of boar (courtesy of the German Archaeological Institute, Rome, no. 64.313)

Figure 194. Peristyle, east portico, boar (courtesy of the Department of Antiquities, Cyprus)

Scholars believe that the zebus were the Cypriot oxen listed as part of Gordian I's display collection of fabulous beasts.[91] It is interesting to note, especially considering its supposed origin, that the Paphian humped bull is a singleton in the group of mosaic friezes that are analogous to the Paphian hunts. A zebu also appears in the hunt border of the Navigium Isidis in the House of the Mysteries of Isis at Antioch, an image suggesting the use of local stock for staged hunts.[92] The inclusion of a zebu in the mosaic of the "fancy-dress banquet" from El Jem proves that these bulls were not of local stock, but rather an imported breed used in the *venationes*.[93] One of the sleeping bulls bears a brandmark in the form of a gladiator—further confirmation that these bulls were destined for the arena.

The bear of the east portico (fig. 185) is our last Paphian beast. Unlike the bull, it conforms to the conventional type found in most visual comparanda.[94] There are slight stylistic differences: of the seven bears with Greek titles in the Kos *venatio* (see one of these bears in fig. 178), none is quite as shaggy as the Paphian version.[95] The bear of the animal medallions surrounding Ganymede from the House of the Arsenal at Sousse (fig. 87) is comparable in its anatomical outlines, long-haired coat, bulging bright eyes, and raised forepaws with extended claws.[96]

The information gleaned from the identification of the Paphian hunters and beasts places the Paphian hunting panels securely within the realm of the arena. Why, then, was natural landscape included? None of the other comparable mosaic friezes refers specifically to any kind of setting, and for this reason the Paphian panels offer an unusual problem of interpretation. The two architectural elements from the north portico (fig. 195) and the east portico (fig. 185) effectively recall the arches and squared openings that gave the beasts access to the arena from their dens.[97] Such doorways or *postica* are found on the Roman reliefs that portray the beasts incited by *venatores* to run through these structures.[98] In Paphos these gates function as signs to the viewer that the hunts take place in an amphitheater. They underline the fact that these trees and hillocks denote an arena spectacle—indeed,

91. *S.H.A.*, *Vita Gordiani* 3.7: "tauri Cypriaci centum." Jennison 1937, 89, points out that this display was put on at the end of the reign of Severus and that the *bestiae herbaticae* far outnumbered the *carnivora*. See also Calpurnius Siculus, *Eclogues* VII.6off., where he describes a Neronian spectacle in which the humped oxen were included (70–71).

92. Levi 1947, 165, pl. 33b.

93. See Salomonson 1960, 37n.66, who dates the mosaic to ca. 230.

94. See Toynbee 1973, 93–100, who cites many of the visual comparisons.

95. See Robert 1940, 191–92, for their names.

96. Foucher 1960b, 42–44, pl. 20a, inv. Sousse no. 57.092; and Dunbabin 1978, 269 (Sousse 12a).

97. See Jennison 1937, 158–61, for a discussion of the various kinds of openings.

98. *Postica* can be either doors of the beasts' dens, which had removable ends, or the traveling boxes in which they were transported; see Jennison 1937, 93–94. A scene in which a lion springs from a squared doorway is found on a relief from the National Museum in Rome which shows a *venatio* in the Circus Maximus; see Hönle and Henze, 1981, pl. 63. In another, a boar springs from a *postica* in the lower register of a marble triple frieze from a tomb outside the Stabian Gate, now in the National Museum in Naples; see ibid., p. 46, pl. 22.

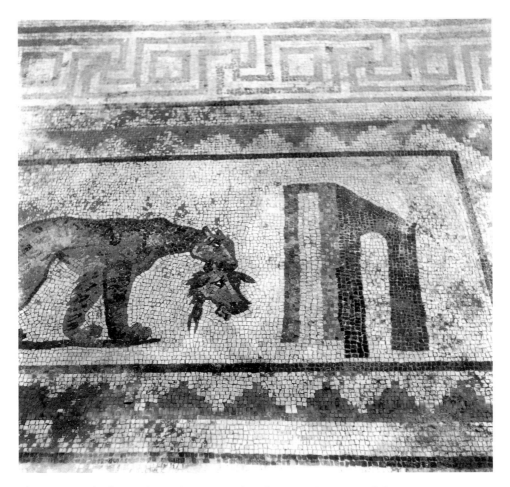

Figure 195. Peristyle, north portico, east end with *postica* (courtesy of the Department of Antiquities, Cyprus)

a particular kind of spectacle—rather than the outdoor setting of the sportsman's hunt. The Paphian *venationes* belong to a category of spectacle called *silvae*, which are rarely described in written sources or in art.[99] Evidence exists, however scanty, to confirm that not only was the arena sometimes artificially transformed into a natural hunt terrain, but that such scenic reconstructions were copied by artists.[100] An account of the games given by the Emperor Probus in A.D. 281 in celebration of his triumph over the Germans preserves the most elaborate description of the creation of a pseudonatural setting within the arena.[101] Probus

99. The following interpretation of the Paphian hunt and its broader implications for the interpretation of myth in Roman art was introduced by Kondoleon 1991.
100. See Aymard 1951, 189–96, for a comprehensive discussion of *silvae* in literature and art.
101. Ibid., 190; and Jennison 1937, 93.

ordered his soldiers to pull up real trees by their roots and plant them in the Circus Maximus so that it would look like a verdant forest.[102] Large numbers of *herbatica animalia* were let loose in this shady wood, and the spectators themselves were invited to hunt. Once the crowds entered the arena, the *venatio* assumed a power that could break the barriers between reality and illusion and the "forest" was no longer an artifice but a palpable environment. But art did not always mimic nature, sometimes it mimicked art, for we learn from another account in the *Historia Augusta* that when Gordian I was aedile in Rome he dutifully gave twelve exhibitions, one for each month, of which the *silvae* were directly inspired by a painting in his ancestral residence.[103] Both descriptions of *silvae* are provocative for what they reveal about the relationships of art, nature, and cultural activities.

The material evidence is also meager, but it quite clearly documents the physical form of the *silvae*. A series of bronze medallions, called *contorniates*, were struck on the reverse with an image of the *venatio* wherein stags, antelopes, and hounds leap about trees and shrubbery set within the walls of the arena podium.[104] These pseudo-*monetae* were produced in the fourth and fifth centuries perhaps as commemorative issues of the great *ludi* given in Rome, and as such were meant to recall, if only in a contractive way, the real events.[105] The precise meaning of these *contorniates* is not known, but the great number of references to the spectacles on the reverses suggests a literal connection rather than a metaphorical one, as observed by J. M. C. Toynbee.[106]

Although somewhat more ambiguous than the *contorniates*, on which the elliptical arena is outlined, a silver pyxis found in the Walbrook-Mithraeum in London is decorated with a detailed hunt frieze laid out in two registers around the body of the casket and on the lid.[107] Hunters clad in helmets and short tunics, some with shields, stalk beasts amid a few landscape elements (boulders, leafless trees). In one episode a man is coaxed out of a rectangular box—possibly a crate or cage. This seems to be a parody wherein human bait is used to lure the

102. *S.H.A.*, *Vita Probus* 19.2–4: "arbores validae per milies radicitus vulsae conexis late longeque trabibus adfixae sunt, terra deinde superiecta totusue circus ad silvae consitus speciem gratia nove viroris effronduit."

103. *S.H.A.*, *Vita Gordiani* 3.5–8: "exstat silva eius memorabilis, quae picta est in domo rostrata Cn. Pompei, quae ipsius et patris eius et proavi fuit, in qua pictura etiam nun continentur cervi palmati ducenti mixtis, . . . tauri Cypriaci centum." Blake suggests that this painting was itself a model of the *Ludi Saeculares* (1940, 116n.225).

104. See Alföldi 1976, 213, reverse 215, pls. 41, 1–12, and several others cited there.

105. For an insightful discussion of the contorniates and their relationship to the great spectacles, see Toynbee 1945, 116–17.

106. Ibid., 117, contradicts Alföldi's explanation of these scenes as general symbols of good wishes for luck and victory. She also notes that the rarity of New Year's references on the *contorniates* seems to disprove Alföldi's theory that they were New Year's gifts.

107. The casket is now in the Museum of London (acc. no. 21579). For a complete description and analysis of the technical and iconographic data, see Toynbee 1986, 42–52, fig. 2, pl. 22; and Buschhausen 1971, 175–79, B1, pls. 1–5.

beasts.[108] One hint that this hunt may have taken place in the arena, rather than out in the fields, is the inclusion of two men, one wearing a conical helmet, who lunge toward each other with hands grasped. Toynbee has read the gesture as a greeting, but it seems more likely that they are in combat.[109] If so, then the other hunt activities chased and cast around the casket may well take place in the arena, and the leafless tree and boulder could be stage props.

Mosaics also give meager evidence for such events. One scholar suggests that the trees and tufts of grasses placed between the stalking beasts on a second-century mosaic basin from Sousse (fig. 192) may reflect scenic devices used to create the artificial *silvae*.[110] It should be recalled that landscape elements, such as trees and boulders, also appear in the arena hunt panels from Chios.[111] A curious feature appears in one of the hunt panels at Oudna, wherein a tiger leaps toward a cylindrical structure (a truncated column or tower?) with a tree growing out of its side.[112] The mass of rocks at one side of this panel is similar to the Paphian outcrops. The Oudna hunts feature exotic beasts typically associated with the amphitheater and they are used to decorate a portico area; they fill the inter-columnar panels around a semicircular basin. The absence of large-scale mosaics representing *silvae* makes the Paphian hunts rare, but they are not without monumental precedents.[113] The almost-life-size animal painting on the garden wall in the House of the Hunt in Pompeii, preserved only in a nineteenth-century drawing, is viewed by J. Aymard as a depiction of a simulated mountain valley.[114] The weapons of the hunters, the activities under way, and the variety of beasts portrayed identify this as a professional hunt scene. It has been proposed that in the minds of Roman patrons such animal scenes and hunts were embedded in the

108. The fact that this vignette echoes one that occurs in the Great Hunt mosaic at Piazza Armerina leads, in part, to Toynbee's assigning the silver casket a 4th-century date. Surely such scenarios were typical of hunting entertainments and, were it not for the vicissitudes of time, representations from the 2d and 3d centuries would also survive. Toynbee puts herself into a difficult position by too closely aligning the silver frieze with the hunt mosaics of the 4th through the 6th centuries, when there are equally good parallels from the 3d century. The author also places the casket with the great silver treasures found in Britain from the second half of the 4th century. Yet given the run-down state of the Mithraeum in the 4th century, it is more likely that such a precious object was collected by the wealthier 3d-century Mithraists; see Toynbee 1986, 51.

109. See ibid., 46–47, who claims that because their right hands are clasped they are greeting each other. Two gladiators in a similar position, although with left hands clasped, occur on the discus of a terracotta lamp of the late-2d or early-3d century in the British Museum, where they are featured within the circus along with racing chariots; see Humphrey 1986, 141, fig. 62a.

110. This was keenly observed by Foucher, but not documented by supporting evidence (1960b, 23).

111. For the Chios mosaic, see above nn. 33 and 34.

112. This panel comes from room 30 of the House of the Laberii at Oudna, dated ca. 160–80; see Gauckler 1896, 205.

113. The Antiochene series of hunt mosaics from the 5th and 6th centuries might be considered late versions of these *silvae*. Yet the numerous references to pastoral subjects, and a host of creatures including birds, lizards, and mice within them makes it clear that these hunts are not staged in an amphitheater; see Levi 1947, pls. 77–78 and 86.

114. Jashemski 1979, 71, fig. 115c, who does not discuss its iconography. See also Aymard 1951, 191–92, pl. 2. Apuleius describes such a wooden mountain erected through the amphitheater floor to simulate Mount Ida; see *Metamorphoses* 10.34.2.

concept of the *paradeisos*—the wild-game parks on Italian aristocratic estates.[115] In other words, large-scale animal scenes could evoke features of villa-culture even in modest town houses. That such traditions reached into the provinces is attested by the discovery of a large-scale fresco frieze from a Roman villa near Mérida, Spain, which depicts beasts stalking beasts and *venatores* in combat with lions; boulders and trees mark the divisions of the scenes (fig. 196).[116]

The Paphian trees and hillocks should be read as theatrical props inspired by actual practices in the arena.[117] The very fact that the Paphian hunts are rare re-creations of the *silvae* invites further speculation about whether they may represent a specific event. Several North African mosaics record in detail "real" moments from the games and were undoubtedly intended as honorific commemorations of the munificence of the *munerarius*, who paid for the games.[118] One such benefactor, named Magerius, ensured that his visitors and posterity would remember his civic gift by commissioning a mosaic of his *munus* for his home in what is now Smirat, Tunisia.[119] In the center of this unusual mosaic are two columns with inscriptions set on either side of a young man holding a tray with four bags, each marked with the symbol for one thousand denarii. On the left column is the record of the request by the venatorial family for a patron to pay 500 denarii for each leopard, and to the right the acclamations of the audience, which responds to the generosity of the benefactor Magerius with "You will give the show at your own expense . . . This is what it means to be rich, to be powerful." He obviously paid double the required amount for each leopard (the bags on the trays are payment for each leopard) as a sign of his largesse.[120] Magerius himself stands to the side while four *venatores* engage in spearing four struggling leopards, all identified by Latin names. The reportorial quality of this mosaic corresponds to what we more typically find in amphitheater inscriptions, and emphasizes the possibilities that domestic decorations can reflect social realities.[121]

115. Zanker 1979, 510.

116. The murals are on display in the Archaeological Museum in Mérida. They are reminiscent of the frescoes found in the Hunting Baths at Lepcis and may be dated to the 3d century.

117. An interesting precedent for the use of trees as props is provided by the Hellenistic procession of Ptolemy Philadelphus in which 150 men carried trees to which were attached wild animals and birds; see Athenaeus, *Deipnosophistae* 5.201b. I summarize this thesis in an earlier essay (1991, 107–9).

118. For a list of 3d- and 4th-century mosaics entirely or partly inspired by the amphitheater, see Salomonson 1960, 54n.182. There is an important parallel in the mosaics depicting Roman circus events. J. Humphrey offers a detailed review of the known pavements and tests their accuracy in terms of circus architecture and paraphernalia (1986, 208–48).

119. For the preliminary publication with a thorough epigraphic analysis, see Beschaouch 1966, 134–57; Dunbabin 1978, 67–69, pl. 53, who offers the logical conclusion that Magerius commissioned the mosaic himself. More recently, Coleman 1990, 50–51, uses the Magerius mosaic to illustrate the relationship between the Roman *munerarius* and the *favor populi*; and Brown 1992, 198–200, offers a detailed description and analysis of both the formal and iconographic aspects of the composition.

120. Beschaouch 1966, 139.

121. There are many other examples, although none is quite as explicit as the Smirat mosaic; see Dunbabin 1978, 69–87; and Brown 1992, 189–207, who reviews the mosaics illustrating events in the arena.

Figure 196. Mérida Museum, fresco panel with lion hunter (photo by C. Kondoleon)

Narrative realism may have been used for stylistic reasons as well as for the explicit documentation of a specific event. The distinction between the two is subtle and often difficult to establish.[122] The Zliten amphitheater frieze, although lacking inscriptions, titles, and names, was conceived with the energy of a fresh creation full of new information and is unparalleled in its account of a full-scale *munus*. The Kos mosaic, while not as exhaustive in the variety of activities presented, certainly includes an unusual display of acrobatics which, along with the Greek names for the hunters and beasts, suggests a treatment of an actual subject. For both these mosaics the closest parallels exist in a series of sculptured friezes that are directly connected with the *munerarii* who had set them up as memorial plaques in theaters or as tomb reliefs. A vivid parallel for the Zliten mosaic comes from a tomb relief found outside the Stabian Gate at Pompeii; it portrays the actors in the *ludi*, namely the musicians, gladiators, and *venationes*, in three superimposed frieze registers (fig. 197).[123] The visual links between the mosaics and reliefs suggest a similar intention.

122. Robert 1940, 37n.1, tries to establish criteria for deciding whether or not a mosaic records a specific *munus*. He judges the Kos mosaic as an actual record because of its Greek labels. That mosaics may be only partly original and realistic is well demonstrated by the circus pavement from Silin. Because the nearby circus structure at Lepcis is well preserved, Humphrey could compare the mosaic of the local circus at Silin with the actual remains of a provincial circus. He determined that the architectural details, at least, were derived from a developed circus iconography that must have circulated through models established elsewhere (Carthage) (1986, 214–15).

123. See Kondoleon 1991, 108–9, figs. 5–7. For Kos, see Robert 1940, 90–92, pl. 24, no. 27, a relief from

Figure 197. Pompeii, tomb relief, scenes from the Games: musicians, gladiators, venatores (after T. Kraus and L. von Matt, *Pompeii and Herculaneum*, New York, 1975, fig. 53)

Literary evidence provides revealing insights into the relationship between these mosaics and real-life performances. For example, the Kos ensemble, that is, the *venatio* border and the mythological panels (figs. 198 and 199), finds its theatrical counterpart in Apuleius' *Metamorphoses*. His description of a three-day *munus* given in Roman Corinth tells us that the gladiatorial combats and *venationes* were preceded by dance and dramatic performances of myths,[124] including a reenactment of the Judgment of Paris. The performance took place on a constructed wooden mountain planted with trees, meant to represent Mount Ida, on which sat an actor dressed as the Phrygian shepherd Paris watching over his flock of goats. Not only were all the *dramatis personae* present—that is, Mercury, Juno, Minerva, and Venus—but they were accompanied by attendant figures such as the Dioscuri and cupids. In the final scene the Graces and Seasons danced onto the stage strewing flowers everywhere. A hunting display followed, after an "interlude" wherein a murderess was condemned *ad bestias*.[125]

The Kos mosaic with the border of acrobatic hunters includes a Judgment of Paris scene as one of three mythological panels in its center (figs. 198 and 199).[126] The figures, here identified by Greek inscriptions, include Paris, Hermes, Aphrodite, Hera, and Athena. They seem to be rather stiff, almost staged in their

Apri (Thrace) with two registers depicting acrobatics with bears, bull-jumping, and *bestiarii* attacking felines with their bare hands; they are as animated as the Kos figures. See also an especially richly detailed series of *venatio* reliefs from Sardis; Hanfmann and Ramage 1978, 120–24, figs. 285–94, nos. 146–49, dated generally to the 3d–4th centuries. A relief from Sofia proves that theatrical performances and dances went alongside the *venatio* in the arena; see Levi 1947, 275–77, esp. 276n.75, fig. 108.

124. Apuleius, *Metamporphoses* 10.29–32.

125. This text has recently been employed as evidence for Roman executions staged as mythological enactments; see Coleman 1990, 52, 64.

126. Morricone 1950, 227.

Figure 198. Kos, great hall, western excavations, detail of central panel with Judgment of Paris (courtesy of the Department of Antiquities, Rhodes)

arrangement in a rocky landscape. This scene is immediately bordered by separate panels depicting the Nine Muses and Apollo (fig. 177); the *venatio* frieze is the outer frame. Although there has been only a preliminary publication of the Kos mosaic, one can imagine a conventional interpretation straining at metaphorical meaning in the juxtaposition of such diverse themes when, in fact, their association in the spectacles may prove to have been the sole inspiration for their combination in this unusual mosaic floor.[127] If the various *venatio* mosaics are accepted as records of actual events, as has been suggested for the Kos frieze, then why not, given the assurance of a literary parallel, assume the same for this entire floor?[128]

The acceptance of this explanation of the Kos mosaic has profound implications for the correct "reading" of the Paphian mosaics, and possibly for many

127. The Muses and Apollo of the Kos mosaic in a sense underline the theatrical character of the scene and serve a function of an attendant tableau, just as did the Seasons and Graces that Apuleius described on the stage.

128. The second mythological panel of the Kos mosaic is badly damaged, but part of the central medallion survives and shows the Education of Achilles by Chiron. This theme was part of the life of a popular hero which was widely illustrated and must have been performed; see Friedlander 1920, 129, for pantomimes of Achilles.

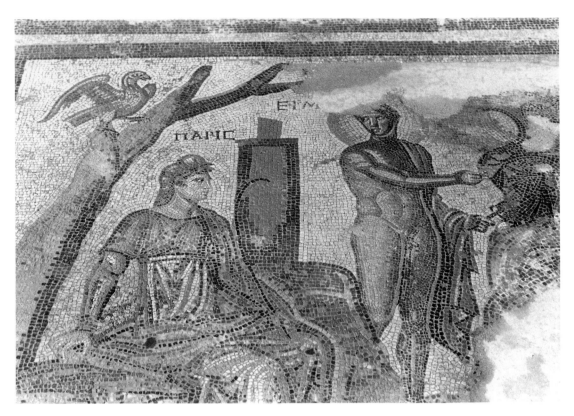

Figure 199. Kos, great hall, western excavations, detail with Paris and Hermes (photo by C. Kondoleon)

other examples of Roman art. First, it is necessary to understand the nature of the various performances that these mosaics may reflect. Roman pantomimes and mimes were the most popular type of dramatic spectacle and were often performed during the amphitheater games.[129] Through such theatrical displays a wide range of subjects drawn from myth, tragedy, and legend passed graphically before the eyes of Roman audiences. Martial, in his *De spectaculis*, recounts several pantomimic performances as part of his description of the Imperial *ludi* in Rome.[130] In a Roman version of "seeing is believing," Martial writes of one of these scenarios "that Pasiphae was mated to the Dictaean bull believe: we have seen it, the old time myth has won its warrant."[131] What Romans were seeing, in fact, was a condemned female criminal, in the role of Pasiphae, forced to simulate or actually couple unnaturally with something or someone in the form of a bull

129. On *mimi*, see E. Wust, in *RE*, s.v. *mimos*, esp. cols. 1727–64; Friedländer 1920, 125–29; *DarSag*, s.v. *mimus*; Bonaria 1965; and Beacham 1992, 129–53.

130. Martial, *De spectaculis* 5–7, 15–16B, and 21. For a recent review of this text in light of actual arena spectacles, see Pailler 1990, 179–83.

131. Martial, *De spectaculis* 5.

before her public execution.[132] Such a grotesque punishment occurs in Apuleius, where Lucius disguised as an ass is about to be mated with a female murderess in the amphitheater at Corinth.[133] Martial describes two other mythological dramas (*fabulae*) involving animals and criminals: both an Orpheus scene and a Prometheus scene served as dramatic vehicles for the execution of criminals.[134] Such graphic spectacles were obviously a debased form of mime adapted to suit Roman penal aims.[135]

Martial undoubtedly reflects the attitude of his contemporaries when he declares, "Whatever fame sings of, that the arena makes real for thee."[136] This is very compelling testimony, indeed, for not only do these episodes make the imaginary real momentarily, they also condition the way the public eye "sees" these myths. The act of attending a performance involves "picture seeing," and we should relate such experiences, where feasible, to the graphic arts. Through the study of spectacles, a sense of the "period eye" emerges, that is, the visual experience and habits of society.[137]

In the Roman world, established pictorial traditions existed for mythological subjects, yet it is also possible that the staging of popular dramas concurrently inspired a recasting of particular myths. Perhaps some of the combinations of seemingly unrelated subjects in mosaics may be better understood in this light. For example, the juxtaposition of Ganymede in a central medallion surrounded by eight medallions depicting amphitheater beasts (fig. 87) in a mosaic from Sousse makes sense if seen in the context of a *munus*: an actor, or more likely a criminal, is posed as the handsome youth about to be attacked by some beast in the midst of a *venatio*.[138] The most striking example of these hitherto unexplained compositions is the mosaic from the House of Fortuna Annonaria at Ostia, which presents a series of octagons: four are filled with amphitheater beasts, and the other four portray the vulture ripping out Prometheus' liver; Actaeon assaulted by his dogs; Ganymede and the eagle; and a centaur.[139] Martial

132. Toynbee 1973, 151, wishes to see the bull in dummy form. Coleman 1990, 64, considers the various means by which such scenes were enacted and offers the example of how Nero had the Christians clothed in animal skins before they were thrown to the dogs.

133. Apuleius, *Metamorphoses* 10.29.34. See also Hönle and Henze, 1981, 58, who state that asses were often substituted for bulls in such scenes; the authors include illustrations depicting these couplings on a series of lamps (fig. 31).

134. For the Orpheus epigram, see *De spectaculis* 21; and for Prometheus, see below.

135. For an extensive discussion of the literary sources describing these "fatal charades," see Coleman 1990, esp. 60–70. In her enumeration of these staged executions, Coleman provides a useful review of the Roman penal system and demonstrates how effectively it exacted human suffering and humiliation on the victims in the public context of the arena (44–48).

136. Martial, *De spectaculis* 5: "quidquid fama canit, praestat harena tibi."

137. The concept of the "period eye" was introduced by Baxandall 1972, esp. 40. In his study he offers a provocative parallel for our study of Roman spectacles and art by his use of *bassa danza*, a stylized form of semidramatic dance popular in 15th-century Italy, to explain the figural groupings in paintings (77–80). He shows that because the dances treated mythological subjects they provided a compositional source for the reinvention of classical themes in paintings.

138. Dunbabin 1978, 269 (Sousse 12a).

139. Becatti 1961, 213–17, pls. 97–99, no. 408, from room 3, dated to the first half of the 3d century.

informs us of a scene in the Imperial *ludi* which showed Prometheus, portrayed by an infamous robber, tied to the rocks and attacked by a Caledonian boar as a substitute for the vulture.[140] Along with the keys provided by the beasts themselves and by the fact that each figural scene involves a beast, it is plausible to interpret this otherwise odd mixture of scenes as derived from performances witnessed in the amphitheater. As if to underscore the ambiguity between the real execution and the myth, arena attendants dressed as the gods Mercury, Pluto, and Charon dragged the dead bodies away.[141]

These few examples strikingly suggest the nature of a common public experience that formed a koine of visual language and stimuli on which artists, as well as performers, could draw. This "encounter with the locally real," in the Geertzian sense, raises the question how the people of Rome saw their art and how their artists responded to the visual capacities of their audience.[142]

In instances in which the influence of performances is obvious, the relationship between spectacle and art is straightforward. A floor mosaic in the triclinium of a Roman house at Mytilene on Lesbos is such an example.[143] The floor includes nine scenes from the comedies of Menander which are composed according to theatrical conventions of posture, gesture, costume, and mask. The presence of such cultural themes in mosaic, painting, and sculpture is usually attributed to the patron's literary tastes and pretensions. It is equally possible, however, that the patron was the sponsor of a staged production of Menander's comedies and desired a domestic record of his munificence, just as his counterpart in Smirat wanted to recall his civic gift of a *venatio*.[144]

These models of influences suggest that whether or not the Paphian hunt records a specific event, the choice of the rarely depicted *silvae* certainly was inspired by the experience of such amphitheater hunts. Although it is not possible to identify the patron as *munerarius*, owing to the lack of epigraphic evidence, the dominant presence of hunting panels in the Paphian house bespeaks their importance and, at the very least, the owner's intention to imply through the mosaics his association with the politically powerful elite who donated the games.[145] In terms of composition, the figure-carpet style of the hunting panels seems anoma-

140. Martial, *De spectaculis* 7.

141. Hopkins 1983, 4–5; and Coleman 1990, 67, who cite Tertullian, *In Defense of Christianity* 15 as the source.

142. Geertz 1983, 102. Geertz uses Baxandall's concept of the "period eye" for his essay "Art as Cultural System." Coleman also evokes the cultural consciousness of the early Empire in attempting to explain the "contemporary attitude" and "climate of thought" in which the mythologically presented executions were performed (1990, 67).

143. Charitonides 1970, esp. 26–52, pls. 2–8, 16–24.

144. An interesting parallel exists, I believe, in the commemoration of a musical concert in the mosaic of the Musicians from Mariamin, now in the Museum of Hama in Syria; see J. Balty 1977, 94–99, nos. 42–44, with illus.

145. On Cyprus, the material evidence of an inscription tells us that Caracalla transformed the Kourion theater into a theater for hunting spectacles and that it held some 7,000 spectators; see Mitford 1980a, 1316n 109.

lous for the place and date of the Paphian mosaics, but the preceding investigation reveals a series created within the Severan period, with antecedents in the early second century, to which the Paphian mosaics belong. This group of late second- and early-third-century mosaics is characterized by an anticipatory combination of paratactic figural arrangements and neutral backgrounds which bears witness to the eastward expansion of western innovations at a much earlier date than hitherto believed. The frieze format favored by this group may, in fact, reflect the sequences in which the spectacles were seen. The escalation of arena spectacles that took place in the first two centuries of the Empire would seem to support the late-second- and third-century dates for these mosaics, if we assume the usual time lag in the production of new compositions. It is also likely that the traditions and institutions of Rome radiated out more slowly toward the provinces.

From these observations we can conclude that the narrative realism of the compositions is underscored by iconographic details. The depiction of the Paphian hunters and beasts belongs to a koine of Roman art and customs which closely ties them to a larger group of hunting mosaics. The representation of a *silva* in the Paphian peristyle is unusual among the mosaics of this group and suggests the possibility that these mosaics in particular may have evoked actual events. The correspondence between literary accounts of theatrical episodes and certain mosaic compositions supports this view.

The activities of the amphitheater formed a core of Roman civic experience and a public means by which the elite expressed political power and privilege.[146] Recent studies of the Roman amphitheater ranging from the archaeological to the social historical cite the increase in their construction from the first century A.D. as testimony to the Empire-wide promotion of Roman spectacles.[147] The games were a public declaration of Roman culture, and their promotion was part of an ongoing cycle of self-representation on the part of the donors and the audience. In producing the games, the ruling elite constructed spectacle—visual and theatrical—as an integral part of Roman culture. The mere representation of the events associated with the games bore the connotations of *Romanitas* and of civic prestige. The great extent to which themes from the games were absorbed into pictorial imagery demonstrates how the visual arts could and did express major interests of Roman citizens and communities in the provinces, as they did in Rome.

The degree to which the institution of the games permeated the thoughts of Roman citizens is noted by Artemidorus when he characterizes as a good omen a dream of being in the arena fighting wild animals.[148] The accurate portrayal of

146. The donation of the games is considered a key aspect of the Imperial form of euergetism (Greek and Roman patronage system); see Veyne 1990, esp. 208–10 for the Republican period, and 386–402.

147. For an excellent review of two of the most comprehensive studies, see Welch 1991, 272–81.

148. Artemidorus, *Oneirokritikon* 2.54 and 5.49. Salomonson 1960, 54n.184, summarizes the dream quite nicely: "For the poor such a dream meant expectations of wealth and prosperity, for the slave liberation."

these arena events in domestic decoration ensured an effective transference of this beneficent message. Such images also functioned in a more general way in that they palpably evoked victory and, by association, success and good fortune for the owners.[149] Certainly, over time, the compositions became codified, and artists relied on intermediary sources such as model books for their execution, but the selection and creation of images were determined by a Roman cultural experience that was visually perceived largely through the spectacles of the amphitheater.

149. See Humphrey 1986, 216, who follows Dunbabin in this interpretation of the circus pavements.

Chapter 9

Conclusions

MY AIM in this book has been to present the pictorial imagery of the Paphian pavements, to analyze their technique, iconography, and style, and to place them in their physical contexts in order to comprehend their meanings and functions. In reviewing the various strands of interpretation that emerge, we gain a new appreciation for the veritable cornucopia of literary and artistic references that leapt at the ancient visitor.[1] The beholder's physical and mental responses to such houses, dense in imagery and laden with signs, has been the subject of recent study.[2]

The preceding analyses of the Paphian pavements leads to at least two paths of interpretation. One approach is to determine what the mosaics can tell us about the process of Romanization in the eastern provinces. The second path is to question whether the decorations resulted from a comprehensive plan, encompassing several, if not all (at least of the figural ones) of the mosaics. That is the more difficult approach, as it has remained an elusive task in Roman studies and is thus more provocative and speculative as an argument. A profile of the patron and his society (and a look at the houses of like-minded citizens in other provinces)

1. To extend the apt metaphor of "talking decoration" used by Clarke in his study of Roman houses, see Clarke 1991b, 371. The phrase is an adaptation of *"architecture" parlante* used by 18th-century historians.

2. For a provocative study that attempts to reconstruct the beholder's response to images of landscape in Roman painting, with special attention to the insights of literary-reception theory, see Leach 1988, passim; and reviews by Bergmann 1991, 179–81, and by Ross 1991, 262–67.

buttresses the concept of a program of decoration. Before we address the issues of patronage and program, however, a summary of what can be concluded about the date of these mosaics is useful.

DATING THE PAPHIAN MOSIACS

The archaeological evidence indicates a date in the second half of the second century for the laying of the mosaics and for the destruction of the house shortly thereafter.[3] Scholars have had difficulty accepting this dating because the stylistic character of the mosaics suggests a date in the third century.[4] Our chronological schemes for mosaic developments are still rather sketchy, however, and an enormous number of new finds, especially in the Roman east, have surprised many by their unexpected qualities. What makes the Paphian site remarkably useful and significant is the carefully established dates of the ceramics found below and above the pavements. Although pottery experts dispute the absolute dates of certain wares, there can be little argument with the fact that no third-century pottery was found on the site! Still, it is informative to analyze some of the evidence marshaled to defend a later date.

Geometric ornament is the one area of mosaic studies which has been subjected to a rather strict typological treatment.[5] The pattern of crosses, octagons, and hexagons which surrounds the west-portico myth panels is a design typically assigned to the late third century at the earliest and is best known from the fourth century and later.[6] The faith in the charted development of such designs is so firm that scholars have used this particular pattern to suggest a late-third-century date for the Paphian mosaics.[7] W. Daszewski, in presenting two earlier variants of this pattern from Ancona and Silin, demonstrates that its dates should not be so constricted.[8] It should be noted that at Paphos the design receives a very simple

3. The archaeological evidence and pottery analysis by J. Hayes is reviewed above in the Introduction.

4. E.g., J. Balty 1981, 418–22, esp. 420–21, where she argues for a Tetrachic date. Gozlan 1990–91, 413–14, questions the Severan date proposed by both Michaelides and Daszewski.

5. E.g., Salies 1974, 1–187, offers the most comprehensive study of the development of geometric designs throughout the Roman empire. See also Guimier-Sorbets 1983, 195–213, as a model of the systematic analysis and statistical tables used to analyze motifs, in this case the key-meander; and Gozlan 1990a, 983–1029, who offers a regional study by tracing the development of North African designs.

6. The pattern is described in *Décor géométrique*, 280–81, pl. 180b, as "outlined orthogonal pattern of adjacent octagons and crosses, forming oblong hexagons." The range of examples is clearly set out with dates and locations in Salies 1974, 8 and 132–34 ("Kreuzmuster"), nos. 346–66. The date of 425 given to the example found in the Constantinian Villa at Antioch (no. 365), however, is incorrect and should read 325.

7. See J. Balty 1981, 420–21; and Gozlan 1990–91, 413–14, who in critizing Daszewski's search for earlier examples of this pattern seems to favor a later date.

8. See Daszewski and Michaelides 1988b, 40–42, for a description of these two mosaics. In her review of this study, Gozlan objects to the use of the Silin example because the crosses are oblique, as noted by Daszewski, but I would concur with the latter that this is a related version of the cross-octagon-and-hexagon pattern. Although Daszewski neglects to date the Silin example, it abuts the spectacular circus pavement in room 14 of the Libyan villa, which has been assigned a late-2d- or early-3d-century date by

and flat treatment; the crosses are solidly filled with color, as opposed to the more complicated fillers (rainbow, rope) found in other examples.[9] The masks and floral designs within the octagons are set against a plain white ground. The density and variation of fillers found in other examples are missing here; the Paphian version functions as a surround for the myths and is subsidiary. These same qualities of flatness and austerity of design were noted for the lozenge-star-and-square pattern found in room 8 and indicate a date early in the development of the pattern.

Another feature of the Paphian mosaics which is often raised in objection to a late-second-century date is the realistic details with which both the vine carpet and the hunt panels are executed. The harvesters in the vineyard, for instance, seem to be excerpted from genre scenes that were more in vogue in late antiquity.[10] Yet daily-life details are plentiful in Roman art of the middle period. An especially striking instance of the combination of myth and industry occurs on a Flavian silver plate now in Madrid which illustrates the gathering and taking of spring water, the salutary effects of which are explained by an inscription.[11] If such reportorial accuracy appears on first-century metalwork, then why should we not accept the realism of the Paphian mosaics in the late second century? Genre scenes appear in the Severan mosaics found at Orbe, in Switzerland (fig. 179), and in the grand mosaic from the House of the Laberii at Oudna (figs. 150 and 159), which is especially known for its detail and for the variety of rural activities displayed.[12]

The representation of the Paphian hunters with the props and dress of professional *venatores* evokes scenes that are more familiar from the third and fourth centuries. One of the earliest and most informative of such depictions is the amphitheater mosaic from the seaside villa at Zliten, in Libya (fig. 175). Although this mosaic is examined in Chapter 8, the controversy surrounding its date is relevant here. It is especially pertinent because several other mosaics from the same Libyan villa share features with the Paphian floors, namely the multiple-design (fig. 39), the *xenia*, and the Seasons (fig. 61). Although scholars have proposed dates ranging from the late first through the early fourth centuries for the Zliten mosaics, the most convincing arguments place them comfortably in the second century.[13] It is not critical for the purposes of the Paphian pavements to

J. Humphrey in his authoritative study of Roman circuses (1986, 211); so the dating of Silin is less open, perhaps, than Gozlan suggests (1990–91, 414). It should also be recalled that the multiple-design mosaic at Silin offers an important comparison for the Paphian version; see above Chapter 2.

9. E.g., the 4th-century versions in room 16 at Piazza Armerina and in the Constantinian Villa at Antioch; see Salies 1974, nos. 349 and 365, respectively.

10. See Geyer 1977, 119, who notes that the dress of the harvesters are "Alltägstracht."

11. The inscription reads "SALVS VMERITANA"; see García y Bellido 1949, 467–70, no. 493, pl. 345; the wagon bearing the barrel of water recalls the one in the Ikarios scene at Paphos. A personification of the source reclines at the top of the plate, underlining the natural discourse between the divine and the natural.

12. For Orbe, see the pastoral figures dated to ca. 200–225; von Gonzenbach 1961, 174–77, pls. 49–53. For Oudna, see Dunbabin 1978, 112–13, and 241 for the early-3d-century date, pl. 101.

13. The most recent review of the dating arguments is presented by Parrish 1985, 137–58, esp. n. 1., where

determine whether the Zliten mosaics belong to the early second century or to the Severan age; in fact, there are those who conclude that the floors were laid in phases.[14] The analysis of the multiple-design mosaics in this book suggest a second-century date for the Zliten version. Correspondences with other mosaics from Tripolitania should be given their due weight, especially the bust of Diana-Luna found in the Baths of Oceanus at Sabratha, which does bear a close resemblance to the facial treatment of the Zliten Seasons.[15] Despite the viability of the many parallels found for the Zliten amphitheater mosaic, it must be regarded as a *unicum* in North African art for the second century, particularly for its reportorial accuracy.[16] Although not comparable in its scope or detail, the Paphian hunt panels should be invoked in future discussions about the Zliten amphitheater mosaic, because they demonstrate how inaccurate are stylistic criteria for dating.

To return to the problem of the Paphian pavements, it seems reasonable to close with the wealth of evidence from Antioch, which supports a late-second-century date. The analysis of the mythological and geometric mosaics in Chapter 2 firmly points to close ties with the second-century mosaics at Antioch. For instance, there are striking similarities between the Narcissus, Phaedra and Hippolytos, and Triumph of Dionysos from Paphos and comparable scenes at Antioch.[17] Idiosyncratic features, such as the twisted-ribbon border with white high-

the previous literature on the mosaics is cited; he pushes for a date in the early 3d century based on his stylistic assessment of the Season mosaic and the amphitheater mosaic. See also Dunbabin 1978, 235–37, for a detailed account of the various evidence given by scholars for dating.

14. E.g., Dunbabin 1978, 237, offers a "reasonable explanation" in suggesting that the earliest floors (amphitheater, volutes, and agricultural scenes) were laid in the late 1st or early 2d century, while the ornamental group of mosaics (one assumes she includes the multiple-design mosaic) should be ascribed to a period of increased Italian influence, the mid-2d century. She hedges about the date of the Seasons and seems to hint that they were produced later by the "local pupils" of the "immigrant workmen from the eastern Mediterranean." This scenario is supported by archaeological evidence of the rebuilding of some parts of the house; Aurigemma 1926, 34, 38. One problem with Dunbabin's theory is the vague identity of her workmen from the eastern Mediterranean; does she mean Alexandrian workshops traveling through Cyrenaica? If so, then the recent analysis of the mosaics of Berenice in Cyrenaica, which concludes that these mosaics have little in common with those of western North Africa, should be carefully heeded; see Michaelides 1989a, esp. 366–67.

15. Here I disagree with Parrish 1985, 143, who unnecessarily discredits this comparison. What is problematic, however, is the certainty with which Di Vita 1966, 51–58, pl. 10b, proclaims the mid-2d-century date of the Oceanus mosaic under which the Luna bust was found. If, in fact, the Oceanus can be dated later, e.g., to the early 3d century, then the Luna bust might be pushed well into the 2d century. Certainly the new finds at Silin, dated to the late 2d or early 3d century, provide some important parallels for the Zliten and Sabratha mosaics, especially for the geometric patterns.

16. Although Parrish offers (1985, 151–57) convincing parallels to situate the Zliten version with arena mosaics of the 3d century, he premises his remarks on the notion that these mosaics shared a vocabulary of established models. I find Dunbabin's observation that the realism of the Zliten scenes indicate a special commission created ad hoc, and unlikely to have been based on "out-of-date models," more compelling; see Dunbabin 1978, 236.

17. In establishing the shared cultural milieu of the Cypriot and east Mediterranean workshops, Michaelides has cited the choice of the same myths in houses at Antioch and on Cyprus; see Michaelides 1989b, 277–79.

lights and the lozenge-star-and-square pattern, indicate a shared vocabulary with the Antiochene workshops.[18]

Although the impact of Antioch is certainly noticeable, other influences are also present in the House of Dionysos. They are less easy to explain but nonetheless indicate a definite link with western mosaics. The pottery finds and architectural features underscore this affinity with the Roman west. The geometric mosaics demonstrate that even in the use of patterns—seemingly the least deliberate type of decoration and thus less susceptible to fashionable or foreign currents—western models were present. For instance, a border motif such as the meander finds its closest parallels in the second-century Italian mosaics and later in second- and third-century examples from Tripolitania and Byzacena. More striking are the Paphian interpretations of the multiple-design (room 14) and interlace "cushion" with *xenia* (room 9) mosaics, which closely correspond to types known exclusively in western Europe and in North Africa and are anomalous for the east.[19] Above all, the spectacular vine carpet of the triclinium and the monumental hunt panels of the peristyle distinguish the mosaic production of Paphos from that of Antioch, where there are no comparable examples from the second or third centuries. It is to North Africa, specifically Byzacena and Tripolitania, that we must turn for such compositions. Are such results merely to be ascribed to the transmission of models through copybooks, or is the House of Dionysos at Paphos a witness to a more dynamic cultural and economic process?[20] If so, as I believe it is shown in this book, then the similarities between these mosaics and others with shared motifs bear meaning and demonstrate shared social realities—namely, as one analyst has put it, the way in which "the ruling culture understood itself as culture."[21]

PATRONAGE AND PROGRAM

In the two preceding chapters, on the vine-carpet and hunt mosaics, the evidence points to the role and tastes of the patron, which, in turn, raises the question about his identity and whether there was a systematic program of

18. For the ribbon border, see the House of the Porticoes, dated to the late 2d century; this house also includes the busts of the rivers, including the Pyramos and Thisbe, that were critical to the discussion of this scene at Paphos; see Chapter 5.

19. For the multiple-design, see above Chapter 2; and for the interlace "cushion," see above Chapter 4.

20. In his survey of western influences on Cypriot mosaics, Michaelides concludes that these "foreign ideas reached Cyprus (presumably through copybooks) and were recreated by local artists" (Michaelides 1989b, 280–81). I tend to agree with Gozlan, who suggests (albeit her statement was based on a communication I gave at a colloquium in Spain) that there were more specific contacts and a deeper level of influence than a mere transmission of models (1990–91, 415).

21. See Bryson 1990, 55, where the process of cultural production is understood in terms of the visual and textual imagery of *xenia*.

decoration. Because the epigraphic evidence is silent about the patron of the House of Dionysos, we are forced to draw on information about his contemporaries in similar communities throughout the Empire and to consider their social and political concerns as related. Recent studies of Romanization—historical, epigraphic, archaeological, and so on—support this approach, as their results have more precisely defined a process whereby elites from all parts of the Empire expressed their *Romanitas* through a shared vocabulary of art, architecture, and even social habits. The self-consciousness with which the upper class adopted the features of Roman culture can be seen in their domestic decoration.

The Paphian house—its plan and pavements—reflects a trend among provincial notables in the Greek east to express their *Romanitas* in the selection of design elements for their homes.[22] A related process has been charted in the houses of Pompeii, where Italian aristocratic villa culture serves as a model for the material and social values of the upper and middle classes. In other words, villa elements crop up repeatedly, ingeniously miniaturized and/or replicated in fresco or mosaic, in the houses of businessmen and merchants of all backgrounds and means.[23] The associative effect of these features and images can be demonstrated by studies of their origins in the grand Italian estates and their earlier prototypes in palaces of Hellenistic nobles. In terms of actual features, the inclusion of mosaic basins within *aediculae*, small *piscinae*, urban-sized gardens with pergolas and statuary within townhouses of all sizes can all be taken as forms inspired by and derived from their more monumental counterparts on villa estates. Mural painting and floor mosaics afforded an even more expansive arena for the demonstration of these affiliations.[24]

Large-scale paintings (megalography), often found on exterior walls, of animals peacefully roaming the landscape, in combat, or being hunted provide a vivid demonstration of this theory. On the garden wall of the House of Ceius Secundus the beasts are shown roaming freely in their natural habitats, without human figures.[25] The manner in which the painted fountains on either side of this animal painting seem to empty into the actual gutter of the real garden reveals the taste behind such compositions. They demonstrate the Roman predilection for imaginary extensions of their gardens, indoors and outdoors, through lush landscape paintings. Just as entire gardens were illusionistically re-created inside houses, they were also painted on exterior walls to expand the scope of the peristyle

22. A study of Roman villas makes a parallel observation: it sees the architectural components employed by builders and patrons in the provinces as an expression of *Romanitas*; M. Kubelik and G. Métraux, *The Villa: An Architectural History* (forthcoming, Yale University Press), chap. 2. I am grateful to G. Métraux for allowing me to read a draft of his manuscript.

23. P. Zanker has given us a detailed and convincing analysis of this phenomenon in his study of the late Pompeian houses in which he characterizes "villa-culture" and traces its impact, especially in the middle-sized houses and in post-earthquake renovations (1979, 460–523, esp. 514–23).

24. The painted expressions of "villa-culture" are explored in ibid., 504–12.

25. Jashemski 1979, 69–70, figs. 111–12; and Michel 1990.

gardens impressively in imitation of grand estates.[26] In the ideal world of representation the owner could create an interior garden with paint. Surely one of the more brilliant examples of the conflation of villa elements—fountain, game park, and fish pond—is found in the *nymphaeum* to the south of the peristyle of the House of the Centenary at Pompeii.[27] As a setting for an elaborate mosaic fountain, a wide frieze of wild animals covers the four walls and is set above narrower panels with a rich catalogue of marine creatures in a body of water.[28] At Paphos, the patron actually had a functioning fish pond installed, but there are many instances of painted pools at Pompeii which undoubtedly express the same desire to evoke the luxurious appointments of villa estates. Similarly, animal paintings are an illusionistic re-creation of the great wild-game parks, the *paradeisoi*. They allude at once to the Imperial Roman menageries, the game reserves on aristocratic Italian estates, and to their antecedents—the royal parks of the Persian kings.[29]

The example of a professional hunt scene, seemingly derived from the arena, in a megalographic mural on a garden wall in the House of the Hunt at Pompeii brings us to the decoration of the peristyle at Paphos.[30] The hunting panels of the Paphian peristyle reflect both the private garden decorations that evoked grander conceits of the *paradeisoi* and the *venationes* of the arena, which may be seen as distinctively Roman and public enactments of the royal privilege of the great game hunts. In an account of the excesses of Emperor Elagabulus, we learn of public displays transferred to the domestic space of the peristyle. Elagabulus brought horse-drawn chariots from the Circus Maximus into the palace and invited his guests to drive them around the porticoes while he dined.[31] Such hyperbolic displays aside, ceremonies and spectacles of the hippodrome and amphitheater did play an important role in the political and ceremonial life of the emperor, and the integration of the hippodromes within palace sites has long been recognized.[32] The placement of the hunting panels in the Paphian peristyle signals an intentional relationship between cultural practice, architecture, and

26. The frequency with which hunt scenes appear in Pompeian gardens can be seen in the number of examples recorded by Allison 1992, 244.

27. See Jashemski 1979, 110–11, fig. 181.

28. On a more modest scale in the North African provinces, the mosaic frieze of wild beasts on the wall of the Sousse basin (fig. 192) captures the bourgeois fantasy of a *vivarium* (game preserve), just as the mosaic catalogue of fish on the bottom of the basin corresponds to the *piscina* (fish pond); see Foucher 1960b, 23.

29. See Xenophon, *Cyropaedia* 1.4.7, where Cyrus' game park is referred to as a *paradeisos* and the animals it contains correspond to those found in the *venationes*. This same interpretation may be applied to garden sculpture that depicts beasts in combat, such as the bronze hounds attacking the boar in the House of the Citharist; see Jashemski 1979, 72, and fig. 29.

30. See Allison 1992, 244, who suggests that "the rectangularity of the landscape elements, including regular cut blocks for the foreground bank, suggests that this was an artificial landscape, perhaps an amphitheatre."

31. *SHA, Vita Heliogabalus* 27.2.

32. See Downey 1953, 111–12, for a discussion of the relationship between the hippodrome and palace sites.

iconography. By virtue of their location within a house, these same mosaics effectively associate the patron with the benefactors who donated the games and with the private pleasure and even virtues of those who hunted and kept wild beasts on their luxurious estates—most notably the emperors.

The evolution of vine compositions, as shown in Chapter 7, makes it clear that the vine-carpet mosaic of the Paphian triclinium can also be traced to ritual practices displayed in Italy and represented in Pompeian homes. Vine pavements evoke actual dining practices in domestic and cult settings and are more intrinsically tied to function than has been previously suggested. The vineyard, like the *silva* in the amphitheater, provides a setting that corresponds to the practices of the inhabitants, whether they be dining, beholding, or performing in public or private.

The vine-carpet mosaic and the hunting panels create ambients that connote the pleasure and luxury of life for the privileged.[33] Yet even motifs such as the *xenia* found in the second dining hall (room 9) can signify prestige (fig. 76). Specifically, these objects represent *apophoreta*, as demonstrated in Chapter 4, and recall the ancient custom of bestowing precious gifts on guests. In this instance, the motifs are a symbol of a way of life bound to status and the display of status.

Domestic pavements can, then, be employed as indicators of Romanization and the prestige associated with it in the same way that scholars have used more strictly enclosed systems of evidence, such as epigraphic habits. In a study of Roman and provincial epitaphs, E. A. Meyer observes that, citizenship notwithstanding, the distinctively "Roman pattern of deceased-commemorator inscriptions" appears throughout the provinces in the second century.[34] A growth in the number of these Roman-style epitaphs, particularly in North Africa and Gaul, leads her to conclude that such funerary markers were status symbols in a society in which the provincials pursued Roman citizenship and quickly adopted the privileges and public habits associated with their new positions.[35] Another kind of evidence comes in the form of luxury objects exchanged as gifts between notables throughout the Empire. The great silver treasures from late antiquity found across the western Empire evince the parallel status of their owners. As K. S. Painter has stated, "The homogeneous class at the top of the late-Roman hierarchy spreads across geographical and provincial barriers and so do the sources of their supply of precious possessions."[36]

33. Images of Orpheus abound in Roman reception halls and suggest another way in which domestic decoration might have reflected social practices and values. The enactment of the Orpheus myth by a performer during a banquet held in the game preserve on the estate of Quintus Hortensius is described by Varro in a key text that illustrates the penetration of popular entertainments and spectacles into Roman imagery; see Kondoleon 1991, 106.

34. Meyer 1990, 74–96, esp. 93.

35. Ibid., 88.

36. The treasures included in this study are the Mildenhall, Chaourse, Kaiseraugst, Esquiline, and Carthage; see Painter 1988, 105.

The mosaics of the House of Dionysos, insofar as they can reveal something about the tastes and intentions of the owner, can also demonstrate the process of cultural Romanization.[37] The compositions and motifs noted herein as typically associated with the west or as Italian should not be identified simply as instances of "foreign" influence but rather as deliberate choices intended to associate the inhabitants with the governing classes from other parts of the Empire. The circulation of these forms amounts to the creation of a koine of Mediterranean art determined by elite tastes that transcend the boundaries of cultural and political traditions. These same patrons were responsible for the maintenance of Roman social and political institutions within their communities.[38]

In a search for a broader meaning for the decorative scheme of the House of Dionysos, I have suggested that certain themes were selected and received as symbols evoking *Romanitas*, Italian villa culture, and its attendant luxuries and pleasures. Is it also possible to detect a thematic organization for the decoration of the whole house which goes beyond such evocations? Scholars have taken on the challenge of proposing programmatic decorations for certain Roman houses with varying levels of success.[39] In a feat of hermeneutics, J.-P. Darmon has "discovered" symbols of marriage in almost every motif found in the House of the Nymphs at Nabeul, in Tunisia.[40] In order to accomplish this he is forced to turn repeatedly to classical Greek sources and to suppose a high level of erudition on the part of the hypothetical patron, not to mention the provincial visitors to the house. Darmon is forced to admit that nothing about the iconography of the Nabeul house is gratuitous and that its decoration represents "a quasi-hieroglyphic system."[41] Critics have correctly noted that this overinterpretation of images steers the author away from taking the disposition of images within the domestic plan and the sequences into account.[42]

In an even bolder attempt to impart thematic unity to diverse mosaics, J. M. C. Toynbee argues that "life, death, and afterlife" are the concepts behind the choice of themes in the House of Dionysos at Paphos.[43] She justifies her farfetched

37. The phrase is borrowed from Brunt 1990, 267–81, whose essay "Romanization of the Local Ruling Classes in the Roman Empire" charts the assimilation of Roman culture for the east and west.

38. See Harl 1987, esp. 3–5; and Brunt 1990, 273, who notes that "the education and economic interests [of] provinicial magnates closely resembled the old Italian ruling class."

39. For the earlier scholarship on programmatic painting in Roman art, see Lehmann 1941, 18–77; Schefold 1952 and an appropriately critical review by Toynbee 1955, 192–95; and Thompson 1960/61, 36–77.

40. See Darmon 1980, esp. chapter 3, wherein he suggests that seven out of thirteen mosaics deal with nymphic themes, including the roses gathered by Erotes in room 15.

41. Ibid., 222.

42. By far the most detailed and insightful review is Quet 1984, 79–104, esp. 102–4.

43. Toynbee 1982, 210–15. Another scholar of Cypriot mosaics errs on the side of overinterpretation in proposing a comprehensive explanation for the six panels found in the House of Aion adjacent to the House of Theseus and in the neighborhood of the House of Dionysos. Daszewski views this remarkable pavement of the second quarter of the 4th century as a pictorial polemic against Christianity; redemption in the Christian sense is represented in the guise of the Greco-Roman divinities (Dionysos, Apollo, Zeus,

funerary interpretations by assuming that "thoughts of death and *Jenseits* preoccupied the minds of its [Roman Cyprus] peoples"[44] Toynbee explains the perplexing mix of myths in the west portico as "symbols of the love of divinities for mortals in this life and of the union after death of mortals with their gods."[45] Although this group of myths is also read as an ensemble in Chapter 5 of this study, their physical relationship to the triclinium offers a key to a more likely (and more pragmatic) interpretation.

The preponderance of Dionysiac subjects in the houses of the second and third centuries has led to a more fruitful exploration of thematic domestic decorations. In her detailed study of the *Realitätsbezuges* (connections with reality) of Dionysiac iconography for the Imperial period, A. Geyer has determined that there was a widespread and well-developed system of decoration.[46] Basically, she supports this assumption by her investigation of Dionysiac-procession mosaics that are positioned in identical locations (namely, the entrance areas of *oeci* and triclinia) in houses built over a large geographic area.[47] Although a wide range of secondary subjects (especially marine and animal scenes) are found in combination with a core Dionysiac repertoire (especially the Triumph of Dionysos), Geyer proposes a consistent underlying theme of *tryphe* (luxury) for the Romans—abundance and prosperity.[48] These concepts complement the reception functions of the rooms and impart a sense of well-being for visitor and inhabitant alike.

Here I take Geyer's theory a bit further in light of what we know about the social and historical circumstances of the owners of these houses. There may, in fact, be an even more direct link between her supposition about the message of *tryphe* and the intentions of the patrons. For this reason, it is significant to draw on what evidence can be culled from Roman Cyprus about its municipal elite. A profile of the putative patron of the House of Dionysos at Paphos may be inferred from the prosopographic evidence of the Flavian citizen Pancles Veranianus of Salamis, on Cyprus.[49] As an expression of his *Romanitas* he founded an amphitheater, a gymnasium, a theater, and a Roman bath house in the late first century A.D. He is also credited with the patronage of dramatic events and musical contests performed in his theaters. These acts undoubtedly bolstered his standing in the community and were linked to the conferral of his *civitas*.[50] The apparent

and Helios); see Daszewski 1985, esp. 38–42. Like Darmon, he assumes the audience for this pavement had a sophisticated knowledge of recondite texts (Neoplatonic, Orphic). Although the use of inscriptions and personifications demonstrates an interest in abstract and academic displays on the part of the owner and/or designer, Daszewski's theory stretches our credibility; see review by Deckers 1985, esp. 163.

44. Toynbee 1982, 214.
45. Ibid., 211.
46. Geyer 1977, esp. 118–22, 133–34.
47. One of her key examples is the House of Dionysos at Paphos; see ibid., esp. 126–28.
48. On the concept of *tryphe* in the Classical and Hellenistic periods, see Harward 1982, 57–79.
49. Mitford 1980a, 1322, 1366–67.
50. The rarity of Roman *civitas* on Cyprus was discussed in the Introduction; see again Mitford 1980b, 275–88.

absence of a record of such a munificent citizen in Paphos, the Ptolemaic and Roman capital of the island, should be ascribed to chance.[51]

Although the literary record remains silent, archaeological evidence speaks eloquently of the Romanization of Cyprus and of the integration of such Roman institutions as the theater. At Kourion the theater was converted, in one of seven phases, into a hunting theater in the early third century at the same time that the Salaminian theater was converted to provide for aquatic games—*naumachia*.[52] The conversion of the Kourion theater attests to the demand for and availability of the *venationes* on the island. Although less is known about the fate of theaters at Paphos, the Paphians could easily have participated in their neighbor's games— the Kourion theater was only a day trip away. Earlier in the second century, gladiators, *venatores*, and wild beasts were brought to the island for the Salaminian amphitheater, the only one thus far recorded on Cyprus.[53] The requisite *familiae gladiatoriae* must have been supported by an association of *philocynegi*.[54] These "friends of the hunt" undertook the renovation and decoration of theaters and most likely donated the games as well.[55]

Similar elite organizations, comprising the descendants of the original Roman business community, supported guilds of performing artists whose patron deity was Dionysos.[56] The activities of such groups converged at certain points of the year, during the celebrations of calendrical festivals. In cities throughout the Empire, particularly in the second century, which saw an expansion of such festivals, games including theatrical performances were given on holidays dedicated to honor particular divinities or rulers.[57]

Several periods in the year involved Dionysiac festivities and amphitheater games. The feast of Liberalia, dedicated to Liber Pater and traditionally linked to Dionysos, occurred in March.[58] Half the month of September was given over to

51. A possible candidate for this type of citizen, although too early for our mosaics, might be "Patrocles, founder of the temple and High Priest for the life of the cult of the Fortune of Paphos, a benefactor, seemingly Hadrianic, of all Cyprus"; see Mitford 1980a, 1363 and n. 396.

52. Mitford 1980a, 1365n.411. Inscriptions from Salamis attest to a Severan conversion of the theater for aquatic games; Mitford 1974, 105, no. 101. It is important to note that the Cypriot epigraphic evidence on the conversion of theaters is rare for the Roman east. In fact, Welch, in reviewing the subject of *naumachiae* and aquatic displays, states that "there is no literary or epigraphic evidence for such spectacles in the provinces" (1991, 278); this view needs to be amended in light of the Cypriot inscriptions.

53. A *venator* from Cyprus named Artemidore is recorded; see Robert 1940, 322, and n. 1.

54. An inscription of *familiae gladiatoriae* for the provinces of Anatolia included Cyprus; see Mitford 1980a, 1369 and n. 434.

55. See ibid., 1322–24, for a discussion of the application and meaning of the term.

56. See Mitford 1980a, 1363; and Mitford 1980b, passim, who sees the C. Iulii of Salamis as descendants of the Roman trading colony established there in the Republican era. On the guilds of performing artists, see Mitford 1980a, 1366 and n. 413. See also Joyce 1980, 323n.80, where she discusses theatrical guilds or the union of Dionysiac artists in relation to the themes set out in the Gerasa mosaic.

57. Advertisements of major festivals on the local coinage minted in the Roman east support this view; see Harl 1987, 65.

58. On the Liberalia, see Scullard 1981, 91–92, who gives the date of March 17 for the Roman celebration. See also Degrassi 1963, 243, which notes the festival as being celebrated with twenty-four circus races.

the Ludi Romani, in which all manner of games and performances were conducted.[59] Although the *vindemiae* were movable feasts depending on local agricultural conditions, it is likely that the vintage celebrations dedicated to Liber coincided with these autumnal festivities.[60]

The confluence of vine harvests, the Mysteries of Dionysos, and the spectacles of the amphitheater for such celebrations offer a provocative parallel to the selection of mosaics in Roman houses. One of the most vivid collections of Dionysiac mosaics comes from the site of El Jem, in southern Tunisia. Parallel mosaics from this town—especially for the vine carpet, Seasons, and peacock—are noted throughout this text. The preponderance of Dionysiac subjects, in particular, points to a local fervor for the cult which reached its height, along with mosaic production in general, during the economic and cultural peak in the second and early third centuries.[61] Certainly the abundance and the good fortune associated with the god of wine appealed to this prosperous community of great landowners and urban entrepreneurs who produced and traded olive oil, wine, and wheat for foreign export.[62]

An excellent pictorial synthesis of these local interests is found in the House of the Dionysiac Procession, dated to the second third of the second century.[63] In the triclinium alone we find a Dionysiac cult procession at the entrance, while the shaft of the T-shaped pavement includes Seasons, seasonal flora and fauna, and Dionysiac figures and masks (fig. 200). Hunting themes appear in the border, with a peopled scroll of Erotes chasing wild beasts, and in two panels flanking the procession panel, which feature bestial combats in natural settings. L. Foucher, in his publication of this house, concludes that a member of the *thiasos* of Thysdrus (El Jem)—that is, those who organized the Liberalia and its *munus*—commissioned this triclinium mosaic as a reflection of that group's values and activities.[64] The seasonal motifs and busts emphasize the earthly abundance guar-

59. See Scullard 1981, 182–86, for a description of the Ludi Romani, which were celebrated from September 5 through 19. They included elaborate processions of figures dressed up as Dionysiac characters, Olympian deities, the Muses, the Graces, Dioscuri, Hercules, and others.

60. See the *Codex Theodosianus*, which made allowance for vintage holidays from August 23 to October 15, Scullard 1981, 189.

61. Dunbabin 1978, 187n.75.

62. Cyprus was known for its excellent wine; that it was exported was evidenced by the elder Pliny, who praised it above all others although he had himself never visited the island.

63. Foucher 1963, 48–63, see fig. 1 for whole floor; Dunbabin, 1978, 260 (El Djem 27c), pl. 175.

64. Foucher 1963, 159. For a similar view proposed by Picard for the mosaic from the House of Bacchus at El Jem, see Dunbabin 1978, 78. A similar interpretation is offered by Joyce for the combination of subjects in a mosaic from Gerasa, where a panel with a Dionysiac procession is surrounded by busts of the Muses and Seasons in a garland border. She states: "It is not going too far, I think, to see in the procession of the mosaic and the related sarcophagi an evocation of the actual processions of artists and cult members which commonly opened dramatic festivals" (1979, 324n.92). She logically proposes that these themes would be entirely appropriate for a patron who was a devotee of Dionysos, and she suggests two candidates from the prosopographic history of Gerasa (325).

Figure 200. El Jem, House of the Dionsyiac Procession, design of the triclinium (after Foucher 1963, fig. 1)

anteed to faithful members of the cult who organized and participated in *thiasoi* and who properly honored Dionysos by the donation of games.[65]

The mosaic ensemble of the House of the Laberii at Oudna, also from the second half of the second century, incorporates vintage and hunting activities and

65. A late-antique synthesis of these themes was found in the peristyle of the House of the Protomes at Thuburbo Maius. In a central panel is a Dionysiac vintage with Erotes who harvest grapes in a fantastic

animal combats.[66] As discussed in Chapter 7, the vine carpet covers the grandest room and surrounds a central scene in which Dionysos gives the vine to Ikarios, offering the only parallel for the combination of these same subjects at Paphos (fig. 150).[67] The decoration of the intercolumniations of four rooms with friezes of wild beasts underlines the association of hunts, both rural and staged, with Dionysos and the vintage.

Although the vintage does not appear in the collection of mosaics at the House of Neptune at Acholla (ca. 170–80), the Triumph panel found at the entrance to the grand *oecus* S, the *xenia* motifs in reception room H, and the seasonal fruits of triclinium M emphasize the idea of abundance which seems to be tied intrinsically to Dionysos (fig. 5). It should be recalled from the Introduction that the plan of this house provides a useful parallel in the architectural analysis of the Paphian plan.

Highlighting themes from these three North African houses of the second century makes it apparent that many of the same themes are spread over several rooms in the House of Dionysos at Paphos. Above all, the vine carpet of the triclinium introduced by the Triumph at the threshold and by the Invention of Wine panel in the west portico signals an emphatic Dionysiac iconography. The hunt panels of the peristyle physically connect with the west portico and should be read in sequence with these Dionysiac themes. If, as I have indicated, these scenes are excerpts from the arena, the correspondences with the North African *venationes* scenes are striking. Certainly, the Paphian peacock, which finds its closest parallels in El Jem, joins with the Seasons in heralding the abundance (see also the *xenia* motifs of the second dining room) and good fortunes of the household that honors Dionysos.

Our picture is unbalanced, because our parallels are drawn from the western provinces and the House of Dionysos stands seemingly isolated from the Roman east, particularly from Syria. Yet recent finds of Roman mosaics in the eastern provinces, especially in Greece, attest to an active process of cultural exchange.[68] We have seen earlier that the discovery of a black-and-white marine mosaic of the second century at Isthmia and of a series of monochrome pavements in the houses at Iasos, in Asia Minor, supports the notion of importations, traveling artists, and an international patrician taste. Sometimes the new models were

vineyard where the vines grow diagonally out of the acanthus. It is surrounded by four columns and a frieze of beasts passing before a landscape of rolling hills and grasses. An outer frame, covering most of the surface area of the room, contains a thick, lush acanthus-rinceaux inhabited by birds, especially peacocks. Even in the 4th century, the vintage is not only a Dionysiac affair but an affair connected with the amphitheater, and such events are literally surrounded by allusions to good fortune and abundance (the peacock and acanthus); see Ben Abed-Ben Khader 1987, 8–17, nos. 259–61, pls. 2–8.

66. For a convenient listing of the mosaics found in the house, see Dunbabin 1978, 265–66 (Oudna 1).

67. Gauckler 1896, 208–10, pl. XX.

68. Many of these recent finds are conveniently collected and discussed in a study of Roman mosaics in Greece with an emphasis on the geometric designs; see Salies 1986, 241–84. The author concludes that during the Imperial period Greece enjoyed completely open cultural contacts with the west (284).

translated into the local idiom. For instance, in the Villa of the Contest of the Nereids at Tagiura (Tripolitania), dated to the mid-second century, the polychrome version of four Nereids riding on sea monsters reinterprets a standard Italian silhouette marine mosaic.[69] A polychrome fragment of a similar marine composition was discovered in a second-century bath at Chania in western Crete, a location that indicates the geographic range of these shared cultural tastes.[70]

This last example calls attention to the island of Crete as a site for some of the more exciting mosaic discoveries of the 1980s. Three areas in particular—Knossos, Chania, and Kastelli—have yielded rich domestic finds that attest to a dependence on Italian models and a penchant for Dionysiac themes.[71] Several impressive black-and-white mosaics were found in western Crete at Chania and Kastelli Kisamou; these are closely related to Italian compositions of the second century.[72] Much more is known about Roman Crete than about Roman Cyprus because of the fair amount of epigraphic evidence, which records civic, administrative, and legal details.[73] Interestingly enough, I. F. Saunders notes that the "largest group of civic inscriptions concerns the games. There were in Crete the five-yearly events organised by the Koinon which could attract contestants at least from the Aegean world."[74] Something of the flavor of Roman life in an eastern senatorial province emerges from such information and helps to fill in the glaring gaps in the Cypriot records.

One of the more complete and striking Roman finds has been the Villa of Dionysos at Knossos, dated by archaeological and stylistic evidence to the Antonine period.[75] The largest mosaic in this peristyle house is found in the *oecus*; it measures 8.5 meters, as does the triclinium mosaic at Paphos. The central octagon is divided into eight panels that depict the heads or masks of the followers of Dionysos; an inner circle portrays a bust of the god himself. Figures of the Seasons stand within acanthus leaves and support this central octagon. In another room, busts of six members of the *thiasos* are set in hexagons surrounding a central medallion depicting the young Dionysos.[76] The focus on Dionysiac subjects throughout this villa recalls a similar interest in some of the North African houses surveyed in this book and has, in fact, prompted some investigators to assign a cult function to the building.[77] Fragments of hunting panels similar to those in

69. Di Vita 1966, pl. 7a–d; and Dunbabin 1978, 272, Tagiura (a).

70. See Salies 1986, 259, fig. 7, who claims it is unpublished, but see Tzedakis 1970, 467–68, pl. 409b.

71. Saunders gives a brief survey of Cretan sites with mosaics (1982, 51–56), but more sites have been found on Chania and Kastelli Kisamou since his work; see below for full references.

72. For a detailed analysis of the patterns and parallels, see Salies 1986, 266–72, figs. 11–14.

73. The historical survey for the Imperial period in Saunders 1982, 6–15, depends heavily on such inscriptions.

74. Ibid., 15, esp. nn. 152–55, for the names of gladiators and their origins.

75. The archaeological finds, especially the pottery, indicate a destruction date of ca. 170–180; see Hayes 1983 and Salies 1986, 270. The most recent publications include Saunders 1982, 51–53, pls. 13–14; Waywell 1983, 11–13; and Salies 1986, 270–71, esp. n. 164.

76. Saunders 1982, 51, pl. 14.

77. The analysis of these mosaics lies outside the bounds of this book; however, several features may be

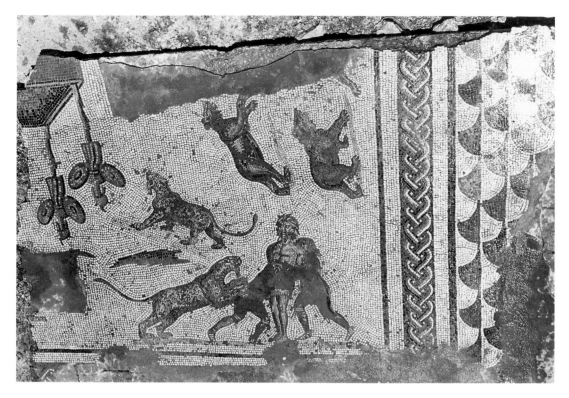

Figure 201. El Jem, Sollertiana Domus, room 3, arena mosaic (photo by C. Kondoleon)

Paphos have also been discovered in the Cretan villa.[78] While the subjects and execution of the Cretan mosaics are quite different from those of the Paphian floors, the Villa at Knossos provides an even earlier expression of an elite domestic taste that spanned the Empire unfettered by regional boundaries or traditions.

Mosaics from two houses from western Crete add to the impression that there was an active local workshop as well as wealthy clients interested in expansive domestic decoration. The triclinium of a house in Kastelli Kisamou features the four Seasons surrounding a central panel; the Three Graces appear at one end of the panel and *xenia* motifs bordered by an animal hunt at the other end.[79] The obvious allusions to hospitality and the "good life" echo the use of similar themes

compared to those in the House of the Dionysiac Procession in El Jem, especially in room Z with the mosaic of the Year (Dunbabin 1978, 260 (El Djem 27a), pl. 60); and to the House of Neptune at Acholla, where the Dionysiac busts and peacocks are quite similar to those found in another room in Knossos; see Gozlan 1971–72, 106, figs. 38–40. I thank E. Waywell of the British School in Athens for making her photographs and her knowledge of the site and excavations available to me. On the possible cult function of the house, see Waywell 1983, 12–13.

78. I owe my knowledge of these unpublished panels to E. Waywell, who generously sent me photographs of them.

79. Tzedakis 1979, 397–98, pls. 203–5. S. Markoulaki is publishing an iconographic study of this pavement in the forthcoming *Acts of the VI Coloquio Internacional sobre Mosaico Antiguo, Palencia-Mérida 1990;* in her communication at this colloquium she proposed a date of the second half of the 2d century for this

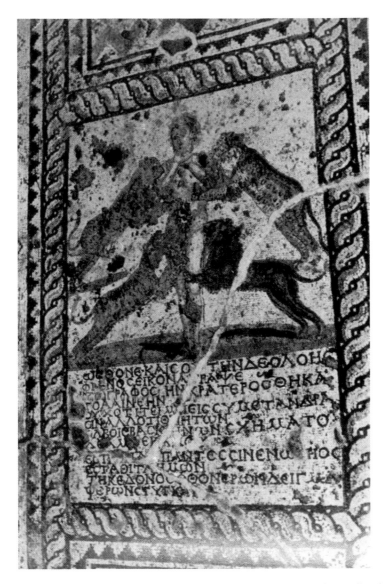

Figure 202. Kephallonia, Roman house, arena scene with *Phthonos* (after Kallipolitis 1961–62, pl. 3)

in Paphos and North Africa, but their juxtaposition within one pavement bespeaks a local adaptation. The group of pavements found in a house at Chania and now in the Archaeological Museum in Chania is later in date—that is, from sometime in the third century.[80] In one room here, the important inscription of

mosaic and noted the likelihood of North African influence on the 2d-century mosaics from Kastelli Kisamou which she presented.

80. See Markoulaki 1986, 449–63, pls. 58–65, who suggests a date in the mid-3d century and notes that the house was destroyed in the late 3d or early 4th century.

an artist from Daphne (Antioch) accompanies the image of Dionysos on a panther.[81] An equally grand mosaic was found in the adjacent room, wherein multiple panels with scenes from New Comedy surround a central medallion featuring Dionysos' discovery of the sleeping Ariadne.[82] The survival of the inscription makes the connection to the mosaics of Antioch inescapable, but again much here is inventive and individual; the role of local artists should not be easily ruled out.

As fine in quality as the Cretan mosaics appear to be, they are somewhat overshadowed by the discovery of a spectacular Dionysiac Marine Triumph at Dion, in Macedonia, dated to around A.D. 200.[83] The skillful modeling and use of chiaroscuro create a painterly effect in this mosaic, which seems to spring from a Hellenistic tradition.[84] These finds confirm the concept of a koine of Mediterranean art fostered by like-minded citizens who were especially invested in Dionysos.

Our final comparison suggests the extent to which the borrowings of images and designs were subject to reinterpretations and to the intentions of the patrons. A mosaic from the Sollertiana Domus in El Jem (fig. 201) portrays an arena setting and shows a bound criminal condemned *ad bestias*.[85] The realism of this late-second-century composition surely reflects actual events in the amphitheater at El Jem. The mosaic is thought to be an original composition commissioned by the patron, perhaps the donor of the games commemorated in the mosaic. A similar bound figure, with four beasts from the amphitheater leaping onto him, appears in an early-third-century house in Kephallonia, Greece (fig. 202).[86] The Greek mosaic decorates a vestibule and is accompanied by an apotropaic epigram identifying the bound figure as *phthonos*, or envy. True to eastern conventions, the realities of the amphitheater have been allegorized, and the scene functions, like the evil eye, to protect the owners of the house against slander.[87]

The Kephallonia mosaic reflects not only a western model but a thoroughly Roman tradition and social concept. Trade and patronage actively supported social and cultural exchange between provinces, certainly before the end of the second century. The mosaics of the House of Dionysos at Paphos illuminate these contacts and bear witness to the dynamic process of Romanization, even in the minor provinces of the Greek east, by the late second century.

81. See the discussion of the Cretan inscription in Chapter 2n.7.

82. The winged Erotes who stand on delicate vines in the corners of the inscribed medallion are reminiscent of the ones at Knossos; see Markoulaki 1986, pl. 58.

83. Pandermalis 1989, 40–45, illus. 42–43, with English summary on 52–53.

84. The painterly qualities remind one of the monumental Triumph from Setif; see above, Chapter 6. It seems that the Dion mosaic and the botched Marine Triumph of Dionysos at Corinth shared the same model, or perhaps the latter was inspired by the former; see above Chapter 6.

85. Dunbabin 1978, 60, 259, El Jem 21(b), room 3, pl. 51; and Foucher 1961, 19–21, pl. 21.

86. Kallipolitis 1961–62, esp. 12–18, pl. 3. Further confirmation of the date is offered by Salies in her analysis of the geometric designs in this house (1986, 276–78).

87. The most thorough treatment of *phthonos* to date is in Dunbabin 1983, esp. 8–9 and 33–37; see also C. P. Jones 1978, 100.

Abbreviations

The journal and series abbreviations used in this volume are those given in the *American Journal of Archaeology* 90 (1986): 384–94. Other abbreviations used are as follows:

AIEMA	*Bulletin d'Information de l'Association internationale pour l'étude de la mosaïque antique*. Fasc. IV, *Repertoire graphique du décor géométrique dans la mosaïque antique*. Paris, 1973.
Colloques I	*La mosaïque gréco-romaine: Colloques internationaux du Centre national de la recherche scientifique, Paris 1963*. Paris, 1965.
Colloque II	*La mosaïque gréco-romaine II: Deuxième colloque international pour l'étude de la mosaïque antique, Vienne, 1971*. Paris, 1975.
Colloquio III	*III Colloquio internazionale sul mosaico antico, Ravenna 1980*. Ravenna, 1983.
DarSag	C. Daremberg and E. Saglio. *Dictionnaire des antiquités grecques et romaines*. Paris, 1875.
Décor géométrique	*Le décor géométrique de la mosaïque romaine: Répertoire graphique et descriptif des compositions linéaires et isotropes*. Paris, 1985.
Inv. Alg.	F. G. Pachtére. *Inventaire des mosaïques de la Gaule et de l'Afrique*, III: *Afrique proconsulaire, Numidie, Maurétaine (Algerie)*. Paris, 1911.
Inv. Tun.	P. Gauckler. *Inventaire des mosaïques de la Gaule et de l'Afrique*, II: *Afrique proconsulaire (Tunisie)*. Paris, 1910.
Matz	F. Matz. *Die Dionysischen Sarkophage (Die antiken Sarkophagreliefs, Band IV, Teil 1–2, Berlin, 1968. Teil 3, Berlin, 1968. Teil 4, Berlin, 1975.

Bibliography

Abad Casal, L. 1990. "Horae," and "Kairoi," *LIMC* V.1: 510–37, and 891–920.

Adrados, F. R. 1980. *Diccionario Griego-Español* I. Madrid.

Adriani, A. 1939. *Le gobelet in argent des amours vendangeurs du Musée d'Alexandrie.* Société royale d'archéologie d'Alexandrie, Cahier no. 1.

Alexander, C. 1955. "A Roman Silver Relief, the Indian Triumph of Dionysos." *Metropolitan Museum of Art Bulletin* 14: 64–67.

Alexander, M. A., et al. 1974. *Corpus des mosaïques de Tunisie,* vol. I.2: *Utique insulae.* Tunis.

Alföldi, A. 1979. *Aion in Mérida und Aphrodisias.* Mainz am Rhein.

Alföldi, A., and E. Alföldi. 1976. *Die Kontorniat-Medaillons.* Berlin, 1976.

Allison, P. M. 1992. "The Relationship between Wall-decoration and Room-type in Pompeian Houses: A Case Study of the Casa della Caccia Antica." *JRA* 5: 235–49.

Almeida, F. de. 1975. "Quelques mosaïques romaines du Portugal." *Colloque II,* 219–26.

Alvarez Martínez, J. M. 1990. *Mosaicos romanos de Mérida Nuevos Hallazgos.* Mérida.

Anderson, J. K. 1985. *Hunting in the Ancient World.* Berkeley.

Andreiomenou, A. 1953–54. "Psiphidota in Chalkidi." *ArchEph,* pt. 3: 303–13.

Arce, J. 1986. "El mosaico de 'Las Metamorfosis' de Carranque (Toledo)." *MM* 27: 365–74.

Ashmole, B. 1956. "Cyriac of Ancona and the Temple of Hadrian at Cyzicus." *JWarb* 19: 179–91.

Atzaka, P. 1973. "Katalogos Romaikon Psiphidoton Dapedon me Anthropines Morphes ston Helleniko Choro." *Hellenica* 26: 216–50.

Augé, C. 1986. "Dionysos (in Peripheria Orientali)." *LIMC* III.1: 514–31, and III.2, 406–19, for illus.

Auguet, R. 1972. *Cruelty and Civilization: The Roman Games.* London.

Aurigemma, S. 1926. *I mosaici di Zliten.* Rome.

——. 1960. *L'Italia in Africa. Le scoperte archeologiche. Tripolitania,* I: *I monumenti d'arte decorativa,* Parte I: *I mosaici.* Rome.

——. 1974. *The Baths of Diocletian and the Museo Nazionale Romano.* 7th ed. Rome.

Avi-Yonah. 1975. "Une école de mosaïque à Gaza au sixième siècle." *Colloques II*, 377–83.

Aymard, J. 1951. *Essai sur le chasses romaines*. Paris.

Bairrao Oleiro, M. 1965. "Mosaïques romaines du Portugal." *Colloque I*, 257–64.

Baldassarre, I. 1981. "Piramo e Thisbe: Dal mito all'immagine." *L'art décoratif à Rome à la fin de la République et au début du Principat, Collection de l'École française de Rome* (Rome) 55: 337–47.

Balmelle, C. 1990. "Quelques images de mosaïques à *Xenia* hors de Tunisie." *Recherches franco-tunisiennes sur la mosaïque de la Afrique antique: I, Xenia. Collections de l'École française de Rome* (Rome) 125: 51–66.

Balmelle, C., and J.-P. Darmon. 1986. "L'artisan-mosaïste dans l'antiquité tardive." In *Artistes, artisans et production artistique au moyen âge. I*, ed. X. Barral I Altet. Paris, 235–49.

Balty, J. 1977. *Mosaïques antiques de Syrie*. Brussels.

———. 1981. "La mosaïque antique au Proche-Orient, I: Des origines à la Tétrarchie." *ANRW* II.12.2: 348–429.

Balty, J. Ch. 1981. "Une version orientale méconnue du mythe de Cassiopé." *Mythologie gréco-romaine. Mythologies périphériques. Études d'iconographie*. Paris, 95–106.

Baratte, F. 1973. "Le tapis géométrique du Triomphe de Neptune de Constantine." *MèlRome* 85: 313–34.

——— . 1978. *Mosaïques romaines et paléochrétiennes du Musée du Louvre*. Paris.

Baxandall, M. 1972. *Painting and Experience in Fifteenth Century Italy*. Oxford.

Beacham, R. C. 1992. *The Roman Theatre and Its Audience*. Cambridge, Mass.

Becatti, G. 1948. "Case ostiensi del tardo impero I–II." *BdA* 33: 102–28, 197–224.

———. 1961. *Scavi di Ostia, IV: Mosaici e pavimenti marmorei*. Rome.

———. 1965. "Alcune caratteristiche del mosaico bianco-nero in Italia." *Colloque I*, 15–27.

Becatti, G., E. Fabricotti, A. Gallina, P. Saronio, F. R. Serra, M. P. Tambella. 1970. *Mosaici antichi in Italia, Regione settima: Baccano, villa romana*. Rome.

Ben Abed, A. 1983. "À propos des mosaïques de la maison des Protomés à Thuburbo Majus." *Colloquio III*, 291–98.

Ben Abed-Ben Khader, A. 1987. *Corpus des mosaïques de Tunisie. Thuburbo Majus, II: 3, Les mosaïques dans la Region Ouest*. Tunis, 1987.

Benjamin, W. 1978. *Reflections*. New York.

Bergmann, B. 1991. Review of E. W. Leach, *The Rhetoric of Space: Literary and Artistic Representations of Landscape in Republican and Augustan Rome, AJA* 95: 179–81.

Berti, F. 1975. "Poseidon ed Amymone: Un mosaico Romano de Chania." *ASAtene* 50/51 (1972/73): n.s. 34/35 (1975): 451–65.

———. 1983. "I mosaici di Iasos." *Colloquio III*, 235–46.

Beschaouch, A. 1966. "La mosaïque de chasse à l'amphithéâtre dé couverte à Smirat en Tunisie." *CRAI*: 134–57.

Beschaouch, A., R. Hanoune, and Y. Thébert. 1977. *Les ruines de Bulla Regia*. Rome.

Beyen, H. G. 1938–60. *Die Pompejanische Wanddekoration vom zweiten bis zum vierten Stil*. Haag.

Bianchi Bandinelli, R. 1971. *Rome: The Late Empire*. New York.

Bieber, M. 1955. *The Sculpture of the Hellenistic Age*. New York.

Blake, M. E. 1930. "The Pavements of Roman Buildings of the Republic and Early Empire." *MAAR* 8: 7–160.

———. 1936. "Roman Mosaics of the Second Century in Italy." *MAAR* 13: 67–214.

———. 1940. "Mosaics of the Late Empire in Rome and Vicinity." *MAAR* 17: 81–130.

Blanco Freijeiro, A. 1952. *Mosaicos antiquos de Asunto Baquico*. Madrid.

———. 1978a. *Mosaicos romanos de Italica I*. Madrid.

———. 1978b. *Mosaicos romanos de Mérida*. Madrid.

Blazquez, J. M. 1980. "Los mosaicos romanos de Torre de Palma (Monforte, Portugal)." *Archivo Español de Arqueologia* 53: 125–50.

———. 1982. *Mosaicos romanos de Sevilla, Granada, Cadiz y Murcia*. Madrid.

Bonaria, M. 1965. *Romani Mimi*. Rome.

Bosanquet, R. C. 1898. "Excavations of the British School at Melos: The Hall of the Mystae." *JHS* 18: 60–80.

Bowersock, G. W. 1990. *Hellenism in Late Antiquity*. Ann Arbor, Mich.

Boyce, G. K. 1937. *Corpus of the Lararia of Pompeii*. MAAR 14.

Brett, G. 1947. *The Great Palace of the Byzantine Emperors: First Report*. Oxford.

Brett, G., W. J. Macauly, and R. K. Stevenson. 1947. *The Great Palace of the Byzantine Emperors* I. Oxford.

Brown, S. 1992. "Death as Decoration: Scenes from the Arena on Roman Domestic Mosaics." In *Pornography and Representation in Greece and Rome*, ed. A. Richlin. Oxford, 180–211.

Bruneau, P. 1984. "Les mosaïstes antiques avaient-ills des cahiers de modéles?" *RA* 2: 241–72.

Bruneau, P., and J. Ducat. 1966. *Guide de Délos*. Athens.

Brunt, P. A. 1990. *Roman Imperial Themes*. Oxford.

Bryson, N. 1990. *Looking at the Overlooked: Four Essays on Still Life Painting*. Cambridge.

Budde, L. *Antike Mosaiken in Kilikien*, II: *Die Heidnischen Mosaiken*. Recklinghausen.

Burkert, W. 1987. *Ancient Mystery Cults*. Cambridge.

Buschhausen, H. 1971. *Die spätrömischen Metallscrinia und frühchristlichen Reliquiare*. Vienna.

Campbell, S. 1988. *The Mosaics of Antioch*. Subsidia Mediaevalia 15. Toronto.

Carandini, A. 1967. "La Villa di Piazza Armerina." *DialArch* 1: 93–120.

Carandini, A., A. Ricci, M. de Vos. 1982. *Filosofiana: La Villa di Piazza Armerina*. Palermo.

Carcopino, J. 1926. *La basilique pythagoricienne de la Porte Majeure*. Paris.

Cesano, S. L. 1927–28. "I Dioscuri sulle Monete Antiche." *BullCom* 55–56: 101–37.

Chapouthier, F. 1935. *Les Dioscures au service d'une déesse*. Paris.

———. 1954. "Les peintures d'un hypogée funéraire prés de Massyaf." *Syria* 31: 172–211.

Charitonides, S., L. Kahil, and R. Ginouvès. 1970. *Les mosaïques de la Maison du Ménandre à Mytilene*. Antike Kunst 6. Berne.

Chéhab, M. 1957–59. "Mosaïques du Liban." *BMBeyr* 14–15.

———. 1975. "Mosaïques inédites du Liban." *Colloque II*: 371–76.

Chopot, V. 1912. "Les romains et Chypre." *Melanges Cagnat*. Paris, 59–83.

Clarke, J. R. 1980. *Roman Black and White Mosaics*. New York.

———. 1991a. "The Decor of the House of Jupiter and Ganymede at Ostia Antica: Private Residence Turned Gay Hotel?" In *Roman Art in the Private Sphere*, ed. E. K. Gazda. Ann Arbor, Mich., 89–104.

———. 1991b. *The House of Roman Italy, 100 B.C.–A.D. 250: Ritual, Space, and Decoration*. Berkeley.

Coleman, K. M. 1990. "Fatal Charades: Roman Executions Staged as Mythological Enactments." *JRS* 80: 44–73.

Comfort, H. 1937. "Nine Terra Sigillata Bowls from Egypt." *AJA* 41: 406–10.

Conan, M. 1987. "The *Imagines* of Philostratus." *Word and Image* 3: 162–71.

Conybeare, F. C. 1912. *Philostratus: Life of Apollonius of Tyana*. Loeb Classical Library. London and Cambridge, Mass.

Corning Museum of Glass. 1957. *Glass from the Ancient World: The Ray Winfield Smith Collection*. Corning, N.Y.

Crawford, M. H. 1974. *Roman Republican Coinage*. Cambridge.

Croisille, J. M. 1982. *Poésie et art figuré de Néron aux Flaviens: Recherches l'iconographie et la correspondance des arts à l'époque imperiale*. Collection Latomus 179. Brussels.

Cumont, F. 1942. *Recherches sur le symbolisme funéraire des Romains*. Bibliothèque archéologique et historique 35. Paris.

Daltrop, G. 1969. *Die Jaqdmosaiken der römischen Villa bei Piazza Armerina*. Berlin.

Darmon, J. P. 1980. *Nymfarvm Domvs: Les pavements de la Maison des Nymphes à Néapolis (Nabeul, Tunisie) et leur lecture*. Leiden.

Darmon, J. P., and H. Lavagne. 1977. *Recueil general des mosaïques de la Gaule*, II: *Lyonnaise, 3*. Paris.

D'Arms, J. 1981. *Commerce and Social Standing in Ancient Rome*. Cambridge, Mass.

Daszewski, W. A. 1968. "A Preliminary Report on the Excavations of the Polish Archaeological Mission at Kato (Nea) Paphos in 1966 and 1967." *RDAC*, 33–61.

——. 1972. "Polish Excavations at Kato (Nea) Paphos in 1970 and 1971." *RDAC*, 204–36.

——. 1976. "Les fouilles polonaises à Nea Paphos, 1972–1975, Rapport Preliminaire." *RDAC*, 185–222.

——. 1977. *Nea Paphos*, II: *La mosaïque de Thésée*. Warsaw.

——. 1985a. *Dionysos der Erlöser*. Mainz am Rhein.

——. 1985b. *Corpus of Mosaics from Egypt I. Hellenistic and Early Roman Period*. Mainz am Rhein.

——. 1986. "Cassiopeia in Paphos—a Levantine Going West." *Acts of the International Archaeological Symposium Cyprus between the Orient and the Occident*. Ed. V. Karageorghis. Nicosia.

Daszewski, W. A., and Michaelides, D. 1988a. *Guide to the Paphos Mosaics*. Nicosia.

——. 1988b. *Mosaic Floors in Cyprus*. Ravenna.

Dauphin, C. 1978. "Byzantine Pattern Books: A Re-examination of the Problem in Light of the Inhabited Scroll." *Art History* 1: 400–26.

——. 1979. "A Roman Mosaic Pavement from Nablus." *IEJ* 29: 11–33.

Deckers, J. G. 1985. "Dionysos der Erlöser? Bemerkungen zur Deutung der Bodenmosaiken im Haus des Aion' in Nea-Paphos auf Cypern durch W. A. Daszewski." *RömQSchr* 80: 145–72.

Degrassi, A. 1963. *Inscriptiones Italiae, XIII.2: Fasti et Elogia*. Rome.

Deichmann, F. W., ed. 1967. *Repertorium der christlich-antiken Sarkophage*, I. Weisbaden.

Delort, Emile. 1948. "L'atelier de Satto, vases unis, 3,000 marques." *Memoires de l'Academie nationale de Metz*, ser. II, 17.

Di Vita, A. 1966. *La Villa della "Gara delle Nereide" presso Tagiura*. Libya antiqua, Supplement II. Tripoli.

Donceel-Voûte, P. 1988. *Les pavements des églises byzantines de Syrie et du Liban: Décor, archéologie et liturgie*. Louvain-la-Neuve.

Donderer, M. 1989. *Die Mosaizisten der Antike und ihre Wirtschaftliche und Soziale Stellung: Eine Quellenstudie*. Erlangen.

Dorigo, W. 1966. *Pittura tardoromana*. Milan.

Downey, G. 1953. "The Palace of Diocletian at Antioch." *Les Annales archéologiques de Syrie* 3: 106–16.

——. 1961. *A History of Antioch in Syria from Seleucus to the Arab Conquest*. Princeton.

Duke, T. T. 1971. "Ovid's Pyramos and Thisbe." *CJ* 66: 320–27.

Dunbabin, K. 1971. "The Triumph of Dionysus on Mosaics in North Africa." *BSR* 39: 52–65.

——. 1978. *The Mosaics of Roman North Africa*. Oxford.

——. 1982. "The Victorious Charioteer on Mosaics and Related Monuments." *AJA* 86: 65–87.

——. 1983. "*INVIDIA RUMPANATUR PECTORA*: The Iconography of Phthonos/Invidia in Graeco-Roman Art." *JAC* 26: 7–37.

——. 1991. "Triclinium and Stibadium." *Dining in a Classical Context*, ed. J. Slater. Ann Arbor, Mich., 121–48.

Dwyer, E. 1982. *Pompeian Domestic Sculpture: A Study of Five Pompeian Houses and Their Contents*. Archaeologica 28. Rome.

——. 1991. "The Pompeian Atrium House in Theory and Practice." In *Roman Art in the Private Sphere*, ed. E. K. Gazda. Ann Arbor, Mich., 25–48.

Eliades, G. S. 1980. *The House of Dionysos*. Paphos.

Ellis, S. 1991. "Power, Architecture, and Decor: How the Late Roman Aristocrat Appeared to His Guests." In *Roman Art in the Private Sphere*, ed. E. K. Gazda. Ann Arbor, Mich., 117–34.

Engemann, J. 1975. "Zur Verbreitung magischer Übelabwehr in der nichtchristlichen und christlichen Spätantike." *JAC* 18: 22–48.

Étienne, R. 1960. *Le quartier nord-est de Volubilis*. Paris.

Fairbanks, A. 1931. *Philostratus the Elder: Imagines*. Loeb Classical Library. London and New York. (Repr. ed., 1979.)

Fisher, N. R. E. 1988. "Roman Associations, Dinner Parties and Clubs." In *Civilization of the Ancient Mediterranean: Greece and Rome*, ed. M. Grant and R. Kitzinger. New York, 1199–1225.

Foerster, R., ed. 1909–27. *Libanii Opera*. Leipzig.

Foucher, L. 1957. "La mosaïque dionysiaque de Themetra." *MélRome* 69: 151–61.

——. 1958. *Thermes romains des environs d'Hadrumète*. Notes et Documents, Institut d'archéologie, n.s. I.

——. 1960a. *Découvertes archéologiques a Thysdrus en 1960*. Notes et documents, Institut d'archéologie, n.s. IV. Tunis, n.d.

——. 1960b. *Inventaire des mosaïques, feuille no. 57 de l'atlas archéologique: Sousse*. Tunis.

——. 1961. *Découvertes archéologiques à Thysdrus en 1961*. Notes et documents, Institut d'archéologique, n.s. V. Tunis, n.d.

——. 1963. *La Maison de la Procession dionysiaque à El Jem*. Paris.

——. 1965. *La Maison des Masques à Sousse, Fouilles 1962–63*. Notes et documents Institute d'archéologie, n.s. VI. Tunis, 1965.

——. 1975. "Le Char de Dionysos." *Colloques II*. Paris, 55–61.

——. 1979. "L'enlèvement de Ganymède figuré sur les mosaïques." *AntAfr* 14: 155–68.

Fox, R. L. 1987. *Pagans and Christians*. New York.

Frantz, A. 1988. *Late Antiquity, A.D. 267–700: The Athenian Agora*, 24. Princeton.

Frazer, J. G. 1913. *Pausanias' Description of Greece*. London.

Frazer, P. M. 1972. *Ptolemaic Alexandria*. Oxford.

——, ed. 1921. *Apollodorus, The Library*. Loeb Classical Library. London and Cambridge, Mass. (Repr. ed., 1976–79.)

Friedländer, L. 1920. *Darstellungen aus der Sittengeschichte Roms*. Ed. G. Wissowa. Leipzig. (Rpt. Darmstadt, 1964.)

Frontisi-Ducroux. 1989. "In the Mirror of the Mask." In *A City of Images: Iconography and Society in Ancient Greece*. Princeton, 151–65.

García y Bellido, A. 1949. *Esculturas romanas de España y Portugal*. Madrid.

Gasparri, C. 1986. "Bacchus." *LIMC* III.1: 540–66, and III.2, 428–56, for illus.

Gauckler, P. 1896. "Le Domaine des Laberii à Uthina." *MonPiot* 3: 177–229.

——. 1897. "Les mosaïques de l'Arsenal à Sousse." *RA* 2: 8–22.

Gazda, E. K. 1981. "A Marble Group of Ganymede and the Eagle from the Age of Augustine." In *Excavations at Carthage, 1977, Conducted by the University of Michigan 6,* ed. J. H. Humphrey. Ann Arbor, Mich., 125–178.

Gazda, E. K., ed. 1991. *Roman Art in the Private Sphere.* Ann Arbor, Mich.

Geertz, C. 1983. *Local Knowledge.* New York.

Germain, S. 1969. *Les mosaïques de Timgad: Étude descriptive et analytique.* Paris.

———. 1971. "Mosaïque italienne et mosaïque africaine: Filiation et opposition." *AntAfr* 5: 155–59.

———. 1973. "Remarques sur des mosaïques de style fleuri de Timgad et d'Hippone." *AntAfr* 7: 259–74.

Geyer, A. 1977. *Das Problem des Realitätsbezuges in der Dionysisichen Bildkunst der Kaiserzeit.* Würzburg.

Gondicas, D. 1990. "Ikarios." *LIMC* V.1: 645–47.

Gozlan, S. 1971–72. "La Maison de Neptune à Acholla-Botria (Tunisie): Problèmes posés par l'architecture et le mode de construction." *Karthago* 16: 43–89.

———. 1974. "Les pavements en mosaïque de la Maison de Neptune à Acholla-Botria (Tunisie)." *MonPiot* 59: 71–135.

———. 1981. "A propos de quelques pavement Africains: Les *xenia* et l'iconographie Dionysiaque." *Mosaïque romaine tardive.* (Paris) 73–87.

———. 1990a. "Quelques décors ornementaux de la mosaïque africaine." *MEFRA* 102/2: 983–1029.

———. 1990b. "*Xenia*: Quelques problèmes d'identification." *Recherches franco-tunisiennes sur la mosaïque de la Afrique antique: I, Xenia.* Collections de l'École française de Rome 125: 85–106.

———. 1990–91. Review of Daszewski and Michaelides, *Mosaic Floors in Cyprus,* Ravenna, 1988, and Daszewski and Michaelides, *Guide to the Paphos Mosaics,* Nicosia, 1988, in *Bulletin de l'AIEMA* 13: 413–16.

———. 1992. *La Maison du Triomphe de Neptune à Acholla, I: Les mosaïques.* Collection de l'École française de Rome 160. Rome.

Grabar, O. 1973. *The Formation of Islamic Art.* New Haven, Conn.

Grant, M. 1960. *The Myths of Hyginus.* Lawrence, Kans.

Grimal, P. 1943. *Les jardins romains à la fin de la République et aux premiers siècles de l'Empire: Essai sur le naturalisme romain.* Paris.

Guarducci, M. 1979. "DOMVS MVSAE: Epigraphi greche e latine in un'antica casa di Assisi." *MemLinc* 23: 269–98.

Guimier-Sorbets, A.-M. 1983. "Le méandre à pannetons de clef dans la mosaïque Romaine." In *Mosaïque: Recueil d'hommages à Henri Stern.* Paris, 195–213.

———. 1990. "Note sur les motifs de *Xenia* dans les mosaïques d'époque hellénistique." *Recherches franco-tunisiennes sur la mosaiques de l'Afrique antique: I, Xenia.* Collection de l'École francaise de Rome 125. Rome, 66–71.

Gulick, C. B., ed. 1927–41. *The Deipnosophists.* Loeb Classical Library. London and Cambridge, Mass.

Gury, F. 1986. "Dioskouroi/Castores." *LIMC* III.1: 608–35.

Hagenow, G. 1982. *Aus dem Weingarten der Antike: Der Wein in Dichtung, Brauchtum and Alltag.* Mainz.

Hanfmann, G. M. A. 1939. "Notes on the Mosaics from Antioch." *AJA* 43: 229–46.

———. 1951. *The Season Sarcophagus in Dumbarton Oaks.* Dumbarton Oaks Studies 2. Cambridge, Mass.

———. 1956. "A Masterpiece of Late Roman Glass Painting." *Archaeology* 9: 3–7.

Hanfmann, G. M. A., and N. H. Ramage. 1978. *Sculpture from Sardis: The Finds through 1975.* Cambridge, Mass.

Hanoune, R. 1969. "Trois pavements de la Maison de la Course de Chars à Carthage." *MèlRome* 81.

———. 1980. *Recherches archéologiques franco-tunisiennes à Bulla Regia*, IV: *Les mosaïques.* Rome.

———. 1990. "Le dossier des *Xenia* et la mosaïque." *Recherches franco-tunisiennes sur la mosaïque de l'Afrique antique*: I, *Xenia.* Collection de l'École française de Rome 125: 7–13.

Harl, K. W. 1987. *Civic Coins and Civic Politics in the Roman East, A.D. 180–275.* Berkeley.

Harward, J. V. 1982. "Greek Domestic Sculpture and the Origins of Private Art Patronage." Diss. Harvard University.

Hauser, F. 1889. *Die Neu-Attischen Reliefs.* Stuttgart.

Hayes, J. W. 1967. "Cypriot Sigillata." *RDAC*, 65–77.

———. 1977. "Early Roman Wares from the House of Dionysos, Paphos." *Rei Cretariae romanae fautorum acta XVII/XVIII*, 96–102.

———. 1983. "The Pottery of the House of Dionysos at Knossos." *BSA* 78: 97–169.

———. 1991. *Paphos III: The Hellenistic and Roman Pottery.* Nicosia.

Henrichs, A. 1982. "Changing Dionsyiac Identities." In *Jewish and Christian Self-Definition* 3, ed. B. F. Meyer and E. P. Sanders. Philadelphia.

Hermary, H. 1986. "Dioscuroi." *LIMC* III.1, 567–93.

Heseltine, M., and E. H. Warmington. 1913. *Petronius.* Loeb Classical Library. London and Cambridge, Mass.

Hill, D. K. 1981. "Roman Domestic Garden Sculpture." In *Ancient Roman Gardens*, ed. E. B. Macdougall and W. F. Jashemski. Washington, D.C., 81–94.

Hill, G. F. A. 1940. *A History of Cyprus.* Cambridge.

Hönle, A., and A. Henze. 1981. *Römische Amphitheater und Stadien.* Freiburg.

Hopkins, K. 1983. *Death and Renewal.* Cambridge.

Horn, H. G. 1972. *Mysteriensymbolik auf dem Kölner Dionysosmosaik.* Bonn.

Humphrey, J. H. 1986. *Roman Circuses: Arenas for Chariot Racing.* Berkeley, Calif.

Jacopich, G. 1928. "Coo-Scoperte Varie." *Clara Rhodos* 1: 98–99.

Jashemski, W. 1979. *The Gardens of Pompeii.* New York.

Jennison, G. 1937. *Animals for Show and Pleasure in Ancient Rome.* Manchester.

Jobst, W., and H. Vetters. 1977. *Römische Mosaiken aus Ephesos*, I: *Die Hanghaüser des Embolos, Forschungen in Ephesos VII/2.* Vienna.

Johnson, P. 1983. "The Mosaics of Bignor Villa, England: A Gallo-Roman Connection." *Colloquio III*, 405–10.

Jones, A. H. M. 1963. "The Greeks under the Roman Empire." *DOP* 17: 3–19.

Jones, C. P. 1978. *The Roman World of Dio Chrysostom.* Cambridge, Mass.

Jones, H. L. 1917–32. *The Geography of Strabo.* 8 vols. Loeb Classical Library. London and Cambridge, Mass.

Jones, H. S. 1926. *A Catalogue of the Ancient Sculptures: The Sculptures of the Palazzo dei Conservatori.* Oxford.

Jones, W. H. S. 1918–35. *Pausanias: Description of Greece.* 5 vols. Loeb Classical Library. London and Cambridge, Mass.

Joyce, H. 1979. "Form, Function and Technique in the Pavements of Delos and Pompeii." *AJA* 83: 253–63.

———. 1980. "A Mosaic from Gerasa in Orange, Texas, and Berlin." *RM* 87/2: 307–25.

———. 1981. *The Decoration of Walls, Ceilings and Floors in Italy in the Second and Third Centuries A.D.* Rome.

Kallipolitis, B. G. 1961–62. "Anaskaphe Romaikis Epauleos en Kephallonia." *ArchDelt. Meletai* 17: 1–31.

Kantorowicz, E. H. 1961. "Gods in Uniform." *TAPS* 105: 368–93.

Karageorghis, V. 1961. "Chronique les fouilles et découvertes archéologiques à Chypre en 1960." *BCH* 85: 292–96.

———. 1975. "Chronique des fouilles à Chypre en 1974, no. 8—Fouilles de la Basilique de Kourion." *BCH* 99: 842–45.

Ker, W. C. A. 1920. *Martial Epigrams.* Loeb Classical Library. London and New York.

Kitzinger, E. 1951. "Studies on Late Antique and Early Byzantine Floor Mosaics, 1: Mosaics at Nikopolis." *DOP* 6: 83–122.

———. 1965. "Stylistic Developments in Pavement Mosaics in the Greek East from the Age of Constantine to the Age of Justinian." *Colloques I*, 341–51.

———. 1977. *Byzantine Art in the Making.* Cambridge, Mass., and London.

Kleingünter, A. 1933. *Protos Herutes.* Philologus Supplement 26:1. Leipzig.

Knox, P. E. 1989. "Pyramos and Thisbe in Cyprus." *HSCP* 92: 315–28.

Kondoleon, C. 1990. "A Case for Artistic Invention: A Cypriot Pyramos and Thisbe." *Archaeologia Cypria* 2: 109–12.

———. 1991. "Signs of Privilege and Pleasure: Roman Domestic Mosaics." In *Roman Art in the Private Sphere*, ed. E. K. Gazda. Ann Arbor, Mich., 105–15.

———. 1994. "The Romanization of Domestic Art and Architecture in Cyprus." *Actas del VI Coloquio Internacional sobre mosaicos antiquo. Palencia-Mérida, 1990.* Palencia.

Kraeling, C. H., ed. 1938. *Gerasa, City of the Decapolis.* New Haven, Conn.

———. 1962. *Ptolemais, City of the Libyan Pentapolis.* Chicago.

Kriseleit, I. 1985. *Antike Mosaiken, Staatliche Museen zu Berlin.* Berlin.

Kritzas, Ch. 1973–74. "Argos: Odos Tripoleos." *Deltion* 29, *Chronika*, 230–46.

Lancha, J. 1977. *Mosaïques géométriques: Les ateliers de Vienne-Isère.* Rome.

———. 1990. *Les mosaïques de Vienne.* Lyons.

Lauer, J. Ph., and C. Picard. 1950. *Les statues ptolemaiques du Sarapeion de Memphis.* Paris.

Lavagne, H. 1977. "Deux mosaïques de style orientalisant à Loupian (Herault)." *MonPiot* 61: 61–86.

———. 1978. "La mosaïque, art industriel ou art mineur?" *Forme I*, 8–11.

———. 1994. "Les Trois Grâces et la visite de Dionysos chez Ikarios sur une mosaïque de Narbonnaise." *Fifth International Colloquium on Ancient Mosaics Held at Bath, England, on September 5–12, 1987 (JRA Supp. Series No. 9)*, ed. P. Johnson, R. Ling, and D. J. Smith. Ann Arbor, Mich., 238–48.

Lavagne, H., and J.-P. Darmon. 1977. *Recueil général des mosaïques de la Gaule*, II: *Lyonnaise 3.* Paris.

Lavin, I. 1963. "Hunting Mosaics of Antioch and Their Sources." *DOP* 17: 179–286.

Leach, E. W. 1988. *The Rhetoric of Space: Literary and Artistic Representation of Landscape in Republican and Augustan Rome.* Princeton.

Leach, E. 1991. "The Iconography of the Black Salone in the Casa di Fabio Rufo." *KölnJb* 24: 105–12.

Lehmann, K. 1941. "The *Imagines* of the Elder Philostratus." *ArtB* 23: 16–44.

Lehmann, K., and E. C. Olsen. 1942. *Dionysiac Sarcophagi in Baltimore.* Baltimore.

Leschi, L. 1924. "Une mosaïque de Tébessa." *MèlRome* 41: 95–110.

Levi, D. 1941a. "The Allegories of the Months in Classical Art." *ArtB* 23.

———. 1941b. "The Evil Eye and the Unlucky Hunchback." In *Antioch-on-the-Orontes*, III: *The Excavations of 1937–1939*, ed. R. Stillwell. Princeton, 220–32.

——. 1947. *Antioch Mosaic Pavements*. Princeton.

——. 1953. Review of G. M. A. Hanfmann, *The Season Sarcophagus in Dumbarton Oaks*. In *ArtB* 35: 233–39.

——. 1969–70. "Le campagne di Scavo, 1969–1970." *ASAtene* 47–48: 522–25.

Liapounova, S., and M. Mat'e. 1951. *Khudozhestvennyie tkani Koptskogo Egipta*. Moscow.

Ling, R. J. 1979. "The Stanze di Venere at Baia." *Archaeologia* 106: 33–60.

McCann, A. M. 1978. *Roman Sarcophagi in the Metropolitan Museum of Art*. New York.

McKay, A. G. 1975. *Houses, Villas and Palaces in the Roman World*. London.

Macleod, M. D. 1961. *Lucian VII*. Loeb Classical Library. London and Cambridge, Mass.

Maguire, H. 1987. *Earth and Ocean: The Terrestrial World in Early Byzantine Art*. University Park and London.

Mahjub, O. al. 1983. "I mosaici della Villa Romana de Silin." *Colloquio III*, 299–306.

Maiuri, A. 1933. *La Casa del Menandro e il suo tesoro de Argenteria*. Rome.

Mansuelli, G. 1954. "Mosaici Sarsinati." *Studi Romagnoli* 5: 151–83.

Manuel Helleno. 1962. "A 'villa' lusitano-romano de Torre de Palma (Monforte)." *O Arqueólogo Português* (Lisbon) 4: 313–38.

Marconi Bovio, J. 1940. "Marsala: Villa romana." *Le Arti* 2: 389–91.

Marec, E. 1953. "Deux mosaïques d'Hippone." *Libyca* 1: 102–7.

Markoulaki, S. 1986. "Psiphidota Oikias Dionysiou sto Mouseio Chanion." *Pepragmena tou Diethnous Kretologiko Synhedriou Al*. Chania, 449–62.

Mastoropoulos, G., and A. Tsaravopoulos. 1982. "Psiphidoto Dapedo ste Chio." *Chiaka Chronika* 14: 4–7.

Meiggs, R. 1960. *Roman Ostia*. Oxford.

Merlin, A., and L. Poinssot. 1934. "Deux mosaïques de Tunisie à sujets prophylactiques." *BAC* 34: 128–76.

Meyer, E. A. 1990. "The Epigraphic Habit in the Roman Empire." *JRS* 80: 74–96.

Meyers, E. M., C. L. Meyers, and E. Netzer. 1992. *Sepphoris*. Winona Lake, Ind.

Michaelides, D. 1986a. "A Season Mosaic from Nea Paphos." *RDAC*, 212–21.

——. 1986b. "A New Orpheus Mosaic in Cyprus." *Acts of the International Archaeological Symposium "Cyprus between the Orient and the Occident," Nicosia, 8–14 September 1985*. Nicosia, 473–89.

——. 1987a. *Cypriot Mosacis*. Department of Antiquities, Cyprus: Picture Book no. 7. Nicosia.

——. 1987b. "A Catalogue of the Hellenistic, Roman, and Early Christian Mosaics of Cyprus with Representations of Human Figures." *RDAC*, 239–51.

——. 1989a. "Berenice and the Mosaics of Roman Cyrenaica." *L'Africa romana: Atti del VI convegno di studio, Sassari, 16–18 decembre 1988*. Sassari, 357–72.

——. 1989b. "Cypriot Mosaics: Local Traditions and External Influences." In *Early Society in Cyprus*, ed. E. Peltenburg. Edinburgh, 272–92.

——. 1991. "The House of Orpheus." *The Conservation of the Orpheus Mosaic at Paphos*. Santa Monica, Calif.: J. Paul Getty Trust.

Michel, D. 1990. *Casa dei Cei*. Munich.

Mielsch, H. 1975. *Römische Stuckreliefs*. RM-EH 21.

Miller, M. J. 1983. *Autochthonous Heroes from the Classical to the Hellenistic Period*. Ann Arbor, Mich.

Miller, S. G. 1972. "A Mosaic Floor from a Roman Villa at Anaploga." *Hesperia* 41: 332–54.

Milne, M. J. 1962. "Three Attic Red-Figured Vases in New York." *AJA* 66: 305–6.

Mingazzini, P. 1966. *L'insula di Giasone Magno a Cirene*. Rome.

Mitford, T. B. 1951. "Excavations at Kouklia Cyprus." *Antiquaries Journal* 31: 51–66.

——. 1980a. "Roman Cyprus." *ANRW* II.7.2 (Berlin): 1286–1384.

———. 1980b. "Roman *civitas* in Salamis." *Salamine de Chypre histoire et archeologie, Lyon 1978.* Paris, 275–88.

Mitford, T. B., ed. 1971. *The Inscriptions of Kourion.* Philadelphia.

———. 1974. *The Inscriptions of Salamis.* Nicosia.

Moevs, M. T. M. 1987. "Penteterìs e le tre horai nella Pompè de Tolomeo Filadelfo." *BdA* 42: 1–36.

Morricone, L. 1950. "Scavi e Ricerche a Coo (1935–1943), Relazione Preliminare." *BdA* 35: II, "Cronaca d'Arte," 219–46.

Müller, F. 1929. "Die Typen der Daphnedarstellungen." *RömMitt* 44: 59–86.

Neudecker, R. 1988. *Die Skulpturenausstattung römischer Villen in Italien.* Mainz am Rhein.

Nicolaou, I. 1990. *Paphos II: The Coins from the House of Dionysos.* Nicosia.

Nicolaou, K. 1963. "The Mosaics at Kato Paphos, the House of Dionysos." *RDAC*, 56–72.

———. 1966. "The Topography of Nea Paphos." In *Mélanges offerts à K. Michalowski.* Warsaw, 561–601.

———. 1967. Excavations at Nea Paphos, the House of Dionysos: Outline of the Campaigns, 1964–1965." *RDAC*, 100–25.

———. 1968a. *Ancient Monuments of Cyprus.* Nicosia.

———. 1968b. "A Roman Villa at Paphos." *Archaeology* 21: 48–53.

———. 1971. "Some Problems Arising from the Mosaics at Paphos." *Annales archéologiques arabes syriennes* 21: 143–46.

———. 1981. "Akme." *LIMC* I.1, 446, and I.2: 341, illus.

———. 1983. "Three New Mosaics at Paphos, Cyprus." *Colloquio III*, 219–25.

Nilsson, M. P. 1957. *The Dionysiac Mysteries of the Hellenistic and Roman Age.* Lund.

Nogara, B. 1910. *I mosaici antichi conservati nei Palazzi Pontifici del Vaticano e del Laterano.* Milan.

Obbink, D. 1993. "Dionysus Poured Out: Ancient and Modern Theories of Sacrifice and Cultural Formation." In *Masks of Dionysus*, ed. T. H. Carpenter and C. A. Faraone. Ithaca, 65–86.

Oswald, F. 1936. *Index of Figure-Types in Terra Sigillata.* Edinburgh.

Osward, S., and T. D. Pryce. 1920. *An Introduction to the Study of Terra-Sigillata.* London.

Pace, C. 1979. "Pietro Santi Bartoli: Drawings in Glasgow University after Roman Paintings and Mosaics." *BSR* 47: 117–55.

Packard, P. M. 1980. "A Monochrome Mosaic at Isthmia." *Hesperia* 49: 326–46.

Pailler, J.-M. 1990. "Le poète, le prince et l'arène: À propos du "Livre des spectacles" de Martial." *Spectacula, I: Gladiateurs et Amphitéatres.* Lattes, 179–84.

Painter, K. S. 1988. "Roman Silver Hoards: Ownership and Status." *Argenterie romaine et byzantine: Actes de la Table Ronde.* Ed. F. Baratte. Paris, 97–105.

Palagia, O. 1986. "Daphne." *LIMC* III.1, 344–48, and III.2, 255–60 (illus.)

Pandermalis, D. 1989. "Dion." *Archaiologia* 33 (December).

Papapostolou, I. A. 1973. "Achaia." *Deltion* 28 B2: 225–26.

———. 1989. "Monuments des combats de gladiateurs á Patras." *BCH* 113: 351–401.

Parlasca, K. 1954. Review of D. Levi, *Antioch Mosaic Pavements*, in *Gnomon* 26: 111–14.

———. 1959. *Die römischen Mosaiken in Deutschland.* Berlin.

———. 1975. "Hellenistische und Römische Mosaiken aus Ägypten." *Colloque II*, 363–69.

Parrish, D. 1981a. "Annus-Aion in Roman Mosaics." *Mosaïque romaine tardive.* Paris, 11–25.

———. 1981b. "The Mosaic Program of the 'Maison de la Procession Dionysiaque' at El Jem." *Mosaïque romaine tardive.* Paris, 51–64.

———. 1984. *Season Mosaics of Roman North Africa.* Rome.

———. 1985. "The Date of the Mosaics from Zliten." *AntAfr* 21: 137–58.

Pelekanides, S. 1974. *Corpus mosaicorum christianorum vetustiorum pavmentorum graecorum*, I: *Graecia Insularis*. Thessalonika.

Pelekanides, S., and P. Atzaka. 1974. *Syntagma ton Palaiochristianikon Psiphidoton Dapedon tis Hellados*. I: *Nisiotiki Hellas*. Thessalonika.

Phillips, K., Jr. 1960. "A Ganymede Mosaic from Sicily." *ArtB* 42: 243–62.

Picard, C. 1941. "Sur les scénes de vénerie d'une mosaïque de Coron, et leurs suites." *Revue archéologique* 18: 159–63.

Picard, G.-Ch. 1956. "Poseidon lysippique de Bérytos et la surprise de la nymphe Béroé, éponyme de Bérytos." *RA*, 224–28.

———. 1959. "Les mosaïques d'Acholla." *Études d'archéologie classique* 2: 75–95.

Picard, G. 1968. "Les Thermes du Thiase Marin à Acholla." *AntAfr* 2: 95–151.

Pickard-Cambridge, A. 1968. *The Dramatic Festivals of Athens*. Oxford.

Poinssot, L., and P. Quoniam. 1952. "Bètes d'amphithéâtre sur trois mosaïques du Bardo." *Karthago* 3: 129–65.

———. 1953. "Mosaïques des Bains des Protomés à Thuburbo Maius." *Karthago* 4 155–67.

Pollitt, J. J. 1966. *The Art of Rome, c. 753 B.C.–337 A.D.* Englewood Cliffs, N.J.

Price, T. H. 1972. "Aurelian Ivory Plaque with Dionysos Triumphant." *ArchCl* 24: 48–58.

Quet, M.-H. 1984. "De l'iconographie a l'iconoglogic: Approche méthodologique: La symbolique du décor des pavements de la 'Maison des Nymphes' de Nabeul." *Revue archéologique* (n.s.) 1: 79–104.

Quinn-Schoffield, W. K. 1967. "Castor and Pollux in the Roman Circus." *Latomus* 26: 450–53.

Rainey, A. 1973. *Mosaics in Roman Britain*. Devon.

Rakob, F. 1964. "Ein Grottentriklinium in Pompeji." *RömMitt* 71: 182–94.

Reinach, S. 1922. *Répertoire de peintures grecques et romaines*. Paris.

Restagno, D. 1955. "Il mosaico de Loano." *RStLig* 21: 129–53.

Rice, E. E. 1983. *The Grand Procession of Ptolemy Philadelphus*. Oxford.

Richardson, L., Jr. 1988. *Pompeii: An Architectural History*. Baltimore and London.

Rizzo, G. E. 1929. *La pittura ellenistico-romano*. Milan.

Robert, L. 1940. *Les gladiateurs dans l'Orient Grec*. Paris.

———. 1948. "Monuments de gladiateurs dans l'Orient Grec." *Hellenica* 5: 77–99.

Robertson, M. 1975. *A History of Greek Art*. Cambridge.

———. 1988. "Europe I." *LIMC* IV.1, 76–92, and IV.2, 33–48, illus.

Rodenwaldt, G. 1930. *Der Klinensarkophag von San Lorenzo*, in *JdI* 14.

Romanelli, P. 1965. "Riflessi di vita locale nei mosaici africani." *Colloques I*, 275–83.

Ross, D. O. 1991. "A New Book on Landscape, Literature and Art in the Late Republic and Early Empire. *JRA* 4: 262–67.

Rouse, W. H. D. 1940. *Nonnos Dionysiaca*. Loeb Classical Library. London and Cambridge, Mass.

Rumpf, A. 1947. "Classical and Post-Classical Greek Painting." *JHS* 67: 10–21.

Russell, D. A., and N. G. Wilson, 1981. *Menander Rhetor*. Oxford.

Salies, G. 1974. "Untersuchungen zu den geometrischen Gliederungsschemata römischer Mosaiken." *BonnJbb* 174: 1–187.

———. 1986. "Römische Mosaiken in Griechenland." *BonnJbb* 186: 241–84.

Salomonson, J. W. 1960. "The Fancy Dress Banquet." *BABesch* 35: 25–65.

———. 1962. "Late-Roman Earthenware with Relief Decoration Found in Northern-Africa and Egypt." *Oudheidkundige Mededelingen Leiden* 43: 53–95.

———. 1965. *La mosaïque aux chevaux de l'antiquarium de Carthage*. The Hague.

Sauer, B. 1890. "Fedra." *RömMitt* 5: 17–24.

Saunders, I. F. 1982. *Roman Crete*. Warminster.

Schefold, K. 1952. *Pompejanische Malerei: Sinn und Ideengeschichte*. Basel.

———. 1957. *Die Wände Pompejis*. Berlin.

Schreiber, Th. 1894. *Alexandrinische Toreutik*. Leipzig.

Schröder, S. F. 1989. *Römische Bacchusbilder in der Tradition des Apollon Lykeios: Studien zur bildformulierung und Bildbedeutung in Späthellenistisch-Römischer Zeit*. Rome.

Schüler, I. 1966. "A Note on Jewish Gold Glasses." *JGS* 8: 48–61.

Scranton, J. W., and L. Ibrahim Shaw. 1976–78. "The Floor Mosaics." In *Kenchreai: Eastern Port of Corinth*, I. Leiden, 91–121.

Scullard, H. H. 1981. *Festivals and Ceremonies of the Roman Republic*. Ithaca.

Semper, G. 1989. *The Four Elements of Architecture and Other Writings*. Trans. H. F. Mallgrave and W. Hermann. Cambridge.

Seyrig, H. 1927. "Inscriptions de Chypre." *BCH* 51: 139–54.

Shear, L. 1930. *The Roman Villa: Corinth V*. Cambridge, Mass.

Sherwin-White, S. M. 1978. *Ancient Cos*. Göttingen.

Sichtermann, H. 1953. *Ganymed: Mythos und Gestalt in der antiken Kunst*. Berlin.

———. 1988. "Ganymedes." *LIMC* IV.1, 154–69, and IV.2, 75–96, illus.

Sichtermann, H., and G. Koch. 1975. *Griechische Mythen auf Römischen Sarkophagen*. Tübingen.

Simon, E. 1981. "Amymone." *LIMC* I.1, 742–52, and I.2, 597–608 (illus.).

Simon, E., and G. Bauchhenss. 1984. "Apollo." *LIMC* II.1, 363–464, and II.2, 182–621, illus.

Soprano, P. 1950. "I triclini all'aperto di Pompei." *Pompeiana* (Naples), 288–310.

Sotheby's. 1990. *The Sevso Treasure: A Collection from Late Antiquity*. London.

Spinazzola, V. 1953. *Pompei alla luce degli scavi di Via dell' Abbondanza*. Rome.

Stern, G. 1967. "Mosaïques de Pont-Chevron près d'Ouzour-sur-Trézée." *Gallia* 25: 49–65.

Stern, H. 1965. "Ateliers de mosaïstes rhodaniens d'époque gallo-romaine." *Colloques I*, 233–43.

———. 1967. *Recueil général des mosaïques de la Gaule*, II: *Lyonnaise*, 1. Paris.

———. 1969. "Deux mosaïques de Vienne." *MonPiot* 56: 13–43.

———. 1979. *Recueil general des mosaïques de la Gaule*, I.1. Paris.

Stevenson, T. B. 1983. *Miniature Decoration in the Vatican Virgil: A Study in Late Antique Iconography*. Tübingen.

Stewart, A. 1974. "To Entertain an Emperor: Sperlonga, Laokoon and Tiberius at the Dinner Table." *JRS* 67: 76–90.

Stillwell, R. 1961. "The Houses of Antioch." *DOP* 15: 47–57.

Stillwell, R., ed. 1941. *Antioch-on-the-Orontes*, III: *The Excavations of 1937–1939*. Princeton.

Strong, D. 1980. *Roman Art*. Norwich.

Sturgeon, M. C. 1977. "The Reliefs on the Theater of Dionysos in Athens." *AJA* 81: 31–53.

Stuveras, R. 1969. *Le putto dans l'art romain*. Brussels.

Taylor, L. R. 1912. *The Cults of Ostia*. Bryn Mawr, Pa.

Thébert, Y. 1987. "Private Life and Domestic Architecture in Roman Africa." In *A History of Private Life*, I: *From Pagan Rome to Byzantium*, ed. P. Veyne. Cambridge, Mass., and London, 313–410.

Thompson, M. L. 1960/61. "The Monumental and Literary Evidence for Programmatic Painting in Antiquity." *Marsyas* 9: 36–77.

Thouvenot, R. 1941. "La Maison d'Orpheé à Volubilis." *Publications du Service des Antiquités du Maroc* 6: 42–66.

Thouvenot, R., and A. Luquet. 1951. "Les Thermes de Banasa." *Publications du Service des Antiquités du Maroc* 9: 40–49.

Tormo, E. 1940. *Os desenhos das antiqualhas que vio Francisco d'Ollanda*. Madrid.

Toynbee, J. M. C. 1944. "Roman Medallions." *Numismatic Studies* 5: 115–21.

———. 1945. Rev. of A. Alföldi, *Die Kontorniaten*, In *JRS* 35: 115–21.

———. 1951. *Some Notes on Artists in the Roman World (Collection Latomus VI)*. Brussels.

———. 1955. Rev. of K. Schefold, *Pompejanische Malerei: Sinn und Ideengeschichte*, in *JRS* 45: 192–95.

———. 1973. *Animals in Roman Life and Art*. Ithaca.

———. 1982. "Life, Death and Afterlife on Roman-Age Mosaics." *Jenseitsvorstellungen in Antike und Christentum* 9: 210–15.

———. 1986. *The Roman Art Treasures from the Temple of Mithras*. Special Paper no. 7, London and Middlesex Archaeological Society.

Toynbee, J. M. C., and J. B. Ward-Perkins. 1950. "Peopled Scrolls: A Hellenistic Motif in Imperial Art." *PBSR* 18: 1–49.

Tran Tam Tinh, V. 1974. *Catalogue des peintures romaines du musée du Louvre*. Paris.

Travlos, J. 1971. *Pictorial Dictionary of Ancient Athens*. New York.

Trendall, A. D. 1977. "Poseidon and Amymone on an Apulian Pelike." In *Festschrift für Frank Brommer*, ed. U. Höckman and A. Krug. Mainz, 281–87.

Trilling, J. 1989. "The Soul of the Empire: Style and Meaning in the Mosaic Pavement of the Byzantine Imperial Palace in Constantinople." *DOP* 43: 27–72.

Trypanis, C. A. 1958. *Callimachus: Aetia*. Loeb Classical Library. London and Cambridge, Mass. (Rpt. ed. 1975).

Turcan, R. 1966. *Les sarcophages romains à reprèsentations dionysiaques*. Paris.

Tzedakis, G. 1969. "Kastelli Kisamou." *Deltion* 24 (B2, *Chronika*): 431–32.

———. 1972. "Kastelli Kisamou (Chania)." *Deltion* 27 (B2, *Chronika*): 637–38.

———. 1970. "Anaskaphe Plateias Metropoleos Chanion." *Archdelt* 25 (B2) 467–68.

———. 1979. "Oikopetho Pateraki." *ArchDelt* 112: 397–98.

Vermeule, C. 1976. *Greek and Roman Cyprus*. Boston.

Vermeule, C. V., and M. B. Comstock. 1976. *Sculpture in Stone*. Boston.

Veyne, P. 1990. *Bread and Circuses*. London.

Ville, G. 1965. "Essai de datation de la mosaïque des Gladiateurs de Zliten." *Colloques I*, 147–55.

Vogliano, A., F. Cumont, and C. Alexander. 1933. "The Bacchic Inscription in the Metropolitan Museum." *AJA* 37: 215–70.

von Blanckenhagen, P. 1940. *Flavische Architecktur und ihre Dekoration untersucht am Nerva Forum*. Berlin.

von Boeselager, D. 1983. *Antike Mosaiken in Sizilien*. Rome.

von Gonzenbach, V. 1961. *Die römischen Mosaiken in Schweiz*. Basel.

Waagé, F. O. 1941. "Lamps." In *Antioch-on-the-Orontes*, III: *The Excavations of 1937–1939*, ed. R. Stillwell. Princeton.

Waites, M. 1919. "The Meaning of the Dokana." *AJA* 23: 1–18.

———. 1920. "The Nature of the Lares." *AJA* 24: 241–61.

Wallace-Hadrill, A. 1983. "Ut Picura Poesis?" Review of J. M. Croisille, *Poésie de Néron aux Flaviens: Recherches sur l'iconographie et la correspondance des art à l'époque imperiale*. *JRS* 73: 180–83.

———. 1988. "The Social Structure of the Roman House." *PBSR* 56: 43–97.

———. 1994. *Houses and Society in Pompeii and Herculaneum*. Princeton.

Ward-Perkins, J. B. 1952. "The Shrine of St. Peter and Its Twelve Spiral Columns." *JRS* 42: 21–33.

———. 1975–76. "Workshops and Clients: The Dionysiac Sarcophagi in Baltimore." *RendPontAcc*, 48: 191–238.

———. 1980. "Nicomedia and the Marble Trade." *PBSR* 48: 23–69.

Ward-Perkins, J. B., and J. M. C. Toynbee. 1949. "The Hunting Baths at Lepcis Magna." *Archaeologia* 93: 165–95.

Waywell, S. E. 1979. "Roman Mosaics in Greece." *AJA* 83: 293–321.

———. 1983. "A Roman Villa at Knossos, Crete." *Mosaic: AIEMA British Branch* 8: 11–13.

Webster, G. 1969. *The Roman Imperial Army of the 1st and 2nd Centuries A.D.* London.

Wegner, M. 1976–77. "Gewundene Säulen von Ephesos." *JOAIBeibl* 51: cols. 48–64.

Weinberg, S. S. 1960. *Corinth I, V: The Southeast Building, the Twin Basilicas, the Mosaic House.* Princeton.

Weitzmann, K. 1941. "Illustrations of Euripides and Homer in the Mosaics of Antioch." *Antioch-on-the-Orontes*, III: *The Excavations of 1937–1939*, ed. R. Stillwell. Princeton, 233–47.

———. 1979. *Age of Spirituality: Late Antique and Early Christian Art, Third to Seventh Centuries.* New York.

Welch, K. 1991. "Roman Amphitheaters Revived." *JRS* 4: 272–81.

Wigley, M. 1992. "Untitled: The Housing of Gender." In *Sexuality and Space*, ed. B. Colomina. Princeton, 327–88.

Wiseman, J. 1979. "Corinth and Rome, I: 225 B.C.–A.D. 267." *ANRW* VII:2. Berlin, 439–547.

Yacoub, M. 1970. *Musée du Bardo, Musée Antique.* Tunis.

Zanker, P. 1979. "Die Villa als Vorbild des späten pompejanischen Wohngeschmacks." *JdI* 94: 460–52.

Index

Nonnos, 151, 155, 156, 166–67, 172, 173, 176n, 182, 188. *See also Dionysiaca*
North Africa. *See also names of North African sites*
 female busts in, 95n, 96–98
 influence of, on Paphos, 100–104, 231, 235–42, 253, 255, 266, 269, 288
 mythological subjects in, 30
 Paphian architectural comparisons with, 13–14, 16–17, 20–21, 23, 119–20, 146
 patterns in, 60, 72–74, 78n, 120, 125–26, 131, 133, 145, 319
 peacock mosaics from, 113–16
 and transmission of models, 59, 75, 76, 84, 123, 241
nymphaeum, 23. *See also* fountains
nymphs, 154, 166–67, 189, 190

Oceanus, 98, 114, 318
Oea (Libya), 280
oecus. *See also* reception areas
 in House of Menander, 86
 in House of Neptune, 13, 16, 20, 328
 in House of Tertulla, 216, 218, 238
 in House of the Laberii, 177, 267
 in House of the Labors of Hercules, 22
 in Villa of Dionysos, 329
oinochoe, 130
d'Ollanda, Francesco, 196
Olympia (Greece), 59
Oppian, 228
opus sectile, 76, 278, 279, 280, 280
opus signinum, 76
opus tessellatum, 76
Orbe (Switzerland), 38, 182n
 Ganymede in, 137, 138, 141
 genre scenes in, 258, 258, 317
 hunting scenes in, 285, 286, 288, 290, 294, 299
Orontes River (Syria), 155, 170
Orpheus, 322n. *See also* Volubilis: House of Orpheus
Ostia (Italy)
 Baths of the Seven Sages, 276, 293n, 294, 299
 fountain courts in, 23
 Horrea Epagathiana et Epaphroditiana, 78
 House of Fortuna Annonaria, 311
 House of Jupiter and Ganymede, 136n
 House of Serapis, 130–31
 House of the Dioscuri, 225–26
 patterns in, 77, 82
 Temple of the Shipbuilders, 79
ostriches, 275, 294
Oudna (Tunisia), 165
 House of the Laberii, 17n, 254, 287
 genre scenes in, 255, 267, 317
 hunting scenes in, 285–87, 298, 300n, 305, 311n, 327–28

vine carpet and Dionysos mosaic in, 177, 178, 180, 238, 239, 241, 242, 253n, 255
Ouzouër-sur-Trézée (France), 69, 70, 73–74, 124
Ovid, 148
 on Apollo and Daphne, 168–70, 173, 174
 on Ganymede, 136
 on Hippolytos and Phaedra, 50
 on Narcissus, 34, 36
 on peacock "eyes," 116n
 on Pyramos and Thisbe, 150, 153–54, 156

pageants (Dionysiac), 105–6, 238, 250, 264
Painter, K. S., 322
paintings. *See also* Pompeian paintings
 as models for mosaics, 35–36, 38, 82, 159, 188–89, 201, 219, 220, 238
 and mosaics from Campania, 12, 102, 104, 105
 Philostratus' description of *xenia*, 129
 and poetry, 186
 similarities between mosaics and, 196, 320–22
Palaipaphos (Cyprus), 4. *See also* Paphos
Palmyra (Syria), 185
Pan, *color plate 2*, 193, 193, 198, 201, 203, 205–6, 208, 211, 212, 218
Pancles Veranianus of Salamis, 324–25
Paphian Aphrodite, 4, 6
Paphian workshop. *See also* models; Paphos: House of Dionysos; workshops
 connections between Antiochene workshop and, 28–29, 50, 51, 58–59, 83, 84, 96, 147–48, 154–56, 174
 creativity in, 32–33, 36–37, 53, 55, 58, 61, 64, 66–67, 71, 81, 84, 86, 103, 113, 116, 120, 124, 132, 149, 180–82, 192, 235–36, 253–55, 259–60, 262–63, 268–69, 281, 319
 definition of, 28n
 eastern identity of, 29–30, 58–59, 75, 76, 80, 83, 123, 147
 eastern influences on, in House of Dionysos, 29–30, 75, 95–96, 121–23, 147–48, 154–55, 167, 170–72, 174, 185, 188, 242, 253, 318, 328–29, 332
 geometric design characteristics of, 53, 55, 58–60
 mistakes of, 205, 210–11, 213–14
 North African influence on, 100–104, 231, 235–42, 253, 255, 266, 269, 288
 practices of, 83–84, 259–60, 262–63
 quality of, 29, 36–38, 83, 196, 219
 western influences on, 25, 61, 75, 77, 84, 95–96, 113, 116, 121, 122–24, 131–32, 170, 253, 274, 281, 288–89, 319, 323, 328
Paphos (Cyprus)
 amphitheater in, 4
 House of Aion, 56, 184–86, 198, 199, 323n